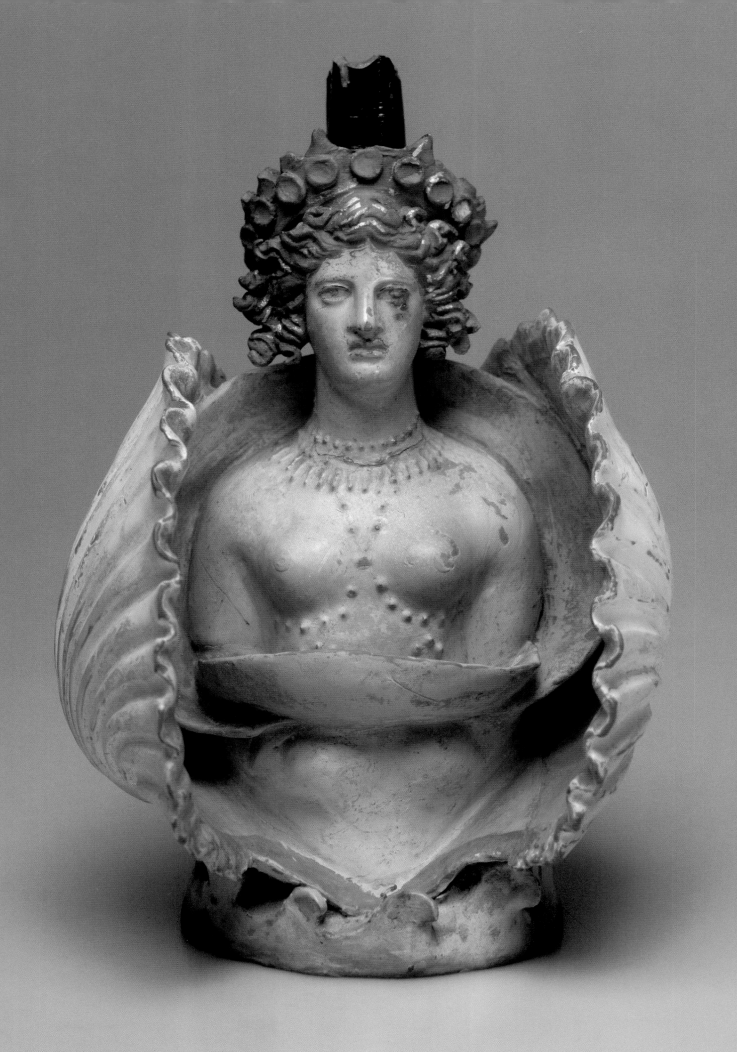

Edited by Anna A. Trofimova

Greeks on the Black Sea

Ancient Art from the Hermitage

J. Paul Getty Museum · Los Angeles

© 2007 J. Paul Getty Trust
© 2007 Text and Illustrations, The State Hermitage Museum

Published by decision of the Editorial Publishing Council
of The State Hermitage Museum and by the J. Paul Getty Museum

This catalogue is issued in conjunction with the exhibition *Greeks
on the Black Sea: Ancient Art from the Hermitage,* held at the Getty Villa,
Malibu, June 14–September 3, 2007

The exhibition was sponsored by

Merrill Lynch

Getty Publications
1200 Getty Center Drive, Suite 500
Los Angeles, California 90049-1682
www.getty.edu

At The State Hermitage Museum

Organizing Committee of The State Hermitage Exhibition

Prof. Dr. M. B. Piotrovsky
Director of The State Hermitage Museum
Prof. Dr. G. V. Vilinbakhov
Deputy Director of The State Hermitage Museum
Dr. V. Y. Matveyev
Deputy Director of The State Hermitage Museum
Dr. A. A. Trofimova
Head of the Department of Greek and Roman Antiquities

Editor
A. A. Trofimova
Head of the Department of Greek and Roman Antiquities

Curators
A. A. Trofimova
Head of the Department of Greek and Roman Antiquities
Y. P. Kalashnik, *Senior Researcher*

Editorial Preparation
N. C. Jijina, *Senior Researcher*

Working Group
A. A. Miklyaeva, *Head of Rights and Reproductions*
A. M. Butyagin, *Researcher*
D. E. Chistov, *Researcher*
Y. I. Ilyina, *Senior Researcher*
N. C. Jijina, *Senior Researcher*
N. Z. Kunina, *Senior Researcher*
O. Y. Sokolova, *Senior Researcher*
S. L. Solovyov, *Senior Researcher*
E. V. Vlasova, *Researcher*
M. M. Akhmadeyeva, *Assistant*

The restoration work on the exhibited works was conducted
under the supervision of the Deputy Director of the
State Hermitage Museum, Head Curator T. I. Zagrebina, and
the Head of the Department of Scientific Restoration and
Conservation, T. A. Baranova.

Restorers: K. N. Blagoveshchensky, N. A. Bolshakova, N. V.
Borisova, S. G. Burshneva, E. P. Cherepanova, M. V. Denisova,
L. P. Gagen, V. A. Klur, K. V. Lavinskaya, K. N. Medvedkov,
N. A. Panchenko, S. L. Petrova, M. G. Popova, A. I. Pozdniak,
O. L. Semenova, O. Y. Senatorova, T. V. Shlykova,
G. I. Ter-Oganian, M. P. Vinokurova, N. B. Yankovskaya.

S. V. Suetova and K. V. Sinyavsky, *Photographers*

At Getty Publications

Mark Greenberg, *Editor in Chief*

Benedicte Gilman, *Editor*
Daniel Rishik, *Translator*
Mary Christian, *Manuscript Editor*
Jeffrey Cohen, *Designer*
Elizabeth Chapin Kahn, *Production Coordinator*
David Fuller, *Cartographer*
Marian Stewart, *Illustrator*
Diane Franco, *Typesetter*

All illustrations have been provided by The State Hermitage
Museum, St. Petersburg.

Printed in China by South Sea International Press, Ltd.

Library of Congress Cataloging-in-Publication Data

Greeks on the Black Sea : ancient art from the Hermitage /
edited by Anna A. Trofimova.
 p. cm.
 Catalog of an exhibition at the J. Paul Getty Museum,
June 14–Sept. 3, 2007.
 Includes bibliographical references and index.
 ISBN 978-0-89236-883-9 (hardcover)
1. Art, Greek—Ukraine—Black Sea Lowland—Exhibitions. 2. Art,
Ancient—Ukraine—Black Sea Lowland—Exhibitions. 3. Art—
Russia (Federation)—Saint Petersburg—Exhibitions. 4. Gosu-
darstvennyi Ermitazh (Russia)—Exhibitions. 5. Black Sea Lowland
(Ukraine)—Antiquities—Exhibitions. I. Trofimova, Anna A.
II. J. Paul Getty Museum.
 N5871.U472B554 2007
 709.38'07479494—dc22

 2007008006

Halftitle page: Drawing of carved gem, cat. no. 154.
Frontispiece: Plastic vase with Aphrodite in a sea shell, cat. no. 60.
Page v: Gold phiale, cat. no. 139.
Page vii: Silver pyxis, cat. no. 77.

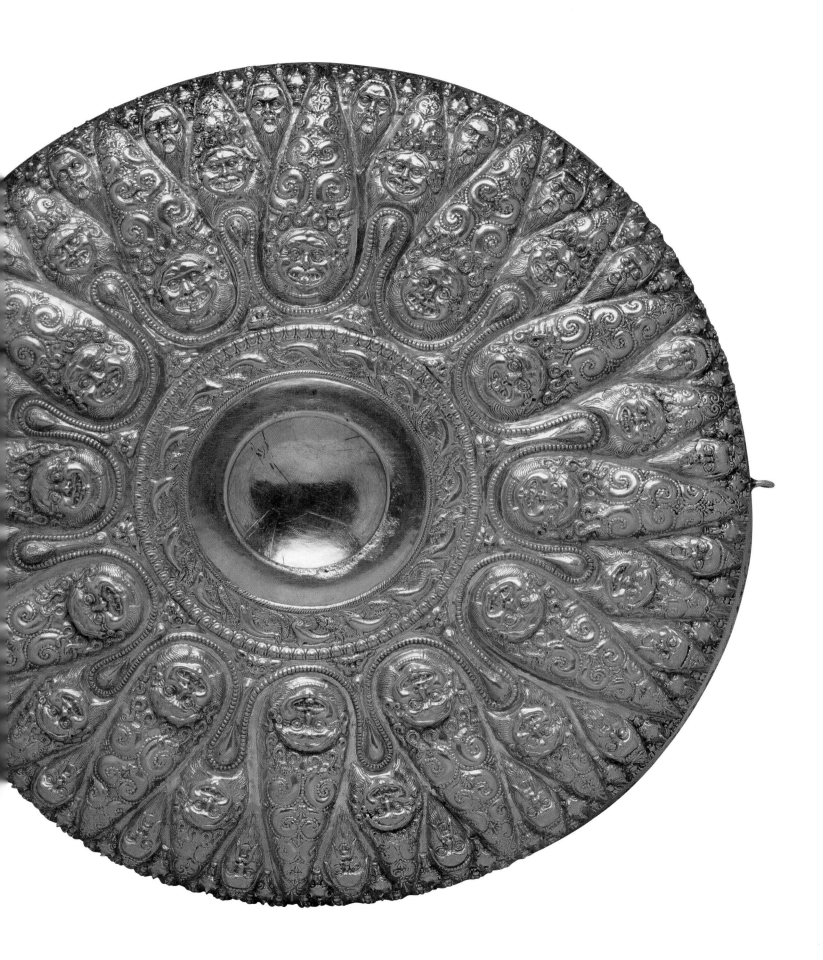

Contents

Catalogue

Foreword

When ancient Greeks first ventured into the Black Sea, in the eighth and seventh centuries B.C., they were entering the unknown. The Greek geographer Strabo (63 B.C.–A.D. 21) relates that, when the Greeks first encountered the dark, forbidding waters of the Black Sea, they called it the Inhospitable Sea; but once they had occupied the area, they renamed it the Hospitable Sea. Greek colonies were soon established near major rivers and on both sides of the Kerch Strait, the narrow waterway that links the Black Sea with the Sea of Azov—the traditional division between Europe and Asia. The earliest Greek settlement in the northern Black Sea region, Borysthenes, was founded in the late seventh century B.C. on the island of Berezan. It was soon followed by others, including Pantikapaion (present-day Kerch), Olbia, and Chersonesos.

During the early periods of these settlements, objects, especially clay vessels, were generally imported from throughout the Mediterranean region. As the cities prospered through trade with indigenous peoples, particularly the Scythians, local production of artifacts increased and distinctive types and styles emerged. Artisans working in these northern Black Sea colonies produced many unique works that show evidence of links between Hellenic artistic traditions and the ancient cultures of the Eurasian steppes. Gold was abundant and readily available, and the Scythians already had a preference for luxurious objects.

Greeks on the Black Sea: Ancient Art from the Hermitage is the first major exhibition in the United States to showcase the great variety of material both imported and locally produced in cities founded by ancient Greeks in the northern Black Sea regions. Because these areas had long been inhabited by various nomadic tribes, most notably the Scythians, many items show the cross-cultural influences of eastern and western elements. Nearly two hundred works of art have been selected from the rich holdings of the State Hermitage Museum, which acquired its first objects from the region in 1818. The accidental discovery of a silver wine cup and a lidded box (cat. nos. 76 and 77) piqued the interest of Czar Alexander I (r. 1801–1825), who then supported systematic archaeological explorations by Hermitage staff on his behalf. Nearly two hundred years of investigation in the northern Black Sea region has brought to the Hermitage some of the most spectacular and distinctive objects produced either in or for this easternmost part of the ancient Greek world.

The exhibition comprises a range of works from the Greek and Roman periods—including many masterpieces of gold working—from the settlements of Borysthenes, Olbia, and Chersonesos, the area of the Bosporan kingdom in the Crimea, and from burial mounds such as Kul Oba, Yuz Oba, the Great Bliznitsa, and the Seven Brothers.

We are grateful to our colleagues in the State Hermitage Museum for the opportunity to present this art from the periphery of the Greek world that will, in turn, help illuminate its center. Special thanks are due to Mikhail Piotrovsky, Director of the State Hermitage Museum, for his enthusiastic support of this project. Our sincere gratitude goes

to Merrill Lynch, whose sponsorship helped make this extraordinary exhibition possible. We appreciate their continued support of the J. Paul Getty Museum's special exhibitions and programming.

This exhibition will expand our vision of the accomplishments of ancient Greek artists by adding a different dimension to the achievements that are more familiar to us. The picture that emerges of ancient Greek art is one more inventive, colorful, and opulent than previously imagined.

<div align="right">

MICHAEL BRAND

Director, The J. Paul Getty Museum
Los Angeles, California

</div>

The Hermitage and the Black Sea

The exceptional display of unique items in this exhibition presents an astonishing phenomenon in the world's history. Greek colonies on the shores of the Black Sea—a specific region of the Hellenic world—were closely connected with their motherland, the center of their economy. The Greeks brought their culture to the territory, which much later became known as Russia. The art and culture of Greek colonies formed the background of our antiquity and tied us directly to the foundation of European civilization.

The area of the North Pontic Greek poleis proved to be a surprising symbiosis of the classical Hellenic world and the world of Scythian "barbarians." The result of this unusual cultural phenomenon was the development of a local art that combined the aesthetics of antiquity with a specific tradition of nomadic style. This synthesis played a great part in the evolution of many cultures in Europe and Asia.

Research and archaeological excavations in the Black Sea area that have been going on for more than two centuries are important parts of Russian scholarly studies of the nineteenth and twentieth centuries. These undertakings became both the result and the cause of renewed interest in Hellenic culture, bringing this heritage back to our consciousness. Greek cultural achievements and Greek myths penetrated into Russian life to become an integral part of it.

For years the Hermitage participated in archaeological research and preservation of wonderful finds from the Northern Black Sea coast. The museum's galleries and scholarly publications open a page of beautiful illuminations in the book of mankind's history.

It is with great pleasure that we present this exhibition to the world. It far surpasses all previous exhibitions ever organized by the Hermitage on this theme. Objects from all the important centers of the Northern Black Sea coast are displayed here: They come from the island of Berezan, from the cities of Olbia and Chersonesos, and from the Bosporan kingdom. Many remarkable items are brought together—pieces of jewelry and toreutics, Kerch vases, vessels decorated with scenes from Scythian life, wooden sarcophagi, marble and bronze portraits of Bosporan rulers, Dexamenos's gemstones, and plaster decorations. Among the objects are the world-famous golden earrings from Theodosia made in microtechnique, the Phanagorian plastic vase in the shape of Aphrodite emerging from a seashell, the bronze portrait of a Bosporan queen, and the fresco representing the ship *Isis*. Carefully chosen for the exhibition, these items illuminate both of the ancient world and the Russian school for the study of classical antiquity. The Hermitage scholars and curators have saved this flame of ancient art and old knowledge to share them with the world. I believe that this generosity will help the visitors get the real pleasure of new knowledge and the enjoyment of beauty—at once well known and unusual.

MIKHAIL PIOTROVSKY
Director, The State Hermitage Museum
St. Petersburg, Russia

Acknowledgments

From the beginning, a truly collaborative spirit has infused and invigorated this project with its remarkable assemblage of objects. Our greatest thanks go to Mikhail Piotrovsky, Director of the State Hermitage Museum, for his immediate interest in the concept of this exhibition and for his agreement to lend some of the Hermitage's most precious treasures. We must also express our gratitude to Michael Brand, Director of the J. Paul Getty Museum, for his enthusiastic support and guidance.

A congenial partnership developed among the lead curators of the exhibition, on the one hand, Anna Trofimova, head of the Department of Greek and Roman Antiquities, and Yuri Kalashnik, emeritus head of the Department of Greek and Roman Antiquities, at the State Hermitage Museum, and, on the other hand, Janet Grossman, associate curator of antiquities at the J. Paul Getty Museum. Expertise and experience combined to bring this exhibition to the Getty Villa. Jens Daehner, assistant curator of antiquities at the Getty Museum, and Maria Akhmadeyeva, research assistant at the Hermitage, assisted the lead curators, and we are grateful to them for their efforts. Karol Wight, the Getty Museum's acting curator of Antiquities, lent her support and encouragement.

Vladimir Matveyev, Deputy Director of the State Hermitage Museum; Quincy Houghton, assistant director at the J. Paul Getty Museum; and Liz Andres, exhibitions coordinator for the Getty Villa, ably handled the many complex administrative details for the exhibition. Olga Ilmenkova at the State Hermitage Museum was of invaluable help for contract and shipping details.

Each object selected by the curators for the exhibition was assessed by Hermitage conservators; many objects were given special treatment so that they would appear at their best in the exhibition. We gratefully acknowledge that work excuted by many members of the Department of Scientific Restoration and Conservation at the State Hermitage Museum, under the direction of T. A. Baranova. At the Getty, Marie Svoboda, associate conservator of Antiquities, and Jeff Maish, associate conservator of Antiquities, directed the effort to provide specially designed mounts for each object to mitigate the effects of a possible earthquake. Our thanks go to mountmakers B. J. Farrar, McKenzie Lowry, and David Armenderiz for their work.

Appreciation goes to Merritt Price, Davina Henderson, Andrew Pribuss, Lily Lien, and Robert Checchi for the innovative and elegant design of the exhibition; to Sahar Tchaitchian for her meticulous editing of all promotional and gallery texts; to Bruce Metro, Kevin Marshall, Marcus Adams, Alfonso Aguilar, and Justin Lowman for their careful handling and installation of the works of art; and to Sally Hibbard, Nancy Russell, and Sarah Christie, who worked with their Hermitage counterparts to make arrangements for the shipping of the objects to the Getty.

The exhibition was enlivened by seventeen GettyGuide™ audio stops and by a special feature on the Getty's website. For production of the audio tour, we are grateful to Alison Glazier and Andrew Clark; for the creative web pages, Susan Edwards.

The scholarly and sumptuous catalogue of the exhibition was written by Hermitage curators, all reknown experts in their fields. Georgy Vilinbakhov, Deputy Director for Research at the Hermitage Museum, oversaw the research process and secured approvals in St. Petersburg. For the essays, we thank Alexander Butyagin, Lyudmila Davydova, Nadia Jijina, Yuri Kalashnik, Oleg Neverov, Anna Petrakova, and Anna Trofimova. Entries for each object in the exhibition were written by Alexander Butyagin, Dmitry Chistov, Lyudmila Davydova, Yulia Ilyina, Nadia Jijina, Yuri Kalashnik, Nina Kunina, Lyudmila Nekrasova, Oleg Neverov, Anna Petrakova, Olga Sokolova, Sergei Solovyov, Anna Trofimova, Lyubov' Utkina, and Elena Vlasova. Production of the catalogue for the exhibition was coordinated by Elizabeth Kahn, edited by Benedicte Gilman and Mary Christian, and designed by Jeffrey Cohen, all of Getty Publications. Daniel Rishik provided the translations from the Russian. Photography of the objects was done at the Hermitage by S. V. Suetova and K. V. Sinyavsky.

A special note of recognition is due Nadia Jijina, senior researcher at the Hermitage Museum, who was extraordinarily helpful to the editors, making herself available to them night and day for weeks on end, and answering promptly and efficiently upward of a thousand e-mail queries.

We are indebted to all of our colleagues in this endeavor and hope that the presentation of these master works of art will be an inspiration and revelation for visitors and readers alike.

DR. ANNA A. TROFIMOVA
*Head of the Department
of Greek and Roman Antiquities
The State Hermitage Museum
St. Petersburg, Russia*

DR. JANET B. GROSSMAN
*Associate Curator of Antiquities
The J. Paul Getty Museum
Los Angeles, California*

Abbreviations

Ael.	Aelianus
Ar. *Vesp.*	Aristophanes *Wasps*
cat.	catalogue
cc	cubic centimeter
cf.	compare
Cic. *Flac.*	Cicero *Pro Flacco*
cm	centimeter
D	depth
Diam	diameter
Diod. Sic.	Diodoros of Sicily
ed.	editor/edited by
edn.	edition
exh.	exhibition
fasc.	fascicule
fig./figs.	figure/figures
g	gram
H	height
Hdt.	Herodotos
i.e.	that is
Just. *Epit.*	Justinus *Epitome*
L	length
no./nos.	number/numbers
p./pp.	page/pages
pl./pls.	plate/plates
pt.	part
rev.	revised
Strab.	Strabo
s.v.	under the word
Trans.	translator/translated by
vol./vols.	volume/volumes
W	width

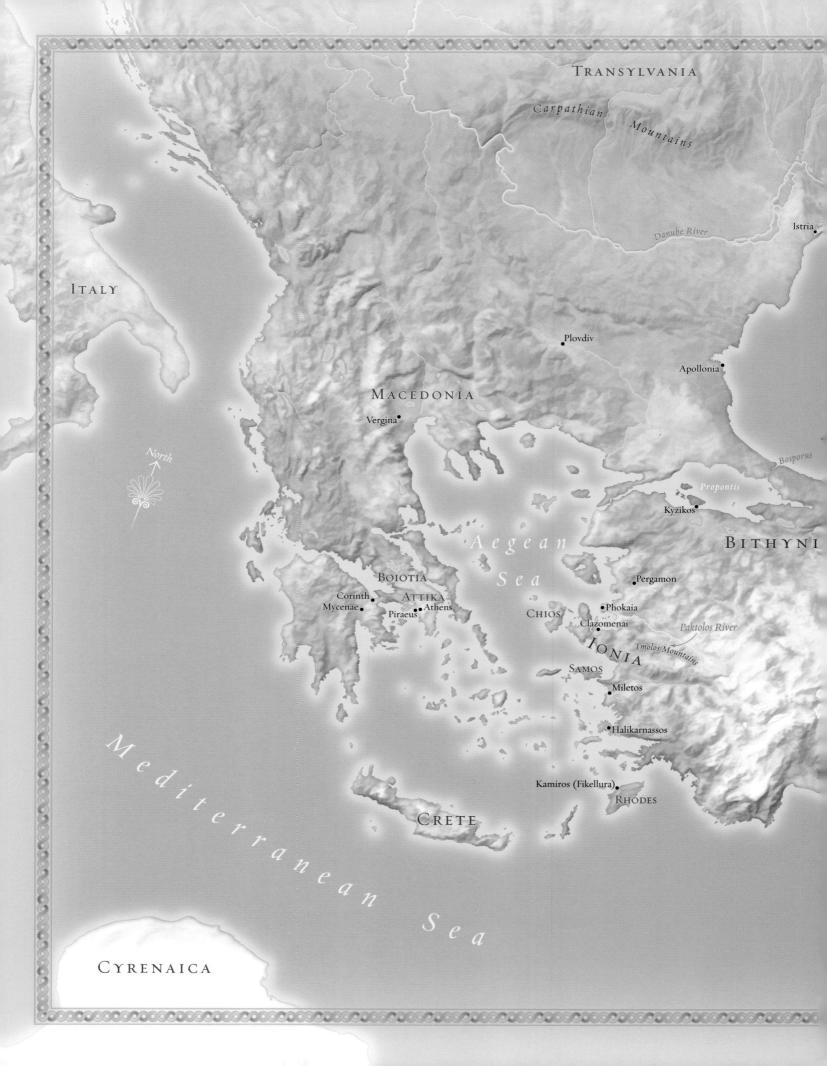

TRANSYLVANIA

Carpathian Mountains

Danube River

Istria

ITALY

Plovdiv

Apollonia

MACEDONIA

Vergina

Bosporus

North

Propontis

Kyzikos

Aegean Sea

BITHYNI

BOIOTIA

Pergamon

Corinth

ATTIKA

Phokaia

Mycenae

Athens

CHIOS

Piraeus

Clazomenai

Paktolos River

Tmolos Mountains

IONIA

SAMOS

Miletos

Halikarnassos

Mediterranean Sea

Kamiros (Fikellura)

RHODES

CRETE

CYRENAICA

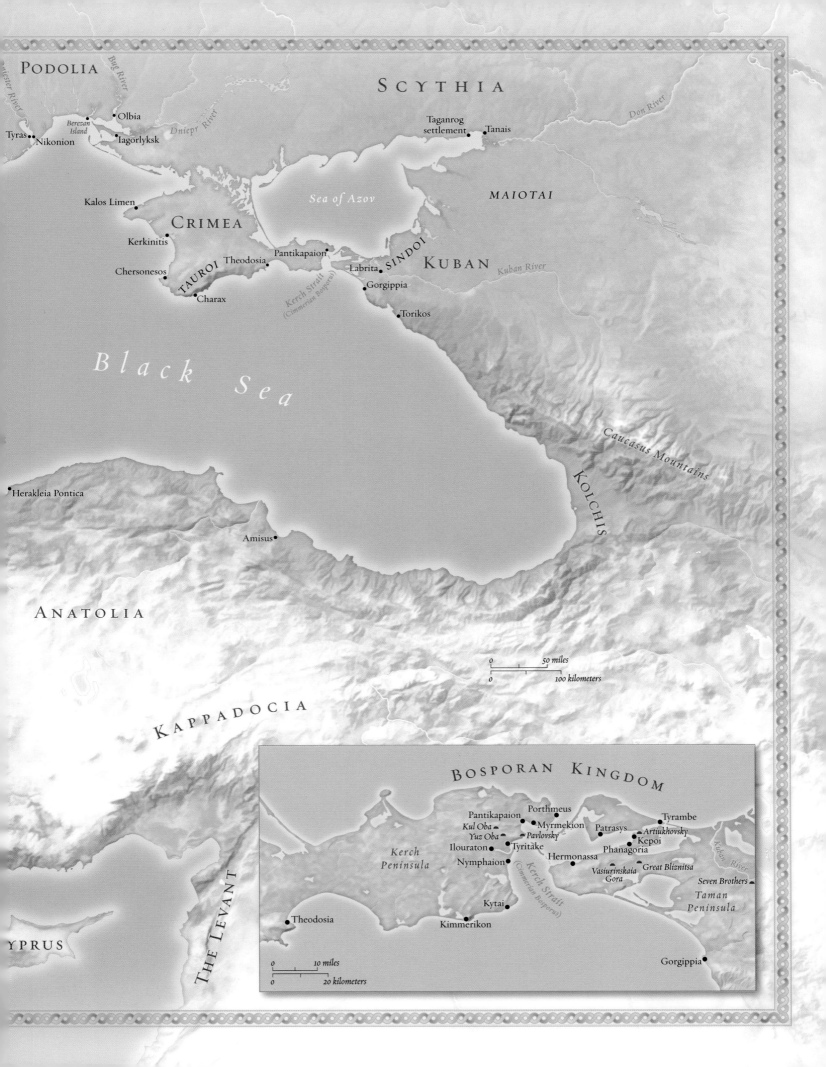

PODOLIA

Bug River

SCYTHIA

Don River

Olbia

Berezan Island

Tyras
Nikonion
Iagorlyksk

Dniepr River

Taganrog settlement
Tanais

Sea of Azov

MAIOTAI

Kalos Limen

CRIMEA

Kerkinitis

Theodosia
Pantikapaion

Labrita
SINDOI
KUBAN

Kuban River

Chersonesos
TAUROI

Gorgippia

Charax

Kerch Strait (Cimmerian Bosporus)

Torikos

Black Sea

Caucasus Mountains

KOLCHIS

Herakleia Pontica

Amisus

ANATOLIA

0 50 miles
0 100 kilometers

KAPPADOCIA

THE LEVANT

CYPRUS

BOSPORAN KINGDOM

Kerch Peninsula

Pantikapaion Porthmeus
Kul Oba Myrmekion Patrasys Tyrambe
Yuz Oba *Pavlovsky* *Artiukhovsky*
Ilouraton Tyritake Kepoi
Nymphaion Phanagoria
 Hermonassa
 Vasiurinskaia Gora Great Bliznitsa
 Seven Brothers

Kerch Strait (Cimmerian Bosporus)

Kuban River

Kytai
Theodosia

Taman Peninsula

Kimmerikon

Gorgippia

0 10 miles
0 20 kilometers

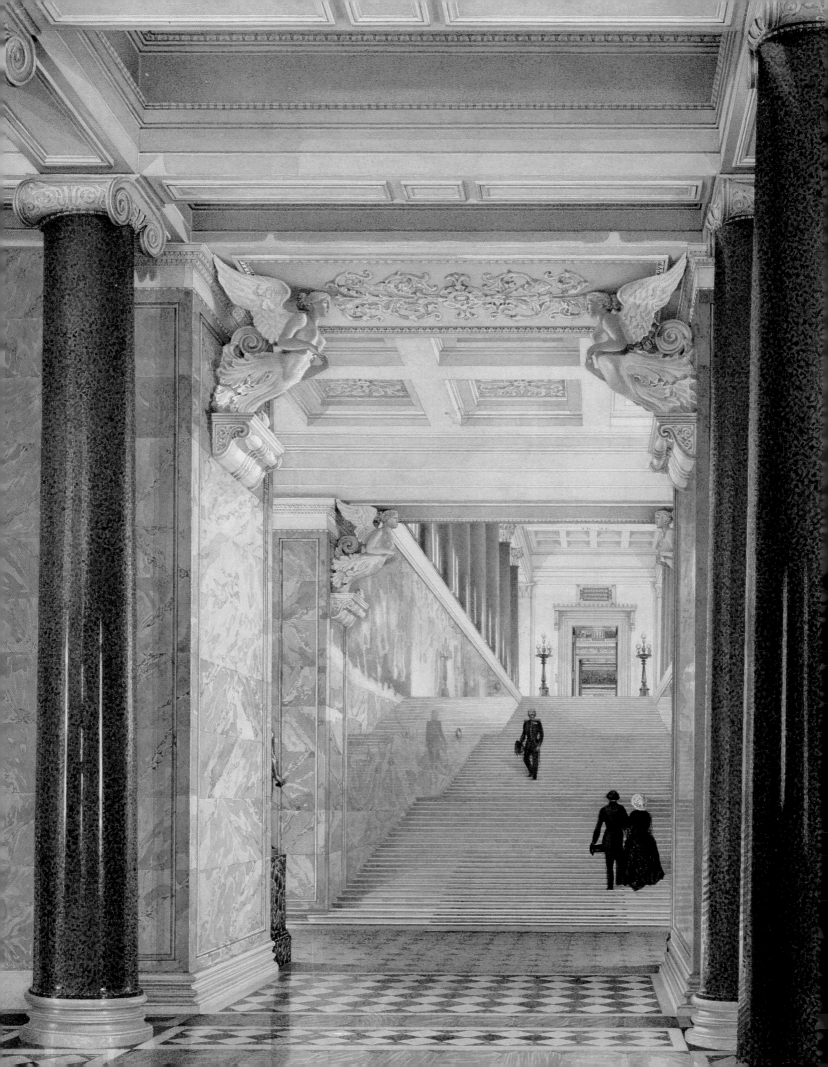

The History of the Exploration of the Northern Black Sea Region and Ancient Monuments at the Hermitage

YURI P. KALASHNIK

B Y THE END OF THE EIGHTEENTH CENTURY RUSSIA HAD BECOME ESTAB- lished on the Black Sea by annexing its northern shores and Crimea following its victories in the Russo-Turkish Wars. At the end of that cen- tury the area was visited by the academician P. S. Pallas; Russian and foreign travelers P. I. Sumarokov, M. Gouthrie, and E. D. Clarke; and three decades later by F. Dubois de Montpereux. They were the first to document city ruins, charting and sketching ancient walls, individual monuments, and the mainly Greek inscriptions.

Already in the early part of the eighteenth century scholars had been expressing an interest in the ancient history of the Black Sea coast. The works on this region by G. S. Bayer are well known. At that time, on the basis of the writings of ancient historians and geographers, the first attempts were made to establish the location of Greek settlements on the Black Sea. Even before the main archaeological discoveries had been made, H. K. E. Köhler, the first Hermitage antiquities scholar, published a treatise on fishing on the ancient Black Sea coast: *TAPIXOΣ, ou recherches sur l'histoire et sur les antiquités des pêcheries de la Russie méridionale* (St. Petersburg, 1832). Understandably, his sources were rather meager, but interest in the economic history of the region was part of the process of settling it. Thus, by the beginning of the nineteenth century there was already a considerable body of knowl- edge about classical antiquity in southern Russia. The Russians gave the names of ancient Greek cities to many of the towns and cities that were being built in the newly acquired territories, although they were not very meticulous about the exact correspondence of the chosen names with the names of the neighboring ruins of ancient cities. Thus Odessa, Kherson, Eupatoria, and Sevastopol made their appearance. On the other hand, such an ancient name as Theodosia blended organically with the new toponyme. The efforts of the

Front staircase and entrance hall of the New Hermitage, St. Petersburg.
Watercolor by Konstantin Ukhtomsky, 1853.

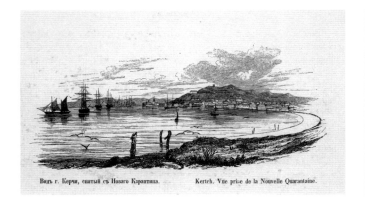

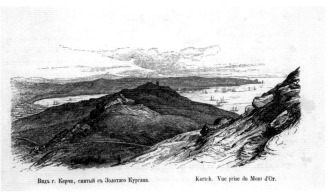

Fig. 1.1. View of
Kerch (ancient Pan-
tikapaion) from
the New Quarantine.
The hill above the city
is Mount Mithradates.
From *ABC*.

Fig. 1.2. View of
Kerch from the Golden
(Zolotoy) kurgan to
the west. The range
in the middle is Mount
Mithradates. From
ABC.

Fig. 1.3. View of Kerch
from the Pavlovsky
kurgan. From *ABC*.

first researchers are still relevant today, for time and human activity have destroyed much of what was still clearly visible two hundred years ago. Modern-day archaeologists who are restoring the outlines of city walls, and who study effaced inscriptions and investigate the circumstances of the first archaeological discoveries turn to the notes and drawings of these inquisitive individuals.

The formation of the Hermitage collection of antiquities was closely linked to the growth of interest in the treasures found in the newly settled territories. The first antiquities, discovered either during construction or as a result of fortuitous excavations, arrived at the Hermitage in the late eighteenth and early nineteenth centuries. H. K. E. Köhler, the antiquities curator at the Hermitage who had begun his career as its librarian and curator of carved stones and medals, visited many of the ancient monuments of the Black Sea region in 1804 and 1821. His books, which were dedicated to various aspects of ancient history and culture, his publication of the first epigraphic finds, and his critical reviews of published essays laid the foundations for the scientific approach to the study of ancient monuments in Russia. In his journeys he saw the mistreatment of ancient ruins in many places and was the first to raise the question of their preservation. As a result, a government decree was issued—the first for that area—ensuring the safeguarding and conservation of ancient monuments.

Köhler himself conducted small-scale excavations during his travels. In 1804 he excavated the so-called Comosarye monument—a pedestal and two statues. The pedestal, with its dedication to the gods Sanergos and Astare, is part of the Hermitage collection, while the statues, which did not fully correspond to contemporary ideas regarding classical sculpture, were left in the south and were soon forgotten—in the 1920s one was found in the Kerch Museum. The exhibition contains the first two objects that were found—a silver cup and a pyxis (cat. nos. 76 and 77) from the kurgan close to the Phanagoria Fortress excavated by soldiers under Lieutenant Colonel Engineer Y. L. Parok'ia in 1818 during a routine dig. The first person to conduct more scientific excavations and surveys of the ancient monuments of the Kerch Peninsula was a modest employee of the Kerch customs house and a supervisor of the salt lakes—P. Dubrux, a Frenchman in Russian service. His maps of settlements and kurgans are invaluable, for many of the monuments have now been lost. Dubrux organized a museum in his home, which was mostly visited by interested travelers. In 1826 a museum opened in Kerch; its director, Jean Moret de Blaramberg, a Flemish noble-man in Russian service, had opened the museum in Odessa the previous year.

A turning point in the study of ancient monuments in southern Russia was the discovery in September 1830 of the Kul Oba kurgan near Kerch (see cat. nos. 138–48). The

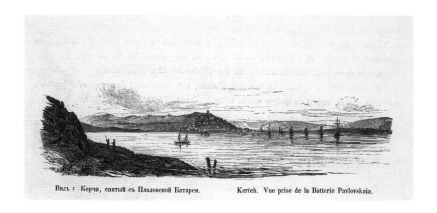

Вилъ г Керчи, снятый съ Павловской Батареи. Kertch. Vue prise de la Batterie Pavlovskaia.

burial chamber was found by accident during the quarrying of stone from the mound, however, its clearing was conducted under the supervision of local archaeologists: Dubrux and Kerch's mayor, I. A. Stempkovsky. The items found in the burial chamber were sent to the Hermitage, where they formed the basis of the archaeological collection of the museum. This discovery attracted the attention of not only the scholarly community but also the imperial court, which saw in the excavations a source of ancient treasures for its museum, the Hermitage. From that time on, the imperial ministry regularly assigned large sums of money for excavations, which were managed by the director of the Kerch Museum, A. B. Ashik, and a government official, D. V. Kareisha. The search for tombs that promised finds turned the excavations by these ambitious amateurs into a contest in which the highest stakes were rewards and the goodwill of their superiors. However, the good of the cause could suffer: often the work on a site would not be completed because attention would shift to another one. For example, in 1854 A. E. Liutsenko, the director of the Kerch Museum and a diligent and persistent archaeologist, discovered on Mount Mithridates a burial with very impor-tant finds (including cat. nos. 54–57). The tomb was under a mound that had been dug ten years previously by Ashik, who stopped 71 centimeters short of the grave cover. Excavations in the Kerch environs and in Taman yielded considerable material on an annual basis. The best finds went to the Hermitage, whereas the more ordinary ones filled the collection of the Kerch Museum. Kareisha's attempt to further develop excavations in Chersonesos did not yield any promising results and was abandoned. The excavations were carried out in a haphazard manner, often by people who were ill prepared for the task. (Incidentally, the level of field work was not much higher in Europe at that time.) The importance of the early amateur archaeological work of these pioneers is very great, for their excavations saved an enormous number of ancient monuments from destruction and looting by treasure hunters.

By the early 1840s the collection of ancient monuments at the Hermitage became so important that its curator in charge of the ancient monuments, F. Gille, having obtained the tsar's approval, initiated a major project making copies of maps and blueprints and preparing sketches of the finest items in the collection.

The result of this activity was the publication in Russian and French of *Antiquités du Bosphore Cimmérien* in three volumes, with illustrations of outstanding quality (figs. 1.1–3, 1.6). The inscriptions were prepared for publication by L. Stephani, an epigraphist, historian of antiquity, and professor at Derpt University, in present-day Estonia. Subsequently he became the curator, and for a quarter of a century he was involved with Hermitage publi-cations. Because the publication became an instant bibliographic rarity, and it was difficult

Fig. 1.4. The room of ancient Bosporan antiquities—the so-called Kerch Room—in the New Hermitage, St. Petersburg. Watercolor by Konstantin Ukhtomsky, 1853.

Fig. 1.5. Detail of wall painting in the Kerch Room.

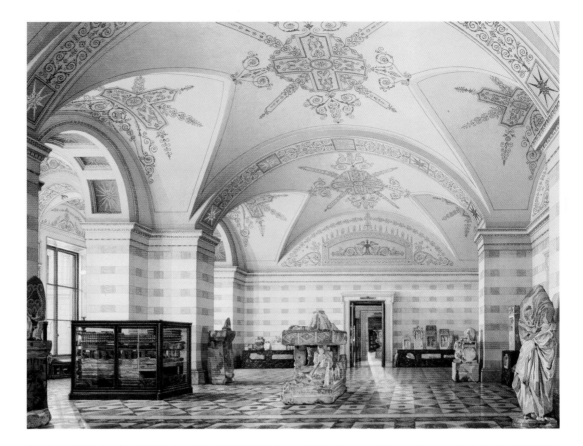

to use the bulky folio volumes, the French archaeologist S. Reinach reissued the French text in 1892 in a more convenient format, including an index of the proceedings of the Archaeological Commission from 1859 to 1881.

The archaeological monuments commanded pride of place in the building of the New Hermitage, built in 1851 by the Bavarian architect Leo von Klenze especially for housing the collection of the imperial museum. The Black Sea finds were exhibited in a special hall. Insofar as they were mostly Bosporan monuments, it became known as the Kerch Room (figs. 1.4–5). The building and its interiors were decorated with elements of Greek architecture and classical ornamentation. Not surprisingly, there was a correspondence between the relief and painted decoration of the halls and the ancient paintings and decorative motifs on the vases and other objects, creating an interior harmoniously integrated with the objects on display (see illustration opposite p. 1 and fig. 1.6).

Gille actively participated in the work of both projects—preparing of the publication and designing the halls of the museum. Of Swiss extraction, he taught French at the St. Petersburg boarding school run by pastor I. Muralt. He was hired to teach the heir of the throne and later received a position at the Hermitage. Although he had no formal education, he was very well read, had artistic taste, and was drawn to science. The decoration and finishing of the exhibition halls was created in accordance with his ideas on the placing of the books, manuscripts, and works of art in the New Hermitage. However, soon after its completion, the collection of the Hermitage increased so much that the original plan was no longer adequate. Just one acquisition by the museum in 1862—part of the collection of the Italian Marquis Campana—increased the holdings of the museum by 78 sculptures, 500 vases, and 193 bronzes. The placement of the new objects necessitated a rearrangement in the halls. The expansion of the antiquities collections accounts for the inconsistent decoration of many of the exhibition halls of the historically formed collection.

A new stage in the exploration of antiquities in the south of Russia began with the establishment of the Archaeological Commission in 1859, which was charged with the administration of the excavations in Russia, publishing reports, and distributing the objects to museums; the best finds were going to the Hermitage. In 1851 the epigraphist and academician L. Stephani became the curator of classical antiquity. Without abandoning his activities in epigraphy, he published the newly excavated works of art in the annual *Comptes rendus de la Commission Impériale archéologique*. The same edition also regularly published his extensive studies analyzing the new south Russian finds, which comprise an important part of Stephani's scholarly legacy. The best of the artistic ceramics from the archaeological digs that became part of the Hermitage collection

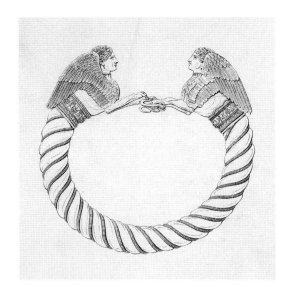

Fig. 1.6. Bracelet from Kul Oba kurgan (cat. no. 140). Engraving. From *ABC,* pl. XIII.1.

Fig. 1.7. Chersonesos. Excavations of the Uvarov Basilica with mosaic floor in the south nave. 1853. Title-page vignette from the account of the excavations in 1853 (St. Petersburg, 1855).

Fig. 1.8. The Athena Room in the New Hermitage, St. Petersburg, with the mosaic floor from the Uvarov Basilica at Chersonesos.

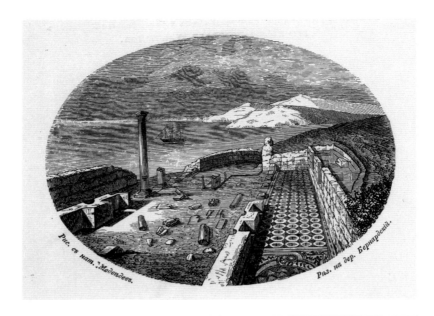

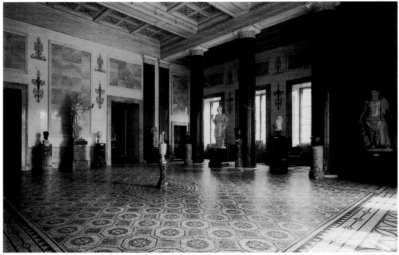

were displayed to best advantage in Stephani's catalogue of painted Greek vases of the Hermitage.

In the second half of the nineteenth century—due to the activities of archaeological experts A. E. Liutsenko, director of the Kerch Museum; Baron V. G. Tiesenhausen, vice-chairman of the Archaeological Commission; and I. E. Zabelin, chairman of the Society of Russian History and Antiquity at the University of Moscow—extraordinary kurgans were discovered on the Kerch Peninsula (Pavlovsky, the kurgans on the Yuz Oba ridge, and the kurgans near Nymphaion) and on the Taman Peninsula (Seven Brothers, Great Bliznitsa, Artiukhovsky). Here only those complexes represented in this exhibition have been named, but in fact there are more. The activity of the local museums was financed by the Archaeological Commission. Along with the excavations of the kurgans and city necropoleis, gradually the exploration of the cities themselves—Chersonesos and Olbia—was initiated. However, the excavation of the city layers of Pantikapaion, begun at the very end of the nineteenth century by K. E. Duhmberg, the director of the Kerch Museum, did not go very far, as they were not yielding (according to the ideas of the time) enough

desirable finds. V. V. Shkorpil, who replaced Duhmberg as director, resumed the excavation of the necropolis.

In 1853 Count Uvarov began to explore Olbia as well as Chersonesos, where in the course of his exploration he discovered a sixth-century Christian basilica with a baptistery (evidently this was the city cathedral; fig. 1.7), however, the outbreak of the Crimean War prevented the continuation of the work. The mosaic floor from the south nave of the basilica, discovered in the course of the excavation, was transported to the Hermitage and restored by the craftsmen of the Peterhof lapidary works, which carried out most of the finishing work for the imperial residences. The mosaic was installed as the floor of one of the halls of ancient sculpture (fig. 1.8). The large-scale excavations in the central part of Chersonesos carried out in 1876–78 were financed by the Odessa Society of History and Antiquity. The systematic exploration initiated by K. K. Kosciuszko-Walużynicz, the director of the local museum, under the auspices of the Archaeological Commission, depended in large measure on the construction work that was being carried out by a monastery situated on the territory of the ancient city.

At the present time about 25 percent of the area of the city has been excavated. This is the result of many years of effort by local and foreign archaeologists. Olbia is being studied on a regular basis—a process begun in 1900 by B. V. Pharmakowsky.

After the Russian Revolution the main emphasis in the work of the archaeologists was placed on exploring cities and settlements rather than funerary monuments. On the basis of several large expeditions, which were carried out primarily by the Academy of Sciences, scientific schools were formed. The Hermitage did not limit itself to passively accepting the materials, but began organizing its own expeditions to explore the most important ancient monuments of the northern Black Sea coast, utilizing its own resources. In 1939 the Hermitage began to excavate the Bosporan of city Nymphaion, on the coast of the Kerch Strait. N. L. Grach, who headed the expedition in 1966 and greatly elevated the scientific standards of the work, extensively explored the city and necropolis. G. D. Belov, in the course of more than half a century, employed first by the Chersonesos Museum and after 1947 by the Hermitage, explored the classical and Byzantine monuments of Chersonesos and was responsible for uncovering a considerable portion of the northern district of the city. Beginning in 1962, K. S. Gorbunova and later L. V. Kopeikina, with the Archaeological Institute of the Ukraine, excavated the settlement on Berezan Island. Today the Hermitage is not only continuing the archaeological study of these monuments, but it is also expanding its exploration activities. For example, in order to study the agricultural history of the Bosporus, the rural settlements on the Taman and Kerch peninsulas are being explored, and the excavation of the Bosporan city of Myrmekion, previously conducted by the Academy of Sciences, has resumed. Thus contemporary fieldwork continues to supplement the information contained in the objects collected by the work of several generations of archaeologists.

2

The History of the
Northern Black Sea Region

ALEXANDER M. BUTYAGIN

COLONIZATION SCATTERED GREEK CITIES OVER A GREAT EXPANSE OF the Black Sea and Mediterranean coasts. Whether on the hot coast of Africa, fertile Sicily, or the lands of the Gauls and Thracians, the Greeks founded many cities that survived for millennia. The settlers, who had to get used to a new climate and natural conditions and establish rapport with the local inhabitants, demonstrated extraordinary resilience.

The northern Black Sea coast occupies a special place among the different regions of Greek colonization. The distinctiveness of this region was determined by the presence of nomadic tribes. This remote corner of the ancient oikoumene was the only area of Greek colonization in immediate proximity to the extensive steppes that extend nearly to the Pacific Ocean. For millennia, hordes of nomads descended on the borders of Eastern Europe from here. Along this "steppe corridor" came the Huns, Alans, and other nomads of the Great Migration period, with the Mongols appearing a thousand years later. The coastal Greek settlements were not so much a defense as an outpost, the first place to meet the blow of the unknown peoples of the steppe. Under these conditions the local inhabitants had to be especially resourceful not to arouse the antagonism of the newcomers while maintaining the inviolability of their freedom and culture. Over the course of many generations there was a considerable change in the makeup of the population of the Greek colonies. The culture came to comprise new barbarian as well as Greek elements, and it soon differed significantly from that of Greece. The first Greek colonists who set foot on the northern coast of the Black Sea in the seventh century B.C. were remarkably flexible, adapting their ways to establish mutually beneficial relations with the neighboring tribes as well as assimilating the most useful elements of those cultures.

Geographically the northern coast of the Black Sea was bounded by areas inhabited primarily by nomadic peoples who were also able to penetrate deep into the forested steppes and piedmonts. On the west the area was bordered by the deep Hister (today's Danube). For centuries it served as a natural boundary that the nomadic barbarians had to cross in order to attack the settled peoples of Europe. In time, however, the boundaries

moved beyond the Danube to include the fertile areas of today's Dobruja, which were under the rule of the so-called Lower-Danube Scythia (Andrukh 1995). After the demise of this state entity the Danube once more assumed its role as a border. The special status of the northern Black Sea shore as a cold and dangerous region was symbolized by the island of Leuke in the Danube estuary, which contained a large shrine to Achilles. The next great river to the east was the Tyras (today's Dniester), which formed a large estuary at its point of entry into the sea. In the estuary were two Greek cities, Tyras on the right bank and Nikonion on the left. Farther along, at the point of entry of the Dniepr-Bug estuary into the sea, there was the tiny island of Berezan, on which one of the earliest colonies in the area was founded. On the right shore of the estuary, formed by the entry into the sea of the Hypanis (today's Southern Bug), was the large city of Olbia, which also controlled traffic on the Borysthenes (today's Dniepr)—the largest water artery in the region. In the Taurikē (today's Crimean Peninsula), which juts out from the north into the Black Sea, there were many Greek cities: on the steppe peninsula Tarkhankut, in the western part of the Crimea, was the city of Kerkinitis in the south and the small settlement of Kalos Limen (Beautiful Harbor) in the north. The southern part of the Crimea is mountainous, so the Greeks did not settle it, both for its lack of arable land and also because of the savage tribe of the Tauroi, who were extremely hostile to outsiders. However, west of the mountains was the large Sevastopol Bay, which formed a convenient harbor, and south of it were the fertile fields of the Herakleian peninsula. In spite of the proximity of barbarians, Chersonesos was located there and managed to exist for almost two thousand years. In the very middle of the southern coast of the Crimea, on the Ai-Todor promontory, Roman troops built the military base of Charax. All of eastern Crimea formed part of the Bosporan kingdom, which united under its power both shores of the Cimmerian Bosporus (Kerch Strait). Linking the marshy Sea of Azov and the Black Sea, the strait was an important channel that was controlled by a group of Greek settlements. At the western end of the Kerch peninsula was the large city of Theodosia, which has retained its name to the present day. On the Crimean side of the strait, near Mount Mithridates, was the Bosporan capital Pantikapaion, next to which were the cities of Nymphaion, Tyritake, Myrmekion, Porthmeus, Akra, Kytai, Kimmerikon, Ilouraton, and others. On the opposite shore—the Taman Peninsula—the biggest cities were Phanagoria and Hermonassa. In ancient times the peninsula was an archipelago formed by the islands of the delta of the Kuban River. There were small and large settlements on this fertile land, of which Kepoi, Patrasys, and Tyrambe deserve mention. Greek geographers considered the Kerch Strait to be the border between Europe and Asia, thus the Crimean part of the Bosporan kingdom was often called European and the Taman part Asian. On the Black Sea coast was Gorgippia (today's Anapa), located near the far west branches of the Caucasus Mountains.

The Caucasus range served as the natural eastern border of the northern coast of the Black Sea. The population of the mountainous areas and Kolchis to the south differed significantly from that of the steppe and steppe forestlands. The delta of the Kuban River and the area from the eastern shore of the Sea of Azov to the Don was settled by a nomadic tribe—the Maiotai—many of whom were conquered by the Bosporan kingdom. The writers of antiquity singled out the Maiotian tribe of the Sindoi, who were sedentary farmers and formed, to the south of the Kuban, the Sind state, which was later also conquered by the Bosporan kingdom. In the middle of it was the city of Labrita, which was either the capital of the Sindoi or an internal Greek colony in Sindike. In the estuary of the Don, the Bosporans founded the city of Tanais, which controlled trade in the north of the land of Maiotis.

It is clear, then, that Greek colonies were located at all of the important points that allowed them to monitor the land and water highways such as the Dniester, Southern Bug, Dniepr, Don, and Kuban Rivers and the Kerch Strait, which as trade routes led deep into barbarian territory.

The steppe part of the Crimea and the entire area of the steppes up to the border of the forested steppe, the southern border of which was at the same latitude as contemporary Kiev, was under the control of the nomadic tribes. From the seventh century B.C. it was inhabited by the Scythians, who themselves were divided into several tribal groups, the most important being the Royal Scythians. Subsequently, the steppe zone was conquered by the Sarmatians. The inhabitants of the steppes formed relationships—not always peaceful—with the inhabitants of the wooded steppes, so they had periodic contacts with the Greek centers on the coast.

When the first Greek colonists settled on the northern coast of the Black Sea, the presence of Scythian tribes was noted in the Kuban region with the rich Kelermessky and Kostromskaya kurgans, and in the forested steppe with miles of earthen ramparts surrounding large settlements. Certainly the steppes were not empty, but they were an area through which the Scythians moved when traveling between their principal areas of habitation. The relative emptiness of the steppe favored the establishment of colonies. The first two Greek settlements were on the coast far apart from each other. The first colony, named Borysthenes, was founded on the island of Berezan. The chronicle of Eusebius dates its founding to 647/6 B.C., but archaeological data points to the last quarter of the seventh century B.C. At the same time a settlement appeared in the estuary of the Don near Taganrog, which is now completely destroyed. The first settlements apparently arose on the basis of the desire to establish trading relationships with the barbarians and secure access to sources of metals. This has been proved by the traces of bronze processing found in the early layers of Berezan (Marchenko 2005, 58). Subsequently, the broad appropriation of the fertile lands became the primary raison d'être of colonization.

The apogee of Greek colonization of the area was in the first half of the sixth century B.C. On the basis of existing fragmentary information, almost all the colonies at that time were founded by Ionian Greeks under the leadership of Miletos—the largest polis in Asia Minor. Certainly Aeolian and Dorian Greeks also took part in this movement, along with other peoples from Asia Minor. At that time Borysthenes was slowly declining, while not far away a new colony was founded and expanded—Olbia, to which the center of the polis was subsequently moved. It is at this time that both sides of the Cimmerian Bosporus were being actively settled with such cities as Pantikapaion, Theodosia, Hermonassa, Phanagoria, and others being founded. Interestingly, not too long before that, in 512 B.C., the armies of the Persian king Darius had invaded the steppes. According to the information provided by the "father of history," Herodotos, they reached the Don, although some scholars think that the Persians did not move beyond the Dniester. Regardless of the military operations, they had absolutely no effect on the tranquil existence of the Black Sea Greeks and their dealings with the Scythians.

In the beginning, the settlers lived in compact sunken mud hut dugouts. The settlements were not protected by defensive ramparts and the number of settlers was small. In spite of some fires—possibly evidence of occasional clashes with the nomadic barbarians—the Greeks lived in relative peace in the early years. From the second half of the sixth century to the early fifth century there was a universal transition from dugout huts to surface dwellings, and the first defensive walls and shrines made their appearance. Members of local tribes begin to settle in or near the cities. Herodotos mentions the legendary story

of the Scythian king Skylas, who attended the Greek feast days in Olbia (Hdt. 4.76, 78–80). The barbarian population was gradually becoming hellenized. The colonies experienced their first peak of development in the early fifth century B.C. Around Olbia, on the shores of the Bug, Berezan, and Dniepr estuaries, many rural settlements sprang up, and there is evidence of members of the various barbarian tribes settling there as well. The islands off the Taman peninsula were also actively being settled.

The natural development of the Greek colonies in the region was interrupted at the turn of the first and second quarter of the fifth century B.C. A new nomadic incursion destroyed the balance that existed between the Greeks and their barbarian neighbors. The agricultural settlements around Olbia almost disappeared and there is evidence of fires in the cities of the Bosporus and traces of the rapid construction of defensive structures. In 480 B.C. a number of cities on the coast of the Kerch Strait united under the leadership of a noble Greek family—the Archaeanactids. It appears that Pantikapaion, Hermonassa, Theodosia, and Phanagoria were members of this union. It is quite likely that the reason for the unification was the need to organize defenses in response to a serious external threat (Vinogradov 2005, 238–45).

The situation stabilized after the middle of the fifth century B.C., when the Greeks managed to establish a *modus vivendi* with the new nomadic tribes. It is quite probable that Olbia fell under the protectorate of Scythian tribes, although not for long. In 438 Spartokos, a Thracian princeling, established his rule in the Bosporus and laid the foundation for the long-lasting rule of the Spartocid dynasty. It is from this time forward that one can speak of a Bosporan kingdom. In the beginning it comprised all of the cities of the Taman peninsula and on the Crimean side Pantikapaion (the capital of the state) and surrounding small towns. The vigorous policy of the new dynasty very soon made it possible to expand the borders of this idiosyncratic state, which consisted of Greek cities governed by barbarian rulers (Gaidukevich 1971, 65–69).

The establishment of peaceful conditions made it possible for settlers from Pontic Herakleia (a city on the southern coast of the Black Sea) to found, in approximately 420 B.C., a new colony in the western part of the Crimean mountains—Chersonesos. In contrast to the other colonies, it was founded by Dorian Greeks on the site of an existing Ionian settlement. In time the city was laid out on a square grid pattern and the surrounding area was divided up among the inhabitants. The unyielding Dorians began a dogged struggle with the neighboring Tauroi, pushing them out of the city's environs, thus demonstrating a different approach to the barbarians from that of their Ionian neighbors. Subsequently, Tauric Chersonesos became the city that most rejected the influences of the local tribes on the northern Black Sea shore.

The fourth century B.C. was the apogee in the growth of the Greek colonies along the entire coast. It was marked by the active development of mutual relationships with the surrounding barbarian tribes. The celebrated royal kurgans in the mid-channel of the Dniepr River are filled with precious objects from the workshops of antiquity. While maintaining good relations with some tribes, the Greeks conquered others and extended the borders of their states. At that time Chersonesos subdued the entire western coast of the Crimean peninsula. It ruled over Kerkinitis and Kalos Limen on the Tarkhanut peninsula. Between the towns a network of small fortified rural farmsteads was set up. Olbia also rebuilt its extensive chora.

In the fourth century B.C., after the short rule of Spartokos I, King Satyros I acceded to the throne and began to implement an active foreign policy. He subdued Nymphaion, meddled in the internal affairs of the neighboring Sind kingdom, and laid siege to Theo-

dosia. However, not everything went according to plan. Theodosia's desperate resistance and the aid of Pontic Herakleia turned the conquest of Theodosia into a protracted war, in the course of which enemy troops were active across the entire territory of the Bosporan kingdom. In order to marry the daughter of Satyros I (the king of the Bosporan kingdom), Hekataios, the Sind king, pushed aside his wife, the Maiotian queen Tirgatio, and had her imprisoned in a fortress. She managed to escape and began a lengthy war against her former husband and the king of the Bosporus. An attempt to assassinate the bellicose lady failed, and the Bosporan kingdom was caught up in a two-front war. At the height of these disagreeable events Satyros I died in 389 B.C., having "fallen into despair," as an ancient writer relates (Poleanos 8.55). It was left to his son Leukon I (ruled 389/8–349/8) and his brother Gorgippos, in whose honor the city of Gorgippia was later named, to remedy the situation. The latter managed to appease the Maiotians, while the Bosporan forces were finally able to subdue Theodosia. Thus the Bosporan kingdom acquired the fertile lands of Sindika and extricated itself from burdensome wars (Gaidukevich 1971, 71–73). At this time the Bosporus became an active supplier of grain to the Athenian market, as witnessed in particular by the resolutions of the Athenian assembly in honor of Leukon I. Not satisfied with its achievements, the Bosporus began an active campaign to subdue the neighboring tribes of the Kuban region. This process is illustrated by the many titles Leukon I assumed, by which he apparently modeled himself after the Persian kings: Archon of Bosporus and Theodosia, as well as king of numerous barbarian tribes, the first of which to be listed was often the Sindoi (fig. 2.1). It appears that the kingdom absorbed the territory of the eastern coast of the Sea of Asov. Without a doubt the Maiotian nomads contributed a contingent to the defensive forces of the Bosporus. Scythian military contingents supported the Bosporus as well. As a result, the Bosporan kingdom became the largest in the region in antiquity. An active building campaign was conducted in the cities, and near them arose immense kurgans with vaulted stone tombs, whose antecedents were the burial structures of the Thracian kings. Leukon's son Paerisades I, who assumed power in 344 B.C., continued his policies.

The situation worsened only after his death in 311/10 B.C., when his middle son, Eumelos, arose against the legal heir, his elder brother Satyros II and his ally—his younger brother Paerisades Pritan. This conflict between the heirs very quickly deteriorated. Satyros was supported by the Scythians while Eumelos was supported by Aripharnes, king of the Sarmatian tribe of the Siraks. The conflict turned into a struggle by two different tribal groups over the control of the Bosporan kingdom. Eumelos was defeated in a great battle on the Thasis River, but Satyros II and Pritan perished soon thereafter, and Eumelos was able to seize power in the Bosporan kingdom (Diod. Sic. 20.22–24). In the third century B.C. the Scythians had to yield their domination of the steppes to the Sarmatians. In place of "Greater Scythia," small kingdoms were formed in the Crimea, with the capital in the Scythian Neapolis (today's Simferopol) and in the lower reaches of the Don River. In 331 B.C. Olbia suffered a great deal of damage as a result of a campaign by Zopyrion, one of Alexander's generals. Apparently the city was besieged as an ally of the Scythians, against whom the campaign had been launched. The siege was lifted and the Macedonian forces were destroyed, but the expended effort was too much for the city, and it entered a protracted period of crisis.

In the third–second centuries B.C. all of the Greek colonies of the northern coast of the Black Sea were in a state of crisis due to the decline in the demand for Pontic grain in mainland Greece and the unstable situation in the steppes. The Scythian kingdoms in the Crimea and Dniepr regions increased their pressure on the Greek cities. Olbia was in con-

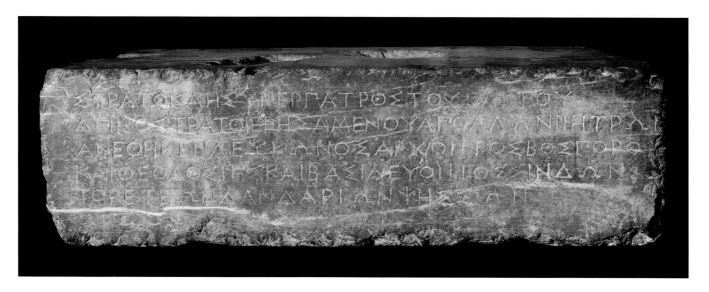

Fig. 2.1. Marble base of a statue from Pantikapaion with the inscription: "Stratokles dedicated to Apollo Physician for his father Dinostratos, former priest at the time of Leukon, archon of Bosporus and Theodosia and king of the Sindoi, Toretoi, Dandariori, Psessoi," fourth century B.C. St. Petersburg, The State Hermitage Museum, inv. PAN.152.

Fig. 2.2. Marble base of a statue of the general Diophantes. From Chersonesos. St. Petersburg, The State Hermitage Museum, inv. CH.1878.1.

stant danger of attack from nomadic tribes and the inhabitants of the chora were ready to support the invaders at any time. About the middle of the second century B.C. the city came under the rule of the Scythian king Sciluros, who began to mint his own coins there (Vinogradov 1989, 178–230).

In the third century B.C. Chersonesos also lost most of its possessions in western Crimea. Kalos Limen and Kerkinitis came under the rule of the Scythian kingdom, while Chersonesos itself barely held back the barbarians. The situation worsened in the Bosporus as well. The great coin hoards of the third century B.C. are evidence of a long-term monetary crisis. In spite of the fact that at that time the kings founded the city of Tanais at the mouth of the Don, relations with the barbarian world were not stable.

A solution appeared only when Mithridates VI Eupator acceded to the throne of the kingdom of Pontos. His ambition was to unite under his rule all of the Greeks of the ancient oikoumene. Toward this end, in 110 B.C. he sent his general Diophantes to aid Chersonesos, who promptly defeated the Scythians, burned their capital Neapolis, and returned Kerkinitis to Chersonesos (fig. 2.2). Subsequently Diophantes successfully negotiated with the king of the Bosporus to will his kingdom to Mithridates. Pontos's successful foreign policy was interrupted by a revolt led by the king's adopted son Saumakos, apparently a Scythian, who managed to seize power in the Bosporus (Gaidukevich 1971, 313–17). The following year, Pontic forces reconquered the kingdom and took Saumakos prisoner. At approximately that time Olbia and Tyras also became part of Mithridates' realm.

With the help of his sons and generals, Mithridates ruled over virtually the entire northern Black Sea coast, whose Greek cities found themselves part of a unified state for the first time. The king of Pontos conducted a clever foreign policy. On the one hand, he defended the interests of the local Greek settlers, and on the other, he actively recruited barbarians for military service. It was at this time apparently, that local tribes settled in the internal lands of Bosporus. Because of the unsuccessful wars against Rome, the Bosporans attempted to separate from Mithridates, but he unfailingly brought them under his rule. After the defeat of the kingdom of Pontos in the Third Mithridatic War, the king turned the Bosporus into his primary base of operations to prepare for a new encounter with Rome. Economic difficulties and an influx of barbarians provoked an uprising in Phanagoria and Pantikapaion in 63 B.C., in the course of which Mithridates was compelled to commit suicide. His son Pharnakes assumed power on the northern Black Sea coast. Soon he began a war with Rome to regain his father's possessions. Defeated in 47 B.C. at Zela by Gaius Julius Caesar, he perished while attempting to return to the Bosporus (*AGSP*, 16–17). It was this victory that Caesar reported to the senate with the three words: *Veni, vidi, vici.*

Pharnakes' death marks a new era in the development of the Bosporan kingdom. Until this point it was ruled by outside dynasties (albeit, also not Greek) but from this time forward it was ruled for the most part by representatives of local barbarian tribes. His death was caused by the governor-general of Bosporus with the Iranian name Asander — who without Rome's consent gained control over the kingdom and, in order to consolidate his power, married Mithridates' granddaughter Dynamis. The attempts by Rome's allies to subdue the Bosporus were unsuccessful. The most important struggle for the control of the Bosporus took place after the death of Asander in 17 B.C., with the participation of several of Rome's henchmen, including Polemon, who married Dynamis and in the course of an internecine war destroyed Tanais (subsequently restored). Local tribes also actively participated in this struggle. The situation was exacerbated by the constant attempts on the part of Chersonesos to free itself from the rule of the Bosporus, under which it had fallen during the reign of Mithridates. Periodically it was successful, as is attested by

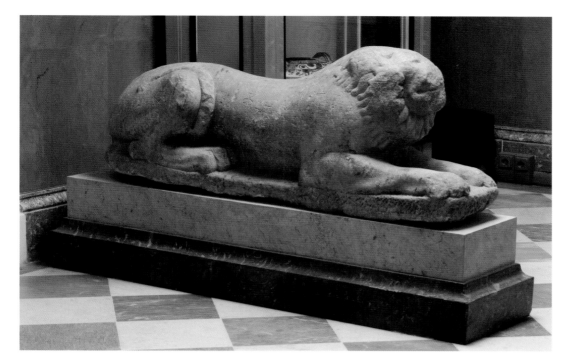

Fig. 2.3. Marble lion, sixth century B.C. From Olbia. Sarmatian "tamga" signs added in the second–third century A.D. St. Petersburg, The State Hermitage Museum, inv. OL.17833.

its minting of coins with the inscription "eleutheria" (freedom) and the introduction in 25/4 B.C. of a new chronology. Finally, in A.D. 10, after a short reign by Dynamis, power in the Bosporus passed to her son Aspurgos, whose name was accordant with the name of a local tribe—the Aspurgi. From that moment until the end of classical times, power in the kingdom passed to the Tiberian-Julian dynasty, so named by its members to demonstrate their loyalty to Rome. The other name of this dynasty is Sarmatian, due to the fact that among its members such names as Sauromates and Rhescuporis frequently appear. The barbarian character of the dynasty manifested itself in such an interesting feature as the use of the tamga—a tribal symbol of the nomads used primarily to brand cattle—as a royal coat of arms (fig. 2.3, cat. fig. 106b, p. 207). Such symbols are frequently found on stone slabs, pottery fragments, and even bronze harnesses. It is particularly in the Roman period that external barbarian influence was clearly felt in the art of the Bosporan kingdom.

Olbia was completely destroyed in the middle of the first century B.C. by an attack by the Thracian tribe of the Gaetai (Vinogradov 1989, 263–72). After some time, life in the city resumed, but its size and economic power were noticeably reduced. Nevertheless, large tombs for the families of the nobility and the wealthy were erected within the city, which shows that there was a certain revival in Roman times. Judging by the evidence, the barbarian influence was not very strong there; this can be explained by Rome's active aid and the presence of an imperial garrison. Life continued also in the rural settlements surrounding Olbia. The city was finally abandoned only in the course of the turbulent events of the fourth century A.D.

During the time of the Sarmatian dynasty the Bosporan kingdom fended off, with changing success, barbarian attacks as well as Rome's periodic efforts to incorporate it into the Roman Empire. The Romans had garrisons in Olbia, Tyras, and Chersonesos and a well-situated base on the coast of Crimea in Charax and were thus fully in control of the northern Black Sea coast, intervening as they saw fit. One such intervention took place during the reign of Mithridates III, son of Aspurgos, who was accused by his brother

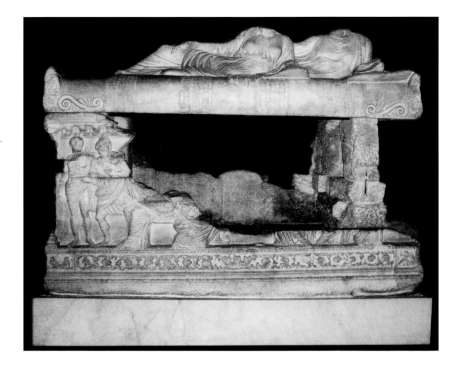

Fig. 2.4. Attic sarcophagus of a Bosporan ruler, second century A.D. From a tomb in the territory of ancient Myrmekion. St. Petersburg, The State Hermitage Museum, inv. P.1834.110.

Kotis of wanting to separate from Rome. Only the presence of the Romans compelled the king to surrender, and his brother received the throne as a reward (Saprykin 2002, 234–59). As a result the king was banished by the Romans and was subsequently captured and brought to the capital of the empire. In the end, common sense prevailed and the Bosporan kingdom continued its existence as a satellite of the Roman Empire. This arrangement made it possible for the Bosporus to fight off the surrounding tribes more effectively than if it were under the control of imperial officials. Another campaign took place during the reign of Nero in A.D. 63, when an expedition under the leadership of the legate of Moesia, Tiberius Plautius Sylvanus Aelianus, landed in the area; the expedition had been ordered to lift the siege of Chersonesos by the Tauro-Scythians. It was at that time that Charax was founded. In their turn, Bosporan and Chersonesan contingents took part in military operations on the Danube together with Roman forces. The numerous Bosporan coins issued in the first through third century A.D. with depictions of war trophies indicate that the Bosporan kingdom was victorious over local barbarians on numerous occasions and it possibly extended its power over substantial areas of central Crimea (fig. 2.4).

This state of affairs came to an end in the fourth century A.D., when Rome, facing a difficult military situation on its borders, definitively withdrew its military forces from the northern coast of the Black Sea and left its inhabitants to their own devices. Powerless to resist the push of the Germanic confederation of the Goths, represented by the Boron and Gerul tribes, the rulers of the Bosporus opened their harbors to them. The Goths took advantage of this situation by conducting several campaigns, sacking the cities on the southern coast of the Black Sea and even pushing on to the Aegean. The economy of the Bosporus fell into a serious crisis. There was a succession of kings, some of whom, it seems, were not of the ruling dynasty. The quality of Bosporan coins deteriorated greatly, and by the end of the 430s minting stopped altogether (*Antichnye gosudarstva* 1985, 20–21; Gaidukevich 1971, 460–96). Many settlements were abandoned, while Tanais—the Bosporus's outpost in the steppes—had been lost as early as the third century A.D. The final blow to the kingdom was administered by the invading Huns in the middle of the fourth

century A.D., after which the Bosporus practically ceased to exist. However, the Huns were unable to destroy the largest cities of the Bosporus, which revived and were able to continue their existence—albeit in a diminished form—into the Byzantine era.

Chersonesos managed to survive the Great Migration best of all, due to its favorable geographic position and probably also due to the unity of its citizenry in the face of external danger. It managed to survive and even consolidate its position in the Crimea as the largest city in the region. Its subsequent development is tied to the Middle Ages.

The ancient cities on the northern coast of the Black Sea were able to survive in the most difficult conditions for almost a thousand years. The ability to rapidly adjust to changing external circumstances, ably use their own resources, rely on those of the surrounding tribes, and adopt useful elements of the local culture made it possible for the small Greek settlements to grow into powerful cities, often becoming the centers of small states. These ancient cities of the northern Black Sea coast were important and long-enduring outposts of ancient culture on the edge of the boundless steppes inhabited by warlike nomads.

3

The Art of the Ancient Cities
of the Northern Black Sea Region

ANNA A. TROFIMOVA

THE EXHIBITION *Greeks on the Black Sea: Ancient Art from the Hermitage* IS AN important event in the life of two great art museums: the State Hermitage in Russia and the J. Paul Getty Museum in the United States. Its significance is not limited to the obvious role it plays in the cultural and artistic life of both countries; it also makes a contribution to the study of the antiquities from southern Russia that have been researched for the past 150 years. This exhibition and its catalogue present, for the first time, a full picture of the development of the art of the ancient city-states (poleis) of the northern Black Sea region. Only the richness of the unique Hermitage collection—the largest collection in the world of northern Pontic antiquities—makes it possible to unfold such an impressive panorama. Over the past 150 years, experts in all areas of antiquities—historians, art historians, archaeologists, numismatists, philologists, and epigraphists—have amassed an enormous amount of material and have worked out in great detail all aspects of the development of Greek civilization on the northern coast of the Black Sea.

Historians of ancient art began a systematic study of the monuments discovered in this vast territory in the second half of the nineteenth century. A long period of collection and systematization followed, with analysis of the archaeological finds conducted from the end of the nineteenth to the beginning of the twentieth century in accordance with accepted scholarly methods for the art of ancient Greece and Rome. European scholars and researchers of ancient culture such as E. H. Minns and S. Reinach published works that are still relevant today on the general history of the plastic arts of antiquity as well as outstanding studies of the history of culture within peripheral areas, including the northern Black Sea region.

The main concern of that period of study was viewing the correspondence between the formal characteristics of a work of art and the names of Greek artists and artistic schools. Scholarship of Russian ancient art, which at the beginning of the twentieth century was represented by such names as G. Kizeritsky, K. Watzinger, B. V. Pharmakowsky, O. F. Waldhauer, and M. I. Rostovtsev, evolved from an iconographical method to the

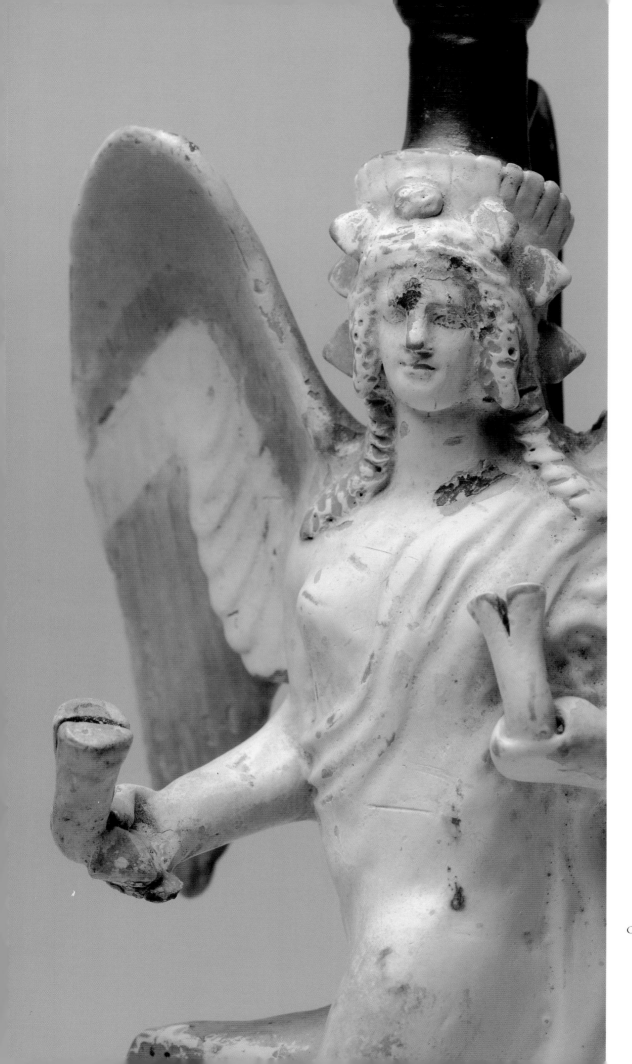

Cat. no. 61, detail.

19

study of art-historical problems. Over time, the history of Greek art came to be identified as a complicated historical process, inextricably linked to political, social, and cultural events, and its stylistic analysis became a means by which the spiritual "architecture" of the periods was penetrated. From the late nineteenth century through the first decades of the twentieth, in connection with the study of late antiquity in Gaul and Germany, there was an interest in barbarian elements within Graeco-Roman civilization. In the 1930s appeared works dedicated to the monuments of Roman Britain, Helvetia, and Palmyra. The recognition by world scholarship of the value of peripheral provincial versions of Greek style contributed to a better understanding of the heritage of the ancient northern Black Sea region, not only as represented by the monuments of material and artistic culture, but also for the paths of the development of ancient civilization and art as a whole.

In Russia, one of the first to appreciate the outstanding artistic significance of the monuments of the northern Black Sea region was V. V. Stasov, the well-known Russian critic and essayist. In an article on a fresco from a Kerch tomb—subsequently named in his honor—he drew attention to the distinctive features in the art of the Bosporan kingdom, underscoring its Graeco-barbarian character. One of the most outstanding figures in the area of the studies of antiquity in the years around 1900 in Russia was M. I. Rostovtsev. In his work on ancient decorative painting in southern Russia (Rostovtsev 1913–14) he developed a chronological system, described basic characteristics, and outlined the course of the development of the region's painting, combining a detailed art-historical analysis of the monuments with historical and archaeological methodology. At this time the scholarly community became focused on attempting to resolve the overriding problem of interaction between classical art and the traditions of the native population of the Pontic steppes. This question stirred many generations of researchers, and from the 1950s to the 1970s it was further developed in the works of Soviet and Russian scholars. Correlations between Greek and barbarian elements came to the forefront in the research of Scythian art, becoming an independent current in Russian archaeology (Vakhtina 2005).

In addition to the enormous number of works dedicated to monuments and groups of material, research on general questions relating to the history of the northern Black Sea region appeared after 1945. In these articles and monographs—by V. F. Gaidukevich (1949, 1971), V. D. Blavatski' (1961a, 1961b, 1961c, 1961d), A. P. Ivanova (1961), and T. N. Knipovich (1955a, b)—the main pathways of artistic development and chronology were identified; the differences and similarities with the Greek heritage were noted; and many practical questions, including those regarding the centers of production of imported artifacts and the existence of local workshops, were worked out. In the 1960s the matter of Greek colonization and the fate of ancient civilization at the outskirts of the Mediterranean world again attracted the attention of foreign researchers.

Important theoretical reasoning on the penetration by Greek civilization into the barbarian milieu, on the interaction of Greeks and other peoples, and on the mutual influence of both sides were expressed in the works of J. Boardman (1964, 1994). On the one hand, in Russian scholarship of the past thirty years there were works that summed up knowledge about the history and archaeology of particular centers and regions (Kobylina 1972; Gerziger 1973; Sokolov 1976; Sokolov 1999a; *Antichna'ia skul'ptura Khersonesa* 1976; Davydova 1990). On the other hand, a tendency toward creating new models and methods of researching art in the northern Black Sea area has recently been taking shape (Savostina 1999; Savostina 2001; Savostina 2004; Vakhtina 2005). Resolving theoretical and methodological aspects of interethnic contacts has been of great importance for subsequent discoveries and for the integrated study of ancient and barbarian societies (Andreyev

1996; *Greki i varvary Severnogo Prichernomor'ia v skifskuiu epokhu* 2005). Now they are beginning to be viewed as "tightly interconnected links of a single pan-oikoumene system of the interrelation between ethnic groups at different levels of historic, social and economic development" (Andreyev 1996, p. 3).

One should admit, however, that there is still no general or systematic history of the art of the ancient northern Pontic centers. To begin with, this is due to the fact that ideas fail to keep up with the accumulation of facts. There are many questions that scholarship has so far been unable to answer—for example, the provenance of some groups of works, or the origins of certain pictorial subjects that combine local and Greek myths. There are, therefore, advantages to presenting an exhibition and catalogue that make it possible to reconstruct a picture of a vanished era facing the imagery and enjoying the artistic value of the original objects as evidence of the development of the regional art, with the hope that in the near future scholars might come to a conclusion about how to define the phenomenon.

The objects from the Hermitage selected for this exhibition represent the most important centers and regions of the ancient northern Black Sea coast: the island of Berezan, the cities of Olbia and Chersonesos, and the Bosporan kingdom. This panorama of the artistic life is presented in its historic development—from the Archaic period, the time of the founding of the first settlements, to the Roman period, which concludes the age of antiquity. With the exception of monumental paintings and architecture, we present the basic artistic groups that could be considered the most representative of northern Pontic art: Kerch-style vases, jewelry, toreutic art, sculptured portraits, Bosporan tomb reliefs, carved stones from Dexamenos's workshop, and details of wood sarcophagi decorations. Collectively, these objects make it possible to see links between the different types of art.

In order to understand the mechanism of cultural development and the place of these monuments in the art of antiquity, let us closely examine these objects together with other famous monuments in the Hermitage collection. At first glance, it is clear that this art is fundamentally Greek and part of the Mediterranean tradition. This can be seen from the subject matter of the images, the forms and types of objects, as well as in the technology of their production. A comparison of the artistic evolutions of the northern Black Sea region and central Greece and Ionia shows that in their development they correspond in all of the stylistic phases: seventh to sixth century B.C., the Archaic period; fifth to fourth century, the Classical period; third to first century B.C., the Hellenistic period; and first to fourth century A.D., the Roman period. Small wonder, for the northern Pontic cities were not only founded by Greek migrants, but, despite the distance from the mother city, they were also drawn into the circle of its influence and supported close relations between Greece and Asia Minor over the course of their entire history. Greek roots fed the religious views, in great part determining the outlook and way of life of the population, the social structure of the states of the northern Pontic region, and even the architectural appearance of the cities. Art was an integral part of the life of every Greek in the northern Black Sea region. It aestheticized his everyday existence and, through ritual and the socially important sphere of life, it also influenced his ideology. Various goods imported from the mother city prove that in the early years of Greek penetration into the northern shores of the Black Sea, as well as in other regions they colonized, part of the art and craft production might have been created by migrant artists, but over time, local production developed within the standard of Greek aesthetics.

As much as the similarities are apparent, the differences among the art of Greece, Ionia, and the northern Pontic Greek colonies are also clear. First of all, let us note how

21

certain forms and subjects lagged behind the general artistic evolution of ancient art. Thus, for example, up to the third century B.C. one encounters Ionian-type ceramic vessels with painting in dark colors on a light background, executed in the style of vase-painting of the Archaic period. Archaic features are also evident in portraiture and coroplastics. It is quite natural to find such archaizing traits in an area so remote from the Greek mother city. Analogous phenomena are indeed typical for a colonial culture—similar ones have been observed also in cities founded by the Greeks in Italy, Sicily, and North Africa.

The second trait is the simplification and schematization of forms, also characteristic of the art of many peripheral areas of the ancient world. In this case we are dealing with an adaptation of tradition transposed into a foreign environment. This phenomenon is known in the vast expanse of the periphery of the ancient oikoumene, where there is "a loss of the barbarian culture's initial originality and its transformation into provincial barbarized versions of Greek or Roman culture" (Andreyev 1996, p. 5).

Finally, the main difference is the appearance of characteristics that resulted from contacts between the Greeks and local tribes of the northern Black Sea region. On the northern shores of the Black Sea the world of the Hellenic polis culture and the world of the nomads came into contact with one another. This had various consequences that lasted many centuries and significantly affected both sides. The contrast between the two cultures' worldview, life, and societal values was very great. There was also significant incompatibility of the artistic systems of these worlds. Thus, the Scythian Animal Style "in its formal features and semantic content may be considered a direct opposite of the Greek art of the Archaic and Classical periods" (Andreyev 1996, p. 9).

A review of the basic trends and development of art makes it possible to see how, with the striking differences between the cultures, the Greek forms completely took root and gradually began to coexist with the environment. In the course of this process the interchange of artistic elements (images, forms, subjects) resulted in original trends in art specific to this region. The interchange mechanism could be diverse. Thanks to the incredible flexibility of the thought of the Greeks, their art forms were easily adapted to various semantic systems. For example, Attic artistic production was quickly—over the course of several decades—transformed under the influence of the local tastes of the Bosporans, as is shown by the Kerch vases. At the same time, the Greek craft tradition, having been transferred to northern Pontic soil together with the settler artists, was filled with new content as happened in the case of toreutics.

The ability to adapt only confirms the fact that the Greeks were the *Kulturträger* (carriers of culture) from the beginning to the end of the existence of the northern Pontic cities, in spite of the gradual increase in local influence. A view of the art of the region in all its completeness and historical development illustrates this very clearly. Having introduced the basic forms of art, the Greeks made productive use of the Scythian milieu, which became the "nourishing soil" for the art of classical antiquity (Kallistov 1949, p. 3; Andreyev 1996, p. 6).

There were regional differences within the mainstream in the development of ancient art of the Black Sea cities. This circumstance reflects the historical specificity of the colonies, which were founded at different times and under different geographical situations and ethnic milieus. In the course of their histories, Olbia, Berezan, and Chersonesos preserved their Hellenic characteristics, albeit with an archaic provincial tinge. The adoption of barbarian elements in Olbia was sporadic and rather eclectic. Chersonesos was even less influenced by local styles—the city remained almost completely secluded. The situation in the Bosporan kingdom was different: There the symbiosis of artistic cul-

ture achieved sustainable forms. "Hellenization did not efface the cultural traditions of the local population, which for the most part was Scythian in the European part of the state and Sindo-Maeotic in its Asiatic part" (Andreyev 1996, p. 14). Syncretism of the elements of the two traditions determined the original style of Bosporan art.

The evolution of the artistic culture of the cities did not develop synchronously. The peak periods of Berezan, Olbia, Chersonesos, and the Bosporan kingdom superseded each other, as one can judge from the preserved archaeological and art historical evidence. The Archaic period is more exceptionally and completely represented in the monuments of Berezan, with Olbia being somewhat less significant. The Classical period through the fourth century B.C. is represented in the works from all the centers of the northern Black Sea region, but it is best characterized by the finds from Chersonesos, in particular, and the territory of the Bosporan kingdom. The second peak period came to the Bosporan kingdom in the first centuries of the Roman era, while for Chersonesos, the Hellenistic period and the first and second centuries A.D. were important.

As noted, in the beginning the culture of the colonies on the northern coast of the Black Sea had a Hellenic character. Archaic sculpture, which has survived in a few fragments, was imported into the cities of the northern Pontus from the mother city. Outstanding examples of the Severe Style are a polychrome stele with a two-sided image presenting a youth and a Scythian with an Amazon (Chersonesos Museum), and the fragment of a tomb relief with the head of a youth from Kerch (cat. no. 47). This relief, with its masterful outline with soft, evanescent contours, is one of the most outstanding examples of Ionian sculpture (Grach 1972). Its artistic virtues make it stand out among monuments not only in the northern Black Sea region but also in Early Classical Greek sculpture.

Compared with sculpture, there were considerably more painted ceramics imported into the northern Pontic cities in this period. Vases from East Greek centers, including Rhodes and Samos, had the widest distribution. It should be noted that the quality of these imported works was high. The best known of the earliest vases was found in the Temir-Gora kurgan, near the city of Pantikapaion (fig. 3.1). This vase, which was made in 640–630 B.C., is an outstanding example of Early Archaic Ionian ceramics executed under strong Eastern influence. Typical for vases of this type is a frieze composition with stylized figures of animals, and a carpet-like painting covering the entire body of the vase. In Archaic times large quantities of Clazomenean vases with scale ornamentation (cat. no. 4), and vases in Fikellura style (cat. no. 5) with images of deer, goats, and fantastic creatures were imported. Especially widespread were vases with purely decorative ornamentation, which influenced local production. At the same time Corinthian and black-figure ceramics from central Greece were beginning to be imported.

From an artistic point of view, the production of local ceramics of that time cannot be considered to be original craft output. They imitate Ionian ceramics with painting in the form of bands, concentric circles, and stripes, and, more rarely, one encounters vases with floral ornaments and animal figures. Local types of Archaic coroplastics—protomes and figures of a seated goddess—replicate models brought in from Asia Minor and Ionia.

Among all of the currents of art in the northern Black Sea region at the earliest stage, toreutics stand out in their extraordinary originality. From the end of the sixth century B.C., Olbia was the source of the most outstanding material. Local as well as Greek imported objects have been found in the burials and the city. These monuments are so exclusively original that it is customary to speak of the existence of a distinct Olbian style of metalwork. The most impressive group is considered to be that of the Olbian mirrors (cat. no. 30). While Greek in type and decoration, they were executed in a specific tech-

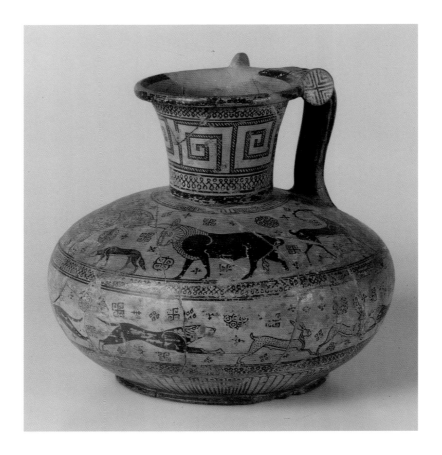

Fig. 3.1. Oinochoe, 640–630 B.C. From Temir-Gora kurgan near Pantikapaion. St. Petersburg, The State Hermitage Museum, inv. TG.12.

nique—for example, the relief decoration of the handle was cast together with the background. The handles of the bronze mirrors are decorated with small figures of panthers, deer, and masks of Gorgons. There are mirrors of the so-called Scythian type, with non-Greek elements, dating back to a type of mirror without a handle and possibly to the handle of a Scythian knife, widespread in Scythia (cat. no. 29). Some of the finds were discovered beyond the confines of Olbia, in regions as distant as the Ural Mountains. In addition to Olbian artifacts, production began here of Scythian objects of certain types, for example, metal ornaments of bronze, iron, and electrum with Scythian animal forms.

The development of toreutic arts had also begun at an early stage in the territories that later joined the Bosporan kingdom: from the seventh century B.C. (on dating, see Kisel 1993, p. 125; Kisel 2003, p. 99), artistic production here had a pronounced local tinge. Among the outstanding artifacts of the early period is a magnificent gilded silver mirror from the Kelermessky kurgan, now in the Hermitage collection (fig. 3.2). The mirror is divided into eight fields with images of a *potnia theron* (mistress of animals), fantastic creatures, animals, and scenes of animal combat. The style of the figures is close to Archaic Greek art of Asia Minor (Prushevskaia 1955, p. 335; Maximova 1954, p. 287; Kisel 1993, p. 111; Kisel 2003 p. 97). The subject matter is Oriental, while the style of the execution is Greek. The figure of the ram in a leaping pose is characteristic of the Scythian animal style. The long-haired barbarians fighting a griffin are apparently Arimasps—a mythological tribe that, according to the Greeks, inhabited the ends of the earth. Possibly the craftsman who made the mirror was appealing to his client, a representative of the local Maiotian tribal nobility. There is a hypothesis that mirrors like the one from the Kelermessky kurgan were intended for ritual purposes. It is known that mirrors played an impor-

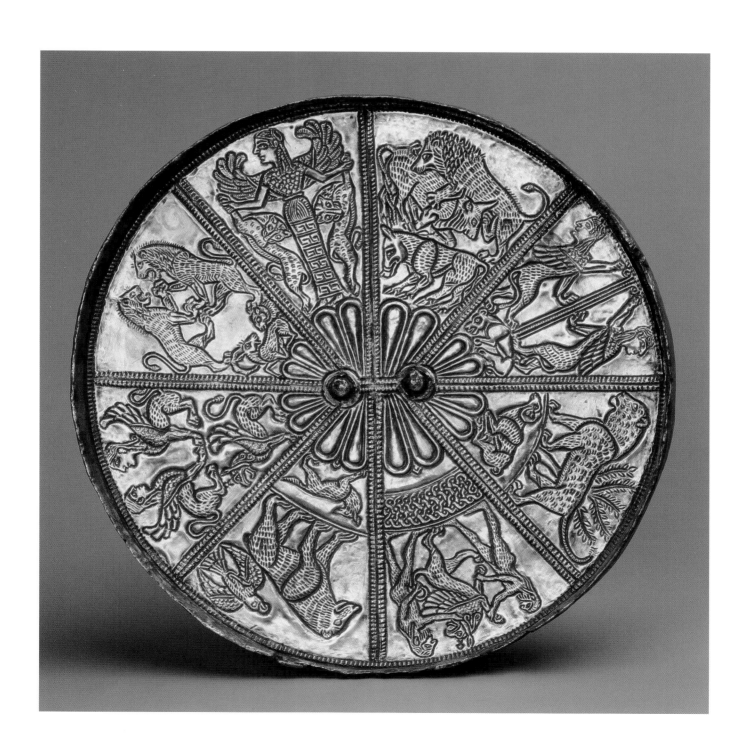

Fig. 3.2. Silver mirror, 650–620 B.C. or 670–640 B.C. From Kelermessky kurgan. St. Petersburg, The State Hermitage Museum, inv. KU.1904.1/27.

tant role in the burial customs of the local inhabitants of the northern Black Sea region (Blavatski' 1985, p. 139).

As for the production of toreutics, the entire northeast region of the northern Pontus was "extremely creative" (Prushevskaia 1955, p. 336). From the sixth century B.C. on large-scale metal production developed in the Bosporan kingdom, in Scythia, and in the Kuban and Bug regions. The influence of local tastes was especially strong, as was the general influence of Iranian styles. The subject matter was linked to the circle of common religious concepts typical for the tribes of western Asia, the northern Pontus, and Siberia. In the first half of the fifth century B.C. a production center arose on the Kuban River where the metal artifacts found in the Seven Brothers kurgans obviously originated. These stamped plaques made from electrum were intended to be sewn onto clothing and sometimes had unusual subjects—for example, a winged boar (cat. no. 111) or an eagle carrying a hare (cat. no. 121).

With the advent of the Classical era, and especially in the fourth century B.C., there was an upsurge in all facets of the arts, local as well as imported. Monumental marble sculptures of that time are found in practically all of the ancient centers: for example, in Pantikapaion—the statue of Dionysos (see fig. 5.3, p. 44) and the torso of a "Bosporan king" (see fig. 6.1, p. 47); in Chersonesos—the head of a youth in the style of Skopas; and in Olbia—the head of a pathetic god. Sculptures were brought in from the mother cities, but the quantities were significantly smaller than was customary in the cities of Greece and Asia Minor.

Of great importance in the artistic life of the northern Black Sea region in the fifth and fourth centuries B.C. were painted ceramics. A special place was taken up by magnificent artifacts with vivid polychromy and very complex ornate decoration. These were Attic red-figure vases of the "magnificent" style—the so-called Kerch-style vases (cat. nos. 45, 63, 150, 151), which were imported in great quantities into the Black Sea region, particularly into the Bosporan kingdom, and vases of the "quick" style (cat. nos. 64, 65, 66) that replaced them. The main outstanding feature of this period is that the imported ceramics exhibit original characteristics typical precisely for imports to the northern Pontic region. These characteristics were manifested in the style of the painting and decoration as well as in the specific subject matter.

One of the most outstanding examples of the magnificent Kerch-style vases is one of the two lekythoi made by Xenophantos, an Athenian painter, with a depiction of a hunt in which Greeks, Persians, and Scythians are taking part (fig. 3.3). They are hunting real and fantastic creatures—deer, wild boar, and griffins. The figures of the barbarians are executed in Greek style—conventionally, and with the exception of the dress, they are devoid of ethnographic details. The form of the vase, the style of execution of the figures, and the composition of the painting are Greek. The influence of the local client manifests itself in the choice of subject matter and in the distinct barbarian sumptuousness of the finish and the exuberant polychromy. The unusual exotic impression that these vases make has to do with the fact that the complexity of the decoration and the dynamism of the composition contradict the architectonics of the Greek vase, originally intended for the harmony of its elements and a balanced combination of forms. Analogous phenomena can also be observed in Italian vase-painting of the same time with complex relief friezes and abundant use of color.

A unique group of ceramics complete the Attic figure vessels found in the necropolis of Phanagoria: Aphrodite emerging from a shell (cat. 60), a Sphinx, a Siren, a winged deity (cat. no. 61), Dionysos, and two women. The colors, which are pure and of exceptionally beautiful hues, are well preserved: gentle light blue, pink, deep blue, red, and yellow. These

plaster vases make it possible to see with our own eyes the palette of the painter—the combination of colors, their intensity and gradations—to help us visualize the creation of ancient painting and the coloring of terracotta and marble statues. Juxtaposition of the palette of the Phanagoria vessels and the colors that have been preserved on Greek vases and statuettes makes it clear that their hues are close to each other. The difference is in the bold combination of colors: just as in the Kerch-style vases, color is the main attraction for the viewer. The striking polychromy and the vivid directness of the image distinguish these works from the abstract restraint of Classical Greek works.

Although works of art from Athens and East Greek areas were at that time brought into Chersonesos and Olbia, it was the Bosporan kingdom that demonstrated most vividly, in the artistic sense, a basic tendency—the movement of the two worlds toward each other, the transformation of the imports under the influence of local traditions. If sculpture—one of the most conservative of art forms—would not easily answer the local order, the mobile art of vase-painting was adapting very rapidly to it, although the Kerch-style vases remained within the general Greek tradition. The painters depicted the barbarians based on their imagination and painted the vases following their knowledge of that country. It is difficult to know how these ideas were formed and what could have inspired the Attic artists, who for decades used to keep within a rigid canon. Possibly those were myths and legends connected to the northern Black Sea region, or maybe the impressions of travellers to that far-away land.

Another manifestation of this tendency was the founding of a local art school under the guidance of Greek artists, especially in fine metalwork, which was the most outstanding and original artistic phenomenon in the northern Black Sea region. The late fifth and early fourth centuries B.C. saw the greatest flowering of this art, the importance of which clearly transcends the boundaries of the region to be considered one of the most outstanding phenomena in the history of ancient art. At this time in the Bosporan kingdom Scythian-style objects were produced as well as purely Greek artifacts and objects combining elements of the two artistic systems (cat. nos. 123–25, 127–30). Here were found *akinakes* (short Scythian swords); bow cases covered in electrum, or gilded silver ones (fig. 3.4); and electrum and silver tableware of Greek shapes but with Scythian subject matters (cat. no. 138). Taking into consideration the specific character of this art, it is at times difficult to identify a monument as belonging to this or that artistic school. Scholars agree that the manufacturing center of toreutics was in the Bosporan kingdom, however, its work was directed by Greek artists. They brought to the Bosporan kingdom artistry and tradition while the type and appearance of the artifacts were local. These works received the designation of Graeco-Scythian, as they in equal mix

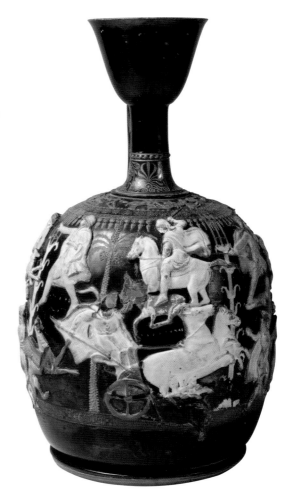

Fig. 3.3. Attic red-figure lekythos attributed to the Xenophantos Painter, 430 B.C. From the necropolis of Pantikapaion. St. Petersburg, The State Hermitage Museum, inv. P.1837.2.

27

Fig. 3.4. Gold bow case (*gorytos*) depicting scenes of the life of Achilles, 350–325 B.C. From Chertomlyk kurgan. St. Petersburg, The State Hermitage Museum, inv. DN.1863.1/435.

Fig. 3.5. Gold comb depicting a struggle between a Greek and two barbarians, 500–450 B.C. From Solokha kurgan. St. Petersburg, The State Hermitage Museum, inv. DN.1913.1/1.

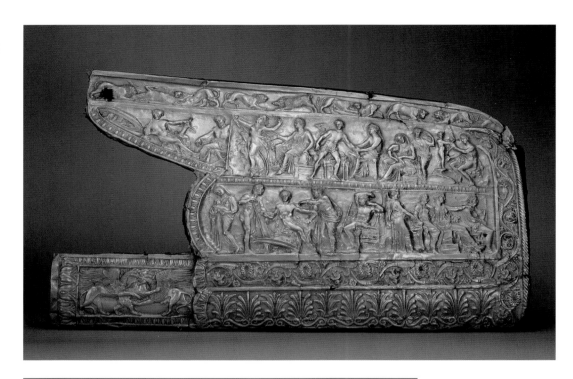

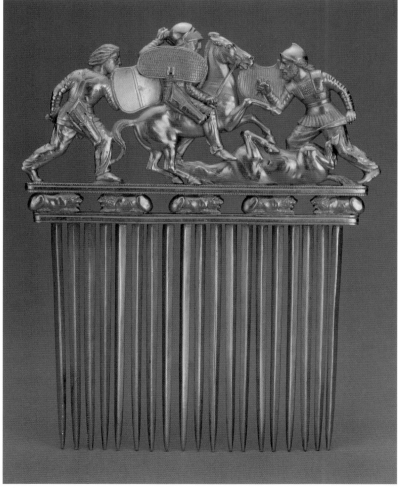

present elements of both artistic cultures, with the combination of both traditions harmoniously balanced.

In the well-known Kul Oba and Solokha kurgans large chased gold phialai were found (cat. no. 139), some of them analogous to the work of the school of northern Greece (Mantsevich 1987, pp. 310–17). It is not out of the question that the rich period of toreutics in the Thrace-Macedonia region in the late fifth to early fourth centuries B.C. influenced the development of the Bosporan workshops. In the same kurgan was also found an object that is world famous—a comb with a depiction of a battle between a Greek and two Scythians (fig. 3.5; illustrated in *Zwei Gesichter* 1997, p. 96). The sculptural composition, reminiscent of the central part of a relief on a temple pediment (Mantsevich 1987, pp. 61, 91), depicts in the middle a warrior on a rearing horse with two dismounted Scythians at his sides. The attire of the Scythians is rendered in the greatest detail—they are holding *akinakes* and have quivers on their belts—in a style known as ethnographic realism. Greek and Scythian elements occur here in a combination of Hellenic anthropomorphic style and Scythian subject matter. Sometimes, Greek myths are depicted on details of Scythian objects found in Scythian burials—for example, gold covers of bow cases and the scabbard from the Chertomlyk kurgan. The obverse of the cover is decorated with several decorative friezes showing fighting animals, floral ornaments, and figures of people. The middle frieze is interpreted as a scene depicting Achilles on the island of Skyros. Three identical covers with the same matrix, differing in minor details, are also known. All of the covers were found in kurgans from the second half of the fourth century B.C. Closely analogous to the Chertomlyk bow case is the one from the Karagodeuashkh Scythian kurgan in the Kuban region and the bow case from King Phillip's Tomb in Macedonia. There is a hypothesis that these ceremonial artifacts were diplomatic gifts of the Bosporan ruler Pairisades of approximately 330–320 B.C. (Alexeyev 2003, pp. 240–48).

An outstanding example of Bosporan toreutics is the silver amphora from the Chertomlyk kurgan, 350/340–320 B.C. (fig. 3.6). The shoulder is decorated with a relief frieze depicting scenes of torment and episodes from Scythian life: Scythians capturing horses with lariats, hoppling and taming them, and performing sacrifices. The details of the hairstyles, faces, weapons, and clothing are realistically depicted. The style of the ornamentation is reminiscent of the finest work of Dexamenos (Maximova 1955, p. 441).

The subject matter of the depicted scenes is based on Scythian mythology, epics, or religious beliefs (see Alexeyev, Murzin, and Rolle 1991, p. 221). Scenes from Scythian life similar to the subject matter of the Chertomlyk amphora adorn other silver objects—vessels of spherical shape with vertical neck, popular among local nomads (cat. nos. 138, 147).

The question of the interrelationship of local and Greek elements was resolved differently in the case of jewelry. High artistic levels and stylistic forms indicate that the pieces were made by Greek artists (*Greek Gold* 1994; *Greek Gold* 2004). More conservative in its nature, jewelry maintained its commitment to the Greek tradition longer than other forms of art. The influence of the local milieu was clearly evident starting in the Hellenistic period. Possibly a large share of jewelry artifacts was brought in from the mother city, but it is not out of the question that Greek artists produced them locally. Be that as it may, these adornments were current at the time and were in great demand by the Bosporan upper classes. They were distinguished by their sumptuousness, complex designs, and abundance of decorative elements. Here were found magnificent necklaces (cat. nos. 131, 163), earrings (cat. nos. 142, 153, 159), large temporal pendants (cat. no. 141), and numerous plaques that were sewn onto clothing. The plaques from the Kul Oba kurgan contained

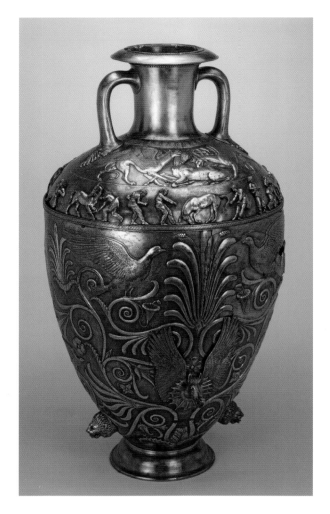

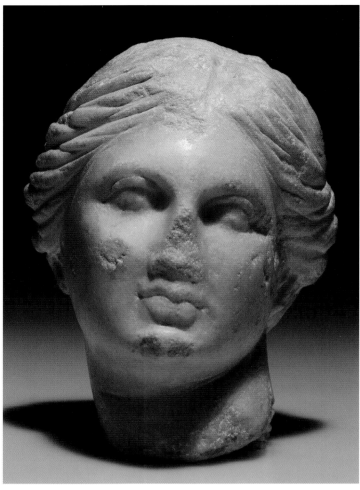

Fig. 3.6. Silver amphora, 350/340–320 B.C. From Chertomlyk kurgan. St. Petersburg, The State Hermitage Museum, inv. DN.1863.1/166.

Fig. 3.7. Marble head of a woman, third century B.C. From Olbia. St. Petersburg, The State Hermitage Museum, inv. OL.637.

Scythian subject matter (Scythian blood-brothers, a galloping horseman, a serpent-legged goddess) as well as Greek images such as dancing maenads and heads of Medusa.

In the fourth century B.C. new types of burial structures made their appearance: vaults with stepped roofs. Together with the idiosyncratic wood sarcophagi, the stepped roofs were a distinctive feature of the interior of Bosporan tombs. These burial chambers were built until the first century B.C., however, the most important ones—those of the Kul Oba, Zolotoi' Melek-Chesmenski', and Tsarski' kurgans—are from the fourth century B.C. Although the Greek character of the construction techniques and concepts has been generally recognized, the sources of these original structures have been interpreted in different ways. Similar structures are known in Thracian tombs, Mycenaean tholoi, Etruscan burials, and the below-ground constructions of the kurgans in the Kuban region.

At the same time one can see the dawn of another characteristic trend of Bosporan sepulchral art: decorative tomb painting. Another surge in the development of painting occurred in the beginning of the Roman period, but one of the earliest painted images—dating to the fourth century B.C.—is that of Demeter's head from the tomb in the Great Bliznitsa kurgan on the Taman peninsula (see fig. 17, p. 270). The painting itself has not survived to the present day; only a photograph has been preserved. The face of the goddess is displayed frontally with her eyes wide open. This manner of depiction cannot be called classical. The fixed hieratic image, its expressiveness concentrated in the eyes only,

is characteristic of a later stage in the evolution of art—in the art of Christianity. Here again one comes across the nonlinear development of peripheral art: some styles and modes lag behind those of the mother cities and others anticipate the future.

Next comes the Hellenistic period marked by changes in all areas of arts and crafts pertaining to the ancient art of the Mediterranean. Athens lost her leading role, and new artistic centers appeared that exported their products to different corners of the ancient world. Works of art manufactured in Alexandria or Pergamon made their appearance in the cities of the northern coast of the Black Sea via the intermediate activity of Rhodes or through direct contacts. The influence of the principal Hellenistic artistic currents manifested itself in the stylistic changes of vase-painting and marble sculpture, although, as was the case in the previous period, the question of the provenance of a particular object cannot always be determined with certainty (fig. 3.7). Another important factor was the intensification of Oriental influence, which as a whole is characteristic of the Hellenistic era. At the same time, from the third century B.C. on Sarmatian style significantly influenced the art of the Greek city-states and the regions of the northern Pontus—to a lesser extent that of Olbia and Chersonesos, and to a greater extent the art and culture of the Bosporan kingdom.

In its picturesque technique and the gentle and soft finish of forms Olbian sculpture gravitated toward the Alexandrian school. An example of the Pergamon style is the head of Mithridates VI Eupator from Pantikapaion, possibly executed by a Greek sculptor resident in the Bosporan kingdom (cat. no. 84).

As for pottery, the importance of East Greek centers grew once more. Athenian imports to the northern Pontus diminished at that time. Vases were imported from Alexandria, from such centers of Asia Minor as Pergamon, and from the islands of Samos and Delos. Black-glazed pottery ornamented with carving and painted in added colors and diluted clay against a dark background became popular and widespread, along with a quite special type of vessel decorated with garlands or applied relief figures. The exterior of these vases has much in common with metal vessels because of the metallic shine of the black glaze and the relief ornamentation inherent in metal objects. Well known from this period are vases—either large and of intricate shape, or simple like the Megara cups—whose surface is entirely covered with relief ornamentation. Vessels painted with delicate floral ornament against a light background came from the workshops of Alexandria and Asia Minor as well.

In the Hellenistic period local pottery production copying different groups of imported ceramics was initiated and developed. Black- and red-glazed ceramics appeared as well as those with Ionian-type painting. Among the local pottery it is interesting to point out a very distinctive technique of decorating the surface of vessels, called "watercolor," used to decorate pelikai (cat. no. 68). These vases are reminiscent of late Attic red-figure technique, with paintings over a dark background depicting various figures, fantastic creatures, or mythological scenes. Although the vases are executed in a significantly rougher manner—the draftsmanship is careless and the forms are sometimes not very precise—one cannot help but notice a developed painterly manner. It manifests itself in the bright polychromy and the use of overtones and shadows.

Precious silver utensils—cups, plates, pitchers, and basins (cat. nos. 74–77) were also produced. These exquisitely shaped objects are covered with subtle engraving and decorated with relief images. Their artistic qualities would be further developed in the works of the Late Roman and Early Byzantine periods. The tradition of making such vessels was reestablished in the Early Middle Ages, and the artworks made at that time became

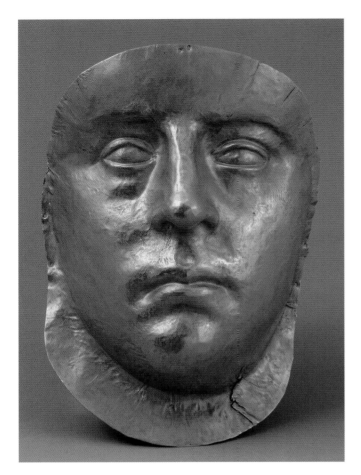

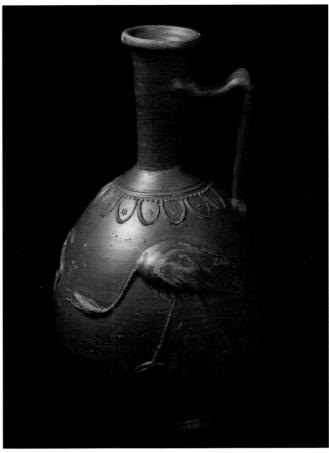

Fig. 3.8. Gold funeral
mask, early third
century A.D. From the
tomb of Rescuporides
III in the necropolis
of Pantikapaion.
St. Petersburg,
The State Hermitage
Museum, inv. R.I.

Fig. 3.9. Red-glazed
terracotta jug with two
herons and a snake,
early first century A.D.
From the necropolis
of Pantikapaion.
St. Petersburg,
The State Hermitage
Museum, inv. P.1908.56.

known as "Byzantine antiques," which included some very famous pieces. The plates, pitchers, cups, and ladles, like those of the earlier time, were created in the major cities of the Byzantine Empire—Antioch, Alexandria, and Constantinople. Their classicism was plainly expressed and embodied in their ancient shapes, classical manner of work, and in the iconography of ancient mythological subject matters. These remarkable monuments, dated by Leonid Matsulevich to the sixth–seventh century on the basis of their marks, illustrate the different forms of the perception of antiquity in the Byzantine period.

Polychromy, which became fashionable with the Hellenistic period, manifested itself in jewelry. The famous Artiukhovsky diadem properly illustrates Hellenistic tastes for large precious stones and striking forms that replaced subtle filigree of the Classical period. Large rings decorated with stones and relief busts were popular at that time, and sumptuous wreaths with thin gold leaves, pendants, and amulets designated for funeral rituals were produced. Typical of artifacts of the Sarmato-Bosporan style were plaques with large gold-framed glass sets. This style developed fully in the third and fourth centuries A.D. The rough luxury of the inlay style, with its use of numerous precious stones and colored enamel, apparently impressed the Bosporans. At that time gold leaf objects continued to be used in burial rituals. The most famous of these is the gold mask found in the burial of Rescuporides (fig. 3.8; Gaidukevich 1971, p. 443), whose interpretation is far from unambiguous. Bosporan ornaments with strongly geometricized floral patterns, typical of Sarmatian art, appear in items discovered in the Kuban and in the Don regions. Those are numerous plaques, finger-rings, and bracelets. Against this background, the jewelry from

Chersonesos, which has no traces of Sarmatian influences, stands out noticeably. During the Greek period and with the advent of the Roman era the culture of classical antiquity would remain much more definite in Chersonesos than in other northern Pontic cities.

In the early centuries A.D.—in the northern Black Sea region as well as in other centers of antiquity—the role of artful ceramics gradually began to decline. This was the time when glass vessels came into wide use, and they were richly represented in the Pontic colonies (cat. nos. 87–91). Characteristic of the period, Italian and, especially Arretine, red-glazed imported ceramics were found in Olbia and Chersonesos. Many vases came to the Bosporan kingdom from Samos and Pergamon; an outstanding example of this group is the glazed jug with relief figures of two herons attacking a serpent (fig. 3.9).

Some forms of art saw their flowering in the beginning of the final—Roman—period of the northern Pontic cities. Painting, which has survived in frescos in tombs from the Bosporan kingdom, received a new impulse in its development. The Hermitage collection includes a good example of a painted limestone sarcophagus from the late first century A.D. (fig. 3.10a–b). The sarcophagus is roughly finished on the outside, but the inside is covered with a thin grounding of plaster. The inside of the lid, painted directly on the limestone, depicts a bird, branches, leaves, and petals. On the side panels painted fluted columns divide the surface into sections. One of those is covered with an ornament, on the others the following scenes are shown: a youth in a short chiton standing by a horse, a studio of a portrait painter, a funeral meal, two horsemen, a group of musicians, and a woman with a child on her knees. On one of the shorter ends is a caricature depiction of dancing pygmies. The figures are disproportionate and executed in an oversimplified manner with neither perspective nor dimensionality of the bodies. However, due to the expressiveness of the poses and faces, a vivid and authentic image has been created. Of particular interest is a picture of a studio of a Bosporan portrait artist who works in encaustic (see fig. 10.3, p. 72). In front of the artist are a brazier for heating wax and an easel. Portraits hang on the wall. This painting suggests that the encaustic technique really did exist in the Bosporan kingdom. Such portraits were possibly intended for residential use, for they have not been found in burials (Ivanova 1955, p. 298; Gaidukevich 1949, p. 398).

The attempt to portray individual features was among the specific characteristics of Bosporan art. This phenomenon occurs in painting, sculpture, smaller plastic works (cat. no. 86), and even depictions on vases. Expressive individualized faces are often found on Bosporan gravestone reliefs and in tomb painting. As evidenced in the various archaeological finds, epigraphs, and written sources, portraits were numerous enough in round sculpture in comparison with those in the decorative plastic arts. Highly developed portraiture is revealed by some famous items of the Hermitage collection, including the bust of the Bosporan queen (cat. no. 85), the portrait of Mithridates, and the funerary statues from Kerch (cat. nos. 81, 82).

In the first centuries A.D. Bosporan funerary reliefs made of local limestone were produced in great quantities (cat. no. 83) presenting the features of local style. Those had a generalized, immobile, flat, and schematic graphic-like quality, "which often is linked to the carefulness of pictorial narration and naive realism" (Maximova and Nalivkina 1955, p. 311). As a group, Bosporan reliefs were stylistically different; experts have identified the sources of influence as being primarily Attika and Asia Minor. Against this background, however, the local style clearly stands out. The characteristics enumerated above combine with conventional composition, realistic details, neutral background, and the lack of perspective. Individualization of the face of the deceased can be considered an important

Fig. 3.10a. Limestone sarcophagus with painted inside walls, late first century A.D. From the necropolis of Pantikapaion. The scene in the center shows a painter's studio (see also fig. 10.3, p. 72). St. Petersburg, The State Hermitage Museum, inv. P.1899.81.

Fig. 3.10b. Scene on the end panel of the sarcophagus figure 3.10a showing dancing pygmies.

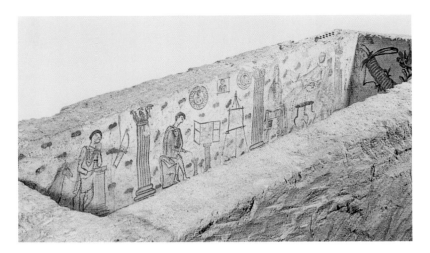

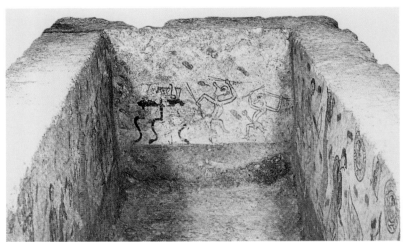

feature of the artistic style. Combination in a given monument of contradictory peculiarities—abstract place and time juxtaposed with portrait quality of the pictured image treated in a linear manner—recalls the style of gravestones of the eastern Roman provinces, especially of Palmyra. In the use of portrait busts, scholars tend to see parallels with funerary monuments of northeastern Macedonia; while in the tendency toward simplification and the elements of folk realism they find a typological analogy with the works of the Western Roman Empire, particularly of the Gallo-Roman provinces. This coincidence of forms, techniques, and characteristics of treatment in provincial works of art located in opposite corners of the ancient world poses the question of common characteristics in the development of peripheral regions. Cultural isolation and seclusion of these territories evidently predetermined the stereotypes of perception of the classical tradition. Its penetration followed the principle of "a scheme and correction," when ancient structure of representation gradually changed until it reached a fundamentally new level, and therefore a new step in the evolution of art.

The art of the ancient cities of the northern Black Sea region is an integral part of the art of the ancient world, for here was created its extremely important local variant, an example of peripheral art of the Greek colonies. On the one hand, in its evolution one can see the reflection of general processes characteristic of similar cultural transformations in the Mediterranean and the area around the Black Sea. On the other hand, the

internal logic of development is also evident—it is the consequence of the specific historical situation the Greeks encountered on the northern shores of the Black Sea. This is why the overall picture of the art of the ancient centers of northern Black Sea region is so peculiar and, in spite of many different currents, so integral. It embodies an independent artistic and historical stage that had an impact on the destiny of ancient culture. The original characteristics of the art of the region productively continued, not only through antiquity, but also into the Early Middle Ages. For these reasons we cannot fail to recognize the significance of this region as a mediator of artistic tradition, not only between peoples, but also between two historic stages of civilization.

4

"Flickers of Beauty": Kerch Vases from the State Hermitage Museum

ANNA E. PETRAKOVA

"KERCH VASES" OR "KERCH-STYLE VASES" ARE THE COMMONLY USED terms for a group of red-figure Attic vases from the fourth century B.C. This term was coined after the city of Kerch, located on the eastern shore of the Crimean peninsula, where many of these vases have been found. Although Attika exported late red-figure vases to other parts of the Mediterranean and Black Sea area as well, the name of one of the places in which they were found has become attached to a whole group of stylistically similar vases, including those not found in Kerch. This name (perhaps not the most felicitous) was first used by A. Furtwängler and subsequently by K. Schefold, who contributed two important scholarly works to the study of Kerch vases (Schefold 1930; Schefold 1934). He developed a system of periodization (early, middle, and late phases of development), categorized groups of vases, and gave names to the painters of the Kerch style.

Kerch vases make up one of the most interesting pages in the history of Attic red-figure vase-painting—its last renaissance before the final demise. The founder of the study of Greek painted vases, John Beazley, described Kerch vases in the following vivid manner: "Attic vase-painting touches bottom in the early part of the fourth century. . . . In the second quarter of the century a revival begins. In the Kerch vases—as these latest of Attic red-figure vases are often called—there are flickers of beauty. The tall, dignified figures are a relief from the debased roly-polies of the sub-Meidian period; but they in turn are often vacuous and mannered, and with a predilection for three-quartered faces and three-quartered and frontal figures, and its neglect of the speaking contour, the style is not really suitable to vase-painting" (Cambridge History 1975).

Two stylistic groups have been identified among the works of the Attic vase-painters from the fourth century B.C. One continued the classic art of red-figure vase-painting of the fifth century B.C., within the framework of the traditions of the severe and majestic style, comparable to the majestic style of the sculptures of the illustrious Pheidias. The other approach originated in the work of the leading vase-painter of the Late Classical period, the Meidias Painter, characterized by a rich polychromy and comparable to the

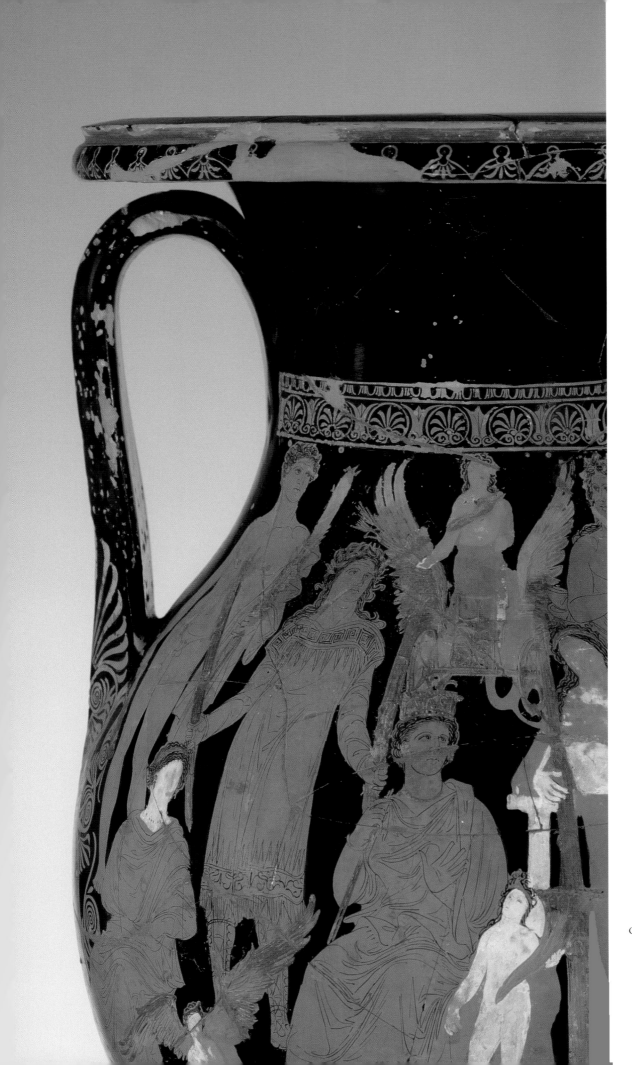

Cat. no. 156, detail.

effeminate style of the sculptures of Praxiteles. The Kerch vases belong to the second stylistic group (although this term is applied more broadly to include vases in which the legacy of the Meidias Painter is not as evident).

Although vase-painting is by definition a flat and two-dimensional art, the drawing on the Kerch vases with its adumbrative and sketchy manner tends toward the plastic elaboration of the figures and three-dimensionality. The characters on the Kerch vases are frequently portrayed in three-quarter view and there is a sense of three-dimensionality in spite of the lack of any elaboration of depth in the painting. From the refined works of the Meidias Painter, with their pure and graceful contours, flowing lines, and details elaborated with energetic lines going off in different directions, the painting of the Kerch vases is distinguished by short, torn, rough, small lines that outline the objects and sketch the details. In the best Kerch vases there was not only a return to the graceful style of the Meidias Painter but a further perfection of it, complemented by the minute elaboration of details and more complex ornamental elements. Besides the two basic colors of red-figure vase-painting—the color of fired clay and the color of black glaze—the decoration of Kerch vases is distinguished by details executed in low profile with applied clay and gilding, as well as by the use of a rich palette of white, yellow, crimson, light blue, and green. In addition to creating ornate polychromy, these colors help to accentuate certain details and characters in the general composition—for example, to set off the figures of Aphrodite or Erotes from the other characters.

Polychromy and the tendency toward three-dimensionality appeared in red-figure vase-painting influenced by Greek models in the late fifth century B.C. when the invention of chiaroscuro by Apollodoros and perspective by Agatharchos paved the way for the painting of Zeuxis and Parrhasios, whose works created almost the same impression on their contemporaries (according to surviving written evidence) as trompe l'oeil did on the modern viewers. The influence of wall-painting on vase-paintings was already evident in the Early and Late Classical periods. However, when the monumental painting of Polygnotos—which essentially consisted of colored drawings without chiaroscuro or three-dimensionality—was transformed into a vase image, it did not disturb the illusionary integrity of the surface of the vessel. The innovations consisted of compositional techniques (the placement of figures in several tiers on imaginary groundlines), more complex poses and angles, as well as the expression of emotions.

The influence of late fifth-century painting, however, created somewhat of a conflict between the aspirations of the vase-painters to implement all of the achievements of illusionary three-dimensionality and the main aim of vase-painting: to conform to the shape of the vessel. The nature of the applied additional colors actually emphasized the flatness of the picture.

This contradiction is most clearly visible in Kerch vases. The tendency toward three-dimensionality affected both the picture and the relief decoration of the vases. On the vases of the Meidias Painter the relief decoration was insignificant, however on the Kerch vases it plays an important role and in some cases is the main artistic element. These works cannot be categorized as simply vase-paintings—they fall between pictorial art and sculpture, similar to the terracotta statuettes in which color and the plastic arts complement each other. This category of vases has been created under the influence of more expensive and luxurious vases, with relief made of precious metals.

The Kerch-style vase-painters had their favorite vase shapes. Among the early works, hydriai and kraters were the most common, whereas at the high point in the development of the style and in later works lekanides, lebetes, and pelikai—one of the most typical

forms of Kerch vases—were preferred. Along with the changing tastes in vase shapes, their proportions became taller, more graceful, and more sophisticated, and the profiles became more refined. Whereas the earlier kraters and hydriai seemed to reach upward, the later pelikai are characterized by somewhat sagging shapes with large, flat lips seeming to hang down. Large vases were often decorated with figures placed in two tiers, one above the other, or by figures placed on different levels, as if on uneven ground or partially obscured by something in the pictorial field. Sometimes, in conjunction with the elongated form of the vase, the figures are also stretched out vertically. In addition, vases were often decorated with large heads of an Amazon, a horse, and a griffin as if coming out of the earth (cat. no. 66; the line of the earth was delineated by the ornamental frame of the pictorial field).

The subjects of Kerch vase-paintings, besides the traditional mythological ones in Attic vase-painting, were the Eleusinian mysteries, Dionysian celebrations, wedding preparations and—depending on the wishes of the prospective customer—depictions of Amazons, griffins, Arimasps—that is, those who, according to the mythological concepts of the inhabitants of Attika, lived on the northern Black Sea coast.

To this day, Kerch vases are the most controversial topic in the area of Attic vase-painting, and their significance and place in the history of Attic vase-painting are judged from various points of view. Scholars cannot agree which groups of late red-figure vases should actually be categorized as Kerch vases. Dating and attributions are also controversial topics. Not all the artists and vase groups identified by Schefold were recognized by the main authority on Attic vase-painting, John Beazley (Beazley ARV^1 and ARV^2) and his successor, John Boardman (Boardman 1989). Besides, using the name of a city—in whose vicinity many examples of Attic vase-painting have been found over many years of excavation—as a label for one style of late red-figure painting has, on occasion, led to all ancient painted vases found in Kerch—not only the ones of the style described above—to be called Kerch vases.

The State Hermitage Museum has a superb collection of Kerch vases from the excavations in Crimea. Among the ones in the exhibition are the works of the celebrated Marsyas Painter, who is among the most outstanding of the Kerch-style vase-painters (cat. no. 151), the Eleusinian Painter (cat. no. 156), as well as numerous unidentified painters of Kerch vases. A different current in the development in Attic vase-painting in the fourth century B.C. is represented at the exhibition by the work of the Kadmos Painter (cat. no. 152).

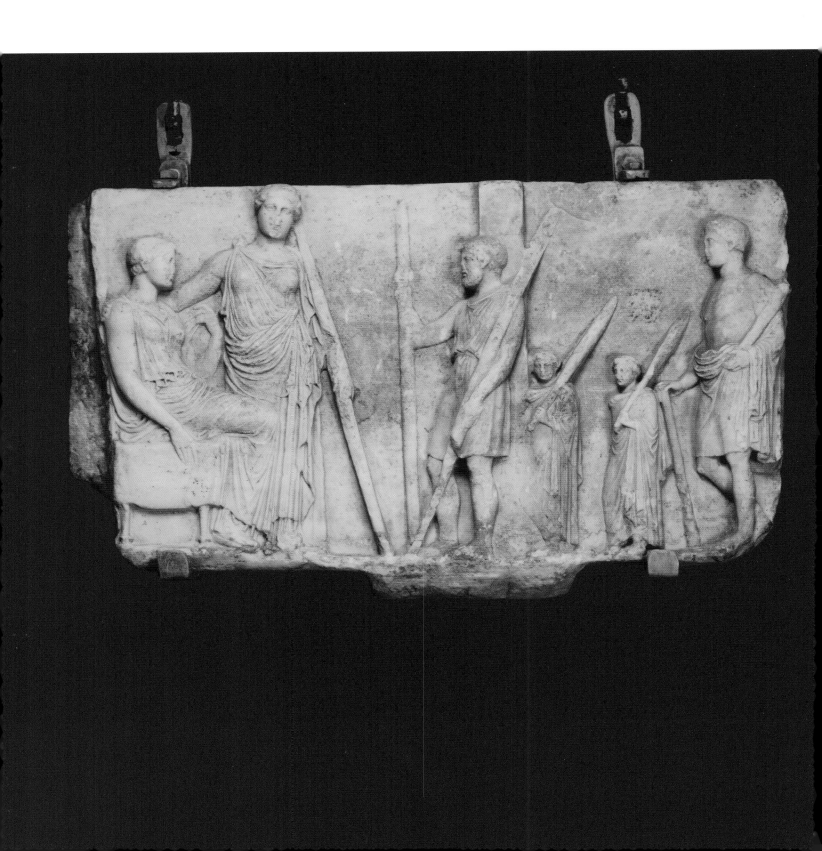

Fig. 5.1. Votive relief with Demeter and Persephone. St. Petersburg, The State Hermitage Museum, inv. PAN.160.

Sculpture of the Northern Black Sea Region

LYUDMILA I. DAVYDOVA

THE HERMITAGE COLLECTION OF ANCIENT SCULPTURES FROM THE Northern Black Sea region—that is, the area of the Bosporan kingdom, Olbia, and Chersonesos—comprises more than one hundred objects by Greek artists as well as local craftsmen and sculptors. Among them, several sculptures can be singled out as being most interesting, both iconographically and from the point of view of the plastic arts.

The head of the goddess discovered in Chersonesos in 1903 (cat. no. 34) is an example of imported cultic sculptures that stood in the temples of the northern Black Sea region. Its attribution as a depiction of Cybele is not called into question, as she is presented wearing the typical headdress of this goddess from Asia Minor. Scholars have already noted on numerous occasions the similarity of this image with the manner and style of the works created by the fifth-century-B.C. Greek sculptor Agorakritos.

Two reliefs from Pantikapaion dated from the middle to last quarter of the fifth century B.C. are surely of Greek—or more precisely, Attic—provenance. The first is a fragment of a tomb stele depicting a standing youth (cat. no. 47). The second is a votive relief, made as an offering to a temple (fig. 5.1), that depicts a scene out of the Eleusinian mysteries in honor of Demeter and Persephone, goddesses of fertility. The ritualistic nature of the scene is indicated through the stylized images of bundles of branches used in the mysteries, held in the left hand of a man standing before the goddesses. We can also see analogous attributes in the hands of the children—adorants and youths behind him.

Among the earliest finds of imported objects in the Bosporus is the statue of a so-called Bosporan king (see fig. 6.1). It was discovered in 1801 in Kerch on Mount Mithridates, on the spot were the Temple of Asklepios stood in antiquity. This temple is known from Eratosthenes' epigram, which was passed on by Strabo (2.1.16), in which mention is made of a brass vessel that burst from the cold in the Temple of Asklepios in Pantikapaion. The statue was sent by the Kerch Museum to St. Petersburg in 1851 for the opening of the Imperial Museum. In the accompanying documents it was described as "a colossal torso of Asklepios made of Paros marble." Subsequently the sculpture became known as the Bos-

poran King. In fact, the statue is iconographically close to the depiction of Mausolos, the fourth-century-B.C. ruler of Caria. On this basis, O. Waldhauer, the first head of the antiquities department and the author of a three-volume catalogue of classical sculpture in the Hermitage, attributed the sculpture to Asia Minor. He did not consider it improbable that it might have been made in the Bosporus, to which a marble block, possibly a ship's ballast, could have been brought for the sculpture.

Such uncertainty also surrounds the attribution of a statue of a woman sent from Kerch in 1838 (fig. 5.2). The absence of attributes makes it impossible to identify the subject; in the old inventory lists of the Hermitage it is referred to as a "marble torso of Juno"; however, the basis for this type of sculpture is the Ionian version of the depiction of Demeter or Kore. The placement of the folds of the chiton and himation on and under the breast has no analogue in known exemplars of this kind. The free, plastic treatment of the drapery in conjunction with the severe, somewhat constrained position of the body should be noted. The unfinished back—that is, the sculpture's orientation to a frontal viewing angle—indicates that the statue stood either in a niche or in front of a wall. The hypothesis that this was a tomb sculpture can hardly be supported. In that case it would have had to stand in a naos or niche fashioned as a portico of a temple. However, there are no known examples of such architectural constructions of grave markers from that time. Most likely, this was a cult statue of a divinity—possibly Demeter—an idea supported all the more by the fact that we know of the existence in the fourth century B.C. of a shrine to Demeter in the acropolis of Pantikapaion from a dedicatory inscription of one Kreusa, daughter of Medonos.

The marble statue of Dionysos (fig. 5.3) is likewise from the fourth century B.C. As is well known, the cult of Dionysos was widespread in the Bosporus; this statue may have been brought over to adorn one of the temples of Pantikapaion. The youthful god of wine and viniculture is depicted in a short-sleeved chiton, girded at the loins, over which is thrown a cloak that falls from the left shoulder to the back and is slung over his left arm. A fawn skin covering his back, breast, and belly is fastened to the right shoulder. On Dionysos's feet are soft sandals, tied above the ankles; at his right foot sits a small panther on its hind legs, upon whom the god's gaze is fixed. Behind the panther is a trunk of a tree, which serves as a support for the entire figure. Based on the sculptural qualities and the features of the image as well as the contemplative mood of the character, this sculpture from the Hermitage is close to the Greek sculptures of the middle to the second half of the fourth century B.C., first and foremost those of Praxiteles, who was known to include in the composition a support in the form of a tree trunk, establishing a naturalistic setting that gave a context for the hero's mood.

The large marble male and female figures from the second century A.D. discovered in the environs of Kerch in 1850 (cat. nos. 81, 82) were, in the opinion of a majority of experts, prepared as tomb statues in advance, but for some reason were not installed on the grave. Even though these works have characteristics indicating a provincial workshop (for example, the barbarian elements in the man's clothing), scholars do not consider the Bosporus to be their place of production—they were probably made in Asia Minor.

Another group of monuments consists of gravestones with reliefs, which became widespread in the Bosporus from the second century B.C. to the second century A.D. The themes of the scenes on them fully replicate the funerary motifs known in all of the oikoumene of antiquity. This includes scenes of the parting of the deceased from his family, where people are depicted clasping each others' hands in a farewell gesture. Often there are scenes of a repast in the afterlife, whose fundamental idea is to introduce the deceased to

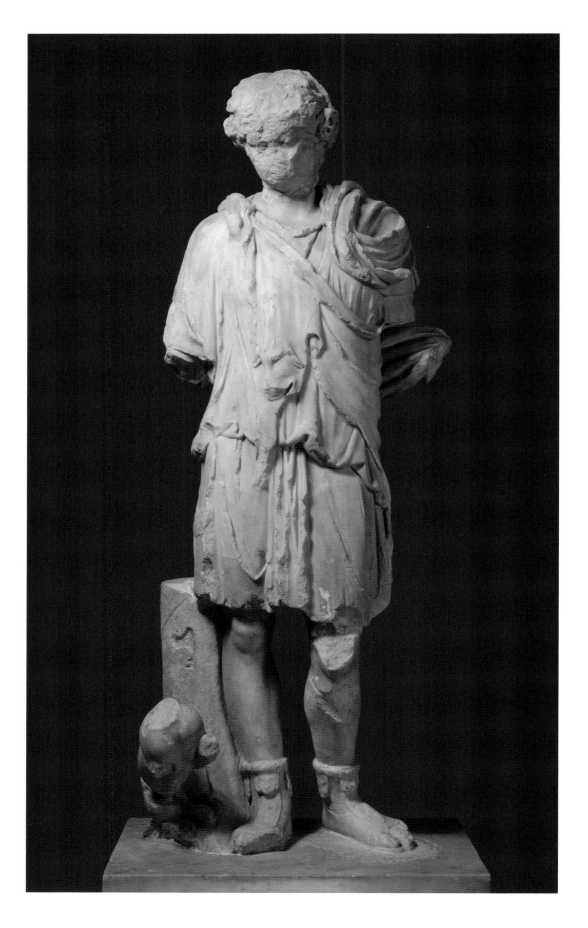

the heroes in a visible embodiment of the eternal bliss of the world beyond. Another popular scene was that of the departure of a mounted horseman (see cat. no. 83), which was based on the same idea of heroizing the deceased by depicting the sacral act of passage from mortal to the ranks of the immortal.

Almost all the Bosporan stelai are fashioned out of local stone—limestone—which is yellowish, warm, and softer than marble. Inasmuch as they were mass produced, they are not of uniform quality. Among them are amateurish copies of imported Greek originals as well as original Attic motifs refashioned with great skill and proficiency by local stonecutters into limestone works. The architectural decoration of Bosporan gravestones was linked to the Greek concept of the stele as a heroön, that is, the abode of and monument to a heroized deceased. The idea of the onset of the new life was expressed by the fact that the action of the scene is set in a temple whose decoration included Greek architectural elements: antae and columns with profiled bases and capitals, arcs and eaves, pediments, and akroteria. However, in the hands of the Bosporan stoneworkers these familiar decorative elements merged with the inimitable Bosporan style, making these unique limestone stelai—like all of the sculptures of the Bosporan kingdom—unlike anything else in the ancient world.

6

The Sculpted Portrait in the Bosporus

ANNA A. TROFIMOVA

THE SCULPTED PORTRAIT IS ONE OF THE KEY ARTISTIC FORMS OF THE Bosporus. The honorary and dedicatory sepulchral portrait, an artistic and social phenomenon of Greek culture, originated in ancient Greece in the Archaic period. It arose from a need to record an individual's role in society and immortalize the memory of him. This determined its purpose, placement, the form of its execution, and the choice of characters. This is why the portrait, better than any other genre, can tell us something about the work of art itself, the context and society for which it was created, the individual represented, and that person's values and ideals.

The history of the sculptural portrait in the Bosporus demonstrates two circumstances important for understanding the culture of the region as a whole. The large number of portraits and their high quality and correspondence to the Greek typologies indicates that the culture in the Black Sea cities essentially replicated that of the metropolitan cities. On the other hand, the striking traits that distinguish Bosporan portraits from Greek and Roman ones reflects the independent historical path of the ancient state of the northern Black Sea coast.

Compared to the other peripheral regions of antiquity, the portrait genre was extremely popular in the Bosporus. This is evidenced by the large number of examples that have survived to the present day, including heads, busts, statues, and torsos in the collection of several museums: the State Hermitage Museum, the Kerch Museum, the Odessa Archaeological Museum, and the Pushkin State Museum in Moscow. The portraits varied in type —honorific, dedicatory, and funerary, as well as functions that have not yet been determined. They depicted women and men, local rulers, Roman emperors, noble Bosporans, and common people. The monuments were made of bronze, marble, local limestone, plaster, semiprecious stones, and even glass.

On the sites of ancient Pantikapaion, Phanagoria, Hermonassa, Gorgippia, Tanais, and other settlements were found numerous plinths with inscriptions describing honorific statues of Bosporan rulers, Roman emperors, and members of their families. The inscrip-

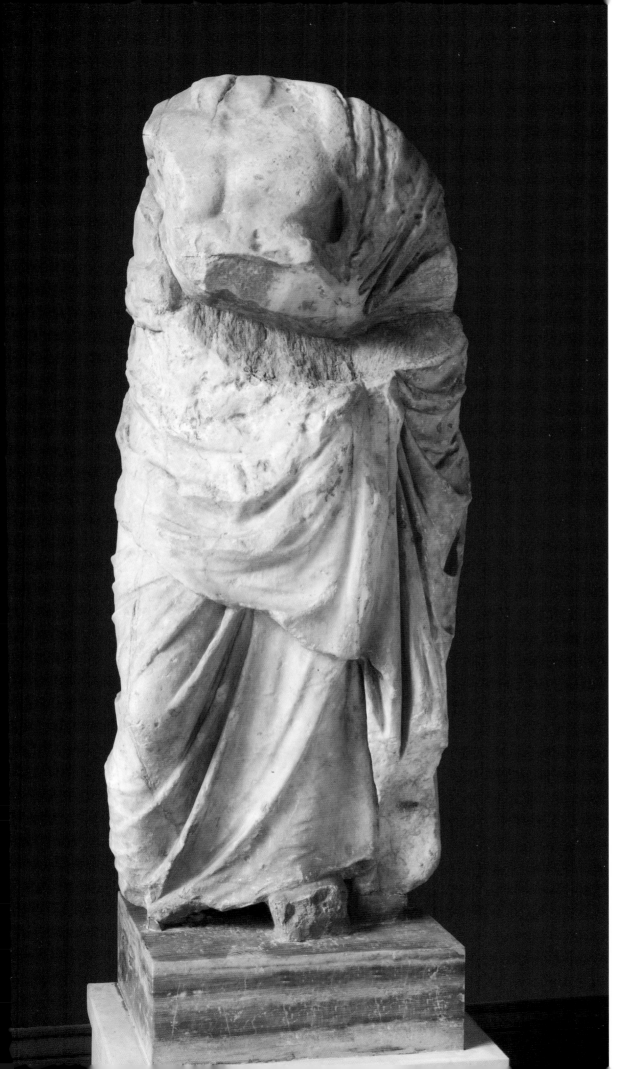

Fig. 6.1. Marble statue of a so-called Bosporan king, early first century B.C. St. Petersburg, The State Hermitage Museum, inv. P.1800.1.

tions mention a statue of the Bosporan king Leukon; the queen Dynamis; Livia, wife of Augustus; and Emperor Vespasian (*KBN* 1965, nos. 38, 40–44, 46–49, 52–56, 68–60, 953, 978, 979, 1046–49, 1119–21, 1240).

An outstanding example of the superior level of the art of the portrait are the coins of the Bosporus, which developed a distinctive portrait style over a period of several hundred years—from the third century B.C. to the third century A.D. The images were of higher artistic quality than those of minted coins of other regions; the portrait series continued up to the end of the empire and were rather close to Roman imperial portrait types (see Frolova 1997; Smith 1988, p. 99).

The history of the sculptural portrait shows how complex and eclectic artistic life in the Bosporan kingdom was. There are well-known imported monuments executed in complete conformity with East Greek (Asia Minor) traditions. Others, possibly made in the Bosporus, come from a part of Greek or Roman tradition, but are distinguished by unusual local characteristics, adapting established conventions to the surrounding environment. Finally, an important group consists of highly original local monuments that are not like the works of other regional schools. In the portraits of all of these groups, however, there is the indelible stamp of local culture: the ethnic character, attributes, the understanding of likeness, and the treatment of form. This is why these unique works have no analogies in the art of the ancient world.

As far as we can trace from surviving monuments, the earliest stage in the history of the Bosporan sculpted portrait dates to the middle of the fourth century B.C., the period to which is dated the torso of the colossal statue of a Bosporan ruler in the Hermitage collection (fig. 6.1). In the opinion of many scholars, the statue represents a divinity—possibly Asklepios or Dionysos. O. F. Waldhauer, who had already noted the high quality of the work, pointed to the stylistic affinity of the torso to the portrait statue of Mausolos from the mausoleum at Halikarnassos from the middle of the fourth century B.C. And B. V. Pharmakowsky identified this statue as representing one of the Spartocids. He compared this figure with the image on the relief from Piraeus: a seated Spartokos II and Pairisades I with Apollonios standing in front of them. The relief is placed above a marble slab with the text of an Athenian decree: "The Athenian people praise Spartokos and Pairisades for being beneficent lords, that they will attend to the shipment of grain, as did their father. As they present the Athenians with the bounty that was presented to them by Satyros and Leukon, they will receive the same honors as Satyros and Leukon." From the text of the decree it is known that the Athenian people erected bronze statues of Spartokos and his ancestors in the Athenian Agora. Pharmakowsky supposed that the Hermitage statue, depicting one of the Bosporan rulers of the Spartocid dynasty, was erected by the Athenians in Pantikapaion in gratitude for Bosporan grain (Pharmakowsky 1925, p. 1133).

The colossal statue from the Hermitage points to close ties between the Bosporus and Athens. These ties, well known in the fifth century B.C., continued in the fourth century as well, during the flourishing of the Bosporus under Leukon (389–349 B.C.) and Pairisades (349–310 B.C.) It is possible that it is at this time that Athenian sculptors established themselves in the Bosporus, and one of them sculpted the Bosporan monument. The Athenian tradition of idealization, majesty, and spiritual loftiness clearly distinguishes this sculptural school. From the middle of the fourth century B.C., when Greek artists began to migrate to other regions, the achievements of the Athenian sculptors were at the disposal of new patrons. As a result, statues of new semidivine rulers and grandiose building complexes praising the virtues of dynasts of Asia Minor made their appearance.

Even though there were no monuments in the Bosporus comparable to the mauso-leum at Halicarnassus, the colossal torso from the Hermitage and other monuments sug-gest that early on Bosporan kings and rulers of Asia Minor were already portrayed as gods. This characteristic is part of the long-standing tradition of heroization, which survived in the Bosporus until very late. Incidentally, from the very beginning to the end of the history of the ancient Bosporus, the image of the ruler differed from that of the Greek or Oriental models.

A head from Phanagoria is a rare work for the Bosporus. Carved from local lime-stone, it is distinguished by great originality in its iconography as well as its style of exe-cution. An elderly man wears a soft felt peaked cap—a hood (*bashlyk*) of the kind often found on examples of Bosporan toreutics and Kerch vases. In Greek as well as Bosporan art Persians, Scythians, Cimmerians, and barbarians in general were depicted in such caps. The broad, flat face is reminiscent of local ethnic types seen on Bosporan gravestones. He has a diadem on his head—evidently this is a portrait of one of the Bosporan kings.

Based on stylistic characteristics, the head has been dated to the second half of the fourth century (Kobylina 1962, pp. 209–14). In Greek art this corresponds to the era of Late Classical art—the period in which the sculpted portrait flourished. A new attitude toward the individual and the changes in sociopolitical conditions brought about the cre-ation of numerous statues of distinguished people, famous thinkers, and poets. Depictions of Alexander the Great created new types of portrayals in this period—the hero-ruler and the divine king—which became the models for royal portraits in Hellenistic times.

The Phanagorian head, unlike the Alexandrian model, repeats earlier, more archaic models. The image is bereft of the emotion and dynamism of the court art of other regional schools. A sense of popular realism and specificity are the distinctive character-istics of this sculpture, reminiscent of Early Classical works, for example, the head of Themistokles from Ostia. These qualities cannot be explained as merely coming from a regional, backward style. From the point of view of the style and technique, the sculptor who worked in Phanagoria followed Greek tradition as far as the treatment of the stone, the character of the modeling, and the plastic naturalism were concerned. What was new for the artist was the subject, for which there were no prototypes in Greek art. In depict-ing a local ruler, the sculptor created a unique portrait, adapting the expressive means of Greek sculpture.

Information on Bosporan portraits from the third to second century B.C. is incom-plete. It should be noted that this lacuna concerns not only the Bosporus, which at that time was part of the kingdom of Pontos, but also Anatolian states, such as Bithynia and Kappadocia. These states were ruled by dynasties of Persian origin and were politically dependent on Macedonia. In the first century B.C. Mithridates VI Eupator rose to power in this region. He left a deep mark on the history of antiquity, having created a mighty world power that became a bastion of hellenism in the East. The outstanding era of Mith-ridates was of great importance for the art not only of the northern Black Sea coast but of the entire Hellenistic world.

An indefatigable fighter against Roman domination, Mithridates VI was very pop-ular in the figurative arts and made a tremendous impression on his contemporaries and descendants. The unique role of Mithridates, who stood as a link between the Oriental and Occidental worlds, has drawn the attention of modern historians: Theodor Mommsen has called Mithridates an "Oriental sultan" (Mommsen 1994, pp. 110, 111) and Théodore Reinach has compared him to Peter the Great (Reinach 1890, p. xiv, see Neverov 1971a, p. 94).

The new persona created in the portraits of Mithridates is usually associated with his independent policy (Smith 1988, p. 141). Compared to those of his predecessors and contemporaries, his representations look more regal and more divine. The dynamic and passionate manner represents the development of the "regal" style going back to the iconography of Alexander. The young beardless face, the long billowing hair and gaze full of pathos recall the likeness of the Macedonian, transmitted with élan and elation.

The identification of the portraits of Mithridates was carried out through a comparison with his representations on coins. There are now ten sculpted portraits, of which some are associated with Mithridates, while others are considered to be in the style of Mithridates. Only one of them has been acknowledged at the present time—the portrait in the lion's skin in the Louvre, which was identified as early as 1894 (Winter 1894). The features of the portrait are very distinct. The portraits in Ostia, Athens, and Venice are more idealized and passionate. The style of the hair, the facial features, and the heroic spontaneity are close to those of Mithridates, although some scholars see in them depictions of the son of Mithridates, Ariarates (see Smith 1988, pp. 99–100).

The Pantikapaion portrait of Mithridates VI Eupator in the Hermitage (cat. no. 84), as well as the comparable portrait from Odessa are on the next level of abstraction. The facial features are enlarged and rendered more severely, the eyes are enlarged, and the turn of the head is sharper. The accent and simplification of the sculpted forms are deliberate in order to intensify the impact of the image. Judging by the craftsmanship in the execution of the neck, the sculptor was in full command of modeling techniques. However, in the depiction of the face he focuses his attention on what seems to be more essential. In the opinion of some scholars, the schematism and abstraction are characteristic of Late Hellenistic classicism of the first century A.D., which was brilliantly represented in the sculpture of Pergamon (Neverov 1972, p. 112). Stylistic parallels do make it possible to attribute the portrait of Mithridates to a Pergamene sculptor; however, it is hard to agree that the monument was created in Pergamon or any other center in Asia Minor, because in this case it is unclear why the head was put together from two parts. It is more likely that it was created in Pantikapaion from an imported piece of marble (see Neverov 1972, p. 113; cf. Sokolov 1999a, p. 273). It should be noted that the expressionism and tendency toward abstraction can be attributed to local influence. These qualities, which were common in the art of the Bosporus, can also be seen in the portrait of the ruler addressed to the inhabitants of Pantikapaion.

In addition to the above-mentioned images of a more idealized nature, other portraits of Mithridates include three monuments found on Delos, the Inopos figure, and the depiction of Herakles freeing Prometheus on the relief from Pergamon. From time to time these identifications are challenged, and there is no consensus at present (see Smith 1988). Also in the collection of the Hermitage is a marble head that is referred to as a head of a Bosporan ruler (fig. 6.2). The depiction is close to idealized and practically devoid of individualized features. It head was sculpted in such a way that it is unlikely that it could have been a fragment of a statue. The broad projection from the neck and the post in the back are more suited for a temple pediment (Sokolov 1999a, p. 271) or a herm. There is a hypothesis that the head was part of a statue seated in a curule chair (Kobylina 1951b, p. 178). The face is rather massive and its details have not been worked out. The quasi-Oriental hairstyle is unusual: long curls descending to the shoulders, with many holes to which metal adornments—hair curls or rays—were apparently attached. The broad ribbon and the curls above the forehead forming an anastole (a distinguishing characteristic for

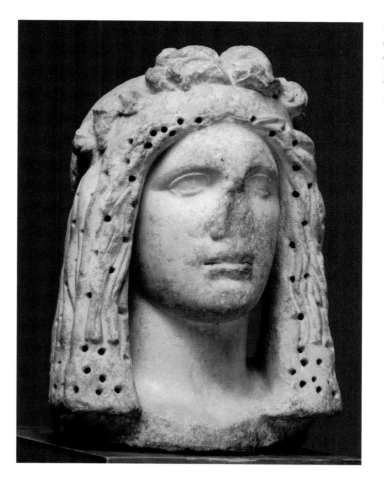

Fig. 6.2. Marble portrait of a Bosporan ruler, early first century B.C. St. Petersburg, The State Hermitage Museum, inv. P.1860.20.

portraits of Alexander) are clearly shown. The monument elicits associations with the depictions of divinities—Helios, Mithras, or Dionysos, and it is not impossible that Mithridates VI Eupator could have been depicted in the guise of one of them (see Savostina forthcoming). The head was sculpted in the period after the king's death (in 63 B.C.), for stylistically it dates to the time of Emperor Augustus. This hypothesis corresponds to our knowledge of the long-lasting popularity of Mithridates, which is known from written sources, coins, and carved stones (Neverov 1968, p. 235). For a long time Mithridates would figure as a symbol of the independent policy of the Bosporus, a policy his successors were eager to continue.

The era of Mithridates and the first centuries A.D. were especially felicitous for the art of the portrait in the Bosporus. Most of the inscribed monuments are dated first through third century A.D.

The bronze portrait of a Bosporan queen (cat. no. 85) is especially well known. This unique, incomparable monument presents a fanciful mix of traditions and the legacy of different cultures. By type, the bust continues the tradition of the royal Hellenistic portrait, which in the Bosporus continued for a considerably longer time than elsewhere. This is confirmed through numismatic data and corresponds to the political credo of the Bosporan rulers. The Hermitage bust depicts a charismatic queen who rules outside of time and space. She is presented with divine attributes. At the same time, this is a fully concrete personality. In spite of the idealization, the portrait shows a purely Roman, almost

unpleasant verisimilitude in the depiction of the facial features and pedantry in the depiction of "contemporary" features in the external appearance, for example, the hairstyle. The image exudes Oriental solemnity and symbolism. A great deal of attention has been paid to the decorative elements, especially the palmettes and rosettes on the headdress, which it seems are no less important then the facial features. This convention is not intrinsic to Roman portrait art, rather it links the Bosporan bust to Oriental models.

As will be set forth below, it seems possible that the sculptor who created the bust had connections with the artistic traditions of northern Syria. Based on its stylistic features this monument is dated to the A.D. 30s. It is difficult to say where this bust was actually cast, but it is evident that it is a copy of a portrait type or likeness "from nature." The identification of the bust as that of Queen Dynamis, which was suggested by Rostovtsev (Rostovtsev 1916) was based on the dynastic symbolism of the Achaemenids: the Phrygian cap and the eight-rayed star. Taking into account the depiction of the star, as well as the fact that the queen was the granddaughter of Mithridates, of Persian origin, and conducted a policy of maintaining Bosporan independence (i.e., continued the policies of Mithridates), Rostovtsev concluded that the bronze bust was a depiction of the celebrated queen. This point of view was shared, albeit with provisos, by many scholars (Gaidukevich 1955, p. 128; Gaidukevich 1971, p. 337; Kobylina 1972, p. 12; Voshchinina 1974, p. 194; Sokolov 1976, p. 93; Saprykin 2002, p. 96; opposed by Molchanov 1971, p. 101; Parlasca 1979, p. 397). It is important to note that this attribution contradicts the dating of the hairstyle, which is contemporary with the time of Agrippina, and numismatic data, according to which Hypepyria was depicted with such a hairstyle (see more details in cat. no. 85). Unfortunately, the question of who is depicted in this bronze bust cannot yet be resolved.

The Asia Minor school of sculpture of the second century A.D. is represented in the Hermitage by two portrait statues — a pair of standing statues of a man and a woman, found in Kerch (cat. nos. 81, 82). It is quite probable that both sculptures were made in Asia Minor and brought to the Bosporus (Voshchinina 1974, p. 196). The composition of the statue of the man replicates a common motif of the funerary sculpture of Greece in Hellenistic and Roman times, the so-called Youth from Eretria. This motif was also used in Bosporan sculpture, for example, in the statue of Neokles. The style of the execution is analogous to the sculpted portraits of Asia Minor in this period. The lively, asymmetrical face with the expressive eyebrows and forehead, as well as the thick head of hair, similar to the hairstyles of Bosporans depicted on gravestones, are completely local elements. The trousers (*anaxirides*) tucked into the soft boots are not elements of Greek clothing. The attribute — a casket with a lock, pointing to the social status of the depicted — is meticulously made. The face of the man is unique and exceptionally effigial. The statue of the woman, replicating the canonical Large Herculaneum Woman type, is considerably less individualistic. Her doll-like face is in sharp contrast of that of the man, but it is unlikely that this can be explained by the fact that the statue was unfinished (Voshchinina 1974, p. 197). Such typology was characteristic for female Graeco-Roman portraits, especially funerary statues.

Another very important monument of Bosporan sculpture is the second-century-A.D. portrait statue of a notable Bosporan, Neokles (Kobylina 1951b, p. 172; Sokolov 1999a, p. 432). The statue has an inscription stating that it was erected in A.D. 187 by the son of Neokles, the ruler of Gorgippia Herodoros in honor of his father in the twelfth year of the reign of Sauromatos. Neokles is shown wearing a himation, but with an ornament on his neck whose style—massive, with snake heads and a plaque depicting the head of a bull—

corresponds to the ones found in the Bosporus. The inscription provides a basis for dating, which is why it is especially interesting to compare this portrait with contemporary Roman ones. Technically and stylistically they have many features in common—for example, in the treatment of the eyes in the shape of double hemispheres with sharply incised irises, and in the rendering of the full head of hair and the curly beard with drill holes. However, there are considerable typological differences, as well as differences in the depiction of the portrait and the means by which it was created. Compared to the characters of the Roman metropolitan portrait, Neokles is perceived in a more concrete way—simpler, more down to earth, closer to nature. He is not idealized as in Roman statues— the head is too large, his shoulders are narrow, and he has a sunken chest. In the execution of the sculpture there is a combination of the three-dimensionality of sculptural forms and the graphics of details. The distinguishing trait of the sculpture is the immediately noticeable planar quality: from the side, the statue looks like a high relief.

The Bosporan depicted in a statue fragment (slightly under life size; fig. 6.3) in the collection of the Hermitage seemingly resembles the face of Neokles. Stylistically, this portrait is from a later time—the era of the Severans in the early third century A.D. (Kobylina 1951b, p. 172; Voshchinina 1974, p. 198; Sokolov 1999a, p. 366). This work is distinguished by very high quality carving and various stone cutting and sculptural techniques. Many different tools were used in the execution of this sculpture—a thin drill in the corners of the lips and the tear ducts, a sharpened chisel for the irises of the eyes, and various degrees of polishing. The sculptor fully mastered the techniques of modeling, as can be seen in the free rendering of the tresses and the soft working out of the surface of the face. The outlines of the eyes and eyebrows create the impression of a pensive gaze. In spite of this refinement, which is comparable to that of Roman portrait sculpture, the depiction of the Bosporan is distinguished by simplicity, a lack of ostentation, and an idiosyncratic vivacity that also pervades other forms of Bosporan art. As is the case with the statue of Neokles, an asymmetry of the face imparts movement to his expression, and a deliberate flatness, resulting in the cut-off shape of the back of the head.

Not only the structure of Bosporan society but also the climate and landscape brought about the inimitable qualities of its art. Because of the absence of marble, sculptures were often made of rare materials or as acroliths, in which only the head and extremities were marble, and drapery covered a wood trunk. In the territory of Kerch, plaster portraits have been found, which form unique displays in museum collections.

The man's portrait from the Hermitage (fig. 6.4) (Sokolov 1999a, fig. 262), in spite of its badly preserved state, has an astound-

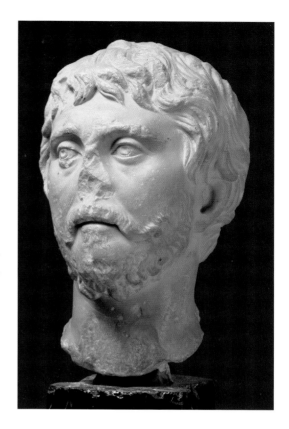

Fig. 6.3. Marble portrait of a Bosporan citizen, third century B.C. St. Petersburg, The State Hermitage Museum, inv. P.1842.107.

Fig. 6.4. Plaster male portrait, mid-third century A.D. St. Petersburg, The State Hermitage Museum, inv. P.1842.104.

Fig. 6.5. Limestone funeral half-figure statue with the inscription "Nikarchos, Eration, sons of Sosigenos— to mistress Kyria, farewell," second century A.D. St. Petersburg, The State Hermitage Museum, inv. PAN.1619.

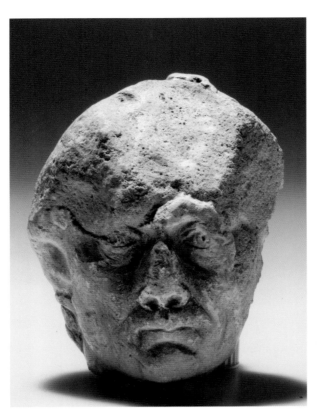
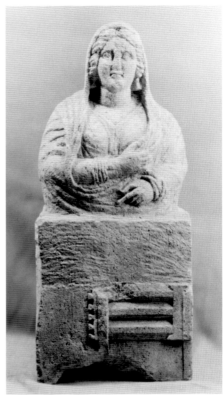

ing effect because of its expressiveness and naturalism. As a whole, it corresponds to the character of the Roman portrait of the middle of the third century A.D. but is considerably more piercing and acute. The man has a somber and cruel expression, bags under his eyes, and sunken cheeks. Judging from its small size, the portrait was not intended for public viewing in the city, but rather for an interior installation (Sokolov 1999a, p. 261). As was the case with other plaster works, the head was painted, which further intensified the effect.

A separate and very important category for understanding this regional art are the funerary half-figure statues of human figures made of local limestone (Kobylina 1951b, pp. 178–88; Ivanova 1961, pp. 73–95; Sokolov 1999a, pp. 168–170). The tradition for these half-figures, which goes back to the anthropomorphic sculptures of the pre-Scythian era, was unknown in Greece and the eastern Mediterranean. This type was formed and spread in the Bosporus in the fourth through third century B.C. and continued to evolve in the first through third century A.D. The statues depicted a heroized deceased who was given the distinct features and corresponding attributes of chthonic divinities. The features of the clothing and faces reproduce the appearance of actual residents of the Bosporus. Besides the autochthonic traditions, Greek funerary statues, which were widespread in the different areas of the Mediterranean in Hellenistic times, also influenced the development of these sculptures.

In the collection of the Hermitage is a half-figure with an inscription (fig. 6.5). The bust is placed on a high plinth, on which a triglyph has been preserved. The meticulous elaboration of the details, the linearity, the tendency toward abstraction, and the distinctive face are similar to the funerary sculptures of Palmyra.

Next to these statues is a large group of block-shaped, abstract funerary statues with relief details. These limestone statues can be regarded as local popular sculpture. The small size and inexpensive material would indicate that they were intended for and appreciated by average townspeople. The combination of Greek and local characteristics in the outward appearance and dress indicates that they were used by an ethnically mixed clientele with tastes that corresponded to the style: conventional, frontal, immobile, with attention to realistic portrait features.

In summing up our findings on the history of the portrait we can conclude that this genre of art developed in the Bosporus for at least five centuries—from the fourth century B.C. to the third century A.D. Beginning with the second half of the fourth century B.C. the links with Athens are indisputable, as is the strengthening of the artistic ties with Asia Minor from the first century B.C. to the first century A.D. It is not impossible that some artists who worked at the court of Mithridates, and in particular metal craftsmen (Molchanov 1971, p. 107), settled in Pantikapaion. Beginning with the second century A.D. the Roman portrait became very influential.

Even though all types of portraits existed in the Bosporus, the depictions of rulers were especially important. Apparently this can be explained by the importance of the sovereign, which in the Bosporan kingdom existed from the fifth century B.C. and maintained its political and economic importance throughout the Roman era, up to the third century A.D. At the same time, one can conclude that the local type of tomb portrait, which was not known in other regions, was created in the Bosporus and developed over the course of six centuries. This type of sculpture developed out of the most ancient traditions of tomb sculptures of the northern Black Sea coast, the Sea of Azov region, and the Caucasus.

An important artistic quality was born in the process of making the portrait representation concrete. This was achieved through the local realism, which manifested itself in the factual rendering of the facial features, characteristics of the physique, and clothing, all giving this type a fresh immediacy unique to the region. Yet with that specificity, sculptors still show inclinations toward abstraction and schematization, which increased in the Roman era.

Thus in the Bosporus the art of Greek portrait sculpture, like a young sapling transplanted to a far-off land, established itself and grew into a magnificent tree. Here flourished a local variant of a genre that never lost its ties to Greek culture, but as these portraits show, it was not firmly dependent on its Greek roots. Having assimilated the influence of various artistic centers and local artistic orientation, the Bosporan portrait became a dynamic creation of ancient art.

7

Gold from Ancient Monuments of the Northern Black Sea Coast

YURI P. KALASHNIK

I N NATURE GOLD IS FOUND IN LODES IN ROCKS, IN THE FORM OF GOLD-BEARING sand, or as nuggets. The most important sources of gold for the ancient Greeks were deposits in Macedonia, Thrace, and on the island of Thasos. In Asia Minor there were rich deposits in the Paktolos River valley and in the Tmolos Mountains. The legend of the Golden Fleece suggests gold mining in Kolchis. Nubian gold could have reached Greece via Egypt. It is possible that gold reached the Black Sea region from the east as well—from the Urals and the Altai. There is circumstantial evidence for gold from the Urals and the Altai, based on the legend of the gold that was guarded by griffins and the Arimasps who fought them for it. The finds in the kurgans of the Scythian steppes and the Altai have given rise to many legends of the incalculable wealth of ancient rulers, and today the finds from the kurgans serve many as proof of the presence of gold in these regions. The outstanding scholar of Black Sea numismatics A. N. Zograf, already in prewar discussions of the minting of Pantikapaion gold staters, warned against illusions regarding the supposed cheapness of gold in the Bosporus (Zograf 1951, p. 173). This was more a question of the abundance of natural resources, the volume of trade, and the aspirations of the local aristocracy. In fact, in the manufacture of new objects, old jewelry was often melted down and used alongside new metal.

In Classical times high-quality gold was used in the production of jewelry, but platinum was added as well. The melting temperature of the latter is higher than that of gold and its presence can easily be detected. For example, metal crystals lighter than gold seemingly emerge through the surface of the shield of a ring, swelling it (cat. no. 55). It must be supposed that in order to avoid possible ruptures, the jewelers did not add that kind of raw material when making thin foil or wire.

Most of the adornments are complex works consisting of many parts, which were made using various techniques. However, the methods and instruments were rather simple, so the main factors determining the quality of the work were the skill of the jeweler, his experience, and his knowledge of the artistic potentials of the material. It appears that goldsmiths

had been working in the cities on the northern Black Sea coast from the earliest times, as is evidenced by the finds of casting molds, many of jewelry particular to the region. This includes the unique ear pendants (cat. no. 27), the distinctive spiral pendants (cat. no. 70), and the earrings with pendants in the form of women's heads. Of special interest are barbarian objects that were made using Greek techniques and forms of decoration (cat. no. 138). This is an exact replica of a round-bottomed Scythian cult vessel (the ringlike stand was soldered to it at a later time). The reliefs on the frieze clearly are of a narrative character—perhaps episodes from a local legend (Raevskii' 1977, pp. 34–36). The depictions of the Scythians are so full of realistic details that the immensely talented artist must have observed them with his own eyes. Evidently this is one of a series of masterpieces produced by artists active in the Bosporus in the middle of the third century B.C. It is interesting to note, by contrast, that depictions on Attic vases of barbarians (whom the painters never saw in real life) show them wearing clothing and weapons that did not correspond to reality.

The most popular and oldest method of gold working was hammering. Rods of various thicknesses were hammered, pieces of gold were flattened into thin sheets, from which unfinished parts were cut for later use, and the piece was given the required shape. Wire for filigree was made of narrow strips of thin gold leaf, and unfinished grains were made of finely cut pieces of gold leaf. Almost every piece of jewelry was hammered in one way or another, whether simple or complex, such as in earrings (cat. nos. 142, 162), which used thin sheets of gold and wire of different thickness, as well as the finest grain and filigree.

For the production of relief parts, matrices and dies (*poinçons*) were used. A relief made in such a way often formed part of a more complex object. For example, the bezel of the ring with the depiction of a sad Penelope (cat. no. 54), the figure of the Nike tying her sandal from Kul Oba (cat. no. 142), and the bezel of the massive ring (cat. no. 73) where the relief serves as a setting for the cameo head of Athena. A relatively thin gold leaf could be pressed into a matrix or, if a die was used, the leaf was placed under a lead plate, or the unfinished metal was fastened to a cushion of special resin. Once the relief was stamped, the jeweler would finish it through hammering or engraving. This is how the numerous appliqués used to decorate cloth were made. In many cases, when the relief was very high, the left and the right halves were stamped in separate matrices and then soldered. This is how the birds of the Olbia earrings (cat. no. 26), the lions' heads of the ear pendants (cat. no. 27), the bracelet finials (cat. nos. 56, 140, 164), the figure of the dog on the rhyton (cat. no. 120), and the so called amphora-like pendants (cat. no. 161) were made. As a rule such sculptural artifacts were filled with resin or other material to ensure firmness. On the shoulders of the pendants of the lower row of the necklace from the Great Bliznitsa kurgan (cat. no. 163) one can see a specially made hole through which a white filler paste was introduced. The pendants of earrings in the form of women's heads, made of a front and back half (cat. no. 71) were filled with brown resin introduced through an opening made for that purpose in the bottom of the finished pendant. A resin substance was also used to fill the inside of the figure of the sphinxes (cat. no. 140). Sometimes gold leaf was wrapped around a metal base (cat. nos. 140, 164). On the ribs of the figure of the lioness (cat. no. 164) the head of a pin shows through the gold leaf; this was probably used to connect the hoops of the double bracelet and the metal base of the figure.

Casting was used in the production of jewelry. Halves of casting molds were found in different parts of the ancient world, including Olbia (fig. 7.1) and Nymphaion (figs. 7.2a and 7.3a). Such molds were used for casting simple objects (figs. 7.2b and 7.3b). Complex three-dimensional figures were cast in the lost-wax method. For mass-production, the wax models were made in molds. Then the models were covered in clay and heated. During heating

the wax flowed out through a special opening, as the molten metal displaced the wax, completely replicating all of the details of the model. There are true masterpieces of miniature sculpture in the Hermitage that were made in this way, for example, the earring pendants from Nymphaion (cat. no. 132) and Yuz Oba (cat. no. 153). The parts of these figurines were made separately, then attached to the casting, and the entire work was then given a finishing process. The figures of the Nikes on the earrings from the Pavlovsky kurgan were cast in one piece (cat. no. 159). The details of stamped reliefs underwent further elaboration (cat. nos. 141, 161): a very fine drawing was applied—the plumage of the wings of the sphinx and Nike (cat. nos. 140, 159). Through incisions and engraving, images were made on seal-rings (cat. nos. 28, 38, 52, 55, 135). Sometimes lines were applied with light strokes of a stylus, creating an effective geometric decoration on the smooth surface (cat. no. 120), vaguely reminiscent of the painting on the red-figure cups of the Saint-Valentin group and the skyphos from the Nymphaion necropolis (cat. no. 126).

In the design and decoration of many of the adornments some components are made of thin wire. Actually, this is not wire as we know it—it was not extruded; that technique was invented only in the Middle Ages. In ancient times wire was twisted of narrow strips of thin gold leaf. It was rolled numerous times between two plates, as a result of which the seam was never straight, but twisted in a spiral. If the surface of the rolling plate had grooves, the wire acquired relief. Such wire was widely used to imitate granulation.

Wire was used for creating filigree ornamentation, chain pendants, braids, and lacing that resembled braided threads but were actually made up of interconnected rows of wire loops. Half loops were inserted into one another, forming chains. Several flat interconnected parallel chains formed bands, outwardly similar to knitted fabric (cat. nos. 37, 158, 163), and a bunch of chains formed a braid (cat. nos. 41, 175).

Granulation was made from finely cut strips of gold leaf. Mixed with charcoal, they melted when heated and turned into bead drops. The filigree ornamentation from wire and the granulation pattern were soldered to a thin sheet of gold leaf. When heat was applied, the solder melted and the details of the ornamentation were firmly and precisely soldered

7.2a

7.2b

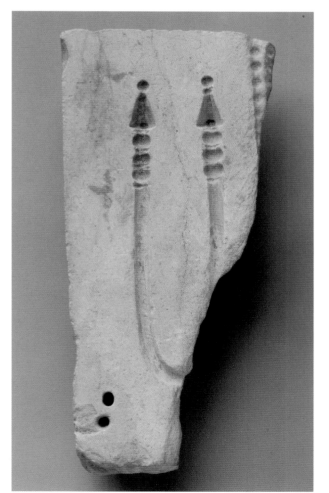

7.3a

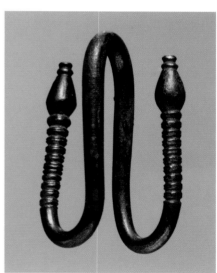

7.3b 1:1.5

Fig. 7.2a. Stone half mold, third century B.C. L: 8.2 cm. From Nymphaion. St. Petersburg, The State Hermitage Museum, inv. NF.48.1202.

Fig. 7.2b. Gold pins, third century B.C. H: 9.5 and 10.3 cm. St. Petersburg, The State Hermitage Museum, inv. P.1834.58 and T.1910.7.

Fig. 7.3a. Stone half mold, fourth century B.C. L: 10.5 cm. From Nymphaion. St. Petersburg, The State Hermitage Museum, inv. NF.70.334.

Fig. 7.3b. Silver spiral pendant, fourth century B.C. H: 3.9 cm. St. Petersburg, The State Hermitage Museum, inv. D.1066.

as intended. It was very important to pick the optimal temperature, for the small parts could melt if the temperature was too hot, which would make the ornamentation imprecise, and low temperature would make the bond too weak. The height of this technique is represented by the so-called Rich Style of earrings. There are fourteen known examples of such earrings; the Hermitage has seven, of which two are in the exhibition (cat. nos. 142, 162).

Filigree patterns were sometimes combined with colored enamel. For this a powder-like substance was placed in the individual cells of the decoration. When the object was heated, the powder melted and adhered firmly to the surface of the gold (sometimes the surface of the gold was scratched to ensure better adhesion of the enamel). On the adornments presented at the exhibition one can distinguish four basic colors of enamel used by the Greek artists: green, blue, light blue, and white (rarely). Cinnabar was used for rare red color (cat. no. 142). The pendant-medallion of the pin from the Artiukhovsky kurgan (cat. no. 176) from the second century B.C., was fashioned in a technique that was rare for antiquity. It is reminiscent of cloisonné, in which the rosette, whose contours are outlined by bands of gold leaf placed on their side, is filled with pieces of green and brown glass.

In Hellenistic and Roman times, in accordance with new tastes, colored stone inserts became immensely popular. They were fastened in special bezels fashioned out of vertically placed strips of gold leaf, the upper edge of which tightly pressed to the stone (cat. no. 175). This technique became widespread in the first centuries A.D. The relative rarity of filigree and granulation in the Roman era can be explained by a change in fashion rather than a loss of skills—an example of a successful use of granulation in Roman times is the decoration of the butterfly pendant (cat. no. 41).

Gold was used to give a more elegant appearance to objects made of other materials. There are examples in the exhibition of gilding applied to silver objects. This includes now barely discernible elements such as scallops on the bracelet's terminals (cat. 56) and the gilding of engraved drawing on silver vessels (cat. nos. 77, 147). Athenian potters from the end of the fifth century to the first half of the fourth century B.C. accented with a thin coat of leaf gold the adornments of the characters in their paintings (cat. nos. 149–52, 156).

The jewelry in the exhibition is mostly from the fourth century B.C. and represents the achievements of Late Classical jewelers. The earlier jewelry of Ionian craftsmen found in Olbia and of the Hellenistic and Roman periods make it possible to trace the stylistic development. In Late Archaic and Classical jewelry, the artistic possibilities of the metal itself were fully exploited. The brilliant surface of the base, on which traces of forge work are preserved, outlined the dull fluorescence of the granulation (cat. no. 27). In Classical times the favorite technique for decoration was a symmetrical but free design of a filigree decoration combined with small granulation (see, e.g., cat. nos. 70, 142, 162).

Color as an artistic means was of secondary importance; this consisted of a modest inclusion in the filigree of light blue, green, and white enamel on the rosettes of necklaces (cat. nos. 57, 131), bracelet fasteners (cat. nos. 140, 163), and festoons on budlike pendants of necklaces and temporal pendants (cat. nos. 141, 161, 163).

By the end of the fourth century new motifs appear in the repertoire of decorative elements, of which the most popular is the Herakles knot (cat. no. 37). It is noteworthy that earrings of the so-called Rich Style are decorated with minuscule sculptures, which were rare even in the fourth century and in later times were considered no more than a piece of art. It was possibly objects such as these that the Roman-era writer Claudius Aelianus had in mind when he wrote of Myrmekides of Miletos and Kallikrates of Lakedaimon, who fashioned a quadriga smaller than a fly: "It seems to me that these things will never

merit the praise of a serious person: is this not a waste of time?" (Ael. 1.17). In Hellenistic times a new style came about, whose most outstanding feature was polychromy. Objects were copiously adorned with colored stones, mostly garnets (cat. no. 73), and there was an increased use of many types of glass. Sometimes the jewelry turned into an array of colored blots set in gold (cat. nos. 175, 176). The change in tastes was a result of the influence of the Oriental propensity for color as well as the increasing possibility of obtaining colored stones from far-off lands in the wake of Alexander the Great's campaigns. This tendency predominated in the first century A.D. An example of this is the necklace with the butterfly, which has not only multicolored stones and glass but also pearls (cat. no. 41), probably brought from either the Red Sea or the Persian Gulf.

All of the jewelry was found in graves. The deceased was accompanied by things that had surrounded him in life. Often they were gifts, sometimes family relics as, for example the ring in cat. no. 54. Sometimes objects represented high social status: perhaps the woman buried in Kul Oba performed priestly functions, inasmuch as next to her was found a vessel (cat. no. 138), which judging by its form was used in Scythian cult practices. The same can also be said of the woman buried in the first burial chamber of the Great Bliznitsa kurgan in a magnificent funerary vestment. Based on the opulence of the attire and the subject matter of the red-figure pelike (cat. no. 156), we can surmise the priestess status of the woman buried in the Pavlovsky kurgan as well.

The objects shown at the exhibition do not reflect the full array of the variety of jewelry found on the northern Black Sea coast, but they make it possible to observe the development of certain tendencies, for example, in earrings: from simple bird pendants (cat. no. 26) to the exquisite little sculpture of Artemis riding a deer (cat. no. 132) or the ecstatic dancing maenad (cat. no. 153). Having appeared for a relatively short time in the fourth century B.C., the earrings in the Rich Style (cat. no. 159) demonstrate how dissimilar works can be produced from very similar elements.

8

Dexamenos of Chios and His Workshop in the Northern Black Sea Region

OLEG Y. NEVEROV

THE ENGRAVER DEXAMENOS OF CHIOS WAS THE LEADING ARTIST IN THE area of glyptics in the fifth century B.C. Four of his signed works have survived. Since the beginning of the twentieth century it is thought that Dexamenos was one of those Ionians who worked in Athens. The influence of Pheidias on his work has been noted. Dexamenos's signed Boston gem was found in a necropolis near Athens. This provided the basis for locating his workshop there. However, the ties of the engraver to the northern Black Sea coast were so long and constant that there can be no doubt of his presence there. Half of the signed gems come from there, all of the genres of his works are represented there, and his influence on local artists cannot be denied. The recent appearance of a new portrait gem of the master in Berlin has enlivened the discussion. And that gem is of Crimean provenance— from the Kerch collection of the physician I. Streletsky.

One of Dexamenos's best works, in which he proudly proclaims himself to be from Chios, shows him to be a master of the animal genre. On a light-blue chalcedony he carved a flying heron (cat. no. 154). All of the components of the glyptic language are assigned their own visual function: color, the flowing oval of the gem, replicating the free beating of the wings. The result is a poetic image of spring—the return of the birds. The silhouette of the bird—"herald of dear spring, herald of agricultural work"—awoke hope in the human breast. Passionately in love with the beauty of the animal world, as if unable to tear himself away from his chosen object, the artist turns to interesting variations on one theme. Thus appears series of animals at rest and in impetuous movement. From Phanagoria comes the signed gem depicting a standing heron (cat. no. 49). The timid bird, hiding in a thicket of reeds, seems to be afraid of something and lets go of its prey—a tiny grasshopper.

Standing steeds are counterposed to running race horses. The Kerch gem becomes a symbol of freedom in the hands of the artist (cat. no. 155). The horse without a rider completes the race. This is seemingly an illustration of the verse by Theognis:

I am a beautiful racehorse, but hopelessly wretched
Is my rider who drives me. This pains me the most.
Oh, how often I have wanted to run, tearing off my reins
Suddenly throwing this rider to the ground.

Dexamenos's depictions of musicians, among whom he prefers harpists, are poetic (cat. no. 51). His love for parallel undulating lines points to the influence of the style of the sculptures of Pheidias.

If we knew with certainty the works of the metal engraver we would have to attribute a series of gold rings from the northern Black Sea coast. One of them is a repetition of the gem with the flying heron (cat. no. 52). Another depicts a duck having let go of its prey —a fish. On the third, a griffin torments a horse (cat. no. 135). Apparently these are works by local jewelers, as is a gem from Theodosia that shows a simplified version of the standing heron. Here the engraving is of a decorative generality; only the musical silhouette is preserved and is naturally incorporated into the oval of the composition as explored by the celebrated man of Chios. Familiarity with his work became a fruitful resource for local artists.

Thus portrait gems, elegiac scenes from the life of the women's quarter, youths and young girls playing musical instruments, and an especially rich animal subject matter are the contribution of Dexamenos to the development of the art of glyptics in the middle to the second half of the fifth century B.C.

A scene of griffins tormenting a horse evidently shows the influence of the Oriental Persian world on the thoughtful newcomer from Ionia. It is curious that for one of the Bosporan clients Dexamenos carved a Chian amphora as the emblem of his seal ring (cat. no. 50). Such amphorae with wide necks were used to transport the much-desired sweet wine from his native Chios. Possibly the customer who ordered the stamp was a trader, a ship-owner from Pantikapaion. Apparently a wealthy citizen of Pantikapaion ordered the gem that has a carved griffin and is connected with the cult of Iranian gods. It was found on the ridge of the Yuz Oba kurgans, a necropolis of privileged Bosporan notables.

Even though the information we have so far is sketchy, the links between Dexamenos and his workshop with the northern Black Sea coast appear in a new light: they were not limited to the intermediary trade between Athens and the Bosporus, but were carried on in a more direct manner of contacts between the artist and this peripheral region of the ancient world.

Fig. 9.1. Terracotta figurine of a herdsman with a bull, third century A.D. Found in Ilouraton. St. Petersburg, The State Hermitage Museum, inv. IL.49.5.

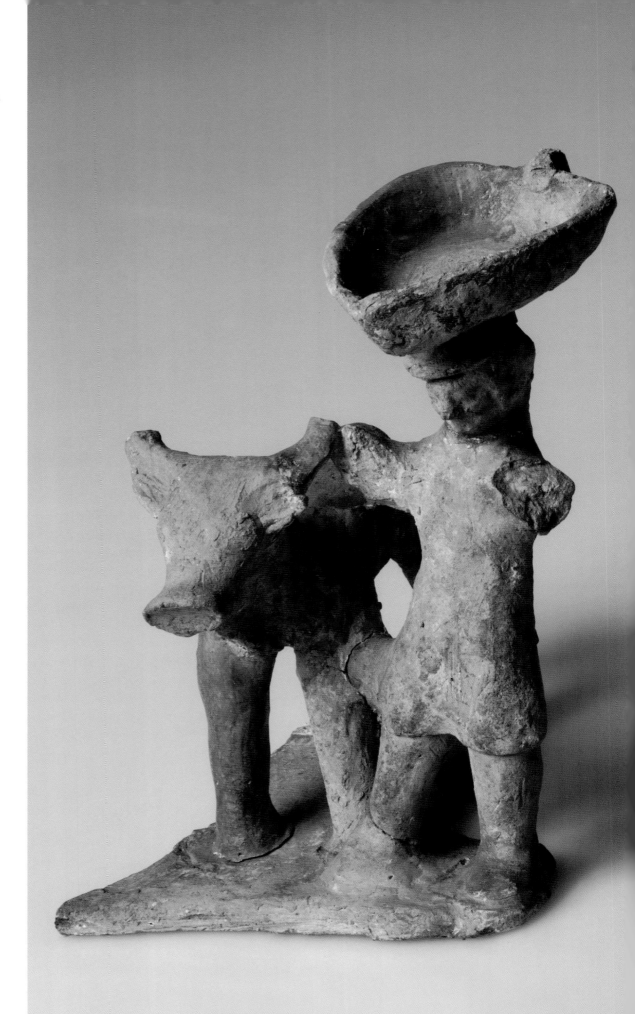

Barbarian Art in the Cities of the Northern Pontic Region

ALEXANDER M. BUTYAGIN

I T WOULD BE DIFFICULT TO EXAGGERATE THE IMPORTANCE OF THE BARBARIAN tribes that surrounded the Greek cities on the shores of the Euxeinos Pontus, or Black Sea. Many orbits of activity—and sometimes the very existence of the colonists and their descendants—depended on the local tribes, so it is only natural that evidence of the constant barbarian presence would be found in the works of art discovered during the archaeological exploration of the northern Pontic region. Russian archaeologists have always devoted meticulous attention to these ancient influences of local and barbarian tribes on the Greek settlements of the region. In spite of the wealth of new material collected over the past decades, we can still agree with what T. N. Knipovich wrote a half century ago: that in studying the art of the Greeks in the area of the northern shore of the Black Sea, we "are dealing with an exceedingly complex phenomenon" (Knipovich 1955b, p. 164).

We still do not have a clear picture of the situation, in particular what comprised "barbarian" art, that of the middle and lower strata of the local population of the Greek cities and their environs. A closer examination of the art of the northern Pontic region suggests that we are dealing with several distinct lines of cultural development that remained independent for a long time, despite an intermingling of those cultures. First, there are monuments produced in the Greek metropolis. They were carried into the northern Pontic area throughout the entire period of antiquity, and further spread into the area of barbarian settlement as far as the forested steppes and even into the interior of the boundless expanses of Eurasia. One should also take into account the periodic appearance on the shores of the Black Sea of professional itinerant jewelers and stonecutters, who could have been attracted to the area by the wealth of the local rulers. Works from the metropolis permitted the Greek masters of the northern Pontic cities to remain abreast of artistic changes and, circumstances permitting, they incorporated these innovations into their own crafts (Knipovich 1955b, 166–70). Naturally, barbarian influences are completely absent from these pieces.

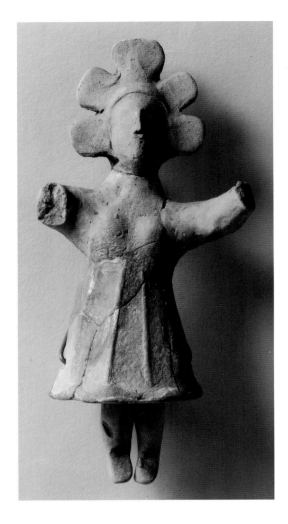

Fig. 9.2. Terracotta marionette, third century A.D. From Ilouraton. St. Petersburg, The State Hermitage Museum, inv. Il.49.27.

Objects made by Greek artist-craftsmen in the ancient centers of the northern Pontic area constitute the second cultural line (figs. 9.1 and 9.2). As is often noted in ancient sources, the population of the cities actively resisted the penetration of the barbarians, who seem to have assimilated and hellenized themselves. Even the reduction in the fifth century B.C. of such evidence of their presence as sherds of rough molded pottery, which were plentiful in seventh- through sixth-century layers, shows the penetration of barbarian culture into the cities to be minimal, even while Olbia was under a barbarian protectorate. It is difficult to distinguish barbarian art even at the stage when the increase of the local tradition is noted unanimously by all scholars (fig. 9.3). It is held that beginning with the Hellenistic era, the art of the northern Pontic region became increasingly influenced by local tribes. Nevertheless, it is hard to identify those traits that developed independently in the art of the Pontic Greeks, who were somewhat isolated from the metropolis. It is possible that many of the characteristics of the art of the Greek cities of the northern Pontic region, which at times anticipated artistic developments of the Roman Empire, were actually natural consequences of northern Pontic influences. Certainly these processes developed in different centers of the region, and along different paths that determined their cultural distinctiveness (Ivanova 1953).The Chersonesos community was always determined not to allow barbarians in its midst; however Olbia was more lenient in regard to the surrounding local population, while the Bosporan kingdom was a Graeco-barbarian formation. Thus in the art of the Greek cities the barbarian influence manifested itself only periodically, and then mostly at a later stage of their existence.

One should pay special attention to high-quality objects that served the needs of the aristocracy of the local tribes and the adjoining ruling classes of the Bosporan kingdom, on whose territory, evidently, most of the toreutic workshops were located. These objects, which included many precious metalworks, have come to be identified with the northern Pontic region and represent the melding of the best of Greek and barbarian art, with their predominantly Scythian subject matter. The particular development of this line of art can be explained specifically in that the Spartocid dynasty, which ruled the Bosporan kingdom from the fifth to the second century B.C., contained from the outset a barbarian, predominantly Thracian, component. Thus, from the very beginning this aristocratic line was linked not only to the influences of the local aristocracy but also to its Thracian roots.

In spite of the many objects of high artistic caliber found in the excavations of the kurgan necropoleis, only rarely have barbarian works of art been discovered in and around the Greek cities. From the seventh through the fourth century B.C. such monuments are represented exclusively by fragments of horse bridles, which have been found in wealthy as well as relatively poor burials. A prime

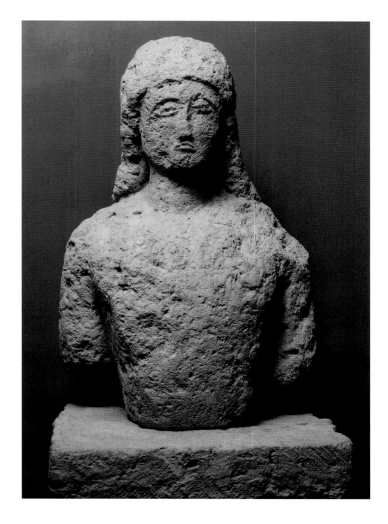

Fig. 9.3. Limestone kouros (youth), late sixth–early fifth century B.C. From Olbia. St. Petersburg, The State Hermitage Museum, inv. OL.69.3470.

example of simpler bridles are the fragments of bone plates that are occasionally found during excavations of ancient cities. One such artifact was found during the exploration of Myrmekion (fig. 9.4). Curiously, horse bridle decorations were subject to only minimal Greek influences, probably taking their form and décor from a natural development within Scythian art.

A major increase in the elements of local art in the ancient Greek cities of the region can be observed only at the turn of the millennium, when the northern Pontic area was undergoing significant change: Olbia was being rebuilt after an attack by the Goths; Chersonesos was under constant pressure by the Tauro-Scythians; and in the Bosporan kingdom, power definitively shifted to a Sarmatian dynasty. These tendencies were especially pronounced on the Sarmatian territory, where a considerable number of representatives of the local tribes had settled, and also in the cities and settlements of the Bosporus.

The influence of local tribes was most pronounced in terracottas. This can be explained, first of all, by the general accessibility and mass distribution of this type of art. The many terracotta objects that have been found in Bosporan cities and rural settlements demonstrate both the appearance of a large amount of figures with rough features and hypertrophied separate body parts and subject matter exclusively linked to the nomadic lifestyle. In this regard the most illustrative are the bull and wagon that were found in the necropolis of Pantikapaion (cat. no. 106). The extremely schematic image of

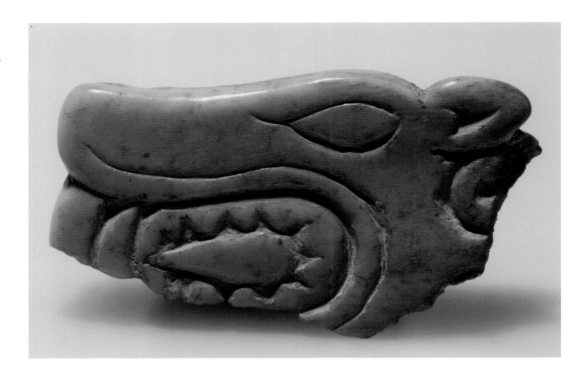

the animal, the total absence of dynamics, and the original use of the wheels all speak of a tradition fundamentally different from that of antiquity.

This said, several of the details are astonishingly precise: for example, the clearly visible construction of the nomad wagon and the *tamga* brand on the shoulder of the bull (see p. 207, fig. 106b). It is worth noticing the schematic rendering of the animals, evident also on a fragmented terracotta lamp from Ilouraton. Curiously, other animals, for example, the terracotta deer recently found during the excavations of Myrmekion, also resemble the image of the bull, in fact, it can be recognized as a deer only by a single attribute, the antlers. The numerous images of goddesses in enormous hypertrophied headgear are also considered to be part of this tradition. The face of the divinity is highly schematic; the hands stretched forward are too long. In any case, no matter which goddess this was meant to represent, it is principally different from those images encountered on toreutic works from the Scythian kurgans.

Of special interest are the Bosporan marionette figurines. They usually consist of a female figure with a bell-shaped skirt under which two legs were attached through an opening in the upper part (see fig. 9.2, and cf. cat. no. 105). In spite of the fact that marionettes made of clay, bones, and metal were known in Greece from the earliest times, figurines of this shape are unique, for their legs are jointless (unlike traditional Greek marionettes, which bend at the knee); their faces are schematic; and they have sausagelike hands. They might hold flutes, cornucopia, or timbrels, that is, objects used as attributes of ancient divinities or during religious ceremonies—although some of these objects cannot be so easily identified. Therefore, in spite of the roughness of the rendering, the tradition of making such figures and their attributes have ancient Greek roots.

The characteristic coarsening of the style of Bosporan art manifested itself in the decorations of the sarcophagus from the second century A.D. from Kerch. This can be seen especially well in the relief with the depiction of the death of the Niobids (see fig. 10.4, p. 74). In spite of a somewhat grotesque dynamism, the two-dimensional figures are com-

pletely devoid of fluidity and proportionality of the details, which was characteristic of ancient Greek works of art (Sokolov 1999a, pp. 410–11). The composition of another sarcophagus, depicting a battle between a hunter armed with a spear and a lion, is executed in the same style and is also extremely two-dimensional.

We will limit ourselves to general comments about Bosporan funerary reliefs, as they are discussed in Chapter 10. The schematism and coarseness of Bosporan funerary sculptures from the Roman period has often been remarked upon by scholars (Sokolov 1999a, pp. 374–89, and 471–82; Maximova and Nalivkina 1955, pp. 308–21). Moreover, this quality intensified through the second and third centuries A.D. While such a situation might seem quite natural for the "barbarized" Bosporus, the appearance of analogous processes in the stone funerary sculpture of Chersonesos is extremely significant. In spite of obvious attempts to impart portraitlike qualities to the faces, there is a discernable disregard for proportions. In fact, several figures or busts are schematic as a whole, including the depiction of the face. It is unlikely that such tendencies are linked specifically to the presence of barbarians in the city; rather it seems to have been a sui generis development of the northern Pontic funerary portrait as a whole.

After briefly examining the most important monuments that can be linked with barbarian representatives in the ancient cities of the northern Pontic region, we can draw the following conclusions: for almost the entire duration of their history, the compactly settled ancient population actively resisted the penetration of barbarian elements into its culture, which is characterized by an almost complete absence of works of art by local tribes in the ancient cities. A certain blending can be observed only in the aristocratic circles of the Bosporan kingdom and surrounding local tribes. It was only at the beginning of the Roman era that this phenomenon intensified, when the number of barbarians in the Greek poleis gradually increased and power passed to a dynasty descended from the representatives of local tribes—but even then the local influence was hardly discernible in all areas of artistic activity of the ancient Greek colonies. One of the more prominent areas of local influence manifested itself in terracotta statuettes (see fig. 9.1) depicting animals and syncretic divinities. Yet even here there was significant Greek influence, for example, in the use of ancient attributes and general artistic techniques. The coarsening quality in the building of the graves, evident over the entire area of the northern Pontic region, is not necessarily proof of barbarian influence, but rather it demonstrates a separate line of development from that of the metropolis.

One may say that from the very beginning of its appearance on the shores of the Black Sea, Greek culture resisted the influence of the local tribes. While in Roman times examples of merging styles or of the preponderance of barbarian taste seemed to increase, they were probably the exception. This is further proof of the remarkable tenacity of ancient Greek culture in the harsh conditions of barbarian surroundings.

IO

The Decoration of Bosporan Sarcophagi in the First and Second Centuries A.D.

NADIA C. JIJINA

THE ANCIENT SARCOPHAGI IN THE COLLECTION OF THE STATE HERMITAGE Museum, which were acquired from the excavations in Kerch and its environs in the nineteenth and twentieth centuries form a diverse group in terms of their decorative programs and care of execution. They are rare as fine examples of the art of woodcarving in the Classical and Hellenistic periods. They include the finds from the Yuz Oba and Serpent (Zmeinyi) kurgans (fig. 10.1), the so-called Anapa sarcophagus from the Gorgippia necropolis on the Taman peninsula (fig. 10.2), and the marble sarcophagus from second-century-A.D. Attika, discovered in the necropolis of Myrmekion—the only one of its type (see fig. 2.4). The paintings decorating the interior walls of the locally made limestone sarcophagus from the necropolis of Pantikapaion (fig. 10.3; see also figs. 3.10a–b) are similar to the murals of the stone crypts. A special group consists of wood sarcophagi with applied reliefs and carvings from the first centuries A.D.

The Bosporan wood sarcophagi from the first through second century A.D. are examples of these, which in the opinion of the late N. N. Sokolskii', the greatest expert on these monuments, "represent the uniqueness of the Bosporus and its contribution to the development of ancient culture and arts" (Sokolskii' 1969, p. 54; Sokolskii' 1971, p. 120; Vaulina and Wąsowicz 1974, pp. 28–29). No other region of the ancient Mediterranean and Black Sea was as rich in wood artifacts of this kind, and perhaps nowhere else, with the exception of Egypt, have they been preserved so well and in such quantities.

Along with grave stelai and burial chamber murals, the Bosporan sarcophagi of the Roman era confirm that in this period a truly original artistic style had taken shape in the Bosporus (Ivanova 1945, p. 167). While the form and decoration of the Bosporan sarcophagi in the fourth century B.C. fall within the Greek figurative tradition, and the adornment of the Anapa sarcophagus "makes it possible to speak of local stylistic tendencies" (Ivanova 1945, p. 184), the decoration of the walls of sarcophagi with wood carvings or terracotta or plaster appliqué work in the first centuries A.D. can be seen as a local adap-

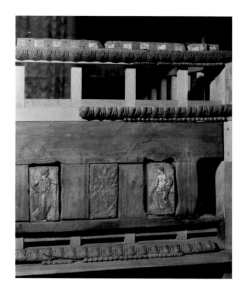

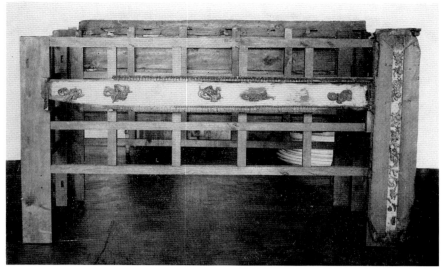

tation of relief compositions traditionally used for Attic, Asia Minor, and Roman marble sarcophagi—that is, they were a local variant of a general tradition of antiquity descended from High Classical art (Waldhauer 1945; Pinelli and Wąsowicz 1986; Pinelli 1987). Artists adopted certain types of representations that had originated in Greek art of the fifth century B.C. and were preserved through late antiquity in different versions all over the ancient world, including remote areas. For example, the depiction of the Niobids on the throne of the Olympian Zeus by the sculptor Pheidias was well known; the sculptor's artistic decisions were universally recognized and had become canonic for sculptors of succeeding generations.

The terracotta and plaster appliqué work for sarcophagi includes many types of multi-figured narrative and ornamental compositions: architectural details, floral ornaments, animals, and mythological characters. Sarcophagi in the form of temples are decorated with carved semi-columns, friezes, cornices, and pediments; the plaster architectural details—column bases, akroteria, and antefixes—would be positioned to correspond to the placement of those elements on the buildings themselves. The placement of other adornments on the exteriors of the sarcophagi is more complicated. During the excavations they were found strewn about in disarray, which is why it is extremely difficult to figure out their original placement. Beginning in the 1840s, the finds from Kerch were published on a regular basis, and attempts to reconstruct the exteriors of the Bosporan wood sarcophagi were made in the nineteenth and the early twentieth centuries, but they were mostly speculative. The publication of finds was at times accompanied by descriptions that were not made at the excavation site, but were based on information that participants and witnesses provided at a much later date. The 1832 find of the sarcophagus with the terracotta and plaster Niobids (two pieces from this set are included here; see cat. nos. 92, 93) is one such case. The finds were not described until sixteen years after the excavation, while the objects themselves arrived at the Imperial Hermitage in two shipments nineteen years apart —in 1832 and 1851 (Sokolskii' 1971, p. 62, cat. no. 87, n. 78). Many of the archaeological objects are known only through surviving drawings in the albums of F. Gross, a brilliant draftsman but someone who had no scholarly understanding of the archaeological finds he was drawing. Two of the earliest publications—both significant for scholars—that touch

Fig. 10.1. Attic wood metope of a sarcophagus with Apollo and Hera, first half of the fourth century B.C. From the Serpent (Zmeinyi) kurgan. St. Petersburg, The State Hermitage Museum, inv. ZM.I.

Fig. 10.2. Wood sarcophagus of Greek manufacture from Anapa, third century B.C. From the necropolis of Gorgippia. St. Petersburg, The State Hermitage Museum, inv. GP.1882.45.

71

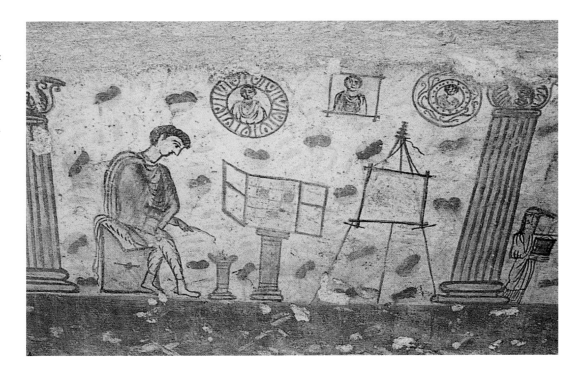

Fig. 10.3. Painted interior wall of a limestone sarcophagus: a painter's studio (detail; cf. fig. 3.10a, p. 34). St. Petersburg, The State Hermitage Museum, inv. P.1899.81.

upon these materials are a brief article on the sarcophagus with the Niobids, originating from the excavations in the 1875 (Stephani 1878), and the well-known summary of mainly Hellenistic Greek wood sarcophagi by K. Watzinger (Watzinger 1905).

In the nineteenth and early twentieth centuries, terracotta and plaster ornaments found in ancient burials—along with many other finds—circulated in the antiquities markets, entering museums and private collections from amateur archaeologists (so-called lucky bastards) or through third parties. Today these objects can be found in the collections of many museums, but the largest collection in the world of these original artifacts of Bosporan craftsmen is in the State Hermitage Museum.

The Hermitage holds plaster appliqués that replicate images well known from the works of art of Greece and Asia Minor. Among the many examples are figures of Attis, a sphinx, and a winged Nike driving a chariot. They appear to be executed in a very plain manner: not only are they remote from classical canons of beauty, but they are painted in garish colors and seem to be molded by inexperienced hands. They exude an air of the naive directness of a child's perception. The characters have a disproportionate, clumsy, and therefore amusing appearance. The coarse work and the poor artistic merits of the majority of these appliqués can be explained by the nature of the material used in making them (Berzina 1962, pp. 237–56), and by the fact that they were mass produced.

In the course of clearing the burials, many fragments of discarded pieces of spoiled appliqués were found scattered among the remains of the sarcophagi and the appliqués that had fallen off their walls. This shows that the plaster adornments were fabricated and attached to the sarcophagus panels at the place of burial and close to the time of the funeral ceremony (*IAK* 7 [1862], p. 81; see also Berzina 1962, p. 243). Evidently the coroplasts brought the molds to the site and made the plaster works there. In the Nymphaion necropolis, the only sarcophagus found in the stone box was decorated with different types of plaster theatrical masks, that is, appliqué work made in different molds (see cat. nos. 102, 103). This documented archaeological fact absolutely confirms the hypothesis

that not only were the decorations attached to the sarcophagus just before the funeral but that they were also made right at the burial site—so hastily that combinations of duplicate types were made, depending on what was available to the craftsman or to several craftsmen who were working simultaneously.

Unlike ceramics, metalwork, glass vessels, and jewelry, little study has been devoted to plaster objects as a separate group of artifacts. One of the aims of studying them is to find the artistic prototypes the ancient craftsmen used as models for making these sepulchral adornments. Another important aspect of the research is to attempt to penetrate the symbolic system of the funerary decoration as a whole.

All decorative elements of funerary structures were an integral part of the burial ritual and had deep symbolic meaning. However, the significance of each group of elements was not the same. The bases of semi-columns, akroteria, and antefixes that were part of the carved elements of temple-shaped sarcophagi were unlikely to have an independent symbolic meaning. However, ornamental plants, masks, or animal figures and mythological characters, in addition to having intrinsic apotropaic function, were endowed with a deeper meaning. Floral shoots, lotus flowers, and figures of Attis and the serpent-legged goddess were directly linked to the beliefs of the ancients regarding the afterlife and the cycle of life. The concept of the eternal cycle and the inseparable duality of death and eternally reborn life is a fundamental idea symbolically expressed from the earliest times with the aid of visible patterns and images, which were gradually transformed from significant representations into enduring figurative types—certain decorative clichés. The decoration of funerary structures was an application-specific form of artistic creativity that was well integrated into the system of aesthetic values of the ancient world. However, these funerary structures are multifaceted constructs that cannot be interpreted without understanding the ideas of the Greeks and barbarians regarding the interdependence of the earthly and sepulchral worlds.

In Russian as well as western scholarship the idea of a direct correspondence between funerary cults and the use of decorative elements in funerary practice has at times been questioned (Ivanova 1945, p. 175; Cook 1964, p. 30). Some of the motifs and subjects—such as the depiction of genii above the funerary wreath—were recognized as directly linked to concepts of the afterlife, while in other cases unrelated motifs seemed to have been pulled together into a cycle with no single unifying concept. A. P. Ivanova has proposed that in creating the plaster appliqué compositions, the craftsmen, while basing their work on known models and examples, eclectically combined disparate groups (Ivanova 1945, pp. 175–76). However, the fact that the same motifs were repeated in sarcophagus decoration over such a long period indicates that random violations of the funerary ritual were not permitted; likewise it is highly improbable that these craftsmen could make arbitrary choices of motifs and decorative elements. As noticed in Count S. Stroganov's report on the activities of the Imperial Archaeological Commission, consistent features were repeatedly found in ancient burials, whether they are the contents of the offerings in the funerary complex, the particular qualities of the structure, or the way it was decorated: this "is not a question of fortuitous circumstances, but on the contrary, represents a universal and evidently essential condition, which perhaps served to express certain pagan beliefs which consecrated, without a doubt, every step and every action in the rites accompanying the funeral and the erection of the sepulchral monument itself" (Stroganov 1863, p. xviii).

Among the repeated motifs frequently discussed in the literature is the story of the tragic slaying of the children of the Theban queen Niobe, one of the most terrifying legends

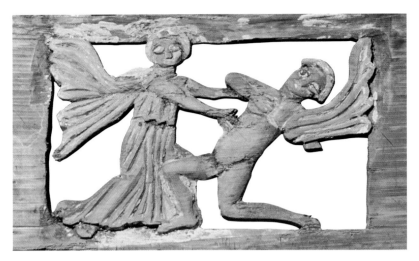

of the ancient world, which was widely represented in sculpture, vase-painting, and terracotta relief (Zhebelev 1901; Waldhauer 1945; Cook 1964, esp. pp. 41–57; Sokolskii' 1969; Geominy 1984; Pinelli and Wąsowicz 1986, esp. pp. 62–83; Pinelli 1987; Gilby 1996/98). The characters of the myth of the Niobids, placed in a certain figurative context, clearly point to the link between works of art and the concepts of the ancients regarding the relationship between gods and humans, to the absolute dependence of human life on the will of the gods, and to humans' acceptance of time-honored standards of behavior. In the words of O. F. Waldhauer: "Don't think of yourself as greater than you are. If you put yourself on the same level as a god you will provoke his wrath, and the wrath of the gods is terrible" (Waldhauer 1945, pp. 11–12). At the same time, the depictions of the Niobids made out of plaster, terracotta, or wood—as on the sarcophagus found in 1900 in the necropolis of Pantikapaion (fig. 10.4)—not only appear as elements of funerary symbolism, but they perform a decorative function as well, which makes it possible to discuss their stylistic characteristics.

In comparing monuments from different periods and in viewing the Pantikapaion finds in terms of the development of figurative techniques and artistic principles, scholars are inclined to see the artistic origin of the plaster decorations of the Bosporan wood sarcophagi in the tradition of the Greek plastic arts, unanimously pointing out the important links between the art of classical Greece and the local art of later periods of antiquity. There is no doubt that the same sculptural prototypes were adopted for different mythological characters, depending on the objectives and conception of an artist (Jijina 2005, p. 82). Even though an artist might have had conceptual and spatial restrictions, he was allowed a certain amount of freedom in the selection of the composition of the piece. Thus while the placement of the Bosporan terracotta and plaster reliefs on the walls of a sarcophagus might be compositionally similar to the Hermitage relief with the Niobids from the Campana collection (fig. 10.5), the relief itself is derived stylistically from monuments of the second half of the fifth century B.C. (Waldhauer 1945, pp. 15–16; Saverkina 1986, cat. 64, pp. 147–49).

In the opinion of P. Pinelli, who investigated the typology of the relief decorations of the Bosporan wood sarcophagi in connection with the publication of the materials of the Louvre collection, the plaster Niobid figurines from Pantikapaion derive from the celebrated sculptural group now in the Uffizi collection. Moreover, she was able to directly link

one of the terracotta appliqué reliefs in the Louvre with the figures of weepers from the Sidon sarcophagus, reconfirming the universal opinion that Bosporan coroplastics were deeply rooted in Asia Minor (Pinelli 1987, pp. 275–76).

Marble relief sarcophagi of the Roman era and the murals of underground burial chambers also correspond to one another in terms of composition and decorative schemes. While generally following the masters of the large forms, Bosporan craftsmen, who made small adornments from inexpensive and available materials, skillfully and ably—and this is not an exaggeration—combined simplicity and unpretentiousness of execution with the depth of meaning, and even though their rendering of the images was sketchy and conventional, they unequivocally adhered to the aesthetic ideals of the past. The richness of the artistic concept was implemented by those means of expression that corresponded to the tastes of the local customers—barbarized Bosporan Greeks or hellenized barbarians—whose intellectual and artistic potential encompassed the entire breadth of Greek and non-Greek genetic memory.

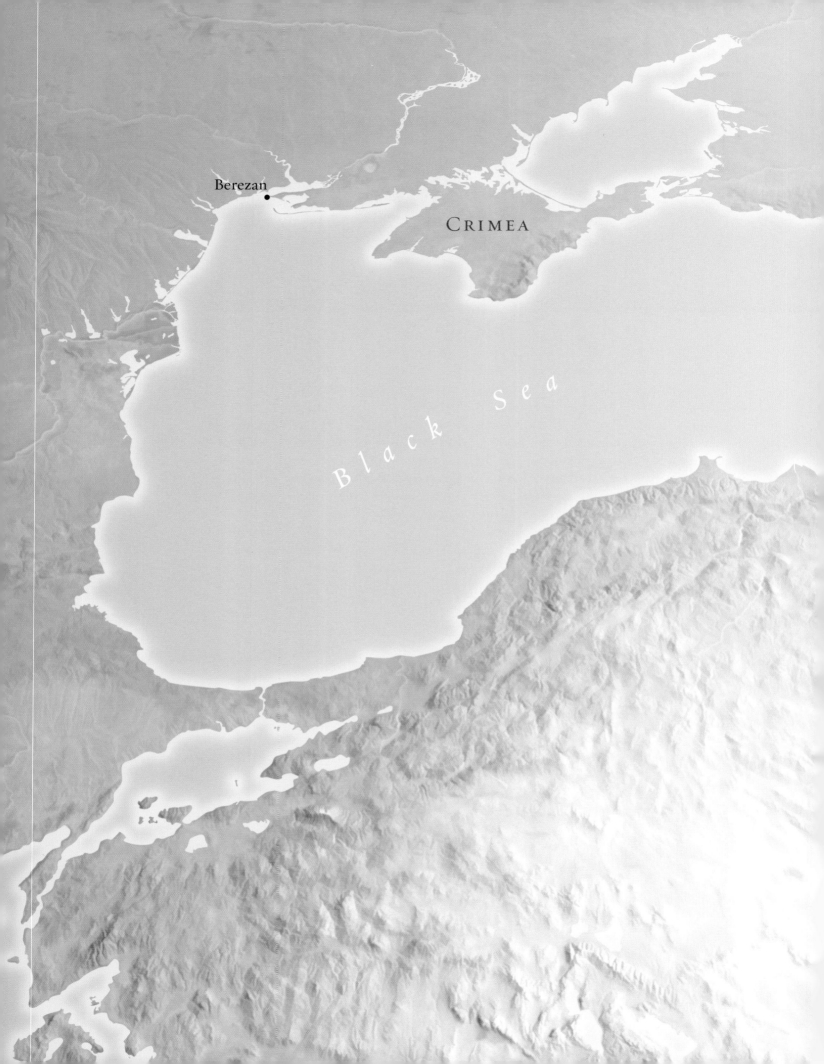

Berezan

CRIMEA

Black Sea

The Berezan Colony

THE ANCIENT COLONY ON BEREZAN ISLAND, SITUATED IN THE ESTUARY of the Dniepr and the Southern Bug Rivers (fig. 1), is now identified with the Milesian colony of Borysthenes mentioned in the chronicles of Eusebius (Eusebius *Chronica* B 1984.P.95b). Borysthenes occupies an important place in the series of ancient monuments from the earliest beginnings of Greek colonization of the northern coast of the Black Sea. The Berezan colony was the first link in the chain of Greek poleis that appeared on the northern coast of the Pontus in Archaic times. It initiated the trade and cultural expansion of the ancient Greeks on the northern coast of the Black Sea and transmitted advanced Hellenic culture to the vast expanses of the Scythian lands. In its role as a zone of Graeco-barbarian interaction, it became a powerful economic and political magnet that attracted the more active of the various local tribes who left many traces of their presence in the material culture of the Berezan settlement.

Although only meager evidence of Borysthenes is provided by the written sources of antiquity, its archaeological evidence is abundant and varied, containing information on the different periods and aspects of life in the colony. The history of the archaeological study of Borysthenes is now more than 120 years old. As a result of the archaeological excavations, more than two hectares (ca. 5 acres) of the territory of the ancient colony and its necropolis have been uncovered (fig. 2); numerous ancient dwellings and auxiliary household buildings have been discovered; and numerous works of Greek and local applied art have been found, many of them unique and of high artistic value.

Of the archaeological materials that are usually associated with the time of the founding of Borysthenes in 647/6 B.C., only an extremely small group of highly specialized painted table vessels, mostly from Ionian workshops but also handmade dishes from forest-steppe Scythia, can be attributed to that time. This points to the existence of trade links between Miletos and other Greek cities of the eastern Aegean and the area of the lower Bug and Dniepr Rivers. The persistence and regularity of the Ionians' visits depended on navigation as well as climatic and demographic conditions. Once the Greeks and the local population expressed a mutual interest in furthering and promoting economic ties, a per-

Fig. 1. Berezan. Plan of the island.

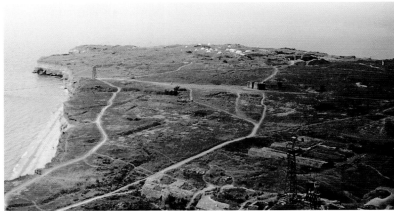

Fig. 2. Berezan. Aerial view of the northwest part of the island.

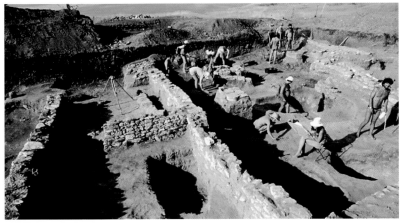

Fig. 3. Berezan. Dwelling and household structures.

manent settlement at Berezan eventually emerged. It was the first area to be settled in the lower Bug area and the entire northwest coast of the Black Sea after a break of many centuries and most likely during the last decade of the seventh century B.C. It is well known that exactly at that time the earliest building complexes were established—dugout huts of small and primitive construction—along with the beginnings of a cultural layer; it contained numerous and varied imported and locally made ceramic materials. All those changes helped establish a new period in the history of the Berezan colony that lasted for seven or eight decades.

The results of the vigorous activity of the Greek traders are clearly reflected in the material objects of the Berezan colony from the earliest time of its existence—first and foremost in the large finds of Greek vessels that arrived in the lower Bug area at the end of the seventh century through the third quarter of the sixth century B.C., mostly from Ionia. Among the Greek merchant-seafarers the leading role was played by the inhabitants of Miletos, Samos, Chios, and the poleis of northern Ionia. Their wares, which dominate the ceramic complex of the Berezan colony, are extremely varied (cat. nos. 2, 4, 5, 10). Due to the intermediary role of the Ionians of the Berezan colony, ceramics from Anatolia (cat. no. 3), the cities of mainland Greece and the Aegean islands (cat. no. 8), and even Egypt (cat. nos. 1, 9) occasionally made their appearance. At the same time, the gradually increasing volume of imported Attic painted pottery (cat. nos. 6, 7) significantly put com-

THE BEREZAN COLONY

petitive pressure in the Berezan marketplace on the ceramic production of the East Greek craftsmen. Amphorae, produced mostly in Ionia, were by far the most numerous of all types of imported tableware, accounting for between 70 and 90 percent of the ceramics of the Berezan colony. During the early years of its existence the colony was first and foremost a large entrepot in the wine and olive oil trade on the northern coast of the Black Sea. The main, if not the sole, activity of its Greek founders was as intermediary traders. Artisan production—mostly metalworking and bronze-casting—was also well developed.

At the same time, the absence of imported kitchenware points to the fact that the inhabitants of Berezan, regardless of their ethnic background, were able to satisfy completely or significantly their demand for food-preparation vessels through locally produced handmade ceramics, which were represented by a wide variety of specialized functional forms.

A cardinal change in the cultural and architectural characteristics of the Berezan colony came about at the end of the third quarter of the sixth century B.C., when in a very short time—literally a few years—the entire territory of the settlement was built up with above-ground Greek-style buildings. The construction took place according to a unified plan involving construction of city blocks with a developed network of streets, as in Hippodamic or similar systems. The construction was on a technologically high level and used various systems of masonry, distinct order elements, and a variety of materials—stone, mud-bricks, and wood (fig. 3). The roofs were made of adobe and on rare occasions tiles were used. The above-ground construction of the Late Archaic period was mostly carried out on an individual, private basis, although the remains of a temple dedicated to Aphrodite have also been found.

The urbanization of the Berezan colony, which took place in such a short period of time, occurred due to a massive migration of Greeks organized by the state. The Ionian—mostly Milesian—origin of the colonists is not in doubt. The presence of a polis-type political organization among the new inhabitants of Borysthenes is also certain. The peak period of the Berezan colony was at the end of the sixth century B.C., when it covered the largest territory.

The basis of the economy of Borysthenes at that time, as before, was trade and crafts. This is attested to not only by the archaeological materials on Berezan and its surroundings but also by numismatic and epigraphic monuments—for example, the well-known lead letter of Achillodoros that was found on the island (cat. no. 13).

Beginning with the second half of the sixth century B.C. the new orientation of the Borysthenes economy was the direct exploitation of the surrounding fertile lands in order to grow agricultural goods for the market. As a direct consequence of this activity, the local population actively began to reclaim the shores of the Dniepr and the Southern Bug Rivers and created the polis's agricultural region—the chora.

At the end of the first third of the fifth century B.C. Borysthenes' building activity decreased sharply and considerably. The decline of the city's economy resulted from the reduction of its civil community, which finally led the polis to the loss of its political independence. From that time onward the Borysthenes colony became a part of the Olbia polis, one of its commercial ports. Herodotos, who visited Scythia somewhat later, not coincidentally called Berezan the emporium (commercial port) of the Boristhenites (Hdt. 4.17), thereby attesting to its special status in the system of the Olbian state.

S.S.

BIBLIOGRAPHY: *Grecheskaya kolonizatsia* 1966; Vinogradov 1989; Vinogradov and Kryžickij 1995; Solovyov 1999.

79

1

Pendant in the Form of the Falcon-God Horus

Naukratis
End of the seventh century B.C.
H: 3.6 cm; Base: 2.7 × 1 cm
Faïence
Excavations of 1987. I. V. Domanskii
Berezan
Acquired 1987
Inv. B.87.313

Pendant amulet in the form of a falcon—
the Egyptian divinity Horus—sitting on a
flat rectangular base. The pendant is made
of white colored faïence, except for the
lower part of the legs, the tail plumage, eyes,
and beak, which are brown faïence. The
eye of the pendant, one corner of the base,
and the flange of the left wing are chipped.

Finds of objects made in Egypt are
extremely rare on the northern coast of the
Black Sea, although this is not the case
with the settlement of Borysthenes. Several
pendants of this kind have been found
at Miletos (Hölbl 1999, pp. 357–61, fig. 20),
and from there they made their way to the
northern coast of the Black Sea.

S.S.

BIBLIOGRAPHY: Solovyov 1999, p. 57, fig. 41; Solovyov
2005, cat. 201.

1 2:1

2

Stemmed Dish

Northern Ionia
First half of the sixth century B.C.
H: 9 cm; Diam: 21 cm
Terracotta
Excavations of 1989. I. V. Domanskii
Berezan
Acquired 1989
Inv. B.89.37

Dining vessel, assembled from fragments, in
the form of a flat dish on a high foot. In the
center of the interior there is a multipetaled
rosette surrounded by bands of brown and
added red. The inner rim is decorated with a
band of meanders. On the exterior three
bands of light brown have been applied.
Similar vessels were mass-produced in ceramic
workshops in northern Ionia and Aeolia
(Walter-Karydi 1973, p. 80, pls. 995, 1000;
Cook and Dupont 1998, p. 53, fig. 8.18).

S.S.

BIBLIOGRAPHY: Solovyov 1999, p. 49, fig. 31; Solovyov
2005, cat. 63.

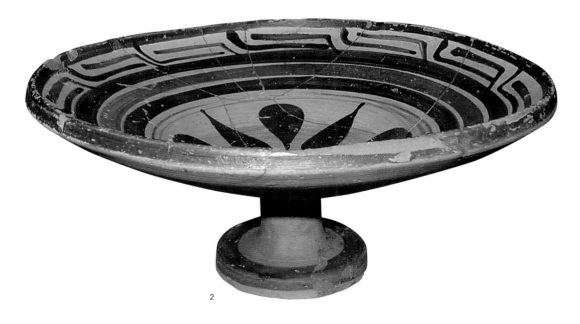

2

80

3

Dinos

Anatolia
First half of the sixth century B.C.
H: 22 cm; Diam: 36 cm
Terracotta
Excavations of 1983. I. V. Domanskii
Berezan
Acquired 1983
Inv. B.83.72

Dining vessel with three pairs of rounded protrusions on the rim and a flat bottom. Decoration in the form of a sequence of geometric patterns painted with a red-brown paint runs around the shoulder of the vessel. The dinos has been assembled from fragments. The surface treatment and the ornamentation resemble Phrygian pottery; however, no close analogy is known.

S.S.

BIBLIOGRAPHY: *Tesori D'Eurasia* 1987, p. 155; *Great Art* 1994, p. 274, no. 259; Solovyov 1999, p. 52, fig. 35; Solovyov 2005, cat. 71.

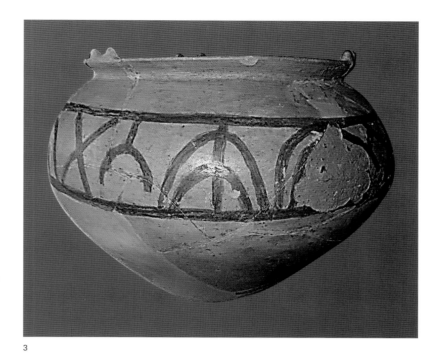

3

4

Askos

Clazomenae
Third quarter of the sixth century B.C.
H: 10 cm; Diam: 11 cm
Terracotta
Excavations of 1982. I. V. Domanskii
Berezan
Acquired 1982
Inv. B.82.340

Flat, round oil vessel on a low, ring foot, with a broad funnel-like mouth and a high bent handle fastened to the top of the vessel. The handle, neck, and lower part of the body are covered with brown gloss. The top of the askos, except for the area of the handle, is decorated with imbrication executed in black; in the middle of each scale is a small dot of white paint. On one side of the vessel is evidence of ancient repair: four pairs of drilled holes. The askos has been assembled from fragments; the bottom is reinforced with plaster. The askos belongs to Knipovich's group of Clazomenian ceramics.

S.S.

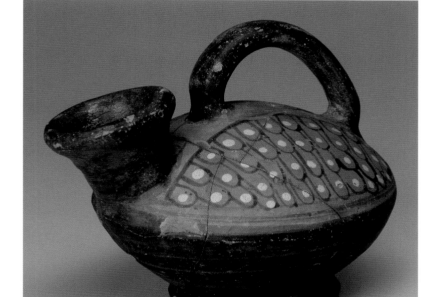

4

BIBLIOGRAPHY: Cook 1952, pp. 136–48; Cook and Dupont 1998, p. 101; Kopeikina 1979, pp. 18–19.

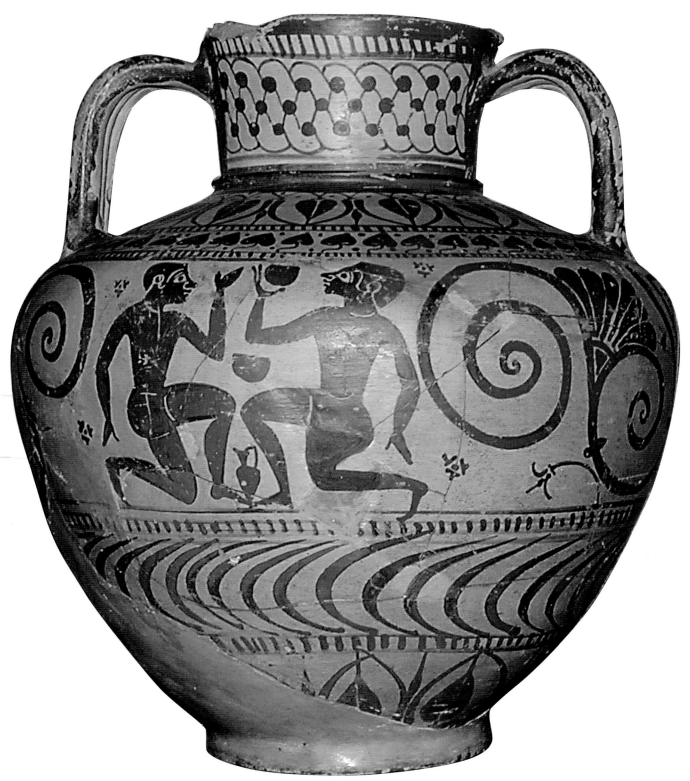

5

5

Amphora in Fikellura Style

East Greek
550–540 B.C.
Diam: 25 cm
Terracotta
Excavations of 1962. K. S. Gorbunova
Berezan
Inv. B.62.1

Amphora with three-barreled handles and broad body on a flat ring foot. The transition from neck to shoulder is accentuated by a fillet. The entire vase is covered with decorative friezes separated by bands of short vertical bars between horizontal stripes. The neck is decorated with plaiting; the shoulder has two floral friezes, one with lotus flower buds and one with ivy leaves. The lower part of the body is decorated with a band of sickle-shaped ornaments above lotus buds. The main frieze has a heraldic composition of two komasts on bent knees; under the handles are volutes and palmettes. One of the komasts holds a cup in his hand; another

cup and an oinochoe are placed in the space between the dancers. According to its stylistic characteristics, the Berezan vase belongs to the group of amphorae of the Altenburg Master (*CVA* Altenburg 1, pls. 10–12; *CVA* British Museum 8, pl. 12.3, 4; Cook 1933–34, p. 16, no. 10). The amphora was assembled from fragments; one side is reconstructed.

S.S.

BIBLIOGRAPHY: Gorbunova 1966, p. 36, fig. 1; Schauss 1986, p. 255, no. 26; *Great Art* 1994, p. 275, no. 260; Solovyov 2005, cat. 104.

6

Kylix

Attika
530s B.C.
H: 9 cm; Diam: 22 cm
Terracotta
Excavations of 1969. K. S. Gorbunova
Berezan
Inv. B.69.157

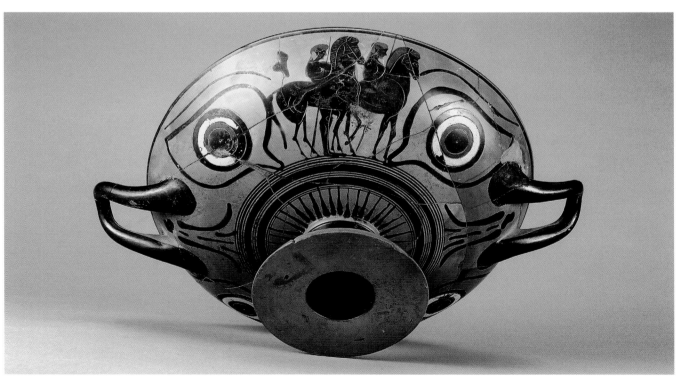

6

Wine cup with two horizontal handles on a high foot. (Eye-cup, Type A: *CVA* Hamburg 1, pl. 39, no. 1960.7; Beazley *Para*, pp. 82–83). On the exterior of both sides of the cup, between the large apotropaic eyes, are two men to right with spears (Dioskouroi?) standing next to horses executed in black-figure technique; under the handles are lotus blossoms. Inside, in the center of the cup, there is a depiction of the Gorgoneion. The irises of the apotropaic eyes; the manes of the horses; the hair of the men; and the eyes, tongue, and hair of the Gorgon are highlighted in added red, while the sclerae of the apotropaic eyes and the teeth of the Gorgon are highlighted in added white. The horses' manes and the musculature of the men and horses, as well as the eyes, hair, and mouth of the Gorgon, are rendered through incision. The cup has been assembled from fragments.

<div align="right">S.S.</div>

BIBLIOGRAPHY: Gorbunova 1982, p. 46, fig. 8; Solovyov 2005, cat. 137; Smith 2007, cat. 66.

7

Kylix

Attika
530–520 B.C.
H: 9 cm; Diam: 22 cm
Terracotta
Excavations of 1978. L. V. Kopeikina
Berezan
Acquired 1978
Inv. B.78.114

Wine cup with two horizontal handles on a high foot (eye-cup Type A: *CVA* New York 2(11), pl. 27c–d, inv. 96.18.50). On the exterior of both sides of the cup, next to large apotropaic eyes, is a depiction in profile of two men (komasts?) executed in the black-figure technique. Under each handle is a lotus blossom. In the tondo, reserved in the color of the clay, is a circle with a dot. The irises of the apotropaic eyes and the hair of the men are highlighted with added red while the sclerae of the apotropaic eyes are highlighted with white. The musculature and some of the details of the human bodies are incised. The kylix has been assembled from fragments and missing pieces filled in with plaster.

<div align="right">S.S.</div>

BIBLIOGRAPHY: Kopeikina 1986, p. 40, fig. 8.21; Solovyov 2005, cat. 145; Smith 2007, cat. 70.

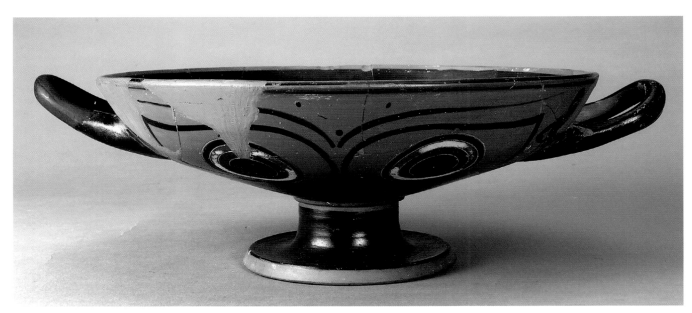

7

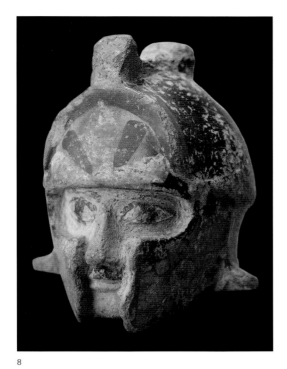

8

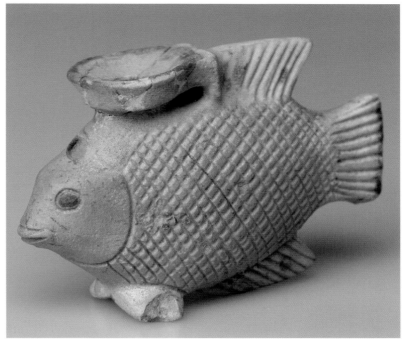

9

8

Plastic Vessel

Rhodes (?)
First half of the sixth century B.C.
H: 5.8 cm
Terracotta
Excavations of 1907. E. R. Stern
Berezan
Acquired 1914
Inv. B.247

Plastic vessel in the form of a male head with an Ionian-type helmet, covered with brown glaze. The eyes, eyebrows, and mustache of the warrior are accentuated with brown paint. The forehead piece and cheekpiece of the helmet are decorated with added red. The surface of the vessel is scratched and covered with dents. The mouth has been lost. There is an opening in the helmet. According to one theory, similar vessels were made in Rhodes and were popular in the Mediterranean. (Maximova 1927, pp. 153–59, pl. xx.79; Ducat 1966, pp. 10, 25, pl. 1.6, 7.)

S.S.

BIBLIOGRAPHY: Skudnova 1966, p. 166, fig. 15; Solovyov 2005, cat. 181.

9

Plastic Vessel

Naukratis
Late sixth century B.C.
H: 5.5 cm; L: 7.5 cm
Faïence
Excavations of 1982. I. V. Domanskii
Berezan
Acquired 1982
Inv. B.82.315

Plastic vessel in the form of a fish. The lower fins and tail are made of white faïence, the head and body are colored yellow, and the mouth of the vessel and the dorsal fin are light blue. The eyes and fin terminals are brown, as are the dots on the upper and lower fin. The mouth of the vessel was assembled from fragments. The lower left fin is chipped.

Faïence plastic vessels in the form of various creatures were produced in large numbers in the workshops of the Greek colony of Naukratis in Egypt. However, no exact parallel to this vessel is known.

S.S.

BIBLIOGRAPHY: Domanskii, Vinogradov, Solovyov 1986, p. 134, fig. 7.2; *Great Art* 1994, pp. 276–77, no. 262.

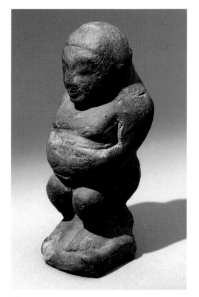

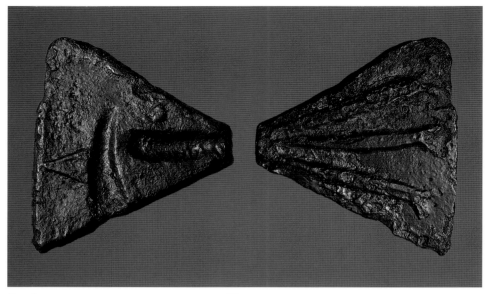

10

11a cbverse 11b reverse

IO

Statuette

> Ionia
> Third quarter of the sixth century B.C.
> H: 7.3 cm
> Terracotta
> Excavations of 1908. E. R. Stern
> Berezan
> Acquired 1911
> Inv. B.251

Terracotta statuette of a stout male divinity squatting on a square foot, hands folded over his stomach. Such statuettes were widely known in the northwest of the Black Sea region and were usually linked to the cult of the Kabiri—divinities that had many functions and were closely associated with the cults of Demeter, Kore-Persephone, and Pluto (Rusiaeva 1982, pp. 103–7, fig. 40.1). They were also found in Cyrenaica (Boardman and Hayes 1966, pl. 100.48, 49) and in Miletos near the Temple of Aphrodite.

<div align="right">S.S.</div>

BIBLIOGRAPHY: Rusiaeva 1979, pp. 94–97.

II

Coin

> Borysthenes
> Second half of the sixth century B.C.
> L: 5 cm; Weight: 41.31 g
> Bronze
> Excavations of 1978. L. V. Kopeikina
> Berezan
> Acquired 1978
> Inv. B.78.216

Coin cast as a segment of trapezoid form. On the obverse is a fish head (tuna?); on the reverse, three arrows. The eye and fin of the fish head are convex, while the mouth and gill slit are concave. These trapezoidal coins— which were erroneously considered by their first discoverers to be weights—were minted exclusively in high denominations, a conscious act on the part of Borysthenes to create its own currency (Pivorovich 2000, p. 121, fig. 4.3; Naumov 2002, p. 33). Such coins were based on the weight standard of the coins of Kyzikos, with which Borysthenes had close ties, as evidenced in epigraphic monuments dated to the Archaic period (Vinogradov 1994). In this case there was an attempt to establish a correspondence between the new polis coin and the weight standards of the coins of Kyzikos, which were widely used in interregional trade. Kyzikos coins were

based on the Phokaian weight standard
(1 stater weighed ±16 g); the Berezan coins,
with rare exceptions, weighed between 28 and
44 grams, which approximately corresponds
to two or three weights of Kyzikos coins—
a nominal correlation to be sure, considering
the value of bronze versus electrum. It may
not be a coincidence that this Berezan coin
bears three arrows. In this case the closest
weight standard could be that of the metro-
politan city of Borysthenes/Miletos, whose
stater weighed ±14 grams. An earlier opinion
held that arrow coins, which were a means
of exchange exclusively for internal polis
trade, were only a symbol of value and were
exchanged according to a set rate.

<div style="text-align: right">S.S.</div>

BIBLIOGRAPHY: Grakov 1971, p. 125; Kopeikina 1981,
pp. 168–69; Krapivina 1986, pp. 107–8; Anokhin
1988, pp. 174–79; Solovyov 2005, cat. 207; Solovyov
2006, fig. 3.3.

12

Lekythos

Attika
480–475 B.C.
H: 23 cm; Diam: 9 cm
Terracotta
Excavations of 1977. L. V. Kopeikina
Berezan
Acquired 1977
Inv. B.77.137

Vessel with cylindrical body on a flat foot with
a narrow neck and looped handle. On the
body of the vase, in red-figure technique, the
goddess Nike performs a libation at an altar;
above her is a meander band. Added red is
used for the shadows and the round object in
her left hand. Palmettes are painted on the
shoulder of the vase.

Images of the goddess of victory became
very popular after the war with the Persians.
The lekythos is attributed to the workshop of
the Bowdoin Painter (Beazley 1939, pp. 7–8,
nos. 16–20).

<div style="text-align: right">S.S.</div>

BIBLIOGRAPHY: Ilyina 2001, p. 167, fig. 11; Solovyov
2005, cat. 166; Shapiro forthcoming, fig. 5.

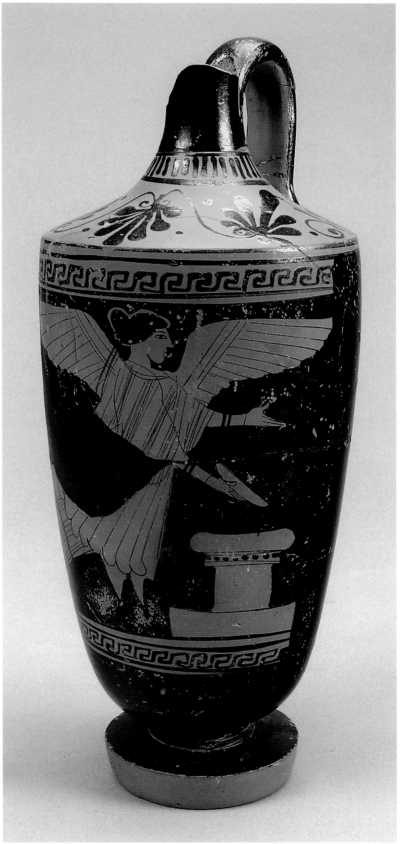

12

13

Letter

Borysthenes
About 500 B.C.
L: 15 cm; H: 6.5 cm
Lead
Excavations of 1970. K. S. Gorbunova
Berezan
Acquired 1970
Inv. B.70.322

Letter on a lead sheet, found rolled in a tube (about lead letters from the northern Black Sea area. see Vinogradov 1998). Not having reached the addressee, it was lost. On the obverse side of the sheet, the address is written crosswise:

Letter from Achillodoros to his son.

On the reverse side of the sheet is the text of the letter, inscribed with a sharp object:

Oh, Protagoras, your father writes to thee. He has been subjected to iniquity on the part of Matasios, indeed he deceives him and has taken his freight carrier[?]
5 from him. Go to Anaxagoras and explain [the situation] to him, as he [Matasios] says that he [the carrier] is a slave of Anaxagoras, asserting that my property belongs to Anaxagoras—slaves, female
10 slaves, and houses. Whereas he [the carrier] shouts and says that he is free and has nothing to do with Matasios; but if there is something [disputable] between himself and Anaxagoras, they know [what
15 is what] by themselves. This should be said to Anaxagoras and his wife. And something else he [the father] writes to you: your mother and your brothers, who are in Arbinatae [?] must be brought
20 into the city; himself...when he comes to him [Anaxagoras?] let him go directly [to the city?].

Our understanding of the essence of the property and social conflict set forth in the letter is made difficult, first of all, by the ambiguity of the word ΦΟΡΤΗΓΕΣΙΟ (sic, genitive), which does not appear anywhere else. If it is a masculine word in the genitive it can be understood to be some person who transports freight, an agent of Achillodoros, dependent on him as Matasias is dependent on Anaxagoras (probably a *xen*, i.e., a foreigner, one of non-Greek descent who has no civic rights). It is he whom Matasias, acting in the name of Anaxagoras, declares to be a slave. But if this is a neuter word, it concerns a cargo ship, and Achillodoros (Anaxagoras's unlucky business partner) himself is declared to be a slave, who everywhere writes of himself in the third person, line 2 has to be translated thus: "indeed (Matasias) subjugates him" and not "deceives him." Both interpretations have their strong points.

LINE 12 (LINE 19 OF TRANSLATION): "Arbinatae" is the name of a populated locality; "to the city" is usually considered to mean Olbia. However, it can be assumed that it could be the settlement on the Berezan island, which at that time, judging from archaeological facts, was the only urban center on the lower Bug River.

LINE 13 (LINE 20 OF TRANSLATION): The pithiness of expression (apparently due to a lack of writing space) and damage to the text interfere with its comprehension: is "himself" a new person? If we read "himself a caretaker of ships," this could be a different meaning of "freight carrier"; "to go directly" (that is, "right away," literally, to "go down," which means movement from the inner regions of the country to the sea—where, incidentally, the "city" is located).

S.S.

BIBLIOGRAPHY: Vinogradov 1971, pp. 74–100; Jeffery 1990, pp. 420, 478, pl. 80.60c; *Great Art* 1994, p. 270, no. 255; Effenterre and Ruzé 1995, pp. 260–63, no. 72; Dubois 1996, p. 23; Wilson 1997–98, pp. 34–38; Solovyov 2005, cat. 269; Tokhtas'ev 2005, cat. 269.

13

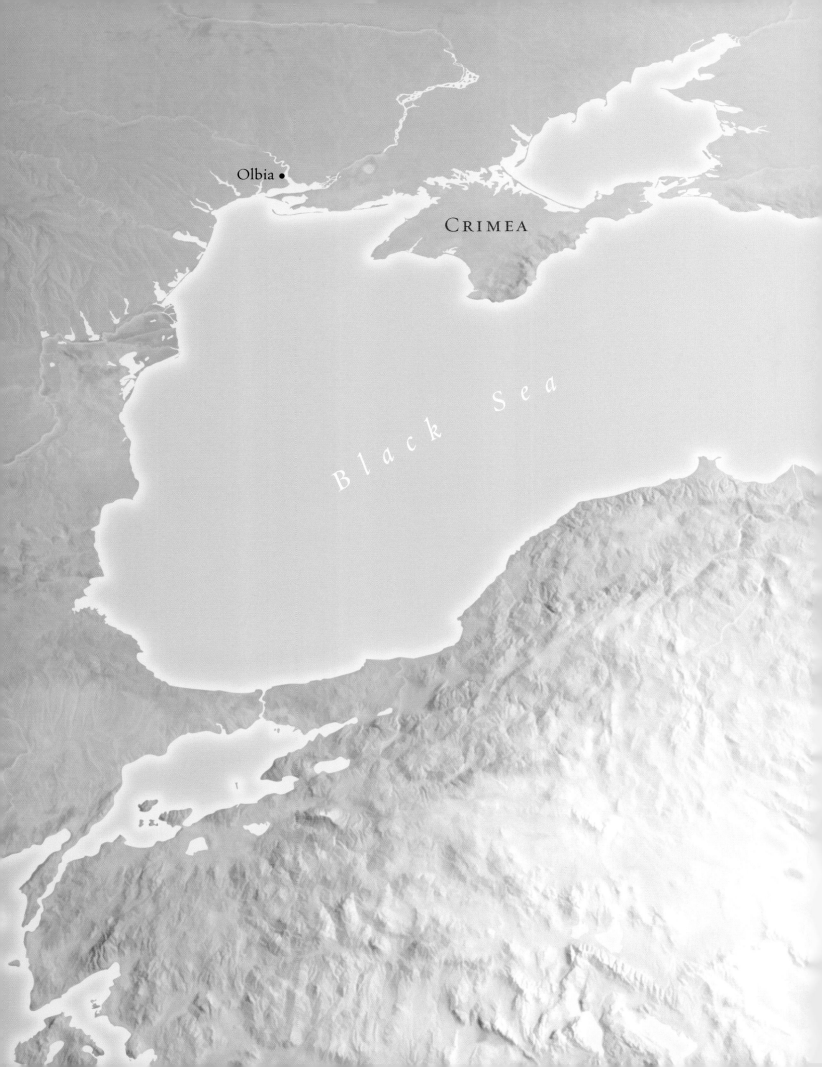

Olbia

CRIMEA

Black Sea

Olbia

CCORDING TO MANY WRITTEN SOURCES, IN THE EARLY PART OF THE sixth century B.C. Milesians settled on the right shore of the Bug River, a few kilometers before its entry into the sea, a site with desirable geographical and topographical conditions. Olbia was situated on a raised triangular plateau, forming two terraces. From the north and west it was separated from the steppe by deep ravines (fig. 4). The natural conditions dictated the layout of the city, which consisted of two parts: the upper town and the section along the river, with its abundant fresh water, where the port was located. The fortifications were placed along the steep slopes of the ravines; on the western side was a broad estuary. Thus the city was situated in accordance with the guidelines of Milesian colonial practice. Two major water arteries—the Dniepr and Bug Rivers—served as trade routes to the steppe lands of the northern Black Sea coast.

Old maps from the nineteenth century—made when it was still possible to identify the traces of ancient buildings on the ground—and successive systematic archaeological explorations over many years make it possible to reconstruct the plan of the city. In the early sixth century B.C. only the southern part of the upper town, which formed a small triangle, had been settled. Gradually the city was extended to occupy all of the upper plateau and the lower shore terrace, which were connected by steps (fig. 5). By the third century B.C. the city covered forty hectares (ca. 100 acres). The main street was laid out on a north-south axis, both sides of which had two *temenoi* with monumental temples and altars dedicated to Apollo the Healer (IHTPOΣ), Apollo Delphinios, Zeus, and Athena—the patron gods of the polis. The main market square, or agora, was surrounded by public buildings: large and small stoai, courthouses, a gymnasium, and a shop. The written sources mention a theater and fish market, whose remains have not yet been found. The residential areas were to the west and north of the public center of the town and on the banks of the river. The houses followed Greek building principles, taking into account local climatic conditions. In quite a few buildings the remains of opulent interior decorations, such as fragments of frescos and mosaic floors, have been preserved. The city had many amenities: the streets were paved with stone slabs and ceramic fragments and there

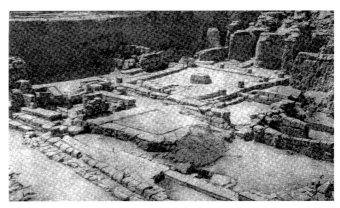

Fig. 4. Olbia. View toward the north. Mid-nineteenth century. From A. S. Uvarov, Collection of Maps and Drawings for *Research on the Antiquities of South Russia and the Shores of the Black Sea* [in Russian] (St. Petersburg, 1853).

Fig. 5. Olbia. Dwelling house of the III–II centuries B.C. in the lower town. *Artistic Culture and Archaeology of the Classical World. Collected Papers in Memory of Boris Pharmakowsky* (Moscow, 1976).

was a developed water system, with cisterns for collection and canals for drainage. The remains of various workshops—ceramic, terracotta, and construction-material kilns—have been found, indicating that the crafts were well developed, as were artistic metalworking, bone carving, and weaving. The products of Olbian craftsmen were widely exported, and grain was brought in from the agricultural chora settlement. Olbia had all of the traditional polis institutions of government: the legislative power consisted of the council and the citizens' assembly. The executive consisted of the collegia and magistrates, who dealt with the various aspects of life of the polis. The decrees in the agora on behalf of other cities testify to Olbia's wide-ranging commercial ties.

The extensive necropolis was located to the northwest, beyond the city walls. Along the main roads were numerous kurgans; although they have now all but disappeared, they were still noticeable in the nineteenth century, giving Olbia the name "boundary of a hundred hills." There are still two large kurgans from Roman times with monumental burial chambers beneath them—the so-called Zeus and Eurasivia and Areta kurgans.

Olbia provides the best example of the organization of a Greek polis on the distant fringes of the ancient world on the northern coast of the Black Sea.

Y. I.

BIBLIOGRAPHY: Latyshev 1887; Pharmakowsky 1915; Gaidukevich 1955; *Olbia* 1964; Levi 1985; Vinogradov 1989; Vinogradov and Kryžickij 1995.

14

Amphora

Northern Ionia
Second quarter of the sixth century B.C.
H: 24.5 cm
Terracotta
Olbia necropolis, 1902. Burial no. 122.
 Excavations of B. V. Pharmakowsky
Acquired in 1904
Inv. O.1902.207

Amphora with a rounded body, gradually narrowing toward the bottom, on a ring foot. The neck is short and broad; the lip is overhanging; and the handles are two-barreled. There is an ornamental motif on the neck in the form of a simple cable. The transition from the neck to the shoulder is marked by a narrow horizontal stripe. The body and the foot of the amphora are decorated with broad and narrow bands. On each side of the shoulder are three sets of concentric circles—executed without a compass—with two double-lotus buds between them.

It was only in the beginning of the sixth century B.C. that amphorae started to appear in the repertoire of Ionian vase-painters; gradually they became very popular, to a considerable degree displacing oinochoai, which had been dominant since the seventh century B.C. The painting on this amphora from Olbia is an example of a simpler version of amphora decoration: on the shoulder is an ornamental motif instead of an image of a goat in the traditional reserve technique. By the first decades of the sixth century B.C. the possibilities of this technique had exhausted themselves, and Ionian vase-painters, under the influence of the vase-painters in Corinth and Attika, mastered the black-figure technique. Vessels appear painted in a simultaneous combination of traditional reserve and black-figure techniques. The pioneering artistic centers were in northern Ionia. Appropriating only the principle of decoration and the technical means (silhouette drawing and incision), they created vase-paintings that were original in subject matter and style. However, the traditional style eventually died out and the painting became less expressive: details

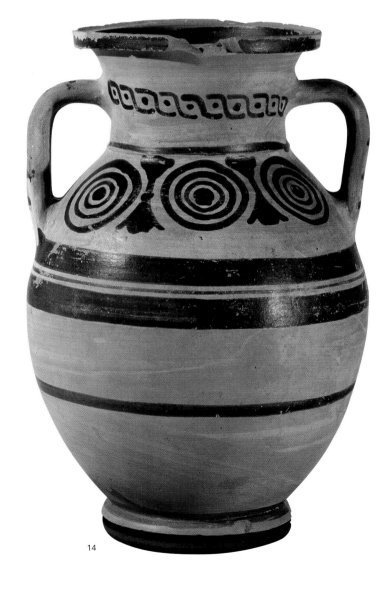

14

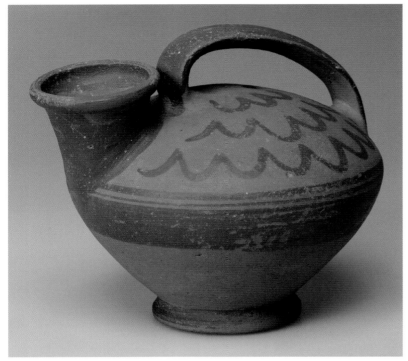

15

15

Askos

Northern Ionia
Third quarter of the sixth century B.C.
H: 15.5 cm; Diam: 18 cm
Olbia necropolis, 1910. Burial no. 74.
 Excavations of B. V. Pharmakowsky
Acquired in 1924
Inv. O.1910.202

Askos with rounded body on a ringlike foot with a flat handle. The spout is broad; the mouth is in the form of a small cylinder. The spout and handle are covered with glaze; bands circle the middle portion of the body and the foot. On the shoulder of the vessel are three rows of undulating lines. Decorations of undulating lines had appeared in Ionian ceramics beginning in the seventh century B.C., but only in the second half of the sixth century do they displace images of traditional animals such as mountain goats, deer, dogs, birds, and griffins. The vessel is decorated with the most popular type of such lines.

The shape of the askos, with its rounded body and handle, is typical for north Ionian centers. A similar shape is found in Clazomenian ceramics in Enman and Knipovich's later groups. To the latter belong two askoi from the Olbia necropolis; one has decoration in the form of ivy, the other, wings. The third vessel of similar shape is the famous Chanenko askos, with images of dancing komasts (Waldhauer 1929, p. 246, fig. 4; Kopeikina 1979, p. 16). This vessel is considered by scholars either to belong to one of the groups of Clazomenian ceramics or to be Samian ware. Askoi and ring-shaped vessels are often found in burials in the Olbia necropolis.

Y. I.

BIBLIOGRAPHY: Pharmakowsky 1913, p. 92, fig. 111; Pharmakowsky 1914b, p. 16, pl. 111.2; Waldhauer 1929, pp. 238, 246, figs. 6, 7.

became smoothed out; proportions became distorted; and filler motifs were first simplified, then disappeared. By the middle of the sixth century B.C. the black-figure technique completely displaced the old system of painting in northern Ionia. The amphorae of this group were widespread on the Black Sea coast. A significant number of them were found in Istria, Apollonia, Berezan, Pantikapaion, and Myrmekion. In the literature of the early twentieth century this group of ceramics was called the "Levitsky Class" because the best examples found on Berezan came from the collection of the priest of the Ochakov Cathedral, Nikolai Lvovich Levitsky.

Y. I.

BIBLIOGRAPHY: Pharmakowsky 1904, pp. 10 illus., 12; Pharmakowsky 1906, pp. 148–49, illus. 94.

16

Black-figured Siphon (*Klepsydra*)

Attributed to the Painter of the
 Carlsruhe Skyphos
Attika
540–530 B.C.
H: 14.5 cm; Diam (bottom): 6.5 cm
Terracotta
Olbia necropolis, 1911. Burial no. 82.
 Excavations of B.V. Pharmakowsky
Acquired in 1924
Inv. O.1911.292

Closed vessel with globular body terminating in a small conical protrusion. The vessel has a hollow handle, in the upper part of which there is a small round opening. The handle and two broad bands on the lower part of the body are covered with black glaze. At the bases of the handles are depictions of sirens, heads turned back. Details of the figures are rendered with incisions, and the wings are highlighted with added red. Frontlets on the heads of the sirens are highlighted with added red. On sides A and B are almost identical images of four naked males, one bearded and three beardless, their hair and beards highlighted with added red. The men wear necklaces with pendants painted in poorly preserved added white. The expressive figures, with their somewhat heavy proportions, have details sparingly rendered by incision. The figures' poses, gestures, and necklaces testify to the erotic content of the scene; the bearded man is courting the boy. The two nude youths flanking the central pair are dancing. An identical composition is depicted on one side of a skyphos by this painter in Dresden (Beazley *ABV*, p. 626, no. 2).

Aristophanes and Empedokles (Ar. *Vesp.* 858; Empedokles B.100, 9) referred to such vessels as *klepsydrai*. This name was used for water clocks as well as for filtering vessels. In the literature on ceramics the term *siphon* has become firmly established. Only eighteen vessels are known, of which eleven were produced in Attika, three in Boiotia, and four in other locations. The volume of each differs

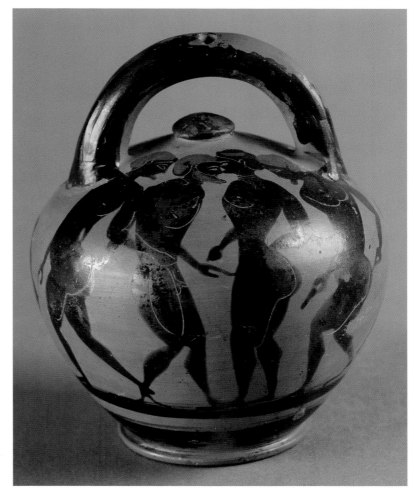

16a

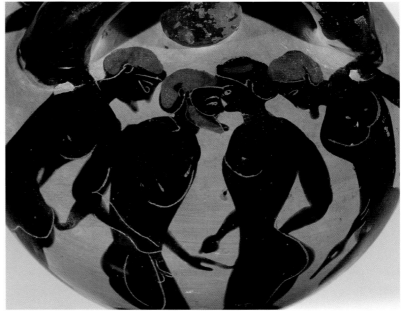

16b

95

slightly, but the vessels all function on the same principle. The unusual shape is used to withdraw liquid from large containers: the siphon is lowered into a larger vessel and is gradually filled through the holes in the bottom. A finger placed on the hole in the handle prevents the contents from flowing out of the vessel. By controlling the opening in the handle, the flow of liquid from the siphon can be slowed to drops.

There are several opinions about the use of these vessels. One suggests they were used to lift wine from the bottom of kraters or amphorae, however, among the numerous illustrations of symposia, none depicts such use. Another hypothesis holds that siphons were used as showers or for removing dust from the floor of palaistrai, but the volume of liquid they can hold (250–650 cc) is too small for these purposes. Pouring liquid in drops could have been used for ritual cleansing or libation. The majority of the vessels come from burials, and two come from shrines of chthonic gods in Eleusis. It is likely that the rare vessels were used for burial and chthonic libations that imitated rain, which purified and fertilized the earth.

<div align="right">Y. I.</div>

BIBLIOGRAPHY: Pharmakowsky 1912, p. 360, fig. 51; Pharmakowsky 1914b, p. 20, fig. 26; Beazley *ABV*, p. 626; Skudnova 1988, pp. 85–86; *Great Art* 1994, p. 287, no. 270; Κεφαλιδου 2002–3, p. 98.

17

Fragmentary Bilingual Eye-cup

Attributed to Oltos
Attika
520 B.C.
Diam: 31 cm
Terracotta
Olbia, 1968. Excavations of E. I. Levi
Acquired in 1987
Inv. OG.19

Fragmentary kylix of Type B. On the exterior, between closed palmettes, there are two apotropaic eyes. In the center of the compo-sition a naked hetaira with krotala in her hands walks to right. She is nude, except for earrings and a fancy headdress decorated with a cruciform pattern and a tassel. Her hair tumbles from under the headdress and cascades onto her forehead in small ringlets, while in the back it falls to her neck as a heavy knot, pulling the fancy headdress down. The tassel of the headdress is rendered in added red and the contour of the figure is executed with a relief line. The eyes are compass drawn, with pupils highlighted with added red. The sclerae are in added white and the eyebrows are rendered by a relief line. The tondo is black-figure. Only the lower part of a pair of legs, in narrow trousers; the elbow of the right hand in a fur jacket; and a poleax with a long handle have been preserved. Nonethe-less, the composition is clear: an Oriental archer is running headlong while swinging his battle ax.

The confident draftsmanship, successful compositional solutions of the interior and exterior painting, and elegance of the various details betray the hand of one of the best painters from the time of the establishment of red-figure technique. A close comparison of the features of the painting, composition, and subjects makes it possible to determine that the kylix from Olbia is a work by Oltos. Only in his work can one find such circular compositions with depictions of warriors and archers. The hetaira is especially close to the paintings on kylikes with Nereids and reclining hetairai. Depictions of women are common in his work. The use of both red- and black-figure technique on one cup and the nearness of the painting to his best works indicate that this kylix can be associated with the prime of Oltos's creativity and can be dated to approximately 520 B.C.

Magnificent red-figure kylikes bought in Athens for religious purposes have been found in the area of the Olbia agora. Two bear dedicational inscriptions to Zeus and Athena. The best examples can be attributed to the leading red-figure painters Oltos and Epiktetos (Gorbunova 1964, pp. 175–87).

<div align="right">Y. I.</div>

BIBLIOGRAPHY: Gorbunova 1970, pp. 573–74, pl. 12.1–3; Cohen 1978, pp. 341–42 (B 45), pl. LXXII.1–3.

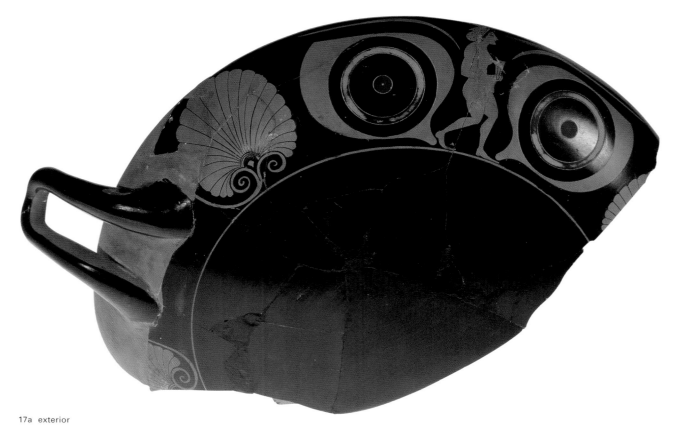

17a exterior

17b interior

18

18

Fragment of a Red-figure Kylix

Attributed to Euphronios
Attika
515–510 B.C.
H: 5.5 cm; L: 9.5 cm
Terracotta
Olbia, 1927. Excavations of
 B. V. Pharmakowsky (?)
Acquired in 1936
Inv. OL.18181

This fragment of the bottom of the large kylix of Type B is covered on the interior with coral-red gloss; in the black-gloss tondo is the foot of a male figure in a long himation. The inscription ΛΕΑΓΡ[ΟΣ] on a black background is executed in added red. The himation, whose folds are rendered with horizontal lines, reveals only the right foot with a minutely drawn nail of the big toe and creases underneath the toe joint. The ankle joint is rendered by a thin relief line. Even such a small fragment reveals the high level of the painting on this cup and the outstanding characteristics of its famous painter.

Such representations of folds in a himation and toe can be seen in several signed works by Euphronios: on the Louvre krater with the depiction of the battle between Herakles and Antaios on one side and the depiction of the music competition on the other, and on the kylix from Munich with

the depiction on one side of Herakles and Geryon and on the other, the stealing of cattle. The interior of the Munich kylix is covered with coral-red glaze, just like this fragment from Olbia. There are no traces of paint on the exterior of the kylix. Out of fifty-four works of this painter, only one fragment was found in Ionian colonies on the Black Sea coast.

Y. I.

BIBLIOGRAPHY: Peredol'skaya 1957, pp. 10–11, pl. III; Beazley *ARV*[2], p. 17, no. 20; *Capolavori di Euphronios* 1990, pp. 178–79, cat. 39; *Euphronios peintre* 1990, p. 195, cat. 45; *Euphronios Maler* 1991, p. 211, cat. 45.

19

Red-figure Lekythos

Attributed to the Dutuit Painter
Attika
490 B.C.
H: 16.6 cm
Terracotta
Olbia 1908. According to the sellers,
 it came from the necropolis
Acquired in 1914
Inv. OL.4350

Cylindrical lekythos of the PL Class. On the shoulder is a striped decoration and five palmettes connected by tendrils. The image on the body is framed at the top by a simple meander, and on the bottom by a reserved line. In the middle is a figure of Eros with a

flower in his right hand and a *kerykeion*
in his left. At each of his sides is an illegible
decorative inscription. The well-thought-
out painterly composition; the elegant
lines of the contours; and the characteristic
representation of the eye, ear, nose, and lips
make it possible to place the Olbia lekythos
among the best works of the Dutuit
Painter—the master of the Severe Style—
who mostly painted small vessels.

Eros is one of the oldest Greek gods, one
of the four original cosmogonic principals.
His image appeared late in Greek art and
did not immediately acquire canonical forms.
It is unusual to see him holding a *kerykeion*
and flower; this might recall an Archaic
tradition in which Eros shared chthonic
features with Hermes. The link between
these gods is figuratively depicted by showing
them with the same attributes. The *kerykeion*
is a staff used for one of Hermes' most
ancient functions: putting to sleep and
waking the dead whose souls he conducts to
Hades. Eros could be represented as a
messenger of the gods, his swiftness aided by
his golden wings. The flower is his usual
symbol, pointing to his links with Aphrodite,
the goddess of love. The rare subject matter
of the lekythos reflects Archaic notions
of the god. This is a beautiful example of
the Severe Style, which was something of a
rarity in Olbia. Lekythoi of different shapes
are frequently found in the burials of the
necropolis.

Y. I.

BIBLIOGRAPHY: Pharmakowsky 1908, p. 188, fig. 20.3;
Prushevskaia 1941, pp. 318–24; Beazley *ARV*[2], p. 676,
no. 14; *LIMC* 3, s.v. "Eros," p. 928, no. 948.

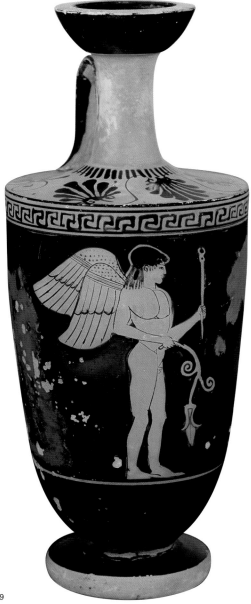

19

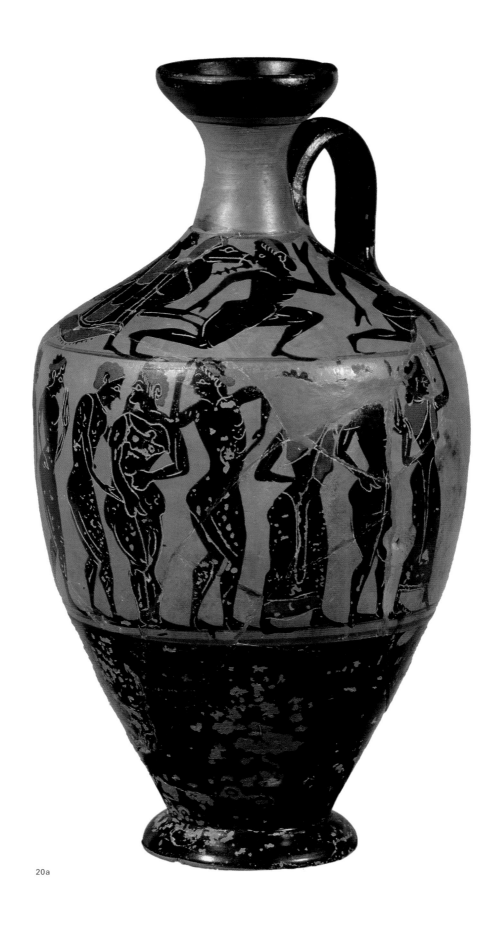

20a

Fig. 6. Olbia. Offerings from burial no. 64. Excavations of 1912. From Skudnova 1988.

Burial no. 64 (cat. nos. 20 – 27)

Burial no. 64, discovered in the northwestern part of the Olbian necropolis, dates from the end of the sixth century B.C. The earthen burial contained twenty-four objects (fig. 6) and is one of the richest in the necropolis. Along with bronzes, beads, and alabaster objects are many examples of ceramics from the different centers represented in Olbia: Ionian, gray terracotta, Corinthian, and Attic black-figure, which is the most common. The burial contains several pieces of gold jewelry.

<div style="text-align: right">Y.I.</div>

BIBLIOGRAPHY: Skudnova 1988, p. 119.

20

Black-figure Lekythos

Attributed to the Painter of
 the Carlsruhe Skyphos
Attika
540–530 B.C.
H: 30 cm
Terracotta
Olbia necropolis, 1912. Burial no. 64.
 Excavations of B. V. Pharmakowsky
Acquired in 1924
Inv. O.1912.272

The lekythos with the rounded body, sloping shoulder, and short neck transitioning to the mouth belongs to the Phanyllis Class. On the shoulder, next to the running horse, is a man in a long himation. The horse's mane, the folds of the himation, and its hem are highlighted with added red. On each side is a running naked youth; their hair and one youth's fillet are highlighted with added red. The body of the lekythos has a composition of eleven figures. In the middle are three naked youths, one of whom is rendered in a complex perspective—frontal, but with his head turned toward the youth behind him—who extends his hand for courting. The hair of the youths is highlighted with added red. To the right and left of them is a procession of alternating figures of women (maenads)

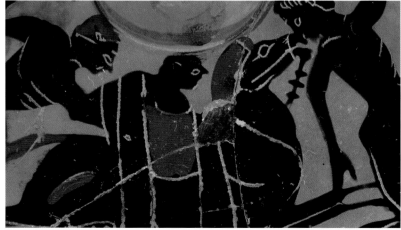

20b

and naked youths. The women's hair falls to their shoulders and they wear headbands of added red and smooth long peploi with added-red hems. The youths wear added-red headbands. The sparing details are incised, and the line is often slipshod, but the abundant use of added red gives the painting brightness and expression. The depictions of the poses and facial expressions of the youths and maenads are typical for this painter.

There are several vases by the same painter in the necropolis (cf. cat. no. 16). This rare example is distinguished by its large size and nonstandard subject matter compared to Phanyllis Class lekythoi. That sets it apart from common mass-produced objects such as the small lekythoi belonging to the "Departing Hoplite" group. The latter are well represented in the Olbia necropolis as well as in the necropoleis of the northern Black Sea coast, Athens, Boiotia, southern Italy, and Sicily.

<div align="right">Y. I.</div>

BIBLIOGRAPHY Pharmakowsky 1913, p. 205, fig. 51.3; Beazley *ABV*, p. 626; Skudnova 1988, pp. 119–20.

21

Black-figure Oinochoe

Attributed to the Group of Vatican G.52
Attika
540–530 B.C.
H: 15.8 cm
Terracotta
Olbia necropolis, 1912. Burial no. 64.
 Excavations of B. V. Pharmakowsky
Acquired in 1924
Inv. O.1912 262

Miniature oinochoe with an elongated body, low narrow neck, sharply bent mouth, and handle looped higher than the mouth. The picture field is bordered on the shoulder with a striped decoration. In the field is a naked youth running to right between two male figures in himations, whose folds are incised and colored with added red, while the hem is outlined with a narrow white-dotted band. The hair is cut short and also colored with added red; facial features are carelessly

rendered with incision. The painting of the oinochoe, with its copious application of added red and its laconic silhouettes, makes it possible to classify it among the earliest vases found in Olbia. A second miniature oinochoe with the same shape (cat. no. 22) was found in the same grave. These two vessels were undoubtedly painted by the same hand. Similarly shaped miniature black oinochoai found in the Agora of Athens are dated 525 B.C.

<div align="right">Y. I.</div>

BIBLIOGRAPHY: Skudnova 1988, p. 119.

22

Black-figure Oinochoe

Attributed to the Group of Vatican G.52
Attika
540–530 B.C.
H: 15.8 cm
Terracotta
Olbia necropolis, 1912. Burial no. 64.
 Excavations of B. V. Pharmakowsky
Acquired in 1924
Inv. O.1912.280

Miniature oinochoe with elongated body, low narrow neck, sharply bent mouth, and handle looped higher than the mouth. The picture field is bordered on the shoulder with a striped decoration. In the field Nike stands between two male figures in himations. She wears a long unusual chiton, its blouse decorated with dots in added red, and the skirt entirely colored. The narrow belt at the waist is incised. Her spread wings have broad bands of added red with sparingly incised plumage. Loose hair reaches her shoulders; on the head it is tied up with a band. Silhouettes of the male figures are identical to those of cat. 21 in their style, proportion, and facial features, but the himation of the right figure is much more decorative: it is covered with dot rosettes in added red and white. The painting of this oinochoe is of better quality than others that seem to be by the same hand.

<div align="right">Y. I.</div>

BIBLIOGRAPHY: Skudnova 1988, p. 121.

21

22

23

23

Black-figure Kylix (Cassel Cup)

Attika
530–500 B.C.
H: 7.7 cm
Terracotta
Olbia necropolis, 1912. Burial no. 64.
Excavations of B. V. Pharmakowsky
Acquired in 1924
Inv. O.1912.263

The kylix has a high stem on a flat foot and an offset lip. On the exterior rim is a band of tongues alternately executed in black or added red. Below that is a band consisting of a wreath of alternating petals, and below that is a band of oblique lines. The lower part of the cup is decorated with rays.

Y. I.

BIBLIOGRAPHY: Pharmakowsky 1913, pp. 205–6, fig. 53; Skudnova 1988, p. 121.

24

Black-glazed Olpe

Attika (?)
End of the sixth century B.C.
H: 10 cm
Terracotta
Olbia necropolis, 1912. Burial no. 64.
Excavations of B. V. Pharmakowsky
Acquired in 1924
Inv. O.1912.276

Miniature olpe with sloping shoulders and a broad body on a ring-like foot. The neck is short and trumpet shaped. The double-barreled handle, which does not rise above the top of the mouth, has protrusions at the upper points of attachment. Two narrow added-red bands adorn the shoulder. An outstanding feature is the accentuated neck, which is unusual for small olpai. The heavy proportions of the vessel do not resemble any other Attic black ceramics; it is possible this was not produced in an Attic workshop. In addition to Attika, in the Archaic period black-glazed and black-figure ceramics were produced also in the Ionian centers.

Y. I.

BIBLIOGRAPHY: Skudnova 1988, p. 121.

25

Tripod Bowl with Lid

Naukratis
Second half of the sixth century B.C.
Diam: 11.7 cm
Alabaster
Olbia necropolis, 1912. Burial no. 64.
 Excavations of B. V. Pharmakowsky
Acquired in 1924
Inv. O.1912.275/1–2

Small semi-spherical cup resting on three legs in the form of nude female figures sitting on animals. On two of the legs the female figures are slightly bent forward with their right legs drawn in, while their left legs bear up against the lion's snout. Their hands grasp the walls of the vase in a broad gesture. On the third leg the female figure is sitting on two animals, probably horses, embracing the cup with one hand and touching the head of an animal with the other. The women have headdresses in the form of lotus buds. The locks of hair cascading down the back are clearly visible. The faces are elongated; the eyes are flat under the arched eyebrows. Each has a frozen Archaic smile on her lips. These figures are probably fertility goddesses. Around the rim of the vessel is a relief band of zigzags on which there are three large rosettes in relief. The lid of the vase is almost flat, with a protrusion in the interior. In the middle of the lid is the figure of a woman in a smooth peplos seated on a throne. At the rim of the lid are three carved groups, each with a crouching nude youth next to a horse. The goddess on the throne is analogous to statu-ettes and may represent Demeter or Kore.

Only five comparable vases are known, four of them from the Olbia necropolis (three are in the Hermitage and one is in the Odessa Archaeological Museum), another with simpler decorative elements comes from the necropolis on Berezan Island and is in the Cherson Regional Museum. One more vase of this type was found in Naukratis and is now in the British Museum.

The style of the execution and form of these vases leave no doubt that they were made in the same workshop. B.V. Pharma-kowsky had already remarked on the Eastern

24

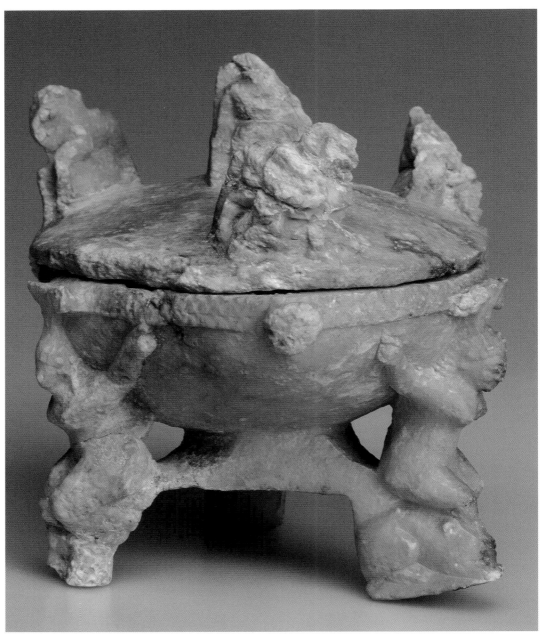

25a

influences in the decorative components of
Olbian incense burners when he compared
them to an alabaster vessel in Galera, Spain,
that depicts the goddess Astarte. Most
scholars agree that the vessel is the work of
a Phoenician artist from the seventh century
B.C. Cultic stone vessels held up by figures
of fantastic animals have also been found in
ancient Palestine and Cyprus. We can trace
the connection between our vases and marble
basins supported by frontally standing figures

of korai, whose forms are based on Eastern
prototypes, that have been found in main-
land Greece and on the islands of the Aegean.
However, the figures of the horsemen and
the goddess seated on the throne are analo-
gous to the small limestone figures produced
in Late Archaic Cyprus.

Many limestone Cypriot votive statues
were found in Naukratis, and there is a
hypothesis that migrant artists from Cyprus
— at that time ruled by Egypt — worked

106

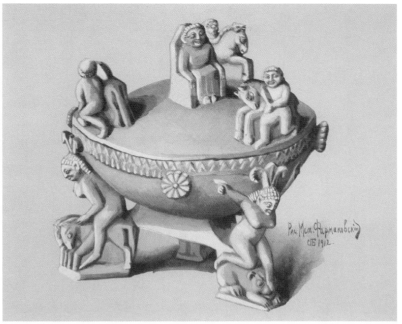

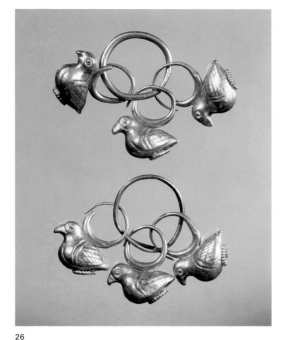

25b

26

there, since local sculpture in Naukratis shows a marked influence of the Cypriote plastic arts. As one of the main centers of the northwest coast of the Black Sea, Olbia had direct contacts with Naukratis. This Olbia alabaster vase is a unique work of Naukratic artists and reflects the diversity of influences in the Archaic period.

Y. I.

BIBLIOGRAPHY: Pharmakowsky 1913, p. 200, fig. 42; Pharmakowsky 1914b, p. 18, pls. 4, 6.2; Skudnova 1988, p. 121; Boriskovska'ia 1989, pp. 112, fig. on p. 134; *Great Art* 1994, p. 283, no. 267.

26

Pair of Earrings with Bird Pendants

Olbia
Late sixth century B.C.
H: 3.5 cm
Gold, silver
Olbia necropolis, 1912. Burial no. 64.
 Excavations of B. V. Pharmakowsky
Acquired in 1924
Inv. OL.17539

Pair of earrings consisting of a wire ring (one gold, one silver) with three pendants in the form of birds, apparently quails. The birds are soldered to the broadened lower part of open rings. Each hollow figurine consists of two die-stamped halves. The broadening lower parts of the rings are reminiscent of boat-shaped earrings, many of which were found, often with wire rings, in the graves of the Archaic necropolis of Olbia and in Nymphaion. It is possible that the bird figurines had a certain meaning—perhaps a symbol of love, for according to one myth, Zeus and Leto united in the guise of quails.

Y. K.

BIBLIOGRAPHY: Pharmakowsky 1912, p. 201, fig. 46; Artamonow 1970, pls. 85, 86; Skudnova 1988, pp. 22, 119–21, no. 182.1; *Zwei Gesichter* 1997, no. 42; *Greek Gold* 2004, p. 69, fig. 40.

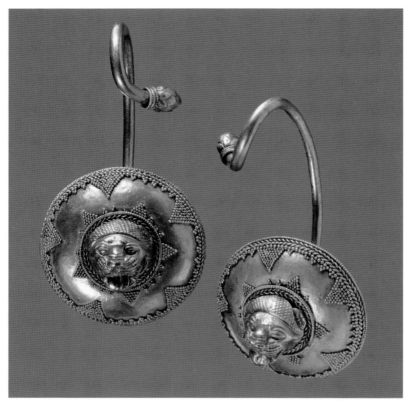

27

rows of beaded and plaited wire. The Hermitage collection holds four more pairs of similar ear pendants from the third quarter of the fourth century B.C. One pair was found in the Scythian kurgan Yemchikha in the middle Dniepr region. These types of pendants among Scythian finds are similar to ear adornments that are about five centimeters high in the shape of a smooth conical shield with a looplike hoop terminating with a semispherical stud. This similarity was recognized already by M. I. Rostovtsev (Rostovtsev 1931, p. 462). On the other hand, ear pendants, although different from the Olbia ones, were known in Greece in the ninth and eighth centuries B.C.

The pendants are made in the best tradition of Ionian art, as evidenced by the beautifully executed animal heads and graceful granule design. This jeweler had complete command of the techniques known to his contemporaries. The form of these pendants was unparalleled in contemporary jewelry in Greece and apparently reflects local fashion.

Y. K.

BIBLIOGRAPHY: Pharmakowsky 1914a, p. 243ff., pl. IX.1, fig. 61; Skudnova 1988, p. 150, no. 234; *Zwei Gesichter* 1997, no. 40; *Greek Gold* 2004, fig. 11, p. 70.

27

Pair of Ear Pendants

Olbia
Third quarter of the sixth century B.C.
H: 8.4 cm; Diam: 4.3 cm
Gold
Olbia necropolis, 1913. Burial no. 64.
 Excavations of B. V. Pharmakowsky
Acquired in 1926
Inv. OL.17580/1–2

Pair of ear pendants consisting of round convex disks and hoops bent to fit the curve of the ear. The shields soldered to the hoops are turned in such a way as to cover the earlobe and be noticeable both from the front and from the profile of the woman wearing them. The free end of each hoop has a pinecone finial. In the middle of the shield is a relief head of a lion, soldered together from two repoussé-stamped halves. The convex surface of the shield is decorated with a modest but expressive design of granules and

28

Seal Ring with Carved Image: Danaë

Ionia
Fifth century B.C.
1.9 × 2.0 cm
Gold
Olbia necropolis, 1902. Burial no. 98.
 Excavations of B. V. Pharmakowsky
Acquired in 1926
Inv. OL.600 (O.1902.146)

The ring has a stirrup form characteristic of early rings, with the hoop broadening in the middle to a pointed oval bezel. On the bezel is a depiction of Danaë carved in the Severe Style, raising the hem of her chiton

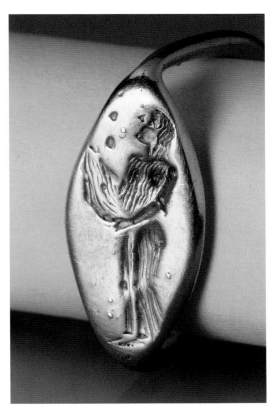

28 4:1

BIBLIOGRAPHY: Pharmakowsky 1906, 13, p. 139, no. 98, figs. 82–83; Neverov 1983, p. 36; Neverov 1986, p. 19.

29

Scythian-style Mirror

Olbia
550–500 B.C.
L (with handle): 34 cm; Diam (disk): 18.5 cm
Bronze
Olbia necropolis, 1912. Burial no. 36.
 Excavations of B. V. Pharmakowsky
Acquired in 1924
Inv. O.1912.136

in the expectation of the golden rain, the guise in which Zeus came to her. For the (female) owner of the ring the subject matter of the seal could symbolize divine bene-faction and heavenly blessing (Furtwängler 1900, p. 143). The sex of the buried person is not clear: a copper mirror and a sword were also found in the burial (*IAK* 13, p. 114).

Y. K.

Mirror with flange raised above the round disk. The handle is made of four ribs termi-nating in a sculpted figurine of a panther. At the base of the handle is a figure of a recumbent deer on a narrow, smooth foot. The unique feature of mirrors such as this is the casting of the thick disk with the verti-cal rim at right angles to the surface. There is a semicircular protuberance where the handle was riveted and soldered to the disc on the obverse.

The form is not typical for a Greek mirror. The animals are executed in Scythian animal style. The recumbent deer is compo-sitionally close to that on the plaque from the kurgan in the Cossack village of Kostrom-skaya, but it lacks its precision: the deer's snout is long and narrow, and the scrolls of the antlers are marked by four indentations. The schematic figure of the panther has a thin and elongated torso, the fat tail is curved in at the end and almost not separated from the body, the snout is narrow, and the details have not been worked.

Identical figures of a deer and panther can be seen on a mirror found on the Taman Peninsula. In the Olbia necropolis Scythian-style mirrors are often found in rich burials with gold jewelry. These mirrors are found also on Berezan, in Olbia, Taman, Podolia, and Transylvania; there is no consensus as to where they were made. Some believe that they were made in Olbia, others think the Carpathian basin played an important role, together with other centers, where other objects in Scythian animal style were made. Remains of bronze casting have been found on Berezan, and casting molds for producing Scythian-style plaques have been found on

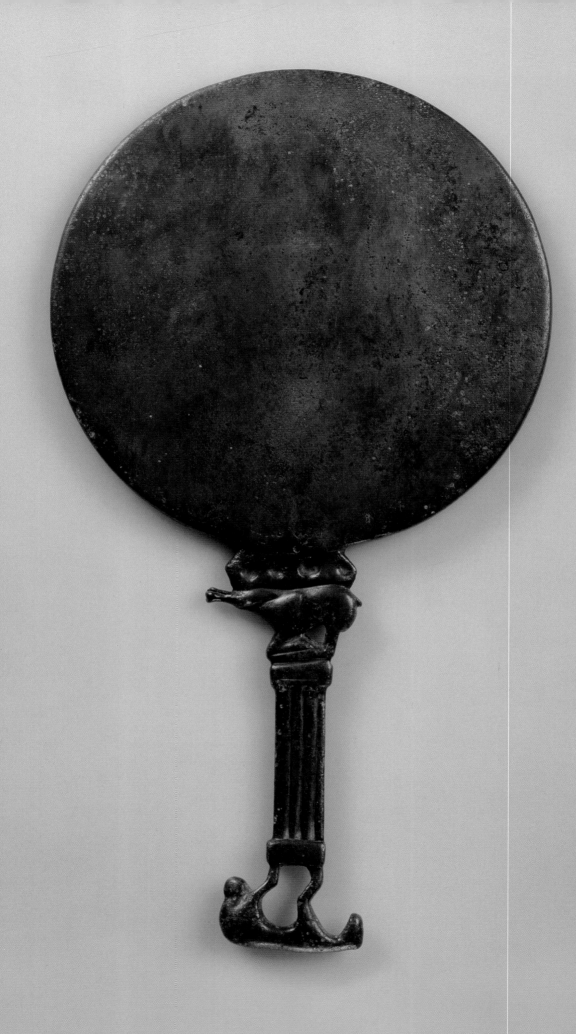

29a

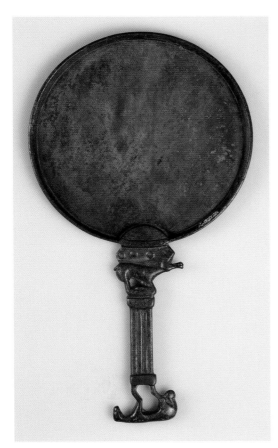

29b

29c

Berezan and in Olbia. This would seem to strengthen the hypothesis that Scythian-style mirrors were made in Olbia. Images of animals lean toward Greek art, where images of deer, panthers, lions, and boars were also popular.

Y. I.

BIBLIOGRAPHY: Skudnova 1962, p. 13, no. 1, fig. 7; Skrzhinskaya 1984, p. 126; Skudnova 1988, p. 113.

30

Mirror

Olbia
Late sixth–fifth century B.C.
L (with handle): 27.5 cm; Diam (disk): 14.6 cm
Bronze
Olbia necropolis, 1913. Burial no. 10.
 Excavations of B. V. Pharmakowsky
Acquired in 1926
Inv. O.1913.23

Mirror of Argive-Corinthian type with a round disk and flat handle terminating in a round medallion with a Gorgoneion. The rim of the disk is framed by plain cable. The handle has small protrusions at the base, decorated with swirling rosettes rendered through delicate incisions. On the handle is a lotus bud in the middle and a pearl thread in relief on the edge. The Gorgoneion at the end of the handle is in Archaic style. Her hair is twisted into ringlets, her almond-shaped eyes have raised brows, she is snub-nosed, and her cheeks and chin form a single oval shape closing at the nose. Her ears are small and detailed, and her open mouth shows her tongue hanging out between her fangs. The proportions of the disk and the handles are well balanced and the unusual composition was skillfully executed. The use of Greek elements in the decoration leaves no doubt that the creator of this wonderful mirror was a craftsman raised in the traditions of Greek Archaic art.

Three more mirrors with similar decoration are known, though their proportions are not as elegant as those of the present mirror, and their decoration is poorer. Mirrors of this type found in southern Russia form a separate group. B. V. Pharmakowsky has pointed out that the influence of Ionia can be seen in the decoration of these mirrors (the lotus bud, the cable), and he considered them to have been produced locally in Olbia. His opinion was upheld by a majority of researchers, even though some deemed his arguments to be insufficient. Now new evidence of the high artistic level of bronze production in the various areas of the northern Pontic region has emerged. Casts, dies, and the remains of workshops have been found on Berezan,

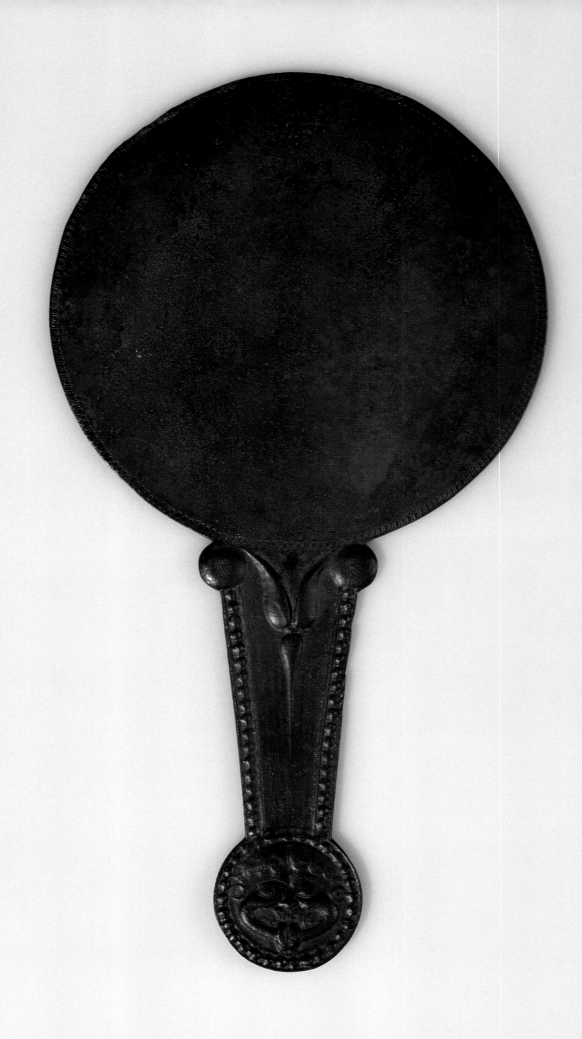

in Olbia and its chora, in the Iagorlytskoe settlement, in Nikonion, and in Pantikapaion, Myrmekion, Phanagoria, and Torikos.

It is especially interesting to compare molds for casting various pendants, parts of earrings, and pins from Olbia (*Greek Gold* 2004, pp. 35, 70, fig. 9) and two molds from Miletos (Treister 1998a, pp. 198–99, figs. 16–17). On all three of them there are similar ribbed perforations, and on one there is a medallion with a depiction of an Archaic Gorgoneion. Olbia was the largest—and apparently the only—center where mirrors were produced in the northern Pontic area. In the early third quarter of the sixth century B.C., Greek craftsmen arrived with the second wave of colonists on the northern coast of the Black Sea. This migration was related to the attack of Persia on Lydia and the Ionic cities in 546 B.C.

Y. I.

BIBLIOGRAPHY: Pharmakowsky 1914a, p. 241, fig. 59; Pharmakowsky 1914c, pp. 27–28, pl. XI; Bilimovich 1976, p. 59–60; Skudnova 1988, pp. 127–29; Skrzhinskaya 1984, p. 124; *Great Art* 1994, p. 281, no. 265.

31

Assos

Olbia
ca. 475 B.C. (or 450–425 B.C.)
Diam: 4 cm
Bronze
Olbia
Acquired in 1925
Obverse: Head of Medusa. Reverse: Wheel, between the spokes the inscription A-P-I-X
Inv. OL.18148

During the first decade of the fifth century B.C. the Olbian polis was entering an era of territorial and economic expansion. The development of commodity production and exchange brought about the need to change the Archaic monetary system that had been formed at the beginning of the sixth century B.C. The salient feature of this system was that coins were not minted, but cast in molds. It was necessary to have valuable copper coins to exchange for Kyzikos staters of electrum, which were the basic means of exchange. Large round cast coins are called *assoi* by analogy with the Italic cast coins. Several series of assoi with different images were issued. These small assoi belong to the second series and have a lesser face value.

Y. I.

BIBLIOGRAPHY: Not previously published.

31a 31b

32

Assos

Olbia
Late 350s–early 330 B.C. or later
Diam: 7 cm
Bronze
Olbia
Acquired in 1925
Obverse: Frontal view of Demeter; reverse:
 Eagle on dolphin, inscription: OΛBIH
Inv. OL.18144

Example of the fourth issue of assoi, which
were produced in large numbers and are
represented by various styles. A similar hoard
of assoi was discovered under the remains
of a courthouse in Olbia (Gilevich 1972,
pp. 74–78).

<div align="right">Y. I.</div>

BIBLIOGRAPHY: Not previously published.

32a

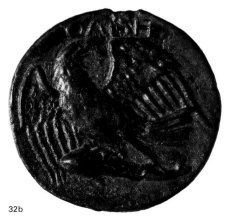

32b

33

Incense Burner with Lid

Olbia
Late fourth–early third century B.C.
H (incense burner): 18.1 cm; H (lid): 10.4 cm
Terracotta
Purchased in 1904 and 1914 in Parutino
 (ancient Olbia)
Acquired in 1924 and 1927
Inv. OL.4836 (incense burner), OL.1312 (lid)

Large incense burner with a cylindrical body,
smoothly tapering to a cone shape in the
lower part of the vessel. The mouth is slightly
everted and contoured. On the inside is a
small indentation for the lid. The small,
conical foot has an indentation in the middle
and was made by hand, in contrast to the
body, which was wheelmade. The looped
handles are round in cross-section and are
attached to the body at its broadest point.

Incense burners were closed with lids
having an arched shape, a long handle, and
triangular openings. The vessel's rough
surface is covered with white primer and red,
pink, blue, black, and yellow mineral paint
that stands out against this background.
Although the details of the painting are now
difficult to make out, its pattern is preserved
in a watercolor of 1916. In the middle of

33a

the body is a branch with large, long leaves painted in blue. Along the rim is an ornamental band of ova in black and white. On the lower part of the vessel and on the foot are alternating broad vertical stripes of pink, blue, and white, separated by narrow black lines. In the middle of the body and on the foot are two narrow horizontal black bands. On the lid, on the white primer, between the horizontal bands, is a red garland of paired broad stylized leaves, not connected by stems.

Traces of ashes and coal are often found in incense burners. Aromatic substances were placed on the glowing coals to produce incense offerings to the gods. The majority of these vessels come from burials, which indicates their special funerary use.

This burner was locally made. The production of pottery in Olbia, which arose soon after the founding of the city in the early part of the sixth century B.C., achieved its greatest flourishing in the Hellenistic era, when painted artistic pottery began to be mass produced along with ordinary everyday dishes. Olbian craftsmen adopted the shapes, the method of priming surfaces with white paint, and painted ornamental motifs from imported vessels to create a distinct form of local pottery.

Y. I.

BIBLIOGRAPHY: Pharmakowsky 1918, p. 51; Zaitseva 1962, p. 185, fig. 1.2, p. 192, fig. 10.1.

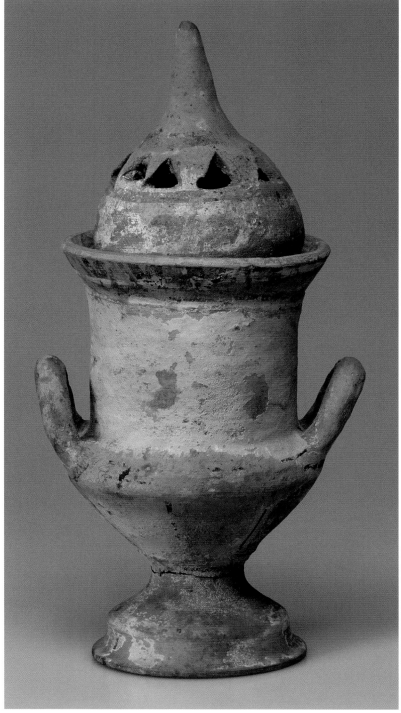

33b

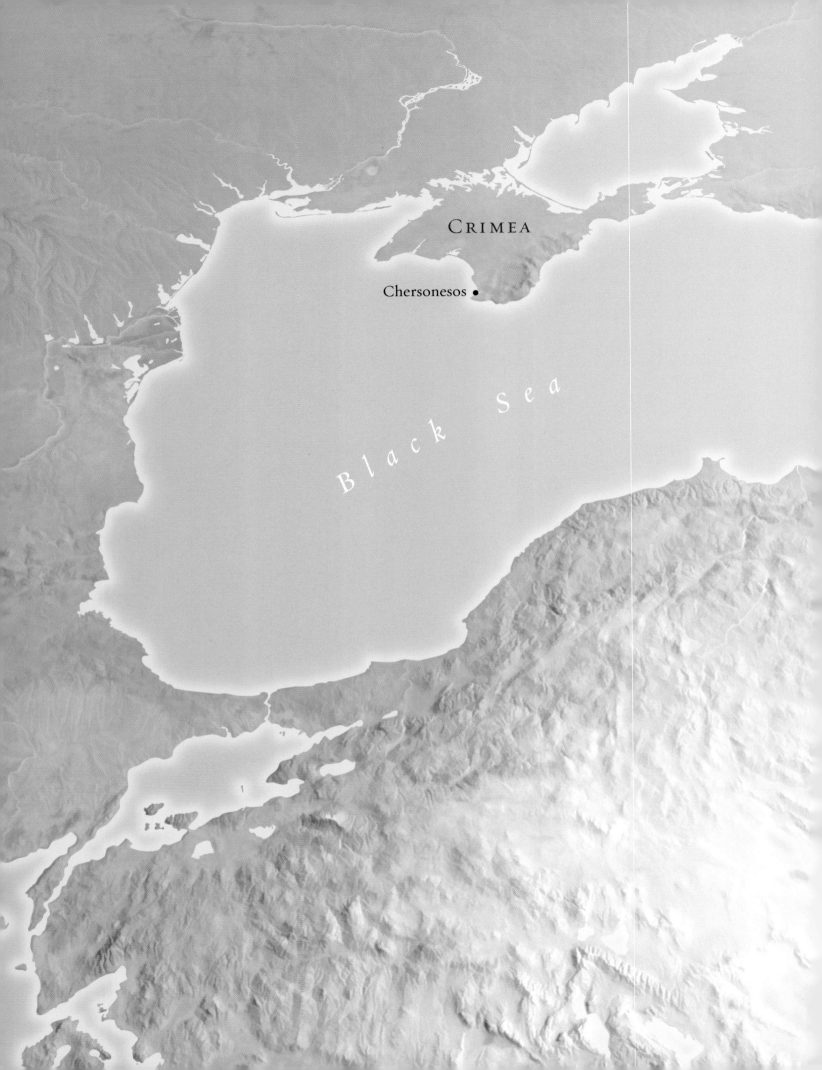

CRIMEA

Chersonesos •

Black Sea

Tauric Chersonesos

T HE RUINS OF CHERSONESOS ARE LOCATED ON THE SOUTHWESTERN extremity of the Crimean peninsula, on the outskirts of contemporary Sevastopol (fig. 7). The settlement was located on the shores of a well-situated bay, on the site of an earlier Greek settlement, Chersonesos was founded by Dorian Greeks from Pontic Herakleia on the southern shore of the Black Sea, and by settlers from Delos in the late fifth century B.C. Located at a maritime crossroads, Chersonesos soon became an important trade and manufacturing center. Having assimilated nearby areas, it gradually expanded to the fertile areas of northwest Crimea, extending its rule to the Greek cities of Kerkinitis (present-day Eupatoria) and Kalos Limen (meaning "beautiful harbor"). The areas adjacent to the city were divided into land allotments. The fertile regions of northwestern Crimea became the granary of Chersonesos. The polis was governed by democratically elected powers.

At the end of the fourth century B.C. defensive walls were erected; they are a magnificent monument to the art of Greek building methods. Constructed to allow room for growth, the walls encompassed not only existing buildings but extra space as well. The city itself was divided into rectangular blocks in a network of intersecting streets (fig. 8).

By the beginning of the third century B.C. the Scythians began to exert pressure on Chersonesos. As a result, the city gradually lost its possessions and was forced to seek protection from the Bosporus and eventually, in the first century B.C., from the Romans, who garrisoned troops in the city and its surroundings.

The military threat was a reason to strengthen the fortifications. During hasty reinforcement in the second century B.C. of the commanding corner tower (the Tower of Zeno), the inhabitants of the city used tombstones from the nearby necropolis as building material. When the tower was explored, forty-two stelai and many architectural features of tombstones were removed from it. The builders took the stones from the cemetery in succession, with the result that the headstones of entire families were found in the reinforcements of the tower. All of the stelai were placed face down. Due to this manifestation of piety, examples of Hellenistic painting unique to the northern Black Sea coast survived, providing us with an understanding of the use of polychrome decoration in Greek architecture and sculpture (see cat. no. 36).

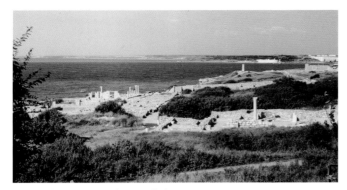

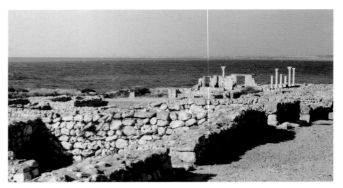

Fig. 7. Chersonesos. The North district.

Fig. 8. Chersonesos. The North district. Longitudinal street.

One of the most advanced crafts was ceramic production, based on local clay deposits of high quality. The demands for roof tiles for construction and good containers for Chersonesos wine, which was exported in branded amphorae to all the cities of the Black Sea coast and deep into the Scythian steppes led to the development of excellent ceramics. Terracotta statuettes were also produced. Often a coroplast would start with an imported figurine as a model and do further work on it, fully demonstrating his individuality. An example of this is the head of Herakles (cat. no. 40). Local artists in other fields were also inspired by Greek examples, as demonstrated by the beautiful examples of encaustic painting and stonework (cat. no. 36). Adherence of the artists of Chersonesos to Greek art is felt in the selection of imported works of art, sculpture in particular. The owner of a small workshop in the third through second century B.C. made molds for the production of terracotta items by making impressions of superb imported marbles, bronzes, and terracottas (cat. no. 39). This pattern in the life and culture of the city continued into Roman times (cat. no. 41). In general it can be said that Chersonesos experienced the influence of the barbarian surroundings to a lesser degree than other cities of the north Black Sea coast. Pliny the Elder noted that Chersonesos maintained Greek traditions to a greater extent than other Pontic cities (Plin. *NH* 4.82).

Y. K.

BIBLIOGRAPHY: Belov 1948; Gaidukevich 1955; *Crimean Chersonesos* 2003.

34

Head of Cybele

Greece
End of fifth century B.C.
H: 20 cm
Marble
Chersonesos, 1903. Central part of the city.
 Excavations of K. K. Kosciuszko-Walużynicz
Acquired in 1905
Inv. CH.1903.118

A woman's head with a kalathos (only the lower part has been preserved). The presence of this feature is characteristic of fertility goddesses, including Cybele or Magna Mater, a goddess of Phrygian origin, and aids in identifying this head as Cybele.

The goddess's oval face is framed by undulating tresses, parted above the forehead. In the back, the hair covers the neck, and two large locks probably came down to the breast. The treatment of the hair and the

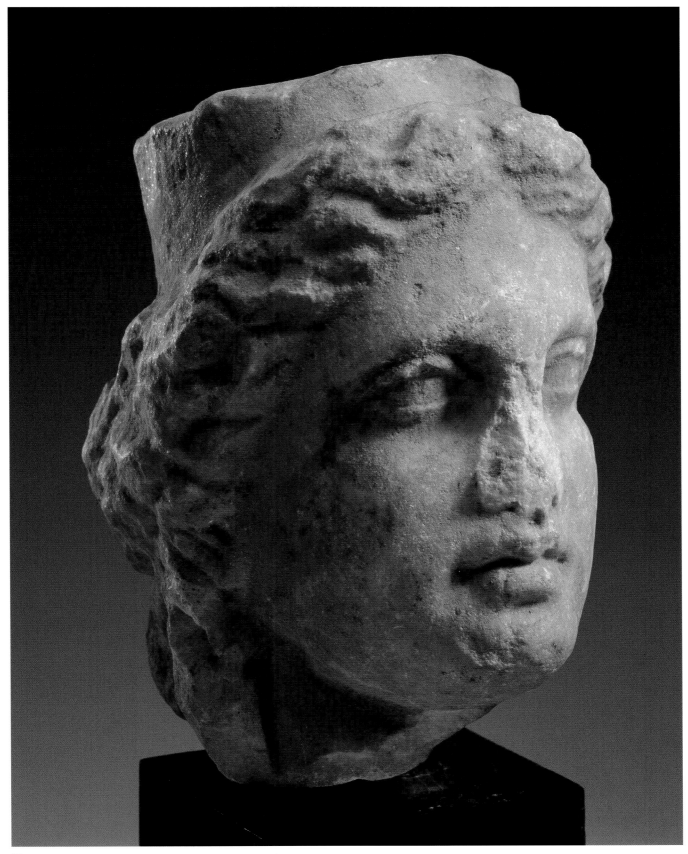

34

TAURIC CHERSONESOS

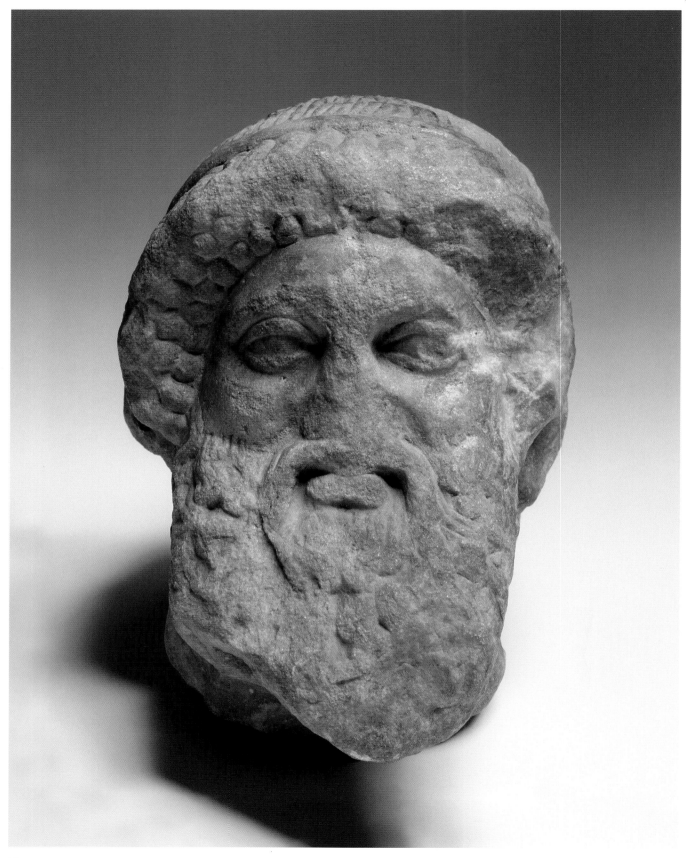

35

TAURIC CHERSONESOS

back of the head are quite standard, while the eyes with their heavy eyelids, the puffy mouth with the deep dimples in the corners, and the heavy rounded chin have been more meticulously executed. The soft chiaroscuro elaboration of the surface of the face and the severity of the general appearance of the goddess are close to the works of Greek artists in the late fifth century B.C., including the sculptor Agorakritos, a pupil of the great Pheidias. The statue of Cybele that stood in the Metroön in Athens is attributed to Agorakritos. It is possible that our head is the work of a sculptor who was inspired by the Cybele that was once brought to Chersonesos but is now in the Hermitage.

L.D.

BIBLIOGRAPHY: *Great Art* 1994, pp. 338–39, no. 326.

35

Head of Hermes

Greece
Fourth century B.C.
H: 18 cm
Marble
Chersonesos, 1890. Northern part of the city.
 Excavations of K. K. Kosciuszko-Walużynicz
Acquired in 1891
Inv. CH.1890.49

Man's head with thick beard and long moustache drooping down around a small fleshy mouth. The almond-shaped eyes are framed with eyebrows in relief. The crown of the head and nape of the neck are covered with thin, wavy locks of hair. Over the forehead the hair is arranged in spiral curls. On top, the hair is tied with a fillet.

The head of the bearded god was thought by scholars to be a depiction of Dionysos or Hermes. The most convincing identification of the sculpture is as a version of the Hermes Propylaios created by the sculptor Alkamenes in 470–460 B.C. for the Athenian Acropolis. The head of the Hermitage Hermes dates to the fourth century B.C., while the statuary type is that of Hermes Propylaios. Apparently

this sculpture was highly venerated in Chersonesos, for in Hellenistic times a clay cast was prepared from it to make terracotta copies.

L.D.

BIBLIOGRAPHY: Willers 1967, p. 94, no. 15; *Antichna'ia skul'ptura Khersonesa* 1976, p. 14 (bibl.); Saverkina 1986, no. 65, p. 150; *Great Art* 1994, p. 339, no. 327.

36

Funerary Stele of Polykasta

Chersonesos
Third century B.C.
H: 1.59 m
Limestone
Chersonesos, 1961. Excavations inside
 the Tower of Zeno (tower XVII).
 Excavations by S. F. Strzheletsky.
 Gift of the Chersonesos Museum to
 the Hermitage
Acquired in 1968
Inv. CH.1968.1

The stele tapers slightly toward the top, where there is a triangular pediment with three akroteria. The details of the relief decoration are complemented by details executed with wax paint: the cornice with ova and the base with a Lesbian cyma. The petals of the relief rosettes on the front and sides of the stele are also accentuated with paint, as are the inscriptions and the tied ribbon and an alabastron hanging on a string, which were common on women's tombs in Chersonesos.

The inscription reads:

Πολυκάστα	Polykasta
Ἱπποκράτειος	Hippokrateios
Δελφοῦ γυνά	Delphou gyna

"Polykasta, daughter of Hippokrates, wife of Delphos"

The grammatical forms of the inscription, which are characteristic of the Dorian dialect of Greek, can be explained by the fact that Chersonesos was a city founded by settlers from the Dorian city of Pontic Herakleia.

The stele was found in the so-called Tower of Zeno (tower XVII), a part of the defensive wall that was filled with monuments taken from graves in the nearby necropolis. Next to it was found the gravestone of her husband, Delphos, which is also now in the Hermitage. Monuments close in style and period were found during the excavations of the large burial mound in Vergina near Aigai, the ancient capital of the Macedonian kings.

<div align="right">Y. K.</div>

BIBLIOGRAPHY: Strzheletskii 1969, p. 15; fig. 7; Danilenko 1969, p. 35; Solomonik 1969, p. 63, no. 11; Solomonik 1973, no. 145; *Tesori d'Eurasia* 1987, no. 171; *Great Art* 1994, pp. 334–35, no. 321.

36

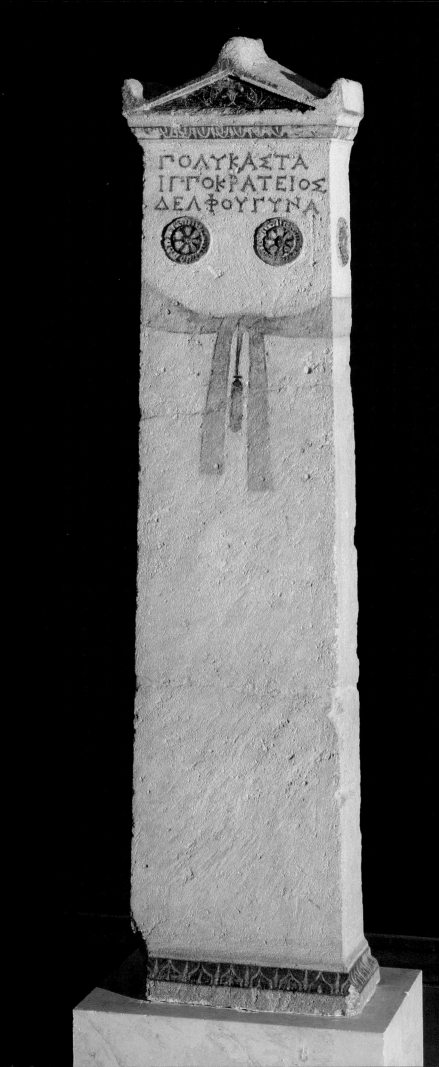

Burial Chamber no. 1012, under the City Wall (cat. nos. 37–38)

The entryway to the burial chamber, which is made of stone slabs, was discovered in 1899 by K. K. Kosciuszko-Walużynicz, the director of the Chersonesos Museum, during excavations of the defensive walls next to the southern city gates. The T-shaped chamber is 89 centimeters high, its ceiling formed by the lower row of the masonry of the defensive wall. Apparently the burial chamber was constructed at the same time as the wall was being erected. The design and location of the burial chamber, as well as what was for Chersonesos an unusually rich collection of objects, make it reasonable to suppose that it was constructed for someone who occupied a high position in the city, maybe an official in charge of the construction of the defensive walls. In the burial chamber were the cremated remains of six people placed in bronze and clay urns. The woman's jewelry presented in the exhibition was in a black-glazed hydria (urn no. 1) not far from the entrance to the burial chamber and was part of one of the last burials in the chamber.

Y.K.

BIBLIOGRAPHY: *IAK* 1, pp. 3–9; Grinevich 1926, pp. 10–40, fig. 10; Manzewitsch 1932.

37

Braiding with Herakles Knot

End of the fourth century B.C.
L: 31.7 cm; Herakles knot: 4.5 × 2.4 cm
Gold
Chersonesos, 1899. Burial chamber no. 1012
 set into the city wall, urn no. 1
Acquired in 1899
Inv. CH.1899.7

The jewelry, apparently a diadem, consists of three parts. At the center is the Herakles knot fashioned out of gold leaf tubes and spiral curls soldered to tubular loops. The jeweler who made the elegant and opulent Herakles knot incorporated a multiplicity of techniques. It is richly decorated with ringlets, shield, bosses, rosettes, and palmettes, the center of which are filled with granules. The edges of the details of the knot are framed by narrow strips of plain and beaded wire. The smooth surface of its loops is covered by a filigree ornamentation of chevrons. In the center is a figure of a siren playing the lyre.

The bands that are attached to either side of the knot are made of two strips of gold braiding, each comprising seven fine chains, interconnected and double pleated. Each end of the two strips is inserted into decorative collars fastened with a gold-wire clamp. The front set of collars, which attach to the central ornament, are decorated with a frieze of filigree palmettes. Each of these terminates with a lion's head and links to the central ornament by a ring in the lion's mouth and snake-shaped hooks on the back side of the piece. The ends of the distal collars that clamp to the straps have bands of braiding and plain and beaded wire and two rows of double filigree ova. These collars are connected to rings, through which it seems a cord would have been pulled to tie the diadem at the back of the head.

This type of elegant and flexible ornament subsequently underwent several changes in its basic decoration, while maintaining all of the component parts of its design. For example, the Herakles knot in the middle of the fragment of a chain of a Pantikapaion diadem from the third century B.C. was decorated with colored inserts. The famous second-century-B.C. diadem

123

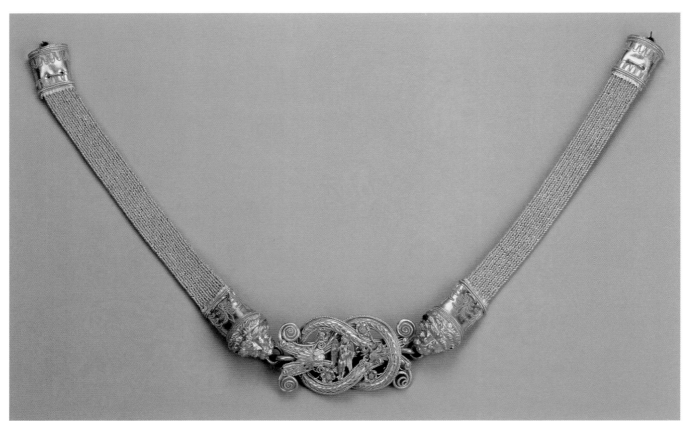

37a

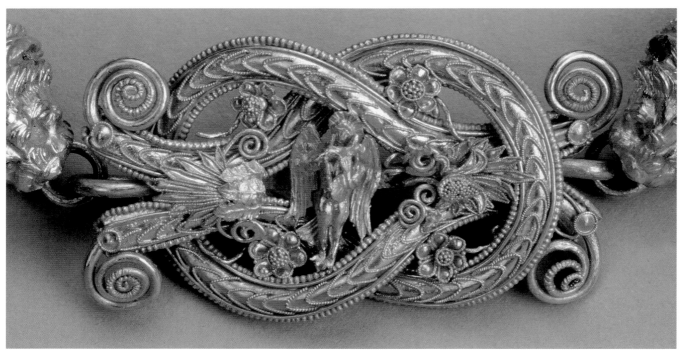

37b

TAURIC CHERSONESOS

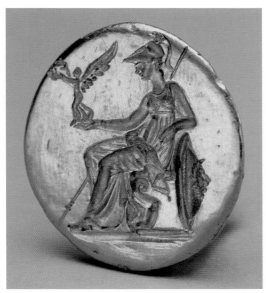

38 3:1

adorning the coins of Lysimachos of Thrace (ruled 306/5–281 B.C.). The goddess is seated on a folding stool, casually leaning against her shield, which is resting against the back of the seat. In the center of the shield is a protome of a lion. Behind the goddess's shoulder is a spear, its tip against the ground. In her extended right hand she holds a figurine of a winged Nike with a wreath. Athena is dressed in a chiton, girded high. Her knees are covered by a himation. The coins themselves and their impressions are often found in the Black Sea coast region.

O. N.

BIBLIOGRAPHY: Manzewitsch 1932, p. 9, pls. 1, 3; *LIMC* 2, s.v. "Athena," p. 977, no. 214; *Great Art* 1994, p. 336, no. 324; *Greek Gold* 1994, no. 133; *Zwei Gesichter* 1997, no. 107; *Greek Gold* 2004, fig. 34.

from the Artiukhovsky kurgan—even though it differs from the Chersonesos piece by its monumentality and the rigidity of its bindings—nevertheless maintains all of the details of the design. Scholars have different opinions regarding the purpose of the exhibited piece of jewelry: Saverkina (*Zwei Gesichter* 1997, no. 105) and Kalashnik (*Greek Gold* 2004, p. 72) call it a necklace with a Herakles knot.

L. N.

BIBLIOGRAPHY: *Greek Gold* 1994, no. 131; *Zwei Gesichter* 1997, no. 105; *Greek Gold* 2004, p. 72.

38

Ring with Image of Athena Nikephoros

Late fourth century B.C.
Diam (bezel): 2.3 cm
Gold
Chersonesos, 1899. Burial chamber no. 1012 set into the city wall, urn no. 1
Acquired in 1899
Inv. CH.1899.9

On the round bezel of the ring is replicated, almost without any changes, the image

39

Mold and Modern Impression of a Head of Hermes

Chersonesos
Third–second century B.C.
H: 19.2 cm; W: 14.3 cm
Clay
Chersonesos, 1888. Coroplast's workshop in the northwestern part of the city. Excavations of K. K. Kosciuszko-Wałużynicz
Acquired in 1891
Inv. CH.1888.43/1–2

The mold was made by an ancient coroplast from the face side of the head of a small statue, similar to cat. no. 35. It was found in the northwest area of Chersonesos. Small defects are noticeable on the right side of the mold, which were caused by the removal of the finished mold from the model.

This is one of forty-three molds found in a small workshop near the main street of the city. The molds were made from objects of high artistic value, such as bronze lids of mirrors, helmet cheekpieces, and various terracotta statuettes and relief vessels. The owner of the workshop apparently specialized exclusively in making molds for terracotta statuettes and reliefs. One such workshop

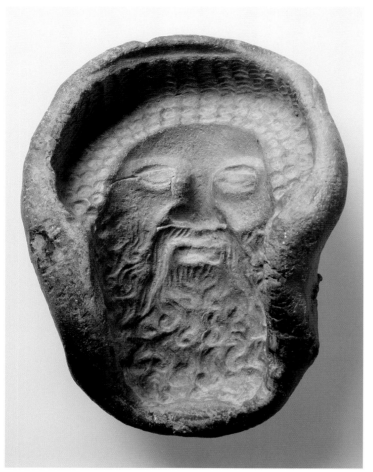

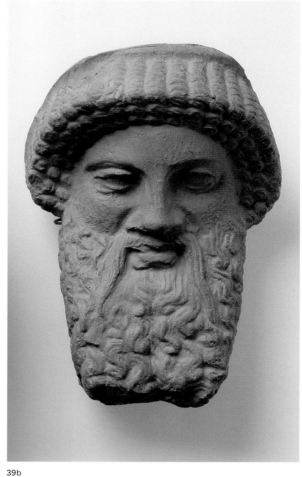

39a

39b

was excavated just outside the city's walls. A. P. Ivanova, like V. K. Mal'mberg, believed that the marble head cat. no. 35 possibly served as the original for the present mold. Though attributing this head to Dionysos, she nevertheless conceded, following E. Minns, that it could be a head of Hermes (Ivanova 1964, p. 134, fig. 1).

Y. K.

BIBLIOGRAPHY: *CR* 1882–88, pp. CCX–CCXI; Mal'mberg 1892, pp. 19–21; Minns 1913, p. 297, fig. 21 (where an impression from the mold is shown, taken off a marble head in its present state; photograph by V. K. Mal'mberg, 1892, p. 21); Knipovich 1955b, p. 167, fig. 2; Richter 1958, p. 375ff. (workshop is mistakenly attributed to Roman times); Borisova 1966, p. 14, pl. 27, cat. 71. pl. 7.1.

40

Head of Herakles

Chersonesos
Third–second century B.C.
H: 9 cm
Terracotta
Chersonesos, 1974. Twentieth block, cellar of
 residential house. Excavations of G. D. Belov
Acquired in 1974
Inv. CH.1974.80

The head is made from a mold taken from a small statuette. The practice of making copies from high-quality imported items was widespread among Chersonesos craftsmen (see cat. nos. 35, 39). In this case the artist presumably used a mold made from a terracotta copy of a statue from the circle of Lysippos (numerous similar copies were made in Hellenistic times in Smyrna). The

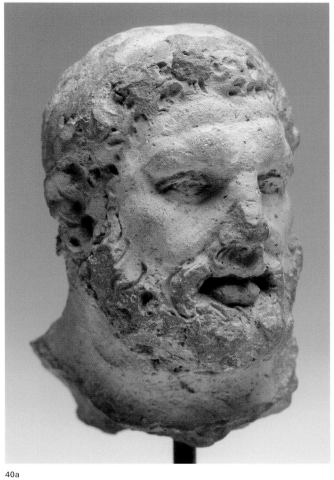

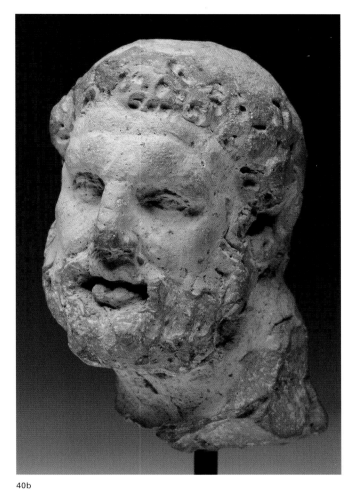

40a

40b

coroplast demonstrated his good taste by
choosing such an excellent original, as well as
his fine craftsmanship, evident in the finish-
ing touches applied by hand to the mold.
The strong three-dimensionality of the
modeling of the face and the skilled use of
chiaroscuro give the head monumentality
in spite of its small size.

The image of Herakles, who for the
Greeks was the personification of industri-
ousness and unbending perseverance,
was exceptionally popular in Chersonesos.
Thus it is understandable that an artist
would use a copy of a famous sculpture of
this great hero.

Y. K.

BIBLIOGRAPHY: Belov 1976, pp. 203–8, figs. 1, 2;
Antichna'ia koroplastika 1976, no. 193; *Prichernomor'e* 1983,
no. 242; *Antichnye gosudarstva* 1984, pl. 102.4; *Tesori
d'Eurasia* 1987, no. 170; *Great Art* 1994, p. 339, no. 328;
Olympism 1993, no. 7.

41

Necklace with Pendant in the Form of a Butterfly

First century B.C.
L: 30.5 cm
Gold, emerald, almandine, garnet, rock
 crystal, glass, amethyst, and pearls
Chersonesos necropolis, 1896.
 Slab tomb no. 630
Acquired in 1898
Inv. CH.1896.18

The necklace consists of eleven pivotally connected medallions with convex inserts (emerald, rock crystal, amethyst, pearls, and glass) and two pieces of plaited gold cord with rings. A pendant formed by five medallions soldered to a butterfly-shaped gold appliqué is fastened by gold wire to the middle link. The details of the butterfly are rendered with emerald and almandine inserts. The legs and tail of the insect are rendered by pearls set on pins (two pearls have been preserved) and the wing covers by vertically inserted plates. The contours of the medallions, the pendants, and the wings of the figure are decorated by good quality granules. In order to keep the butterfly from flipping over, it is fastened by chains to the side tassels with stones at the terminals.

Necklaces with such pendants are very rare, although another one has been found in Chersonesos. By design and style they continue a tradition that began in Hellenistic times (see cat. no. 175); for this reason M. V. Skrzhinskaya and I. I. Saverkina have sug-

gested a date of the second to first century B.C. (Piatysheva 1956, p. 37; Skrzhinskaya 1994, p. 26). However, the majority of scholars date these necklaces to the first century A.D. (Minns 1913, p. 408; Higgins 1961, p. 186, incorrectly attributing them to Kerch; Treister 1997–98, p. 56). The items found in the burial together with the present necklace point to the opening decades of the first century A.D. The place of manufacture of this series of necklaces has not been established. Different workshops have been named: Syrian (*Zwei Gesichter* 1997, no. 108), Syrian and Armenian (Piatysheva 1956, pp. 37, 79), Seleucid, and, for later examples, Pontic (Skrzhinskaya 1994, p. 23), Olbian or Chersonesan (Treister 1997–98, p. 55ff.). In view of the fact that the adornments with precious stones demonstrating significant resemblance in style and technique were widespread everywhere, it is hardly possible to attribute them to one certain center in the eastern Mediterranean.

According to L. Stefani, the motif of the butterfly became popular in Greek art from the fourth century B.C. (*CR* 1877, pp. 30–137); its representations were considered to be appropriate gifts for lovers. In the early centuries A.D. gifts with meaning were often accompanied with the inscription ψυχή ("soul," "darling") (*CR* 1877, p. 137); the same word also means "butterfly" in Greek. For this reason, the necklace with the butterfly pendant appears to be a symbol of love.

Y. K.

BIBLIOGRAPHY: *CR* 1896, p. 179, fig. 555; *Great Art* 1994, pp. 336–37, no. 325; *Zwei Gesichter* 1997, no. 108; Treister 1997–98, pp. 50, 54, fig. 7; *Greek Gold* 2004, p. 72, fig. 22.

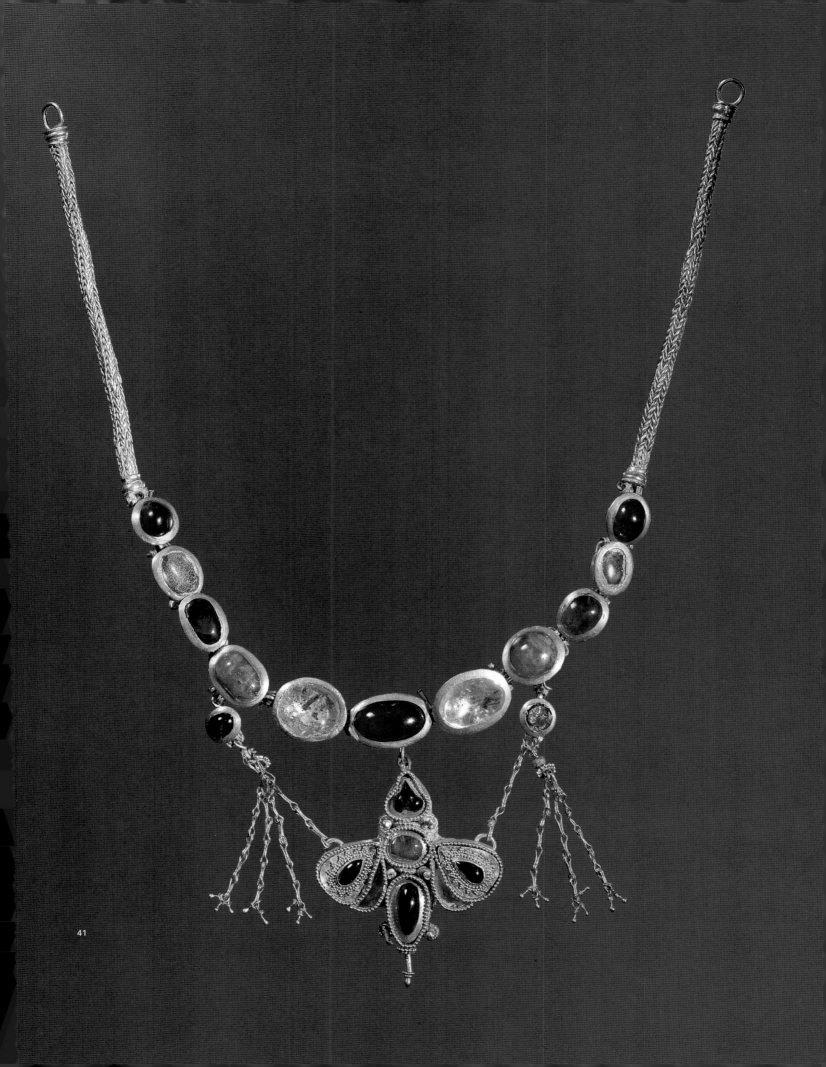

41

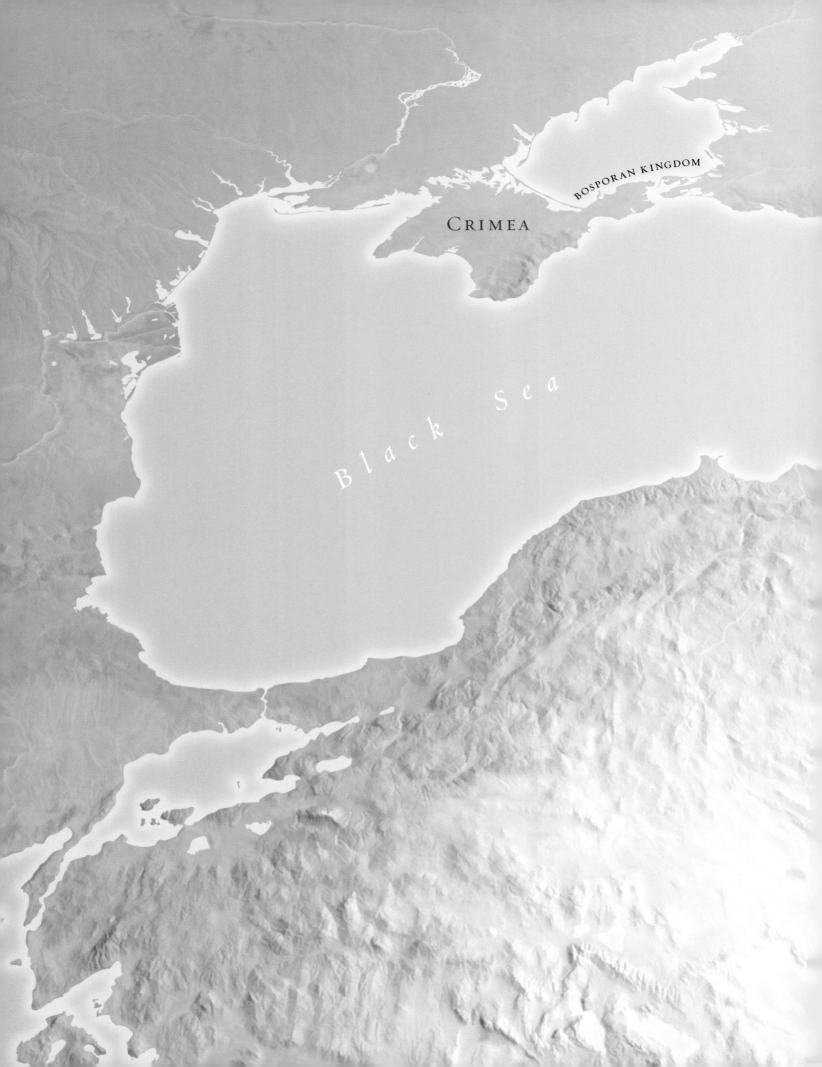

CRIMEA

BOSPORAN KINGDOM

Black Sea

The Bosporan Kingdom

T HE GREEK WORD βοσπορος MEANS "STRAIT" AND FORMED THE BASIS OF the name of the ancient state that occupied extensive territory on both sides of the Kerch Strait, an aquatic isthmus between Euxeinos Pontos and Maeotis (today the Black and Azov Seas). The ancients believed that the strait divided Europe from Asia (see figs. 1.1–3, pp. 2–3). According to ancient sources the predecessors of the Pontic Scythians, the Cimmerians, crossed the strait on the way from contemporary Crimea to Kuban (Hdt. 4.12; Strab. 11.2, 5). For this reason the strait was called the Cimmerian Bosporus, and the powerful state that subsequently emerged on its shores was called the Bosporan kingdom. Over the course of many centuries the achievements of the great civilization of classical antiquity and the unique culture of the barbarians—the farmers and nomads of the forest and open steppes of Eurasia—were tightly intertwined and formed an indissoluble unity in the area commonly known in the nineteenth century as the Southern Russian steppes. In this intertwining of two completely different systems of world perception and understanding, which differed superficially as well as in the most profound sense, arose an original art, known to us principally from the finds in the necropoleis of Pontic colonies, Greek cities settled on the Black Sea coast, and the kurgans of the Graeco-Scythian aristocracy of eastern Crimea, the Taman Peninsula, and the Lower Don and Azov region. The originality of the Graeco-barbarian culture of the Bosporus, which developed and survived for almost a thousand years on one of the most remote fringes of the ancient world, is succinctly and pithily expressed in the term the Bosporan Phenomenon, which has become firmly established in contemporary Russian scholarship. The unique characteristics of this culture have been most completely revealed in the works of the St. Petersburg school of ancient studies (Gaidukevich 1971; *Greek Gold* 2004; Vinogradov 2006). One of the main reasons for this is that the essential resources for the study of the ancient material culture of the northern Black Sea coast in general and the Bosporus in particular have been collected in St. Petersburg. The documents and objects are concentrated in archives and museums, of which the largest is the Hermitage collection of Bosporan antiquities.

In the course of its one-thousand-year history the Bosporan kingdom experienced periods of prosperity and decline, achievement and decay. Two periods were its economic and cultural high watermark—the late fifth to fourth century B.C. and the first two centuries A.D.

Conversely, the Bosporan kingdom experienced a period of trials and tribulations from the third to the first century B.C., when a Bosporan-Scythian confrontation, which had its antecedents in the fourth century, developed after a period of calm. It metamorphosed into a protracted and complex relationship with the Pontic king Mithridates, and ended with the incorporation of the Bosporus into the Pontic kingdom. In later times, the political life of the Bosporus was determined by its dependency on Rome, although it never became a Roman province. The Roman Empire was forced to defer to this distant, politically expedient, and even useful state and to content itself with maintaining an alliance with the kings of the Bosporus.

The Bosporan kingdom was constituted as a unitary state in approximately 480 B.C. under the dynasty of the Archeanactids. The first rulers of the Bosporus were the descendents of Archeanactos, a Milesian who led a group of Greek settlers from Asia Minor in the sixth century B.C. to found the colony of Pantikapaion on the shores of the Cimmerian Bosporus. In time this city became the capital of the kingdom and the most important commercial, economic, and cultural center of the region. The Bosporus was always a major trading partner of the inhabitants of the Scythian steppes and its metropolitan city. From its shores the products of its workshops and imported Greek goods from Athens and Asia Minor—painted earthenware, metalwork, jewelry, and arms—made their way in a north and northwesterly direction to the Scythian steppes. Bosporan traders were middlemen in supplying Athens with grain from the agricultural regions and, later, as trade developed, with fish and local wine.

From the moment of her inception in the fifth century B.C., Athens was interested in the Bosporus as a source of grain and raw materials. This interest became especially heightened after Athens' conclusion of peace with the Persians and Sparta, her unsuccessful attempt to entrench herself in the Egyptian market, and the fall of her political prestige in the Mediterranean world over the course of the Peloponnesian War.

As early as 440 B.C. Perikles, the leader of the Athenian state, even undertook an expedition to the Black Sea coast in order to strengthen commercial ties with the Pontic colonies and to demonstrate the might of the Athenian fleet. In 438/7 the Bosporan kingdom came under the rule of Spartokos, who "took power," as related by Diodoros of Sicily (Diod. 12.31); and from that time on the Bosporus was under the hereditary rule of the Spartocids, a new dynasty of mixed origins. Under the Spartocids the Bosporan kingdom reached the greatest extent of its territory, while its commercial ties with the local tribes and its metropolis were strengthened. In the first half of the fourth century B.C., under King Leukon I, Theodosia, which had for a long time resisted union with the Bosporus, was incorporated into it along with some territories on its Asian side. It is at this time that the special character of the Bosporan kingdom was formed "with its mixed socio-economic structure and original Graeco-barbarian culture, which demonstrably manifested itself in the burials of the Bosporan elite—the famous kurgans of the Cimmerian Bosporus" (Vinogradov 2006, p. 39).

N. J.

Bosporan Necropoleis

The Graeco-barbarian character of the culture of the Bosporus is most evident in the finds from the necropolis of its capital, Pantikapaion. The finest part of the Hermitage collection of Bosporan antiquities, unearthed during excavations of the kurgan necropolis of Pantikapaion, comes from the fourth century B.C. The weapons and armor from the kurgan found on the territory of Mirza Kekuvatsky's estate; the jewelry and ivory carvings from the Kul Oba kurgan, and the magnificent red-figure Attic vessels from the Pavlovsky and other kurgans of the Yuz Oba ridge, excavated in the 1840s and 1850s, provide insight into the character of Greek imported goods to the rich Pontic lands and also into the orientation of the Ionian and Attic artists and craftsmen toward the specificities of the Bosporan market. The most significant artifacts in this regard are the Amazonomachy and gryphomachy scenes on red-figure vases as well as other images depicting barbarians wearing traditional clothing in scenes that are not from Greek mythology but perhaps from indigenous legends and beliefs that were gradually accepted by the Bosporan Greeks. Scenes similar to those on the vessels are also found in highly artistic examples of applied art that were found in the necropoleis of the Taman Peninsula. They include such gold objects as the relief on the kalathos cover from the Great Bliznitsa kurgan or the applied ornaments in the form of battling warriors on a third-century-B.C. wood sarcophagus from the Gorgippia necropolis.

It is significant that along with an abundance of Greek items, the burials also contained objects and tomb construction elements that relate to barbarian traditions and rituals. In the same Kul Oba kurgan, which contained numerous Greek objects of the highest quality, was found a traditional Scythian set of objects for performing funerary rituals: a large bronze cauldron, knives with ivory handles, and many other items. In the necropoleis of the so-called minor cities of the Bosporus, for example, in the kurgans of Nymphaion, were found many bronze plaques and details of horse harnesses executed in Scythian animal style.

Funerary structures from the fourth century B.C. and later did not have as outstanding finds as the large kurgans from the time of the first flourishing of the Bosporan kingdom but they are nevertheless quite varied and no less important for understanding the beliefs of the population and the development of Bosporan art. There were also large sections of the necropolis of Pantikapaion in an extended area of the northern suburb of Kerch, known as Glinishche, and to the east of the city, along the Quarantine road. Excavations have yielded such types of funerary structures as stepped tombs, rock-cut underground tombs with expressive wall paintings (Rostovtsev 1913–14), and modest stone chests and ground tombs covered with slabs. The decoration and execution of vaults from the first century A.D.—the period considered to be the second economic and artistic flourishing of the Bosporan kingdom—are marked by a burst of creative energy on the part of local painters, sculptors, coroplasts, and wood carvers. Throughout the first and second centuries A.D., as well as the first decades of the third century, Bosporan art and culture in general developed under the strong influence and traditions of the local barbarian population. The wall paintings of the Anthesterios vault—built early in the first century and discovered in 1876 on the northern slope of Mount Mithridates, where most of the painted burial chambers were found—exhibit a subtle intertwining of the verisimilitude of life and religious symbolism. The paintings in the Demeter Crypt discovered in Kerch in 1895 present a rough naïveté in style, however they are well thought out, emotional, and convey the

133

THE BOSPORAN KINGDOM

mysterious atmosphere of participating in the sacrament of departing from life. Although they are far removed from the elegiac sentiment of Attic marble funerary reliefs, Bosporan limestone stelai are impressive for their high level of craftsmanship and for the sculptors' ability to transmit "profound psychological meaning" (Davydova 2006, p. 53 footnote).

As time went by, the Bosporus was increasingly beset by problems arising not only from the complexity of its relationship with Rome but also from the activities of pirates who plied the waters of the Pontus and the coastal areas of Asia Minor, with which the Bosporans carried out an intensive trade. As a result, the Bosporus gradually lost its economic power and was, with its surrounding areas, beset by more frequent raids of new nomadic tribes, forcing the kingdom to cede land and once strong political control. Under pressure from an aggregation of tribes, in which the leading role was played by Goths and Huns, the Bosporan kingdom ceased to exist as a part of the ancient oikoumene (settled land) and the leading economic, political, and cultural power in the northeast of the Pontic region.

N.J.

Fig. 9. Nymphaion. Aerial view of the site from the south.

Fig. 10. Nymphaion. South slope of the site plateau. View of the terrace support wall.

Nymphaion

Nymphaion, which was founded in the first half of the sixth century B.C. by Greek colonists from cities in Asia Minor, played an important role in the history of the Bosporan state. Among the cities of the European Bosporus it was next in importance after Pantikapaion, the capital, and Theodosia (figs. 9–10).

The location of Nymphaion has been determined on the basis of information provided by ancient authors. The famous gold earrings in the form of a small figure sitting on Artemis's deer with a torch in its hand (cat. no. 132), discovered in 1866 in one of the famous kurgans, as well as other pieces of jewelry (cat. nos. 131, 133) have focused attention on Nymphaion. The exploration of the territory of the ancient city and its necropolis was first carried out by the Imperial Archaeological Commission in the second half of the nineteenth century. Systematic excavations of the site began in 1939 and were carried out by the archaeological expedition of the State Hermitage Museum.

The fertility of the surrounding area and a good harbor in the city, reported by Strabo (Strab. 8.4), ensured Nymphaion a leading role in the grain trade. Not coincidentally, the cult of Demeter, the patron goddess of farmers, was especially popular, and her shrine, built in the middle of the sixth century B.C., is one of the earliest in the northern Pontic region.

134

Nymphaion flourished from the fifth to the early fourth century B.C., when it maintained its autonomy, minted coins, and carried out an active trade with Athens (see cat. nos. 44, 62, 126, 134) and other cities. Nymphaion differed noticeably from other centers of "Graeco-Scythian tinted culture" (Grach 1985, p. 334; Tolstikov 1984, pp. 41–43). This is clear from the archaeological evidence in the necropolis, which contains a whole group of rich burial mounds with features of barbarian burial rites (Silant'ieva 1959). Of special interest is the presence of accompanying horse burials with richly decorated harnesses, including bronze artifacts executed in animal style (see cat. nos. 127–30).

In the first half of the fourth century B.C., in the period of the military expansion of Pantikapaion against Theodosia, Nymphaion was annexed to the Bosporan kingdom. Despite the destruction suffered by the city, it quickly recovered. The architectural remains from this period testify to an intensive construction program.

Throughout the fourth century B.C. an entrance to the city from the side of the habor was built on the southern slope of the plateau of Nymphaion. An architectural ensemble was created; in the center was a high socle made of rough blocks, and on the sides were steps connecting the terraces. The numerous altars in various parts of the structure make it possible to speak of its cultic character (Grach 1989, p. 68).

One of the main decorative elements of the complex was the propylaion, the main entrance to the sacred area. The graceful Ionian capitals, the bases and column drums, and the details of the cornices make it possible to recreate the graceful appearance of this complex. The inscription, which has been preserved on the facade block of the architrave, testifies that this entrance was dedicated to Dionysos, the god of wine and winemaking.

Later, to the east of the propylaion, a shrine was built to the patron gods of seafaring and sailors. The walls of one of the rooms of the shrine were covered in plaster with polychrome paintings and numerous incised pictures and inscriptions; an earthquake left thousands of fragments of this plaster on the floor. It is only due to the painstaking work of the Hermitage restorers that we are able to admire this unique monument (cat. no. 78). The second flourishing of Nymphaion, as well as that of other Bosporan cities, took place from the first century to the first half of the second century A.D. This was a result of Rome strengthening its position in the northern provinces and in those areas that had only recently recognized the Roman emperors. A large reconstruction was carried out in Nymphaion, preserving the fundamental building principles of the previous periods. The city was involved in extensive commercial activities as witnessed by finds of red-glazed ceramics from Pergamon and glass vessels from the eastern Mediterranean (cat. nos. 88, 90, 91), including Egypt and Syria (cat. no. 87), northern Italy (cat. no. 89), and the Rhine. One of the objects from the first century A.D. is a rare example of miniature glass sculpture: a female head cast from transparent greenish glass (cat. no. 86), bearing a resemblance to the portraits of Livia, the wife of the Roman emperor Augustus. In addition, Nymphaion continued its own production. Besides the pottery workshops, mention should be made of the workshops for the production of plaster and terracotta adornments for the sarcophagi for notable citizens. The original output of these workshops, widely represented among the materials from the excavations of the necropolis of Nymphaion, differs from similar artifacts from Pantikapaion (Jijina 2001). The most popular subjects were painted tragic masks and heads of the Gorgon Medusa (cat. nos. 80, 136, 137).

The second half of the second century and the third century A.D. were times of tribulation in the history of the Bosporus. Economic crisis, reduction of foreign trade, and devastating raids by barbarian tribes resulted in the neglect of the cities and villages of the Bosporus. In the late third century Nymphaion was destroyed by a Gothic incursion, a

135

blow from which it barely recovered. Evidence that life continued in the city in the early fourth century is provided by finds of glass vessels (cat. no. 91) and coins minted by the kings Phophors and Radmsad in the necropolis and in the city itself.

O.S.

BIBLIOGRAPHY: Silant'ieva 1959; Khudiak 1962; Grach 1989; Grach 1999.

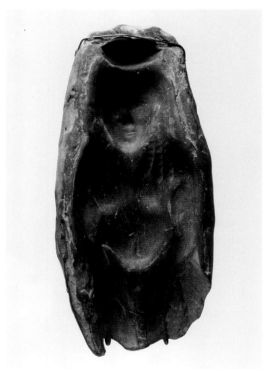

42a

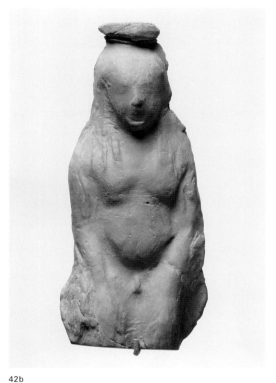

42b

42

Mold and Modern Impression of Plastic Vessel in the Form of a Kneeling Youth

Samos
Second half of sixth century B.C.
H: 14.3 cm; W: 6.5 cm
Clay
Nymphaion, 1941. Near the shrine to Demeter.
 Excavations of M. M. Khudiak
Acquired in 1947
Inv. NF.41.960/1−2

Mold for making a plastic vessel in the form of a kneeling youth, his hands on his knees. His massive features and broad nose are framed by curls falling down to his chest.

O.S.

BIBLIOGRAPHY: Khudiak 1962, pl. 40.2; Tsvetaeva 1966, pl. 17.3; Skudnova 1970, p. 89, no. 43, pl. 34.3.

43

Black-figure Pelike

Attributed to the Eucharides Painter
Attika
Late sixth century B.C.
H: 41.5 cm; Diam (mouth): 17.7 cm;
 Diam (foot): 17.7
Clay
Necropolis of Pantikapaion, 1911.
 Mount Mithridates, between
 House no. 1 and House no. 2.
 Excavations of V. V. Shkorpil
Acquired in 1914
Inv. P.1911.10

The pelike is covered with black glaze.
Both the reserved panels have a three-figure
composition. The panels are bordered at
the top with a band with hanging lotus buds.
The vertical sides of the panels are bordered
by net pattern.

SIDE A. In the middle a nude silenus stands in
profile to left, his hands tied behind his back;
the men on either side of him are holding the
ends of the rope. Behind the silenus is a
panther in profile to right with a frontal head.
The two men flanking the silenus are in left
profile; their faces turned toward him. Both
figures are nude except for a himation over
their shoulders and winged boots. They
each hold two long spears in their right hands.
The beards, headbands, and wings on the
boots are in added red. The details and folds
of the garments on both sides of the pelike
are rendered by incisions. The panel com-
positions, framing decoration, and the types
of figures and faces are characteristic of
the art of the Eucharides Painter, who was
active in Attika from the late sixth century
through the early fifth century B.C. and
who painted vases in both black-figure and
red-figure techniques.

SIDE B. In the middle is a depiction of a
woman in profile to right, enveloped in a
himation from her head to her feet. The face,
feet, and hands are painted in added white.
Behind the woman is a dog in profile to right,
its collar painted red. At the sides of the
woman and facing her are bearded males with

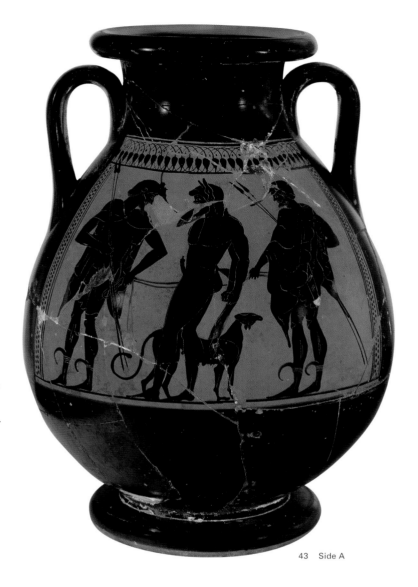

43 Side A

short himations covering their otherwise
nude bodies; on their heads are wreaths and
red headbands, and they hold knotty sticks
in their right hands. Both have red beards.
In the right corner is a folding stool with legs
in the form of animal paws. Three round
elements at the point of intersection of the
legs and at the sides of the seat are drawn
with added white.

A.P.

BIBLIOGRAPHY: *OAK* 1911, pp. 26–27, fig. 42a–b;
Beazley, *ABV*, p. 396, no. 24; Beazley *Para*, p. 173;
LIMC 8 pl. 570, s.v. "Midas," 22; *AK* 31 (1988), pl. 18.4.

137

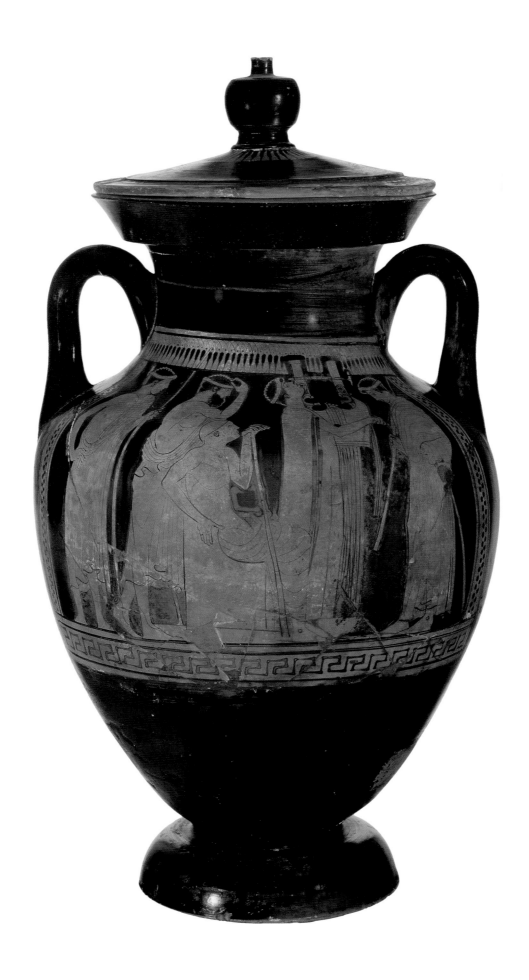

44a Side A

44

Red-figure Amphora Type B with Lid

Attributed to the Leningrad Painter
Attika
480–470 B.C.
H (with lid): 59.5 cm; Diam (mouth): 24 cm;
 Diam (foot): 18 cm
Terracotta
Presumably from the necropolis of Nymphaion.
 From the former collection of A. V. Novikov
Acquired in 1900
Inv. B.2228

The amphora has a prominent mouth, smooth handles round in section, and an echinus foot. The shape is Type B in Beazley's classification. The panels on both sides of the vase are framed by black-figure ornamentation: at the top, hanging lotus buds, at the bottom, a meander, and on the sides, a double net pattern.

SIDE A. Kithara player and audience. In the center, on a cube-shaped armchair with a back (reminiscent in its lines of first-row marble theater chairs intended for honored guests) sits an apparently elderly bald, beardless man wearing a round hat (or, according to a different interpretation, a narrow *taenia*). His right hand leans on the back of the chair while the left rests on a high staff. He is nude from the waist up, with a himation covering his hips and legs. With his head raised and gazing upward he listens intently to the young musician singing and playing in front of him. The singer, dressed in long, smooth garments decorated on the sides with brown ribbons, is singing with his head thrown back in abandon and he plucks the six-stringed kithara, held in his left hand, using a plectrum held tightly in his right hand and tied to the instrument by a red string. The kithara is decorated with carving and a ribbon hanging down from it.

Next to this pair are two youths and a man. They wear himations thrown over the left shoulder, headbands, and they lean on the staffs they hold in their left hands. The youth on the left faces us, his right hand resting on his hip and his head turned toward the singer, whom he listens intently to. The youth on the right rests a staff on his shoulder and faces the singer, his head bowed in deep concentration. The man behind the seated old man wears leather boots. While his eyes are fixed on the singer, he removes his ivy wreath in admiration.

Even though this vase-painter did not possess the outstanding abilities of the great painters and was not a brilliant draftsman, he was able to impart great expressiveness to a common Athenian scene of the fifth century B.C.—that of the musical *agon*. The image seems to be filled with music and wonderful singing that we cannot hear—which enchants not only those who were present at that moment, but also us, in a different world, two and a half millennia later.

SIDE B. Men and youths. Three men standing to right facing a youth standing to left. They all wear fillets around their heads, are dressed in himations thrown over their left shoulders,

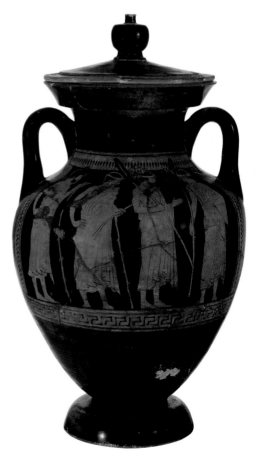

44b Side B

and hold sticks or staves. The man with the long staff in his hand is conversing with the youth in front of him and extends his left hand to him. Two men behind the speaker are present as silent observers. Possibly the man is attempting to convince the youth to sing and play something, which is actually depicted on the other side of the vase. The two men behind holding knotty sticks appear to be silent observers. In addition, the two silent men appear as the predecessors of those himation-wrapped figures who will commonly be placed on the reverse sides of vases beginning in the second century B.C. and continuing to the end of the time of vase-painting. (See, for example, the reverse sides of the pelikai cat. nos. 64–66.)

This vase is from the collection of a Kerch landowner, A. V. Novikov, a passionate collector of ancient vases, who bought them from the so-called lucky bastards (local residents involved in predatory excavations). The items from his collection are undocumented. At best, the place where they were found is known—for example, Eltigen village (ancient Nymphaion), Mount Mithridates (ancient Pantikapaion, now Kerch), and Glinishche (in the vicinity of Kerch). It can be assumed that this vase, assembled from many fragments, was probably found in one of the collapsed tombs of the Nymphaion necropolis.

The vase-painter was identified by J. D. Beazley (Beazley ARV², pp. 567, 571), who named him after the city where the vase was kept. He belongs to the early painters of a group of so-called Mannerists, whose work was distinguished by certain archaic tendencies. Our painter was in the constellation of the most brilliant representatives of this group; he had an apparent inclination to paint large vessels.

L. U.

BIBLIOGRAPHY: Richter 1946, p. 96; Beazley ARV², p. 570, no. 70; Peredol'skaya 1967, no. 95, pp. 95–96, pl. 71; Greek Vase-Painting 1979, pp. 169, 171; Nymphaion 1999, p. 38, cat. 52, p. 37 illus.; Nymphea 2002, n. 18.

45a Side A

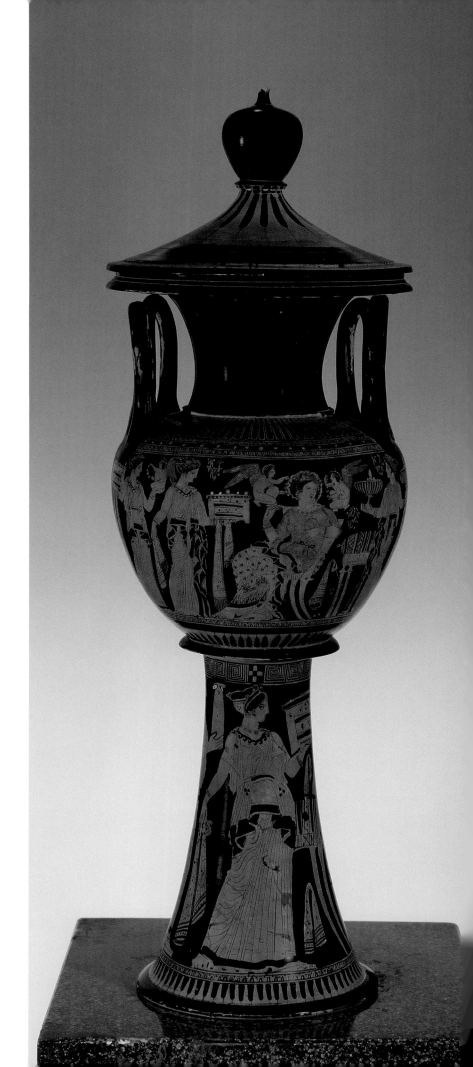

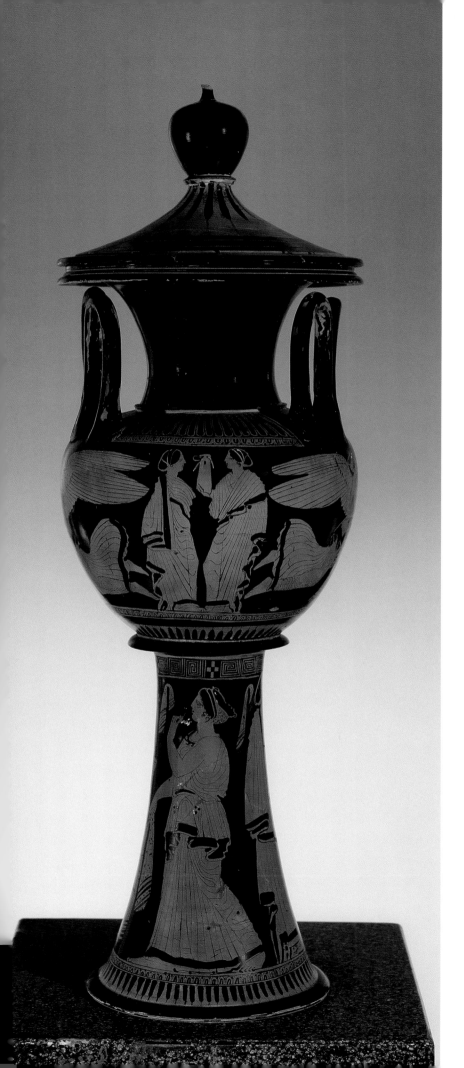

Red-figure Lebes Gamikos with Lid

Attributed to the Painter of Louvre c 11202
Attika
About 410 B.C.
H (with stand and lid): 74 cm
Terracotta
Outskirts of Kerch, 1837. Kurgan on the
 territory of the Kekuvatsky Mirza. Stone
 burial chamber. Excavations of A. B. Ashik
Inv. II.1837.4

The lid with a black egg-shaped knob is decorated with a reserved band on which are drawn long black petals. Around the body, completely covering it and continuing under the handles, is a multifigured composition depicting wedding preparations.

SIDE A. In the middle a woman is seated on a chair facing left in three-quarter view. On either side of her a small Erote hovers above her shoulders, placing a garland on her head. In front of the seated woman are two standing women in left profile holding small chests. Behind the seated woman is a stool with a multicolored cushion and a standing woman in left profile with two incense burners in her hands. The seated woman is twice as large as the others; her scale and location define her as the main character in the scene.

SIDE B. In the middle two women face each other. The one on the right is holding an alabastron in her right hand. To the sides large winged female figures flying in opposite directions (twice as large as the standing figures) hold alabastra with ribbons. On the upper and lower part of the lebes, as if framing the field with figurative depictions, there is a band of ova and another of petals. Around the upper part of the stand is a broad band of meander broken with checkerboard squares.

45b Side B

The entire middle part of the stand is taken up by greatly elongated female figures: the standing woman on side A holds a small chest in her left hand and an alabastron in her right hand; in front of her is a chair in left profile. The walking woman on side B holds a ribbon in her right hand and raises a flower to her face with her left. At the bottom of the stand are two bands, one with ova and one with petals.

The subtle drawing, executed with black and diluted gloss on the body and stand of the lebes, is complemented by many relief details (made with added clay) that are gilded (the jewelry, headbands, and wings of the Erotes), which endows the painting with a special elegance and festive quality. On the basis of a stylistic analysis the lebes was attributed by Beazley to the Painter of Louvre C 11202, who in his work continued the tradition of the Meidias Painter—one of the most outstanding Attic vase-painters of the last quarter of the fifth century B.C., whose work is characterized by the graceful and fluid line of the drawing and by an abundance of gilding and details made with added clay.

A.P.

BIBLIOGRAPHY: *ABC* 1892, XLIX; Schefold 1930, pl. 3a; Beazley *ARV*[2], p. 1332, no. 1; Beazley *Para*, p. 480; Beazley *Add*[2], p. 365; *JdI* 100 (1985), pp. 142–43, fig. 35c; *Great Art* 1994, pp. 304–5, no. 290; *Greek Gold* 2004, fig. 54.

46

Red-figure Mug

Attributed to the Painter of the Leningrad
 Herm-mug (name piece)
Attika
460–450 B.C.
H: 9.6 cm; Diam (rim): 8.3 cm;
 Diam (foot): 6.3 cm
Terracotta
Necropolis of Pantikapaion, 1898. Mount
 Mithridates. Excavations of K. E. Dumberg
Acquired in 1900
Inv. P.1898.42

Small vessel with body swelling slightly toward the bottom in smooth contours. The rim is slightly everted, the handle is flat, the foot is short, flaring toward the bottom. In the center of the body is a bearded man in right profile, with outstretched hands, standing in front of an altar; he wears a himation and there is a fillet on his head. In his right hand he holds a kylix, which he uses to pour a libation on a burning altar. The upper part of the altar is decorated with volute-like scrolls and bands with ova under them; the flames on the altar are painted red. Well behind the man is a palm tree. (A painting between the man and the palm has been lost.) In front of the palm is what appears to be a stone. To the right of the altar is a tall herm, topped by a bearded head wearing a fillet. On the lower part of the herm is a large erect phallus. The figures stand on a thin reserved groundline. The underside of the foot is reserved, with a small black circle with a dot in the center and next to the outer edge a black circle.

A.P.

BIBLIOGRAPHY: *CR* 1898, p. 18; Beazley *ARV*[2], p. 311, no. 2.

46

47

Fragment of a Tomb Relief with Head of a Youth

Attika
Mid-fifth century B.C.
H: 65 cm; W: 54 cm; D: 15 cm
Marble
Found in Kerch in 1848
Acquired in 1851
Inv. PAN.748

Fragment of a gravestone, surmounted by a pediment. Judging by the scale of the pediment and the figure, the slab was probably 1.10 to 1.20 meters wide, while its height could have reached 2 meters. The relief probably depicted a scene in a palaistra consisting of two figures—a young athlete and a boy in the lower left part of the slab. Only this upper part of the figure of the youth, whose head inclines toward his right shoulder, has been preserved. The execution of the sculpted relief testifies to the sculptor's high level of artistry. The fluid lines of the contours of the head and soft modeling of the cheeks and chin contrast with the sharp delineation of the musculature and shoulders, shown in three-quarter view. The depiction is marked by a peaceful and tranquil mood.

N. L. Grach has convincingly associated this monument with a group of Attic stelai of the middle of the fifth century B.C. This is a rare example of an original Classical Greek sculpture from the Bosporan kingdom.

L.D.

BIBLIOGRAPHY: Grach 1972, V.XIII, pp. 56–61; Saverkina 1986, p. 150, no. 65; Davydova 1990, p. 27, no. 10; *Schatzkammern* 1993, pp. 162–63, no. 79.

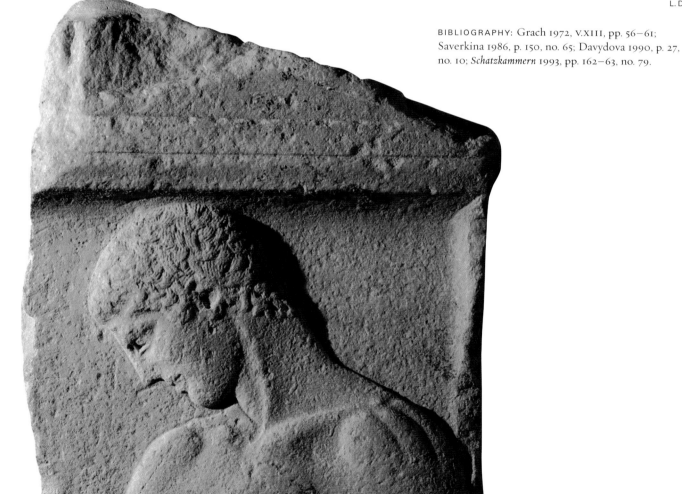

47

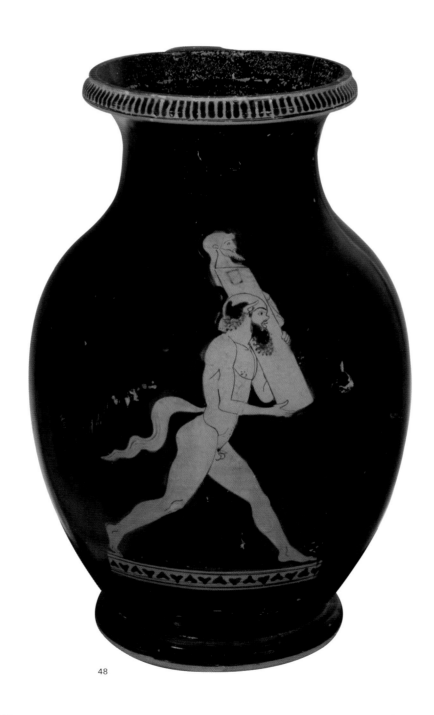

48

48

Red-figure Olpe

Attika
Second half of the fifth century B.C.
H: 27.1 cm; Diam (mouth): 12.5 cm;
 Diam (foot): 11.7 cm
Terracotta
Necropolis of Pantikapaion, 1873. Kerch,
 Mount Mithridates, in the northwestern
 part of kurgan no. XL. Excavations
 of A. E. Liutsenko
Acquired in 1873
Inv. P.1873.132

The overhanging lip is decorated with a band
of vertical black stripes. The center of the
body is taken up by a depiction of a silenus
running to the right. He carries a Dionysian
herm on his left shoulder, supporting it from
below with his right hand. His legs take a
long stride on a groundline formed by a short
reserved band ornamented with black ivy
leaves that alternate in an up-and-down
direction. Similar figures seemingly placed on
a pedestal recall Greek three-dimensional
sculpture.

A. P.

BIBLIOGRAPHY: CR 1874, pl. 2.1–2; Knipovich 1955a,
p. 364, fig. 8b; LIMC 5, s.v. "Hermes," p. 305, no. 173;
LIMC 8, s.v. "silenoi," p. 1122, no. 127a.

49

Ring with an Engraved Scaraboid

Signed by Dexamenos
Middle–second half of the fifth century B.C.
1.8 × 1.3 cm (scaraboid)
Jasper, gold
Phanagoria
Acquired in 1864
Inv. T.1864.2

Scaraboid. Standing heron and locust. Signed:
[work of] Dexamenos.

O. N.

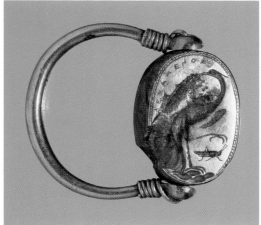

49a 2:1

49b

BIBLIOGRAPHY: *OAK* 1865, p. 95, pl. III; Furtwängler 1900, p. 137, fig. 94; Maximova 1926, p. 42; Boardman 1970, pl. 469; Neverov 1973, pp. 54, 55, fig. 6.

50

Ring with an Engraved Scaraboid

Attributed to the workshop of Dexamenos
Middle–second half of the fifth century B.C.
2.2 × 1.7 cm (scaraboid)
Jasper, gold
Necropolis of Pantikapaion, 1850
Acquired in 1851
Inv. P.1850.31

Chian amphora.

O. N.

BIBLIOGRAPHY: Maximova 1926, p. 43; Boardman 1969, fig. 27; Boardman 1970, pl. 470; Neverov 1973, p. 54, fig. on p. 57 no. 2.

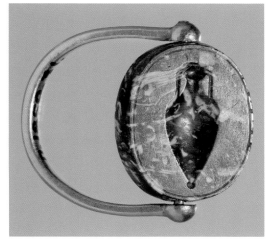

50a 2:1

50b

51

Ring with an Engraved Scaraboid

Attributed to the workshop of Dexamenos
Middle–second half of the fifth century B.C.
2.3 × 1.8 cm (scaraboid)
Discolored stone, gold
Suburbs of Kerch, 1869. Temir-Gora kurgan.
 Cremation burial chamber no. 4. Excavations
 of P. I. Khitsunov
Acquired in 1869
Inv. TG.8

Seated musician with harp (*trigonon*).

O. N.

BIBLIOGRAPHY: *CR* 1870–71, pl. VI; Furtwängler 1900, p. 144, fig. 102 ("Orpheus"); Maximova 1926, p. 45, pl. II.4; Vollenweider 1969, p. 120, fig. 5 ("Herakles"); Boardman 1970, no. 600; Neverov 1973, p. 58, fig. on p. 57, no. 4.

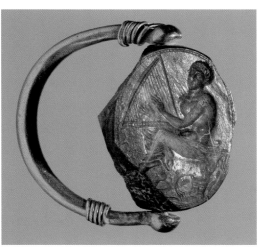

51a 2:1

51b

145

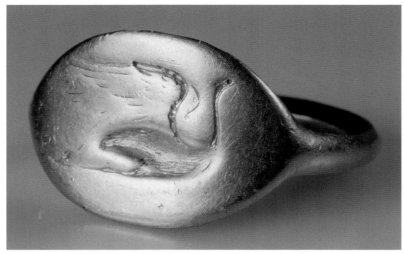

52 3:1

52

Ring

Attributed to the workshop of Dexamenos
Middle–second half of the fifth century B.C.
2 × 1.3 cm
Gold
Necropolis of Pantikapaion. Excavations of
 A. B. Ashik
Acquired in 1842
Inv. P.1841/42.23

Flying heron.

O. N.

BIBLIOGRAPHY: Maximova 1926, p. 44; Neverov 1973, pp. 58–59, fig. on p. 58 no. 2.

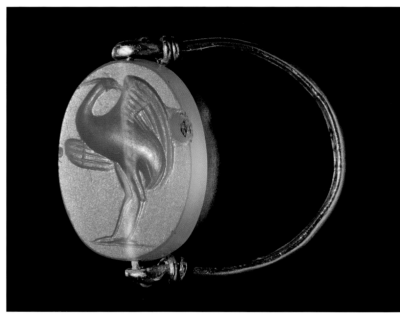

53a 3:1

53b

53

Ring with an Engraved Scaraboid

Attributed to the workshop of Dexamenos
Middle–second half of the fifth century B.C.
1.8 × 1.3 cm (scaraboid)
Chalcedony, gold
Necropolis of Theodosia, 1853. First kurgan
 beyond the Quarantine. Excavations of
 I. K. Aivasovskii
Acquired in 1853
Inv. F.12

Standing heron.

O. N.

BIBLIOGRAPHY: Neverov 1973, p. 59, fig. on p. 58 no. 6.

Necropolis of Pantikapaion. Slab tomb (cat. nos. 54–57)

This tomb was discovered by A. E. Liutsenko in 1854 on the northern slope of Mount Mithridates, by the rocky hill above the Tatar settlement (*sloboda*). The kurgan had been excavated ten years earlier by A. B. Ashik, who stopped 71 centimeters above the roof of the tomb.

The tomb was located in the center of the kurgan, on natural ground at a depth of 3.2 meters from the surface of the kurgan. It was 2.31 meters long; the width and depth were 1.42 meters. Almost its entire space was taken up by a sarcophagus with a gabled roof made of cypress wood. A woman's body lay on the bottom of the sarcophagus, covered with fabric and in a layer of oak bark. The wood sarcophagus rested on a stone slab.

The following items were found with the remains: one pair of spiral-shaped pendants (similar to cat. no. 70); two necklaces (including cat. no. 57); a pair of bracelets (one of them cat. 56); two gold rings (cat. nos. 54, 55); and a scaraboid made of rock crystal with a depiction of a griffin. Also found near the remains were two small round boxes of braided hemp, one of which contained up to ten copper pins; a painted bark box; a brass rod; a wooden comb; a palm-wood spindle; fragments of alabaster; and pieces of violet cloth.

Y.K.

BIBLIOGRAPHY: The Hermitage Archives. Inventory of 1852, file no. 30, sheets 97–100; *ABC*, pp. 137–38; Sokolskii' 1969, pp. 1–42 (no. 38); Sokolskii' 1971, pp. 139, 219, 253; *Greek Gold* 1994, p. 152.

54

Ring with Image of Penelope in Relief

Eastern Mediterranean
Mid-fifth century B.C.
L (bezel): 2.3 cm
Gold
Necropolis of Pantikapaion, 1854. Kerch.
 Northern slope of Mount Mithridates.
 Slab tomb
Acquired in 1855
Inv. P.1854.25

Decorative ring made from a twisted rod of gold with a narrow, leaf-shaped bezel decorated with filigree on the reverse side. Embossed relief image on the obverse: woman seated on a chair, legs crossed, her elbow resting on her knee, while her hand supports a sadly inclined head.

This "grieving Penelope" type is known in the plastic arts. A ring in a New York collection has the name Penelope added to it (Boardman 1970, p. 428). A very widespread subject, often repeated, it served as a symbol of conjugal faithfulness. A similar ring was found in one of the tombs in the vicinity of Pantikapaion (State Hermitage Museum inv. P.1842.110).

O. N.

BIBLIOGRAPHY: Maximova 1926, p. 43; Furtwängler 1900, pl. X.20; Neverov 1986, p. 22; *LIMC* 7, s.v. "Penelope," p. 292, no. 8a; *Greek Gold* 1994, p. 158, no. 98; *Zwei Gesichter* 1997, p. 143, no. 54; *Greek Gold* 2004, p. 86.

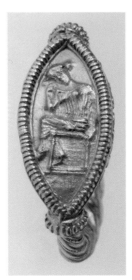

54 2:1

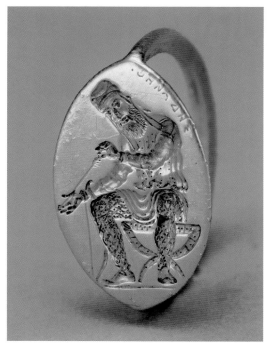

55 3:1

Archaeologists who published this ring were inclined to see the character as a Scythian. It appears that in Scythian art there were also themes involving a hero with an arrow. An Etruscan scaraboid (Hermitage inv. ZH701) has a similar figure accompanied by the inscription "Scythian."

<div style="text-align: right">O. N.</div>

BIBLIOGRAPHY: *ABC* 1892, p. 137; Furtwängler 1900, pl. X.27; Maximova 1956, p. 193, fig. 3; Neverov 1968, p. 19, pl. I.4; Boardman 1970, p. 220, pl. 681; *Greek Gold* 1994, no. 97; *Zwei Gesichter* 1997, no. 56; *Greek Gold* 2004, fig. 23, pp. 51, 86.

55

Ring with Image of a Seated Persian in Intaglio

Signed by Athenades
Asia Minor
Second half of the fifth century B.C.
L (bezel): 2.3 cm
Gold
Necropolis of Pantikapaion, 1854. Slab tomb
Acquired in 1854
Inv. P.1854.26

The hoop is three-faceted in cross-section. On the oval bezel of the ring is a carving of a frontal Persian warrior sitting on a folding chair; a bow stands beside his knee; he holds an arrow and is testing its tip. He wears a soft felt cap and a girded tunic with sleeves, embroidered pants, and soft leather boots. Above his shoulder, along the edge of the bezel is the signature of the jeweler: ΑΘΗΝΑΔΗΣ. M. I. Maximova, after comparing this ring of Athenades to similar images, suggested that this image was based on a statue in one of the cities of the southern Black Sea coast, possibly Sinope or Amisus (modern Samsun) (Maximova 1956, p. 193).

56

Bracelet with Open Terminals (One of a Pair)

Late fifth–early fourth century B.C.
W: 8.3 cm
Gold, silver
Necropolis of Pantikapaion, 1854. Slab tomb
Acquired in 1855
Inv. P.1854.28

The bracelet is made of a massive silver rod with gold terminals in the form of lions' heads, fastened to the ends of the rod by gold collars decorated with filigree. Each lion's head is soldered together from two stamped halves. The details of the relief have been completed on the exterior through embossing. The tongues and teeth were fashioned separately and soldered onto the finished item. Remains of gilding, in the form of sharp-cornered festoons, are noticeable on the silver hoops of the collars.

<div style="text-align: right">Y. K.</div>

BIBLIOGRAPHY: *ABC* 1892, p. 138; Deppert-Lippitz 1985, p. 158-b, fig. 111; Pfrommer 1990, pp. 101, 105, pl. 17.3; *Greek Gold* 1994, no. 96; *Zwei Gesichter* 1997, no. 53; *Greek Gold* 2004, fig. 35.

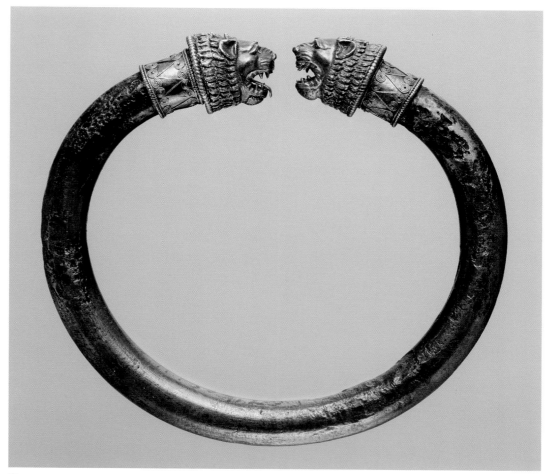

56a

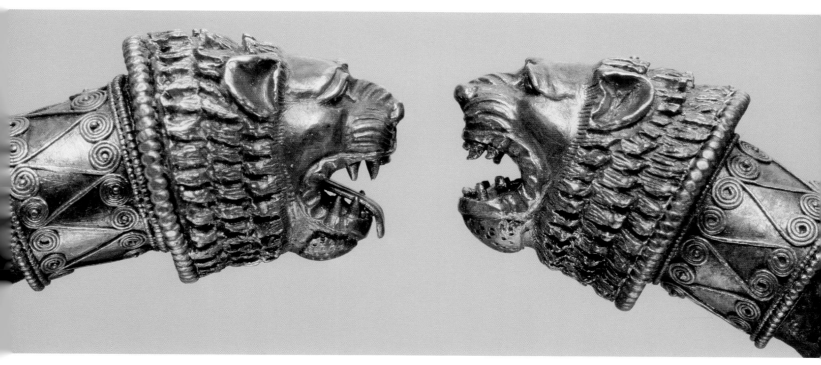

56b

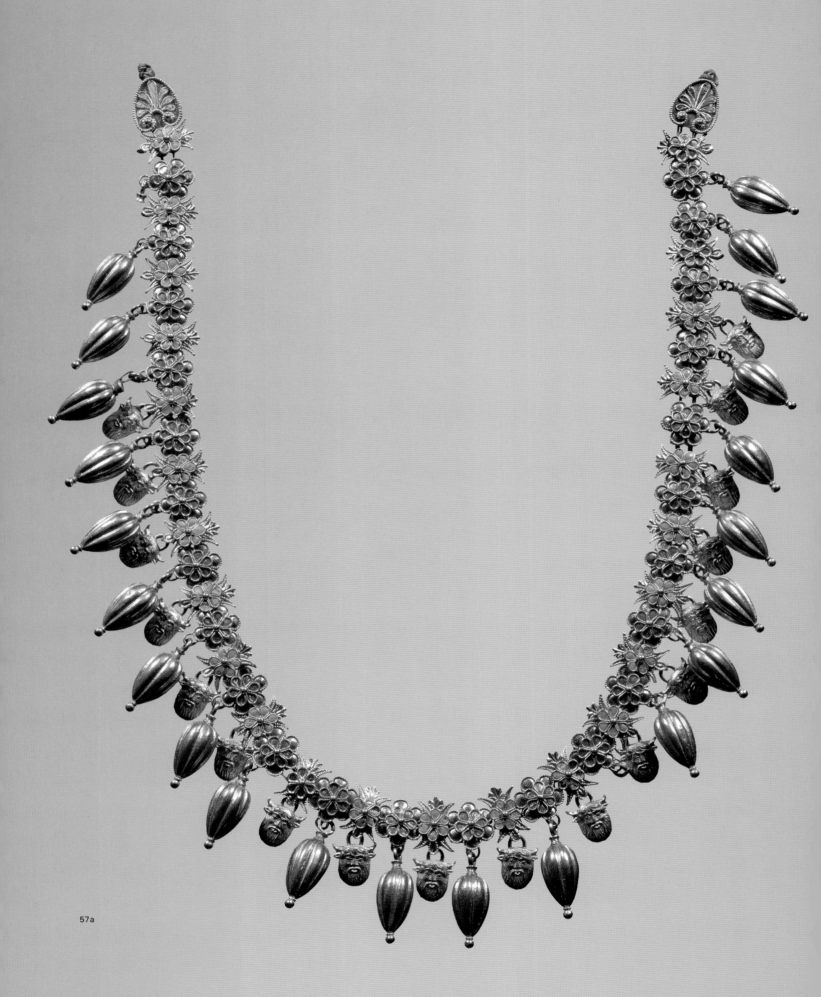

57a

57

Necklace of Filigree Beads with Pendants

Early fourth century B.C.
L: 26.5 cm; Weight: 46.63 g
Gold, enamel
Necropolis of Pantikapaion, 1854. Slab tomb
Acquired in 1855
Inv. P.1855.22

This necklace is composed of two types of links. One consists of double filigree rosettes with stylized graniform pendants; these alternate with rosettes superimposed on double-lotus flowers, to which are attached die-stamped pendants in the form of masks of Acheloös. The filigree is made of plain and beaded wire. The blossoms of the rosettes on the lotuses are filled with light blue enamel.

The complex design of two alternating types of links gives the necklace an exquisite elegance. Some of the elements of the necklace may have had symbolic meaning: grains apparently were considered an allusion to fertility and prosperity. The river god Acheloös, whose mask was frequently used as a decorative element (for example, on plaques from the Seven Brothers kurgan, see cat. no. 112), was perhaps also considered a source of wealth. According to Ovid, his horn, which was broken off by Herakles during their fight for the hand of Deianeira, was filled by Naiads with fruits and flowers and turned into the cornucopia.

Y.K.

BIBLIOGRAPHY: *ABC* 1892, p. 137; *Greek Gold* 1994, no. 94; *Greek Gold* 2004, fig. 16.

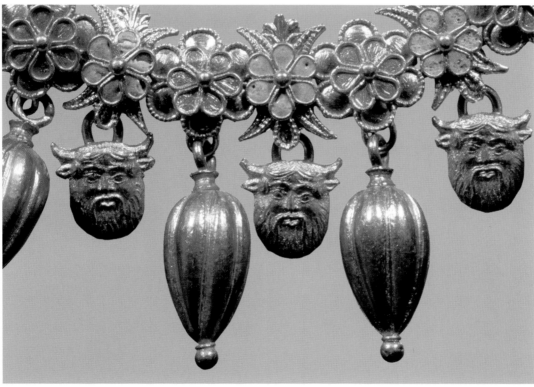

57b

58

Statuette of Demeter Carrying Kore on Her Shoulder

Attika
Late fifth–early fourth century B.C.
H: 20.5 cm; W (maximum): 7.7 cm;
 base 5.5 × 4.4 cm
Terracotta
Necropolis of Pantikapaion, 1875.
 Child's grave no. 4. Found together
 with cat. no. 59
Acquired in 1875
Inv. P.1875.429

Standing on a plinth, Demeter is holding a girl, Persephone/Kore, who sits on her shoulder. Kore's right hand is resting on the head of her mother, Demeter, who is holding the girl with her upraised right hand. With her left hand Demeter is embracing and holding the legs of her daughter. Demeter's and Persephone's himations are covering their legs and the lower parts of their bodies. The end of the himation is thrown over the left shoulder. Demeter has straight, short hair. Persephone has a kalathos on her head, and her hair falls in curls onto her shoulders. The hair of both is colored red. The back of the statuette is flat, with a rectangular opening that served as a vent during firing.

N.K.

BIBLIOGRAPHY: Silant'ieva 1974, p. 17, no. 27, pl. 5.3; *Antichna'ia koroplastika* 1976, cat. 80.

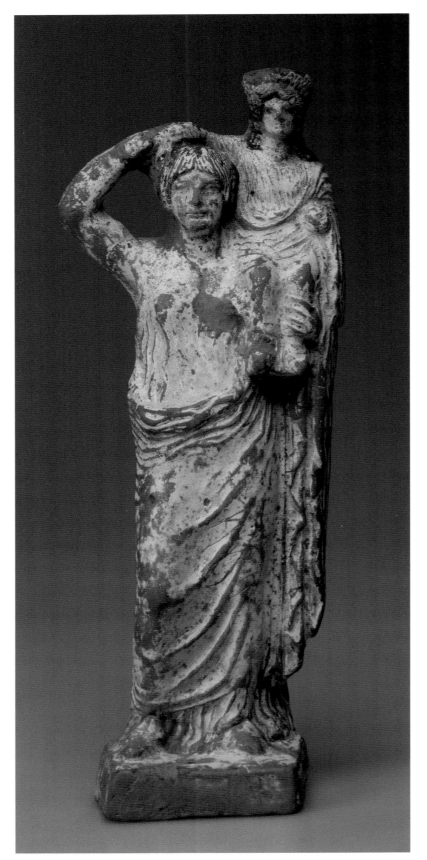

58

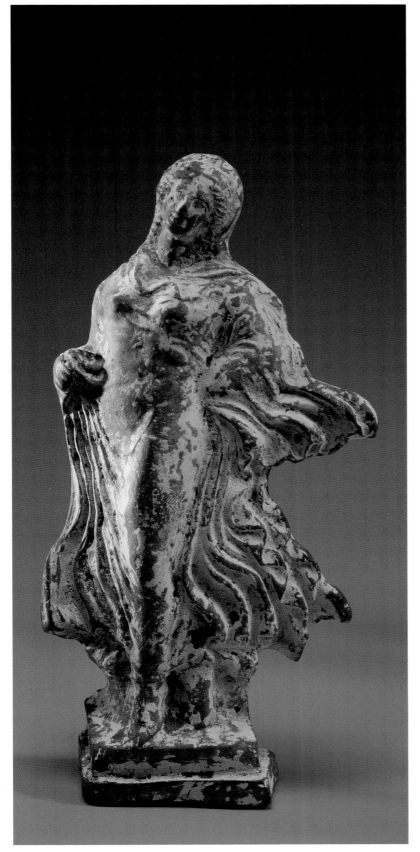

59

Statuette of a Dancing Young Woman

Pantikapaion (?)
Second quarter of the fourth century B.C.
H: 17.5 cm; W: max. 8.8 cm; base: 5.5 × 4 cm
Terracotta
Necropolis of Pantikapaion, 1875.
 Child's grave no. 4. Found together
 with cat. no. 58
Acquired in 1875
Inv. P.1875.428

Figure of a female dancer fashioned in the Attic manner. Her head is slightly tilted toward her left shoulder. The face is framed by hair coming down to the shoulders, and she wears round earrings. She is enveloped from her head to her ankles in a himation, whose end is thrown over her left shoulder. It billows out and back to create the impression of swift movement and reveals the contours of her slender figure. She holds the folds of the himation with her right hand, while her left hand rests on her waist, also supporting the fabric. The body is turned to the left, with the left foot placed forward. Under the hem of the himation the feet of the dancer rising up on her toes can be seen. Under the feet there is a stepped rectangular base. The reverse side of the statuette is flat with a rectangular vent hole.

N.K.

BIBLIOGRAPHY: Silant'ieva 1974, p. 18, no. 35, pl. 8.1; *Antichna'ia koroplastika* 1976, cat. 100; *Muzy i maski* 2005, cat. 107.

59

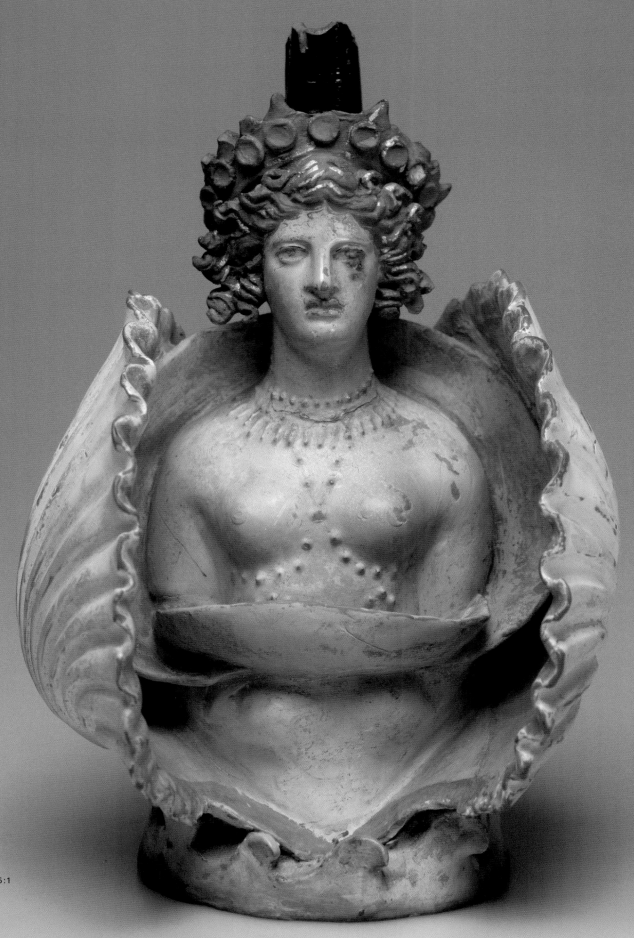

60

Plastic Vase: Aphrodite in a Seashell

Attika
First quarter of the fourth century B.C.
H: 16.9 cm
Terracotta
Taman Peninsula. Excavations
 of Baron V. G. Tiesenhausen
Acquired in 1869
Inv. FA.1869.9

Plastic vase in the form of Aphrodite in a
seashell with sumptuous polychrome paint-
ing. Its form combines a perfume vessel—
a lekythos—and a statuette. The goddess
of love and beauty was born out of the foam
of the sea and arrived in a seashell, on the
island of Kythera, where the first temple was
raised in her honor. The beautiful tender
pink body of the goddess is coming out of
the mother-of-pearl interior of the opened
shell. The opulent headdress, gold necklace,
and earrings impart majesty and solemnity
to the image.

<div align="right">E. V.</div>

BIBLIOGRAPHY: *CR* 1870–71, pp. 11ff., pls. 1, 3, 4;
Winter 1903, p. 203 n. 3; Sokolov 1973, p. 58, no. 43;
Gorbunova and Saverkina 1975, cat. 58; *Antichna'ia
koroplastika* 1976, p. 30, cat. 86; *LIMC* 2, s.v. "Aphro-
dite," p. 109, no. 1083; *Great Art* 1994, p. 315, no. 299.

61

Plastic Vase: Winged Goddess with Krotala

Attika
First half of the fourth century B.C.
H: 22.8 cm
Terracotta
Taman Peninsula. Kurgan no. X,
 stone burial chamber no. 2.
 Excavations of K. R. Begichev
Acquired in 1852
Inv. T.1852.50

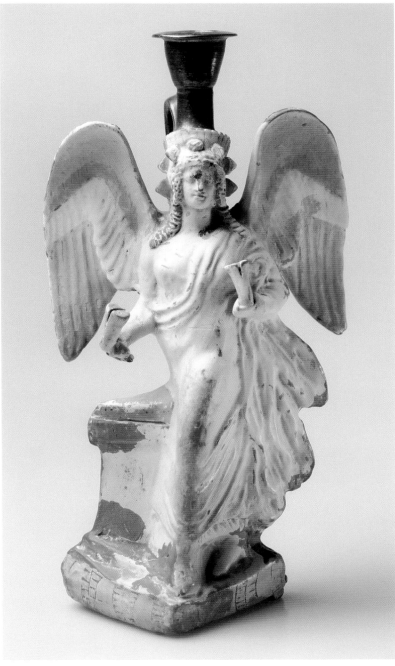

61

Plastic statuette-lekythos in the form of
a winged goddess with krotala in her hands.
The black neck and mouth of the lekythos
rises above the head of the goddess. The head,
with heavy tresses, a garland, and kalathos is
turned slightly upward. The goddess, her
garments billowing and her bluish-gray wings
spread, is shown as if she has just come down
from the heavens to perform a ritual act at the

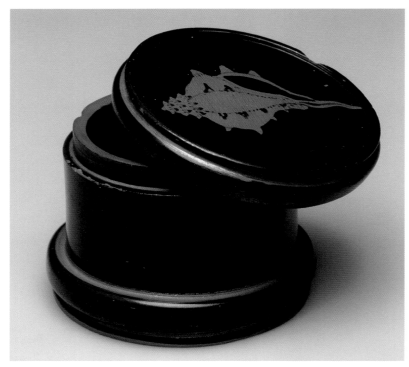

62a

62b

altar on her right. The figure of the goddess and the altar are on a low base. The painting is executed with pastel colors.

E.V.

BIBLIOGRAPHY: Winter 1903, pp. 141.6, 185.6; Μουσειο 'Ερμιταζ 1980, nos. 82–83, p. 17; *Great Art* 1994, p. 315, no. 300.

62

Red-figure Pyxis

Attributed to the potter Mavrionos
Attika
Early fourth century B.C.
H: 5.5 cm; Diam: 6.5 cm
Terracotta
Necropolis of Nymphaion, 1977. Burial A-135.
 Excavations of N. L. Grach
Acquired in 1980
Inv. NNF.77.18

Red-figure cylindrical pyxis of Type D: a small toiletry box with an embossed foot that repeats the form of the lid. The lids of these pyxides were usually decorated with an image of an object, figure, head, or animal. On the surface of this pyxis there is a depiction of a shell—*Bolinus brandaris*—from which purple dye was extracted (on the type of shell, see Delorme 1987, pp. 25, 100, pl. 4)

On the exterior of the box and on the interior of the lid is the mark of a name: M (M), which makes it possible to attribute this pyxis to Mavrionos. (Compare a similar mark on a vessel from Olynthus: *Excavations at Olynthus*, vol. 5, n. 201.)

L.U.

BIBLIOGRAPHY: *Nymphaion* 1999, p. 59, cat. 70, p. 43 illus.; *Nymphea* 2002, n. 34.

63

Red-figure Hydria: Amazonomachy

Attributed to the Workshop of the
 Amazon Painter
Attika
Third quarter of the fourth century B.C.
H: 45.6 cm; Diam (body): 24.4 cm
Terracotta, paint, gilding
Necropolis of Pantikapaion, 1841. Stone-slab
 burial chamber on the Quarantine road.
Excavations of A. B. Ashik
Acquired in 1841
Inv. P.1841.4

Attic red-figure hydria with polychrome painting and gilding. The overhanging lip is reserved. On the top are traces of reddish engobe or paint. The bent vertical edge is decorated with a band of black ova. In the middle of each ovum the vase-painter has applied (only on the obverse and sides of the vessel) thick drops of brown paint covered with gilding, thereby creating an additional decorative effect. At the bottom of the panel is another band of ova with open centers outlined by a line of black, in which the ova alternate with applied dots. The elongated rather narrow neck is adorned, as if with a necklace, by a thin olive branch in added clay covered with gilding, which is only partially preserved. The ends of the branches on the reverse side of the vessel, under the vertical handle, are not closed. The body is egg-shaped; horizontal side handles (round in section) are curved and raised. The embossed foot is separated from the body by a reserved fillet. The vertical edge of the foot is likewise reserved, and as on the mouth, there are traces of red engobe or paint. On the under-side of the foot, applied in dark gray color and in large letters, is a dipinto: ΘΕΔ.

On the front is a depiction of an Amazonomachy. The central part of the dynamic multifigured composition is taken up by the figures of two Amazons dressed in short garments and close-fitting trousers tucked into high boots. Each Amazon wears an *alopekis*—a soft hat with long fringes tied in the back. One of the female warriors has been thrown to the ground and has dropped her

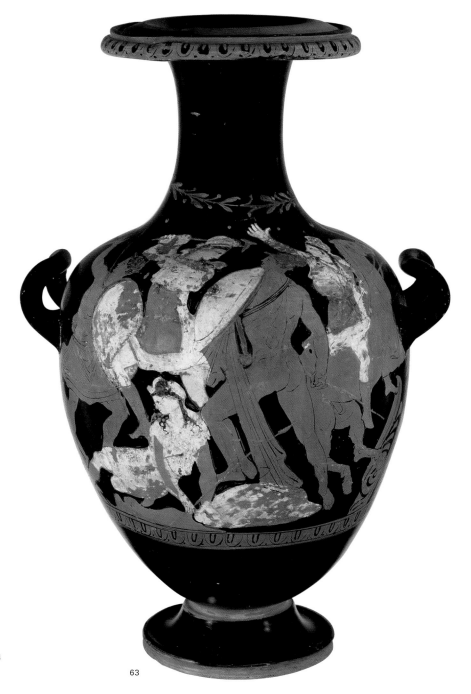

63

157

shield, while continuing to hold her spear in her right hand. She leans on her left hand, semirecumbent between the figures of two Greek warriors and her companion, who continues to fight. Under the figure of the fallen Amazon is a reserved area, denoting a hill with a rough surface. On the shield, seen next to the hill, numerous white and dark spots have been preserved.

The standing warlike Amazon above the head of the previous one is dressed like her fallen partner, in white garments; she also wears an "apron" on which traces of light blue color can be seen. The battling Amazon is shown stridently sallying forth in a complex pivotal movement: with both hands she is holding an axe with a long gilded handle, aiming the blow at the nude warrior with the shield, who is attacking her from the right. He is shown from the back, with his left leg bent at the knee and the right leg set far back. He holds a spear in his right hand and on his left arm is a white shield, held up to protect himself from his enemy. There is gilding on the warrior's helmet, the border of his shield, and the shield's main decorative device (*episemos*), which probably depicts the Gorgon Medusa. The sheath of the sword, hanging from a strap shown across his right shoulder, jutting out from behind the shield, is also gilded. The strap is rendered by several thin lines of black. From underneath the shield the warrior's himation, which is draped around his arm, flows to the ground.

The second warrior, approaching the Amazon from the left, wears a short tunic with a deep neckline that leaves his chest exposed. In his left hand he holds a round white shield with a gold border. Like his comrade, he is depicted with his left leg bent at the knee and the right leg set back. The head of the warrior is depicted in profile inasmuch as he has turned, his right hand raised as if asking for support. Instead of a helmet, he wears a wreath with traces of gilding.

The figure at the extreme right is an Amazon astride a horse, which is galloping to right at full speed. Her head is turned back; her right hand is raised in the same exhortational gesture as that of the warrior wearing the gold wreath. She wears a gold bracelet on her wrist; traces of gilding have been pre-served on the reins and the bridle of her horse. Unlike the other two Amazons, who are dressed in white garments, this horse-woman is dressed in a Scythian-style green coat, tightly closed and girded with a gold strap. Green color is preserved on the lap of the coat, and gilding has been preserved on the belt and the buckles of the high boot. The faces and hands of the Amazons are painted in added white, while the features of the faces and the curly tresses are rendered with dilute and thick black glaze. Several details are executed in brown color.

The reverse and sides of the hydria are completely covered by a design consisting of twelve large red-figured palmettes. The proportions of the vessel, the outlines of the forms, the use of gilding and colors, as well as the general artistic solutions make this work very close to works by the artists of the polychrome style of Late Classical vase-painting—for example, Xenophantos (Peredol'skaya 1945). At the same time, the composition and style of the vessel are also thematically close to the Kerch-style pelikai (Shtal 2000, cat. 81, 86, pp. 54, 57; Scott and Taniguchi 2002, figs. 1–2, pls. 46–47).

N. J.

BIBLIOGRAPHY: Ashik 1848–49, vol. 3, p. 13; *ABC* 1892, pl. 51; *ARV*² , p. 1480, no. 36; *Antichnost' v Peterburge* 1993, p. 95 illus., p. 96, cat. 110.

64

Red-figure Pelike: Eros and Maenad

Attributed to Group G
Attika
360–350 B.C.
H: 26.5 cm
Terracotta
Presumably from the necropolis of Nymphaion.
 Former collection of A. V. Novikov
Acquired in 1900
Inv. B.2233

On the overhanging lip, at the base of the neck, and under the picture are bands of ova, rather carelessly executed.

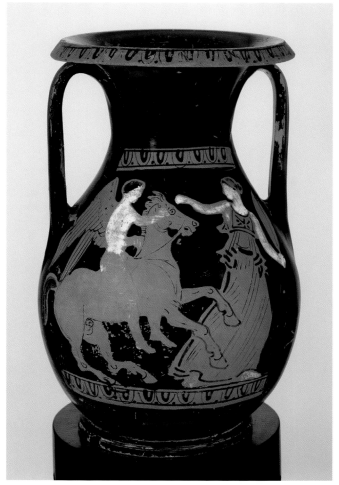

64a Side A

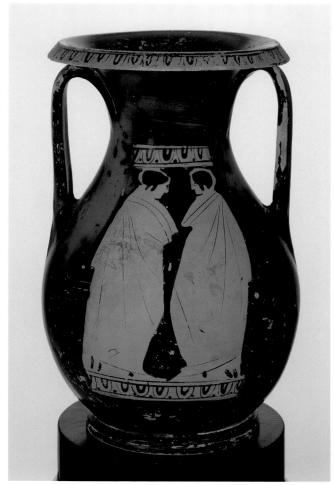

64b Side B

SIDE A. Mounted Eros and maenad. At the left a winged youth is sitting on a horse with the reins in his hands as if to hold back the galloping animal (evidenced by the flying forelocks over the horse's forehead). In front of the horseman is the figure of a woman fleeing to the right. The face and body of Eros, nude to the waist, are painted in added white. His hips were probably covered by a himation, once painted in watercolor, which has not survived. The maenad is dressed in a long chiton, girded under the breasts and embroidered on the chest with a star-like design. She is shown frontally, her head turned back, and extending her right hand toward Eros. In her left hand she holds a tympanon drawn in profile. Her face, neck, arms, and feet are painted in added white.

Similar compositions are typical for the pelike painters of Group G (where G signi-

fies the word *griffin*), although sometimes the horse is replaced by a griffin, in which case the mounted youth should be seen as the Hyperborean Apollo. Abundant use of added white is characteristic in vase-painting of the Late Classical period.

SIDE B. The figures are drawn in a very generalized manner, without any thorough working out of the details, which is characteristic for the reverse sides of all painted vases produced in the fourth century B.C.

As is the case with the amphora with a lid (see cat. no. 44), the pelike comes from the same collection of A. V. Novikov, and was likely found in one of the graves in the necropolis of Nymphaion, for it survived whole. Pelikai from Group G were produced in Athens during the second quarter to the second half of the fourth century B.C.

159

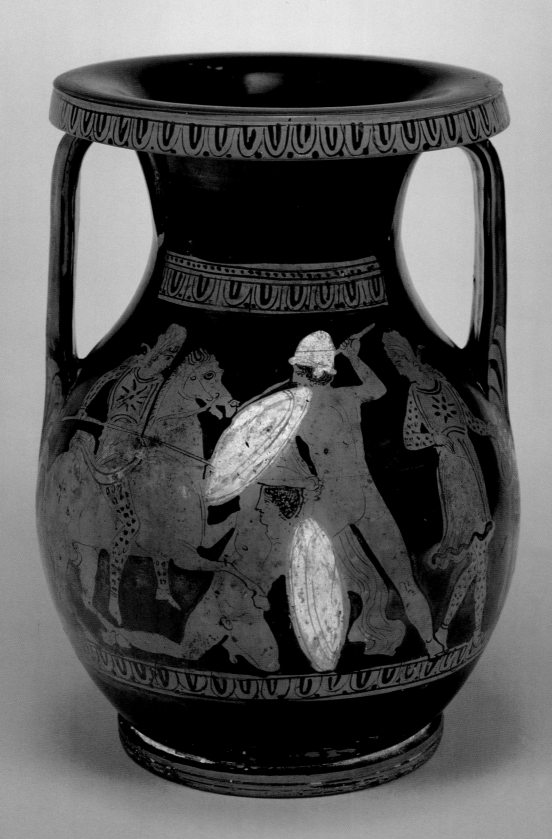

65a Side A

The painting of the vessels mainly reflects the tastes of the inhabitants of the remote areas of the Hellenic world, namely the northern shores of the Pontus Euxinus.

L. U.

BIBLIOGRAPHY: *Nymphaion* 1999, cat. 76; *Nymphea* 2002, n. 24. For Group G, see Beazley *ARV*2, pp. 1462ff.

65

Red-figure Pelike: Amazonomachy

Attika
360–350 B.C.
H: 29 cm; Diam (body): 20 cm;
 Diam (foot): 13.4 cm
Terracotta
Necropolis of Pantikapaion, 1840. Stone burial chamber in a small kurgan on the road from Kerch to Adzhimushkai. Excavations of D. V. Kareisha. Found together with cat. no. 71
Acquired in 1840
Inv. P.1840.45

Red-figure Attic pelike with depiction of two Greeks fighting Amazons. On the bottom is a graffito in the form of a circle and a broken line coming away from it and one more aslant to the right. On the overhanging lip and below the scene there are bands of ova with outlines of dark and light tonguelets inside. Above the image on both sides are sections of the same band and on side A there is an additional reserved band with dots.

SIDE A. Mounted Amazon in Eastern garments and *alopekis* facing right, with a spear in her right hand. Under the hoofs of her galloping horse is a nude youth fallen to his knees who is holding a white painted shield in his left hand. His right hand is behind his head. To the right of him is a standing warrior in a white helmet, aiming a spear clasped in his right hand. With his left hand he is holding and defending himself with a white shield. His right foot is set back and a himation is falling from his left hand in folds. The figure on the extreme right is an Amazon

dressed in a short tunic over pants and a long-sleeved garment. She is moving to right while turning her head back at the central combat.

SIDE B. Three youths in himations near an altar. One of them holds a strigil, another a tympanon and a third a pail. The third person on the extreme right stands facing the two near the altar.

The pelike was discovered in a small kurgan near the road to Adzhimushkai, northwest of Kerch. In a stone box carved into the cliff was, according to the archival documents, a female entombment in a carved wood coffin. In addition to the pelike and the color-enameled filigree jewelry, the burial chamber contained a red-figure Attic lekanis with a

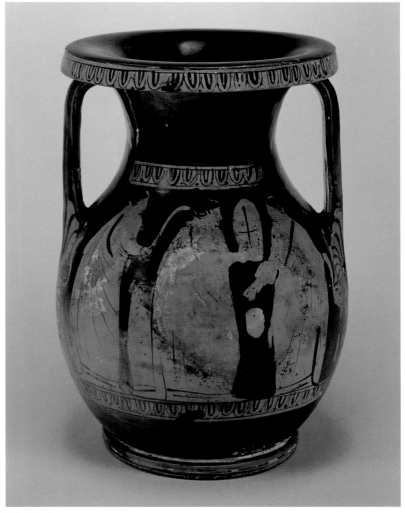

65b Side B

depiction of wedding preparations (*Greek Gold* 1994, p. 162). The painting on both vessels, according to the thematic classification by I. V. Shtal, is symbolically linked to the mythological-epic ideas of Greeks and barbarians of sacred marriage and the battles of the heroes of various legends and myths on the border between the world of the living and the underworld, in which the Amazon appears as the servant of the queen of the underworld (Shtal 2000, p 15). Pelikai with similar subjects, according to scholars, were produced and painted in various workshops in Attika for several decades starting in the 360s (Shtal 2000, cat. 78–97, pp. 50–61). Although K. Schefold dates our pelike to 360–350 B.C., the pelike that most resembles it in terms of composition, style of painting, and ornamental scheme is one from the collection of the Historical-Cultural Conservancy of Kerch attributed to the vase-painters of the Griffin Workshop (Shtal 2000, cat. 81, p. 54).

N. J.

BIBLIOGRAPHY: Schefold 1934, no. 374 (cf. inv. p.1857.49); *Zwei Gesichter*, p. 148, no. 60.

66

Red-figure Pelike: Protomes of a Horse, Amazon, and Griffin

Attributed to the Amazon Painter
Attika
360–330 B.C.
H: 25.5 cm; Diam: 16.1 cm
Terracotta
Necropolis of Pantikapaion, 1874. Stone burial chamber no. 3, near Dolgaia Skala. Excavations of A. E. Liutsenko
Acquired in 1874
Inv. P.1874.51

The overhanging lip is decorated with an ornamental band of ova with reserved tongues; between the ova are black dots. Sections of a similar band are placed on both sides of the vessel, above and below the

images. The vertical handles have a central rib. The ring foot is profiled.

SIDE A. Heads of a griffin, an Amazon, and a horse, all in profile to right. The face of the Amazon is covered with added-white paint. The features of the face, the curls of the hair, and the folds of the soft headdress are drawn with diluted gloss. The dot pattern and the edge of the headdress framing the face are executed with thick black gloss. Using a combination of lines, dots, and daubing of thick and diluted gloss, the details of the bridled horse and the griffin's long bent neck and toothed comb have been applied.

SIDE B. The figures of two youths wrapped in himations are sketchily executed. They are shown standing on either side of an altar facing each other. The folds of the himations are depicted in a tentative manner, through slanted, even, or slightly bent lines. Above the altar, which has the appearance of a short, uneven column, there is a disk with a dot almost in the center, encircled by a broad stripe of black. The youth who is standing to the right of the altar is holding a scythelike object in his right hand, which is touching an object similar to a disk with cut-off segments, decorated with a slanting cross and dots in light sectors.

The symbolism of these types of images is complex: the theme of the large female head, seemingly growing out of the groundline, was well known and widespread not only in Attic but also in Italian vase-painting. The inseparable connection between the afterworld and the subcelestial real world is indicated by different symbolic images in ancient art, among which images of female deities are predominant. The specific character of the northern Black Sea coast, especially in the Bosporus area, is distinguished by the distinctive image of the woman warrior—the Amazon—who takes the place of the traditional image of the goddess in the *kekryphalos* and diadem. In all likelihood, within the context of local mythical-epic notions, the horse and griffin can be seen as representing *mystídes*, participants in mysteries associated

162

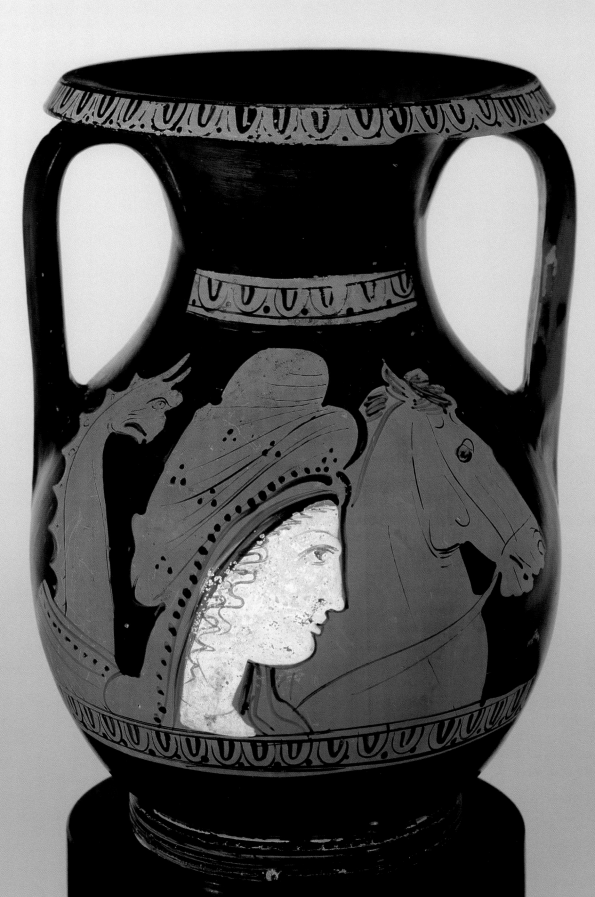

66a Side A

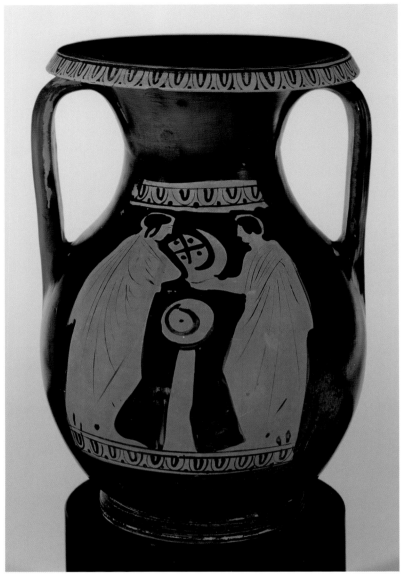

66b Side B

with conducting the souls of the dead to the afterworld. This vessel is similar to a pelike in the collection of the State Historical Museum of the Ukraine (Shtal 2000, cat. 121, p. 71).

<div align="right">N.J.</div>

BIBLIOGRAPHY: *ARV*², p. 1479 no. 21.

67

Red-figure Pelike: Gryphomachy

Attributed to Group G
Attika
340–330 B.C.
H: 28.5 cm; Diam (body): 18.4 cm
Terracotta
Necropolis of Pantikapaion, 1850. Beyond the
 Glinishche. Stone burial chamber in
 barely noticeable earth fill. Excavations
 of K. R. Begichev
Acquired in 1850
Inv. P.1850. 11

Around the lower part of the body, under the image, there is a band of black ova with reserved centers; between them are black dots. Segments of a similar border are also above the image on both sides of the vessel. Under the handles are open double palmettes with volutelike curls in the middle and two droplike petals below.

SIDE A. A mounted Amazon in Oriental garments and *alopekís*, facing right, aims her spear at a horned griffin standing on its hind legs facing her. Under the crossed front legs of the griffin and the galloping horse is a dropped pelta (shield), decorated with black dots, and a linear semicircle along the cut-out, and a nine-ray star with a dot in the center. The Amazon is wearing a short garment decorated with a similar starburst on the breast and a double stripe on the hem. The folds on the skirt are rendered with short strokes of gloss. The narrow trousers that reach down to the ankle are also decorated with dots. The griffin is painted white.

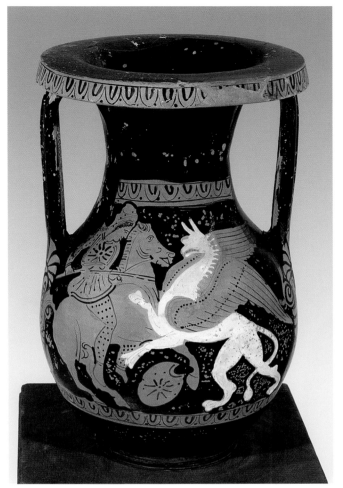

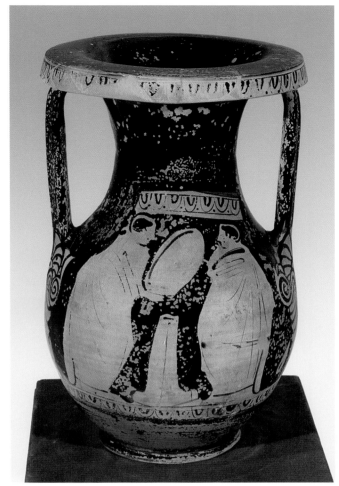

67a Side A

67b Side B

SIDE B. Two male figures dressed in himations stand at an altar facing each other. (On figures in himations, see Isler-Kerényi 1971, p. 30.) One of them has a large tympanon.

The long-standing debate on the identification of the character in the barbarian garments has not yet been resolved. Some scholars see her as an Amazon (Machinskii' 1978), while others see a symbolic struggle in the realm of the dead, in which the griffin is struggling not with an Amazon but with an Arimasp, a legendary progenitor of the aboriginal tribe who has descended to the underworld (Shtal 2000, pp. 12–15). Similar vessels, in Shtal's opinion, came out of the Attic workshop of Group G (Shtal 2000, cat. 53–58, 60–68, pp. 43–48, 147–57). She dates the earliest works from this group of vase-painters to 370–360 B.C., Such a dating does not agree with K. Schefold, who, based

on its shape, dated the pelike to 330–320 B.C. If one agrees with M. Robertson, that the production of red-figure ceramics in Athens practically ceased after 317 B.C. (Robertson 1992, p. 266), one must recognize that the Kerch-style vases, dated to 330–320 B.C., represent the last group. However, the style and manner of painting, the compositional solutions, and the details of the painting, including those on the reverse side, as well as the proportions of the vessel make it closer to earlier examples, such as a pelike in the collection of the Historic-Cultural Conservancy of Kerch (340–330 B.C.), and a similar one in the Pushkin State Museum of Fine Arts (inv. II 1b, 377–350–325 B.C.: Tugusheva 2003, pp. 20–21, pl. 10).

N.J.

BIBLIOGRAPHY: Schefold 1934, p. 46, no. 422 (cf. nos. 420, 424).

68

"Watercolor" Pelike

Bosporan Kingdom
Third–second century B.C.
H: 28.1 cm
Terracotta
Necropolis of Pantikapaion, 1873.
 Mount Mithridates, northern slope
 of the Dolgaia Skala. Catacomb no. 30.
 Excavations of A. E. Liutsenko
Acquired in 1873
Inv. P.1873.118

This so-called watercolor pelike with a ring
foot is made of dark clay with polychrome
painting in gray, white, pink, brown-red, dirty
yellow, and ocher. The everted rim of the
pelike is not broad. Along the flat lip of the
mouth are pink rectangles, alternating with
the reserved gray patches on which the
impression of a frieze composition has been
created through painterly means combining
metopes and triglyphs. The relatively narrow,
elongated neck is decorated on side A with
an image of an olive branch, painted pink,
and a chain of white dots placed like a neck-
lace at the point where the neck transitions to
the shoulder. The upper parts of the vertical
strap handles have a weakly expressed rib,
which disappears toward the body. Where the
handles curve there is a rectangle, painted in
pink, similar to the "metopes" of the mouth.
The globular body is covered with abundant
ornamental painting, consisting of a compo-
sition of a pointed-leafed wreath with a
ribbon or lamellar diadem, a mottled band,
and two olive branches, which as they come
down from the base of the handles to the
bottom, linearly repeat the outline of the
body and frame the entire composition from
below. In the middle of the lower part of the
body, between the mottled band and the ends
of the olive branches, is a white lotus flower
flanked by two dot rosettes. Practically all
of the elements of the ornamentation were
originally painted in white, but later the
pointed leaves of the plant were outlined
with gray. The color of the ribbon or diadem
was marked with red slanted strokes. If one
assumes that the leaves of the wreath are
shown in conjunction with the diadem, it is

69

possible that the vase-painter attempted to convey by painterly means not only its color but also its dimensions. The white fabric of the band, or *taenia*, seems to have been thrown on the vessel. Its lower edge has the same kind of brownish-red border as the band of the wreath. On side B, seemingly thrown over the handles of the pelike, the ends of the fabric with red border are rendered with large droplike daubs of paint. Most of the area of side B, however, has no painting.

This pelike is an example of local pottery production and artistic style of decorating funerary vessels. The Bosporan craftsmen generally followed the tradition of Greek ceramic workshops of the preceding period, but added and developed their own pictorial methods, thus imparting, in addition to the traditional manner of the work, their own element of a creative vision and taste.

N. J.

BIBLIOGRAPHY: Knipovich 1955a, p. 386, fig. 24; Kobylina 1951a, pp. 136ff.; Sokolov 1976, no. 75. p. 46.

69

Two Psalia in the Shape of Deer Heads

Second half of the fifth century B.C.
L (rods): 10.1 cm; L (terminals): 8.1 and 7.8 cm
Bronze
Tuzlinski necropolis, 1852. Taman Peninsula.
 Excavations of K. R. Begichev
Acquired in 1852
Inv. T.1852.64

Cast paired psalia (cheekpieces) with two holes. The psalia have a vertical terminal in the form of the frontal head of a deer with branched antlers. The terminal is flat, only the lower part of the snout juts out slightly. The head has been worked on one side, where the eyes, nose, ears, and folds have been sparingly rendered by engraving.

E. V.

BIBLIOGRAPHY: *ABC* 1892, pl. XXIX.8; *Prichernomor'e* 1983, no. 362.

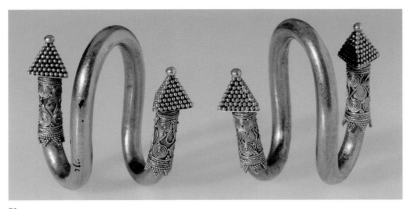

70

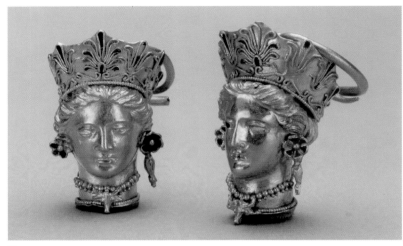

71

the fourth century B.C. The durability of the form and the character of their ornamentation, along with the fact that no analogous finds have been made outside the Bosporus, make it possible that they were produced in local workshops. In Pantikapaion and Nymphaion stone molds for such pendants have been found. There is some controversy regarding the use of these adornments. They may have been earrings; ear pendants; ornaments for hair; or clasps for headbands, clothing, or belts. Although on a Lycian coin a spiral pendant is shown pierced through the earlobe of a king, it is unlikely that this was its general use. It is more likely that they were worn fastened to the hair or a fillet (Hadaczek 1903, pp. 14ff., figs. 20–22; Deppert-Lippitz 1985, pp. 150–52, figs. 99–103; Silant'ieva 1976, p. 130)

Y. K.

BIBLIOGRAPHY: Silant'ieva 1976, p. 128, variant III, fig. 5.10w, 7d; *Greek Gold* 1994, p. 152, no. 93; *Zwei Gesichter* 1997, pp. 141–41, no. 51; *Greek Gold* 2004, fig. 13.

70

Pair of Spiral Pendants

Bosporan Kingdom
Second half of the fifth century B.C.
H: 3.5 cm
Gold, bronze
Kerch suburbs, 1842. Third kurgan on Pavlovsky cape. Excavations of A. B. Ashik
Inv. P.1842.114

Pair of bronze rods twisted into spirals and covered in gold leaf, with tips consisting of collars decorated with filigree and granulation and granulated pyramids. Spiral pendants, developed out of modest Ionian precursors, were widely distributed on the periphery of the ancient world—southern Italy, Thrace, and Cyprus. In the Bosporus spiral pendants are found until the middle of

71

Pair of Earrings with Pendants in the Form of Female Heads

Northern Black Sea coast (?)
Mid-fourth century B.C.
H: 4 cm; Weight: 8.31 and 8.55 g
Gold, enamel, paste
Necropolis of Pantikapaion, 1840. Stone burial chamber in a small kurgan on the road from Kerch to Adzhimushkai. Found together with cat. no. 65. Excavations of D. V. Kareisha
Acquired in 1840
Inv. P.1840.37

Each earring consists of a wire ring with a pendant in the form of a head of a woman wearing a diadem, earrings, and necklace. The head is formed of two soldered, embossed halves, front and back, filled with paste through an opening in the neck. The facial features and hair were touched up after the relief had been finished. The whites of the

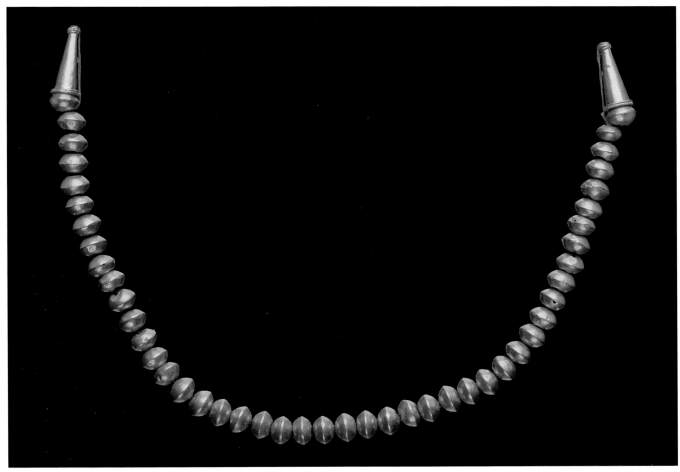

72

eyes and the irises are filled with white and black enamel, and the leaves of the palmettes on the diadem and the rosettes of the earrings are filled with blue and green enamel. The adornments reflect contemporary fashion: this includes the filigree ornamentation on the diadem, earrings in the form of rosettes with seed pendants, and a necklace made of a double row of beads with a pendant in the form of a bull's head in the center. Earrings and necklace pendants in the form of women's heads of this type are known from finds in the necropoleis of the Bosporus dating to the middle of the fourth century B.C., giving reason to believe that they were manufactured locally (Higgins 1961, p. 128).

Y. K.

BIBLIOGRAPHY: *Greek Gold* 1994, no. 103; *Zwei Gesichter* 1997, no. 61; *Greek Gold* 2004, fig. 51.

72

Necklace of Smooth Beads with Two Terminals

Fourth century B.C.
L: 28 cm
Gold
Necropolis of Pantikapaion, 1875. Northern slope of Mount Mithridates at the bottom of the Dolgaia Skala. Catacomb no. 2. Excavations of A. E. Liutsenko
Acquired in 1875
Inv. P.1875.408

Necklace consisting of forty-four smooth beads and conical terminals with a semispherical base. Such necklaces, known since the Archaic period, remained one of the leading types of jewelry in the Classical period. The necklace was found together with

169

earrings with lions' heads and a bronze Pantikapaion coin from the middle (see Zograf 1951, pl. XL.20) or third quarter (Shelov 1956, pl. V.55) of the fourth century B.C.

<div align="right">Y. K.</div>

BIBLIOGRAPHY: *CR* 1875, p. XXII; Ruxer 1938, pp. 200, 228.

73

Cameo Ring with Head of Athena

Northern Black Sea coast (Pantikapaion?)
Early third century B.C.
H (bezel): 5.4 cm
Gold, garnet
Necropolis of Pantikapaion, 1838. City of Kerch. Fourth slab burial chamber in one of the kurgans on the plain beyond the Quarantine Road. Found together with cat. nos. 74 and 75. Excavations of A. B. Ashik
Year of acquisition unknown
Inv. P.1838.16

73 1.5:1

Massive ring with an oval bezel, with a relief of Athena. After casting, the bezel was finished by engraving. The background has been decorated with dots applied with a *poinçon*. A garnet cameo—the three-quarter head of the goddess—has been set in the opening in the middle of the bezel. It is worth noting that a paired ring executed using the same technique (Hermitage, inv. P.1838.15) was found in the same burial. There were four rings with jewels on each of the woman's hands. This ring was made in one of the workshops of the northern Pontic region, possibly in Pantikapaion.

<div align="right">O. N.</div>

BIBLIOGRAPHY: *ABC* 1892, pl. XV.15; Maximova 1955, pp. 440, 442, pl. I; Neverov 1971a, no. II; *Schatzkammern* 1993, p. 238, no. 125; *Great Art* 1994, p. 295, no. 278; *Zwei Gesichter* 1997, no. 64; *Greek Gold* 2004, fig. 73.

74

Kylix with Image of Helios's Chariot

Eastern Mediterranean
First quarter of the third century B.C.
H: 3.8 cm; Diam: 12.5 cm; Diam (with handles): 21.5 cm
Silver, casting, embossing, engraving
Necropolis of Pantikapaion, 1838. City of Kerch. Fourth slab burial chamber in one of the kurgans on the plain beyond the Quarantine Road. Found together with cat. nos. 73 and 75. Excavations of A. B. Ashik
Year of acquisition unknown
Inv. P.1838.25

Shallow cup with thin looplike bent handles. The interior of the cup is decorated with a separately made relief medallion, framed by an ornamental belt of engraved braiding. The relief of the medallion depicts Helios, god of the sun, on a fast-moving quadriga—a chariot pulled by four horses. The head of the god is surrounded by a nimbus of rays. In his upraised right hand he is holding a scepter. The quadriga is depicted in three-

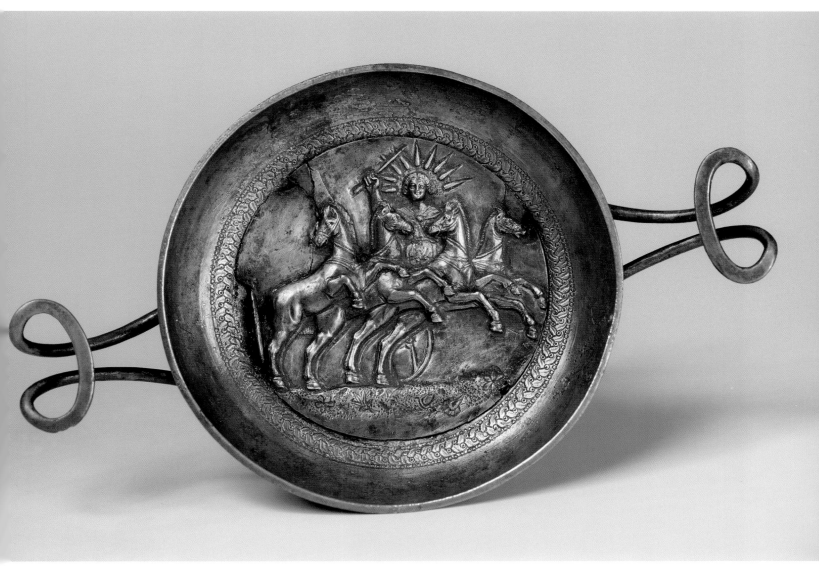

74

quarter view; the front legs of the horses are raised high. The heads of the middle pair of horses are turned toward each other, while those on the sides are turned away. Under their feet the groundline is shown in relief.

N.K.

BIBLIOGRAPHY: Maximova 1979, p. 74, fig. 23, B-1; *Antichnoe serebro* 1985, p. 29, cat. 26, p. 27, illus.; *Great Art* 1994, pp. 318–19, no. 303.

75

Pitcher with Frieze of Floral Decoration

Attika(?)
First quarter of the third century B.C.
H: 12.9 cm
Silver, gilding, casting, embossing, engraving
Necropolis of Pantikapaion, 1838. Fourth slab burial chamber in one of the kurgans on the plain beyond the Quarantine Road. Found together with cat. nos. 73 and 74. Excavations of A. B. Ashik
Year of acquisition unknown
Inv. P.1838.28

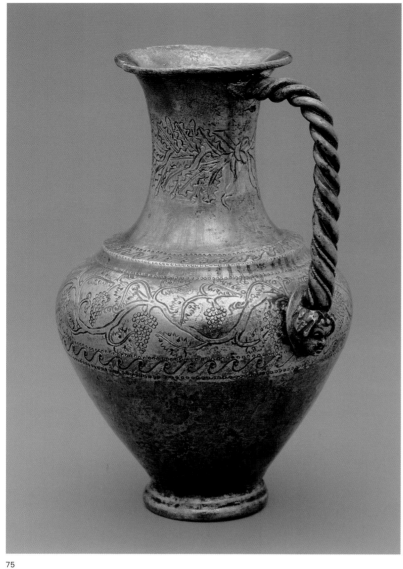

75

Pitcher with tall neck and sloping shoulders, tapering off toward the bottom of the body, on a low foot. The twisted handle is decorated at the lower end with a relief head of a beardless satyr. As the neck of the pitcher transitions to the body it terminates in a projection decorated with engraved bands containing rows of dots, a wave, and vertical lines. The neck and body of the vessel are embellished with areas of engraved ornamentation on a gilded background. On the neck is a wreath of acanthus leaves tied with ribbons. On the body is a broad ornamental frieze filled with grape vines and framed on top and bottom with bands of waves between two rows of dots.

N. K.

BIBLIOGRAPHY: Prushevskaia 1955, p. 347, fig. 31; Maximova 1979, p. 75. figs. 23, B-5; *Antichnoe serebro* 1985, p. 30, cat. 31, p. 33, illus.; *Great Art* 1994, pp. 316–17, no. 301.

76

Ornamented Kylix

First half of the third century B.C.
H: 4.7 cm; Diam: 10.5 cm; Diam (foot): 3.9 cm
Silver, gilding
Taman Peninsula, 1818. First stone burial chamber of the kurgan near the Phanagoria Fortress. Excavations of Lieutenant Colonel Engineer Y. L. Parok'ia
Acquired in 1831
Inv. T.1818.5

Kylix on low embossed foot with carved gilded ornamentation on the inside of the vessel: in the center, a rosette; near the rim, a band of stylized leaves tied in two places and bordered on each side by a beaded ornament.

E. V.

BIBLIOGRAPHY: *Antichnoe serebro* 1985, p. 24, cat. 20; *Greek Gold* 2004, fig. 1.

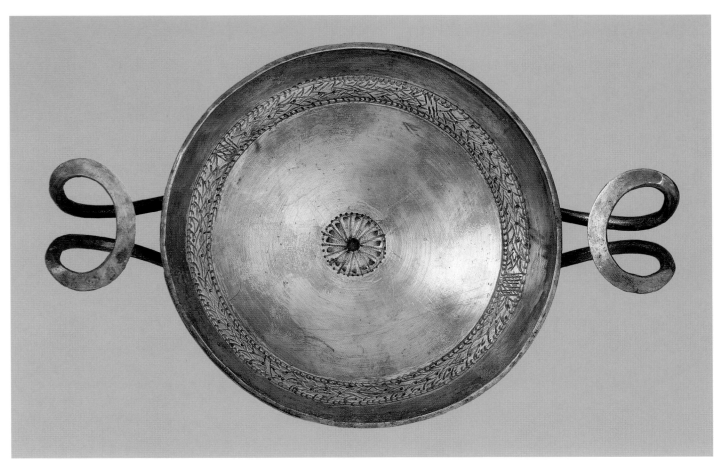

76a

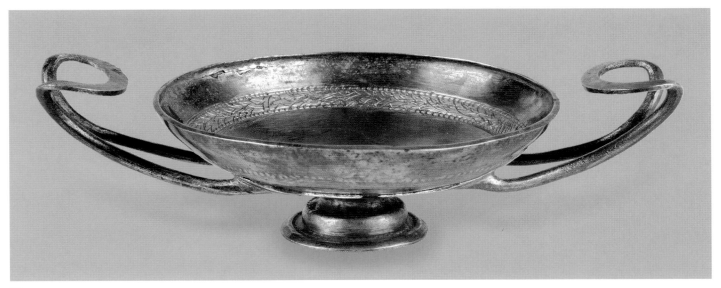

76b

77

Pyxis

First half of the third century B.C.
H: 15 cm; Diam (bottom): 6.8 cm;
 Diam (lid): 7 cm
Silver, gilding
Taman Peninsula, 1818. First stone burial
 chamber of the kurgan near the Phanagoria
 Fortress. Excavations of Lieutenant Colonel
 Engineer Y. L. Parok'ia
Acquired in 1831
Inv. T.1818.9

The embossed lowest part of the pyxis is
decorated with a row of dots with the
engraved gilded band of a Lesbian cyma; in
the middle is a garland of ivy leaves between
two rows of dots; on the underside of the
foot are four concentric circles and the dotted
inscription ΛΛΛΛⱵ. The lid is topped by
a high finial. The vertical side and the top of
the lid are decorated with three bands of
an engraved design of waves between rows
of dots.

E.V.

BIBLIOGRAPHY: *ABC* 1892, pl. XXXVII.3; *Antichnoe serebro* 1985, p. 24, cat. 19; *Great Art* 1994, p. 317, no. 302.

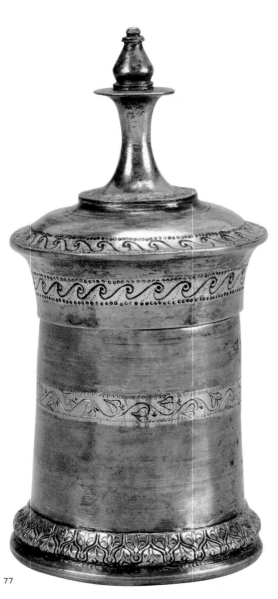

77

78

Fragment of a Wall
with Polychrome Painting

Nymphaion
First half of the third century B.C.
L: 1.6 m
Plaster, painting with encaustic coating
Nymphaion, 1982. Shrine to Aphrodite.
 Excavations of N. L. Grach
Acquired in 1984
Inv. NF.82.526

Part of a decorative wall from one of the rooms of the shrine connected with the cult of Aphrodite-Isis, the patron goddess of seafarers, whose cult was widespread on the Bosporus in Hellenistic times (338–31 B.C.).

The engraved depiction of the ship is 1.2 meters long. It is carved in a yellow belt of the plaster covered with wax paint. The picture portrays all of the details of the ship's design and external adornments; proportions have been meticulously preserved, which has enabled scholars to determine the actual size and type of the vessel—a trireme. The ship is named in honor of Isis, the most revered goddess in Ptolemaic Egypt, whose name is inscribed on the broadside with large letters: ΙΣΙΣ.

This vessel is probably not imaginary. It could have been an ambassadorial ship with an important political mission from Egypt to the Bosporus, to the court of King Pairisades II (ruled 280–275 B.C.) (Grach 1984). It is also possible, however, that it is one of those ships described down to the smallest detail because of their great size and splendor by such classical writers as Kallisthenes, Athenaeus, and Lucian. This magnificent ship could have been depicted on the walls of the shrine in connection with its arrival in Nymphaion for the celebration of the spring holiday of the discovery of navigation as described by Apuleius in the *Metamorphoses* (Semenov 1995). The ship takes up a central position in a whole complex of pictures and inscriptions covering the surface of the walls of the room in the shrine, which was discovered in 1982 during excavations of the Bosporan city of Nymphaion. Long and painstaking work by the Hermitage restorers has reconstructed the decorative elements of the corner of the room, whose walls were covered by plaster with polychrome painting (Gagen and Gavrilenko 1985; Gagen 1997). The walls had colorful separate bands of bright yellow and dark red friezes and were filled with different pictures and texts—appeals to gods, information on ship departures, offerings, repayment of debts, toasts, individual names and whole lists of them, lines of verse, and frivolous inscriptions. The full size of the restored wall is 2.5 meters high and 6.4 meters long.

o.s.

BIBLIOGRAPHY: Grach 1984, pp. 81–98; Basch 1985, pp. 129–52; Höckmann 1985, pp. 106–14; Grach 1987a, pp. 81–94; Grach 1987b, pp. 49–65; Höckmann 1999a, pp. 94–97; Höckmann 1999b, pp. 303–56; Vinogradov 1999, pp. 271–302; *Nymphaion* 1999, pp. 23–24, cat. 11; *Nymphea* 2002, p. 38, cat. 1.

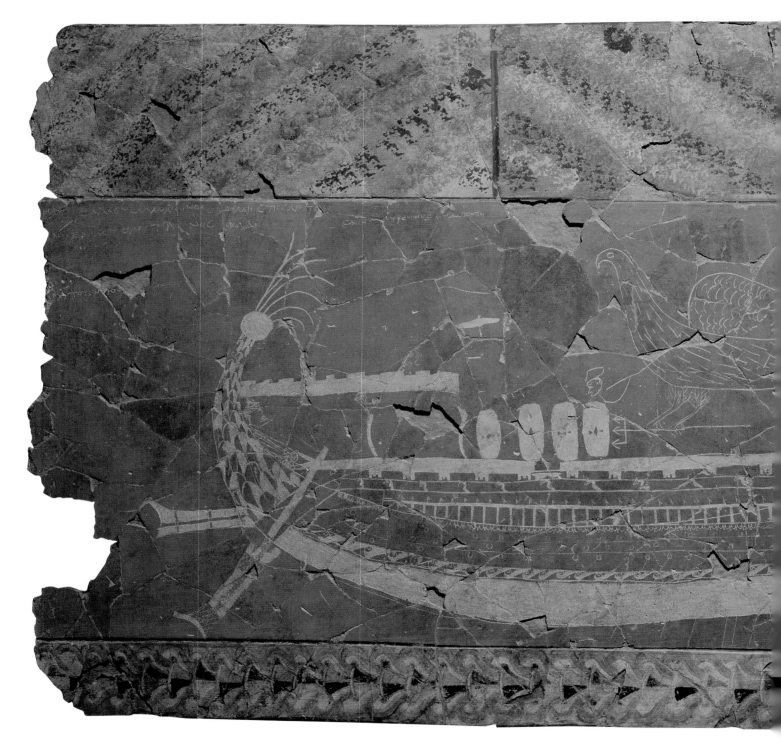

78

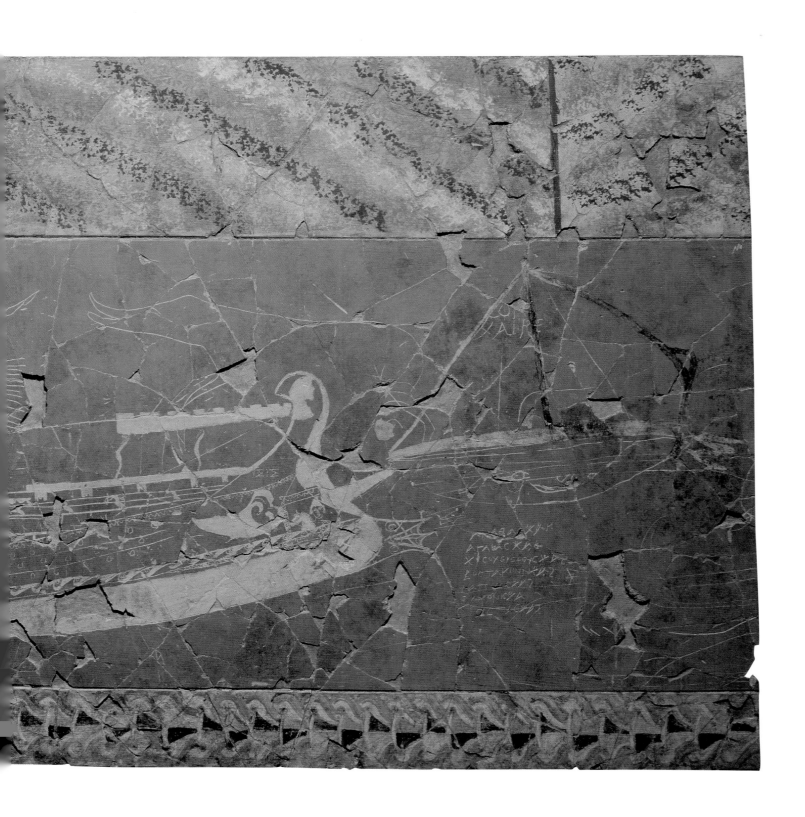

79

Theater Mask

Asia Minor
Third century B.C.
H: 11 cm
Terracotta
Nymphaion, 1984. Cistern 1.
 Excavations of N. L. Grach
Acquired in 1987
Inv. NF.84.400

Terracotta mask in high relief depicting
a beardless male face with thick curly
hair in which small curls are entwined with
ivy. Deep lines are cut into the forehead,
while the eyebrows arch angrily above the
round, bulging eyes with clearly delineated,
convex eyelids. The facial expression is
completed by a large hooked nose and the
gaping hole of a wide-open mouth. There
is a small dimple on the chin. Traces of a
painted layer and pink color have been
preserved on the surface. The reverse side
of the mask is finished by hand. In the
opinion of N. L. Grach, the mask could have
been made in the Bosporus from a mold
imported from Asia Minor. This type of
theatrical mask of the Attic New Comedy
is close to the image of the so-called virtuous
youth. It is possible that the mask had an
apotropaic function.

O.S.

BIBLIOGRAPHY: *Tesori d'Eurasia* 1987, p. 141, cat. 178;
Nymphaion 1999, p. 73 illus., p. 75, cat. 174; *Nymphea*
2002, p. 80, cat. 63; Sokolova 2004, pp. 175–85; *Muzy
i maski* 2005, cat. 96.

79

80

80

Medallion Mask with Gorgoneion

Bosporan Kingdom
First century B.C.
Diam: 14.5 cm
Terracotta
Necropolis of Nymphaion, 1976. Stone burial
 chamber A-80. Excavations of N. L. Grach
Inv. NNF.76.104

Large medallion with relief image of the head
of the Gorgon Medusa.

O.S.

BIBLIOGRAPHY: *Tesori d'Eurasia* 1987, p. 143, cat. 181;
Nymphaion 1999, p. 75, cat. 175; Grach 1999, p. 57,
fig. 19; *Nymphea* 2002, p. 87, cat. 76.

81

Statue of a Man

Asia Minor (?)
Middle–third quarter of the second century A.D.
H (total): 2.04 m; H (figure): 1.94 m
Marble
Necropolis of Pantikapaion, 1850. Glinishche
 district. Accidental find. Found together
 with cat. 82
Acquired in 1850
Inv. P.1850.25

The man is dressed in a thin chiton, the
edge of which is seen on the chest; trousers
(*anaxyrides*) tucked into soft boots; and
a himation wrapped around his body and
thrown over his left shoulder. The himation
is wrapped all the way down his right arm
and to his palm; his right hand is close to his
chest. The left hand probably held a scroll.
The face has regular features, a broad chin,
and full cheeks. The eyes are large and wide
open, with sculpted eyelids. The eyeball
is flat and the eyebrows have been rendered
with incisions. The hairstyle is a luxuriant
head of hair, laid down in small curls. Near
the left leg, under the folds of the himation,

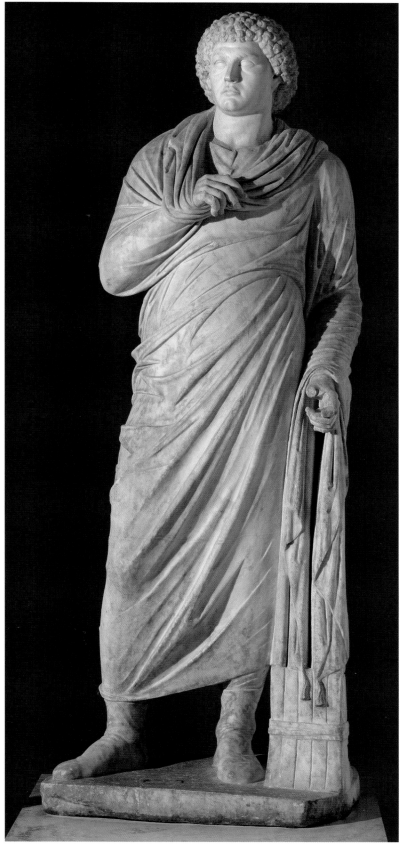

81

179

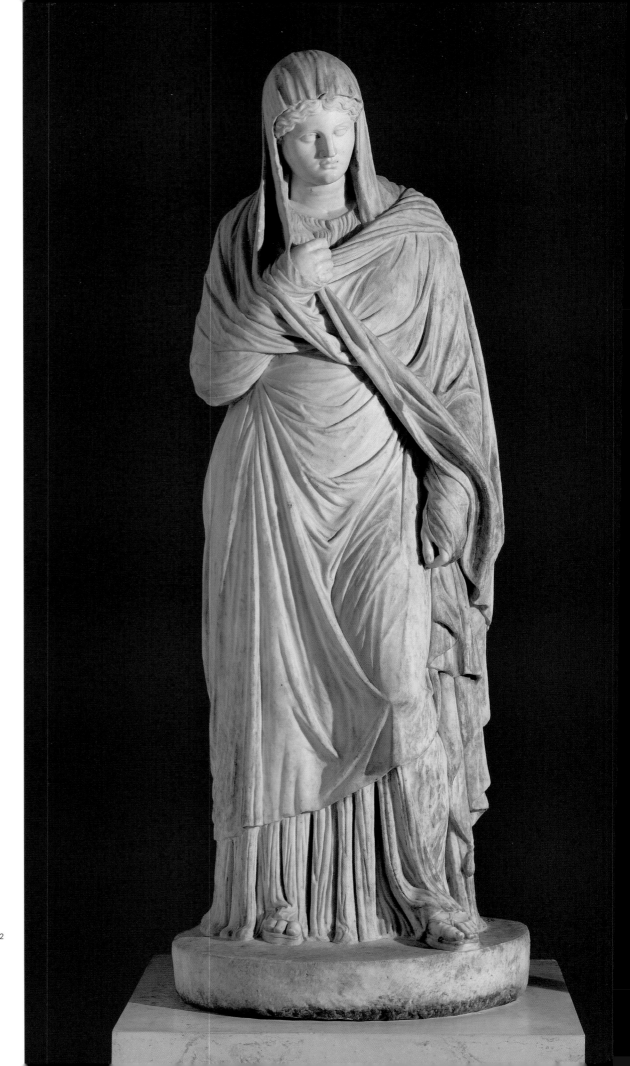

is a semicircular *scrinium* with locks, and
a bundle of book scrolls indicating the high
social status of the person (Voshchinina
and Chodza 1971, pp. 621–27).

The statue has been interpreted by
researchers as a sepulchral monument (Col-
lignon 1911, pp. 283–84; Voshchinina 1974,
pp. 3–4) originally paired with a female
statue (see cat. no. 82) for notable citizens of
Pantikapaion. For unknown reasons they
were found hidden under the kurgan fill of
the Hellenistic-Roman necropolis. The
two statues are similar compositionally and
stylistically. The question as to where they
were made remains open, however, it is most
likely that they are of Asia Minor provenance.

L.D.

BIBLIOGRAPHY: Sabat'e 1850, vol. 4, pp. 43–45,
112–13; Hekler 1909, p. 128; Collignon 1911, pp. 283–
84; Minns 1913, p. 298; Bich 1958, XXVIII, pp. 89–93;
Ivanova 1961, pp. 19–20; Voshchinina and Chodza
1971, XIX, pp. 621–30, pls. 30, 31; Voshchinina 1974,
pp. 196–98, cat. 81, pl. CIX; *Great Art* 1994, pp. 326–27,
nos. 311–12; Tunkina 2002, p. 301. fig. 82.

82

Statue of a Woman

Asia Minor (?)
Middle–third quarter of the second century A.D.
H (total): 1.94 m; H (figure): 1.79 m
Marble
Necropolis of Pantikapaion, 1850. Glinishche
 district. Accidental find. Found together
 with cat. 81
Acquired in 1850
Inv. P.1850.26

The woman stands on her right leg, while the
left leg is bent at the knee and slightly set
forward and to the side. The figure, of the
Large Herculaneum Woman type, is dressed
in a long, thin chiton bunched up at the neck
in small folds. Over the chiton is a tightly
wrapped himation falling down from her
head to her shoulders and thrown over her
left shoulder. The right hand, holding up the
edge of the himation, is pressed to the breast,
while the left hand is lowered along the body
and covered to the fingers by the himation.

Her slightly inclined head is turned toward
the left shoulder. Her face has regular
features: straight nose, full lips, small chin,
large eyes with embossed eyelids and
undefined pupils and irises, and clearly arti-
culated eyebrows. The forehead is framed
by curly tresses parted in the middle. This
statue forms a pair with cat. 81. Scholars
have attributed its origin to the region
of Asia Minor at the time of the Antonines
(Voshchinina 1974, pp. 196–98, n. 6).

L.D.

BIBLIOGRAPHY: See cat. no. 81.

83

Funerary Stele with Horsemen

Bosporan Kingdom
Second half of the first century A.D.
H: 2.09 m; W: 59 cm; D: 19 cm
Limestone
Exact date of find unknown. Found in the area
 near Kerch before 1848; announced by
 A. B. Ashik in 1848
Inv. PAN.151

The rectangular stele is topped by a relief
pediment with akroteria in the form of
palmettes, semipalmettes, and rosettes in
the tympanum and under the pediment. In
the middle of the slab, in a recessed field,
confined at the sides by antae holding up the
profiled cornice, are two horsemen riding to
right on saddled horses. The right-hand
rider is fully visible. He is wearing short outer
clothing with long sleeves, trousers, and a
himation. A dagger is strapped by two belts
to his right hip and a quiver hangs from
his right side. The sculptor has meticulously
executed the details of the weapons and
harnesses. Behind this horseman appears the
front part of a horse with the second rider.
He is dressed the same way as the first, but
since this figure has been better preserved,
we see that the trousers of the warriors
were tucked into short, soft boots. The face
of this hero with large, expressive features is

framed with a magnificent cap of hair and could be a portrait.

Under the relief is an inscription in 4.5-cm-high letters:

Daphn, son of Psycharion, steward of the royal court, farewell. Members of the synod

Judging from the character of the writing, the gravestone is from the first century A.D.

<div align="right">L.D.</div>

BIBLIOGRAPHY: *KBN* 1965 p. 88, no. 78; Davydova 1990 p. 58, no. 48; *KBN* 2004, no. 78.

84

Portrait of Mithridates VI Eupator

Pergamene work
About 80 B.C.
H: 38 cm
Small-grained marble with a yellow hue
Necropolis of Pantikapaion, 1909. Northwestern slope of Mount Mithridates. Accidental find during playground construction
Acquired in 1910
Inv. P.1909.144

The portrait depicts a male approximately twenty-five years old with his head tilted sharply upward to the right, parted lips, and wide-open eyes. The youthful, beardless face, full of inspired heroic energy, is obviously a type of portrait that depicts a Hellenistic ruler, in spite of the absence of attributes, such as a diadem. The classical oval shape of the face and the proportions, which have been taken from idealized sculpture, are combined with original features that recall the likenesses of Alexander the Great, however, the features of this man are larger— and more roughly executed. The huge almond-shaped eyes and full lips especially stand out.

The head, of which only the front part has been preserved, belonged to a statue. In the technique called *membra disiecta*, the upper

83

part of the head was made separately (from limestone?) and connected by means of dowels, from which two holes have been preserved.

The identification of this monument as a portrait of Mithridates VI Eupator is supported by many scholars (Neverov 1971b, pp. 90–92, fig. 7; Neverov 1972, p. 90, fig. 1; Kobylina 1972, pl. XIX). O. Y. Neverov has compared the head with depictions of Mithridates on coins (Lange 1938, pl. 82), with the sculpted portrait in the Louvre (Winter 1894, p. 245, Smith 1991, p. 24, fig. 19), and the presumed image of Mithridates on a relief from Pergamon, on which the king appears as Herakles freeing Prometheus (Krahmer 1925, p. 183, fig. 2; Thomas 1976, p. 17; Himmelmann 1989, p. 140, pls. 22, 23). In the opinion of the present writer the monuments are similar, not only iconographically, but also stylistically. The pathos and dynamism, characteristic of the Pergamon school of sculpture, complement the classicizing traits of the first century B.C.: the summarizing and generalizing in the treatment of the facial features and the flatness of the modeling (Neverov 1972, p. 91). The portrait of Mithridates from Odessa, which is very close to one from Kerch, is associated with the same artistic circle (Vlasov 1960, p. 324, fig. 1). It is likely that these portraits had the same prototype— a statue erected in Pergamon approximately 80 B.C.

Mithridates VI Eupator was king of Pontus—a Black Sea state that also included the Bosporan kingdom—from 120 to 63 B.C. He was a tireless military leader who in the course of the Mithridatic Wars stopped the Roman expansion into Asia Minor. However, during the Third Mithridatic War in 63 B.C. he suffered defeat and took his own life.

The Kerch monument, like many of the other portraits of Hellenistic rulers, was based on the iconography of Alexander the Great. This similarity of the images is clearly visible on coins minted by Mithridates. The comparison between Mithridates and Alexander is found also in written sources, which mention, among other things, that Mithridates considered Alexander to be his ancestor (Just. Epit. 38.7). Following Dionysos and Alexander, Mithridates

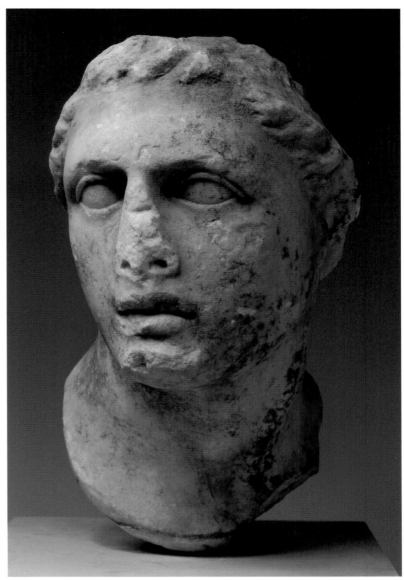

84

positioned himself as the "liberator of Asia" and was named Liber and Bacchus (Cic. Flac. 25), while deified in Pergamon, which became his residence after its liberation from the Romans. The Pontic king appears as the "new Alexander," having proclaimed "the fight against Roman domination and for universal liberation."

It is well known that Mithridates emulated Alexander in politics, ideology, and official imagery (Bohm 1989, pp. 153–55). But this did not mean that he simply imitated his model. In the opinion of Smith, in the portraits of Mithridates the style of Alexander was adapted and further developed as the new exemplar of Alexander-Dionysos, the

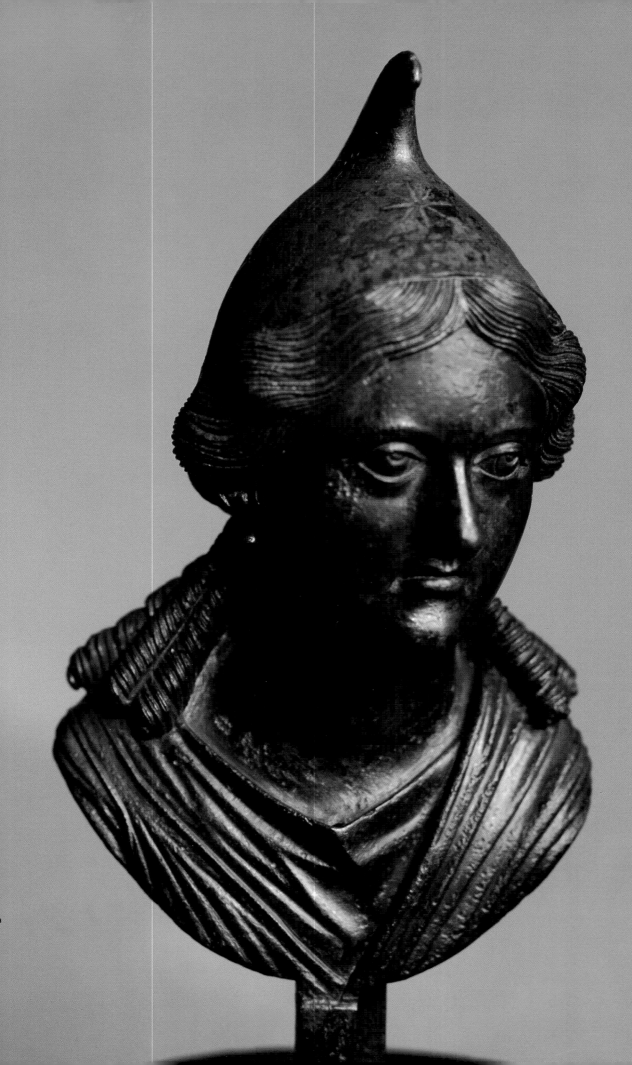

85a

divine liberator of Asia. According to an existing hypothesis, the depictions of Mithridates-Herakles are an indication of the deification of the king in the Greek cities on the northern shores of the Black Sea (Kleiner 1953, p. 87; Neverov 1971b, p. 88).

Not all scholars, however, consider the Hermitage portrait indisputably that of Mithridates. According to Smith (Smith 1988, p. 100; Smith 1994, p. 24; Richter 1984, p. 247, fig. 259), only the head of the ruler in a lion's skin in the Louvre, already identified in 1894 on the basis of comparisons with coins (Winter 1894, p. 247), can reasonably be considered to be his portrait. Smith attributes the Kerch portrait to a circle of monuments "around Mithridates" and does not consider it out of the question that it depicts one of the Bosporan rulers who were emulating the king (Smith 1988, p. 100). However, the monument was created around 80 B.C. during a period of heightened political activity on the part of Mithridates VI Eupator and was erected in Pantikapaion—the capital of the Bosporan kingdom—which was ruled by Mithridates, who was very popular there. The dating, place of the find, and the pronounced Mithridatic style confirm the identification of the portrait.

<div align="right">A. T.</div>

BIBLIOGRAPHY: Kobylina 1972, p. 12, pl. XIX; Neverov 1971b, pp. 86–94; Neverov 1972, pp. 110–19; Sokolov 1976, pl. 88; *Great Art* 1994, pp. 328–29, no. 316.

85

Bust of a Bosporan Queen

Approximately A.D. 30
H (bust): 25.8 cm; H (head): 13 cm;
 H (base): 4.2 cm; Diam (base): 15 cm
Bronze with red copper and silver inlay;
 the chemical compositions of the bronze
 of the bust and the base are identical
Shirokaya Balka, 1898. Fourteen kilometers
 northwest of the city of Novorossii'sk,
 on the estate of I. P. Kuleshevich
Acquired in 1899
Inv. PAN.1726.A, PAN.1726.B

Bust of a woman who is approximately fifty years of age. Her head is turned slightly to the left and up while her gaze is set above the head of the viewer. She is wearing a Phrygian cap covered with images of eight-ray stars and four-petal rosettes. At the center of each silver star is a copper dot and at the center of each rosette is a silver circle with copper inlay. Below the Phrygian cap there is a broad ribbon, possibly a diadem.

Even though the portrait has an inherent idealization and generalization, it is also highly individualistic. The woman has a fleshy, broad face, a very small round chin, a prominent straight nose with a sharp tip, and thin eyebrows. The eyes are accentuated, their size slightly exaggerated. The pupils are rendered through an incised sickle-shaped line disappearing under the upper eyelid. The signs of age—heavy swollen eyelids, bags under the eyes, small wrinkles between the eyebrows, and deep horizontal wrinkles on the neck—are emphasized.

Wavy hair with a central part frame the face, covering most of the ears. In the back the hair is tied in a knot and descends to the neck. The neck and shoulders are covered by corkscrew curls. The hairstyle is very meticulous: the locks of hair have been executed with deep incisions.

This unusual portrait presents a mixture of Hellenistic, Eastern, and Roman traits. The charismatic depiction of the ruler and the rhetoric of attributes is royal Hellenistic in spirit. At the same time this is a realistic Roman portrait, rendering the physical attributes of the model as accurately as possible, and it follows the fashion of the day in the hairstyle.

Together with the bust were found fragments of bronze implements, including a cylindrical base. In the course of a further investigation of the settlement in 1967 a bronze bust-weight and other objects were found. The first and only detailed publication of the bust was made by M. I. Rostovtsev (Rostovtsev 1916), who identified the portrait as that of the Bosporan queen Dynamis and dated it to the first quarter of the first century A.D. The primary reason for making this identification was the Phrygian cap covered with stars. Such caps were repro-

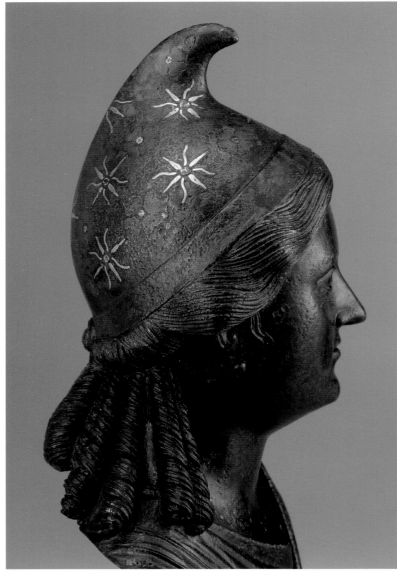

85b

M. I. Rostovtsev believed that the Phrygian cap with symbols reflects the royal status of the model and emphasizes her descent from Achaemenid kings. One of the most outstanding of all the known queens in the history of the Bosporus was Dynamis (reigned 20–12 B.C. and, probably, 8 B.C.–A.D. 7/13), daughter of Pharnakes and granddaughter of Mithridates VI Eupator. While professing loyalty to Rome, she firmly conducted a policy of independence based on preserving the traditional economic structure of the Bosporus. Dynamis emphasized her descent from Mithridates, which was reflected in the Mithridatic symbols on official depictions of the queen. Rostovtsev's hypothesis was accepted by a majority of scholars (Gaidukevich 1955, p. 128; Gaidukevich 1971, pp. 337–38; Kobylina 1972, p. 12; Sokolov 1976, pl. 93; Saprykin 2002, p. 96), however, there are also different opinions. According to Molchanov and Parlasca, the bust should be dated to the time of Claudius and depicts another queen, most likely Hypepyria, who reigned in A.D. 37–38. This dating is supported by the hairstyle, especially the corkscrew locks with the knot on the nape, and also by the dating of the objects found together with the bust (Molchanov 1971, p. 101; Parlasca 1979, p. 397; see Onaiko 1971, p. 73). Voshchinina and Chodza dated the bust to the second quarter of the first century A.D. and, noting the difference from the profile depictions of Dynamis on coins, have proposed that this is a depiction of a Roman lady from the Julio-Claudian dynasty —either Antonia the Younger, Agrippina, or Livia (Voshchinina 1974, p. 194).

It is difficult to ignore the convincing historical interpretation of M. I. Rostovtsev. Nevertheless, it is also obvious that the bust, whomever it depicts, belongs to a time after the death of Dynamis. There are similar hairstyles in Roman portraits. The corkscrew curls and the knot low on the neck are characteristic features of portraits of Agrippina the Younger (A.D. 15–59) (Trillmich 1974, p. 187; Zanker 1983, pp. 6, 45); or they go back to the hairstyle of Agrippina the Elder (14 B.C.–A.D. 33) (Hausmann 1975, pp. 33–34). An earlier analogy can be seen in a portrait of a woman (Museo Capitolino, no. 55: Fittschen and Zanker 1983, p. 45), which is

duced on Pontic coins with the profile of Mithras during the reign of Mithridates. The Pontic emblem of Mithridates—the moon and the sun—appear on the gold staters of Dynamis, Mithridates' granddaughter, and his other successors. Rostovtsev believed that the headdress, which he called *tiara orte*, was a symbol of the power of Asiatic kings. He compared it to reliefs and statues in shrines on the terraces of the burial mound Nemrud Dağ in northern Syria, which was built by Antiochos III of Commagene. Ahura Mazda, Mithras, and one of the ancestors of Antiochos, the Great Persian King, are shown wearing similar tiaras.

dated to the beginning of Tiberius's reign (A.D. 14–37).

It is this type of hairstyle that is depicted on coins bearing the profile of Hypepyria (Frolova 1997, p. 74, XIX, 1–3, 8–19). It is evident that this hairstyle, which followed Roman fashion, could not have appeared on a portrait of a Bosporan queen before it appeared in Rome. It is also unlikely that a posthumous portrait of Dynamis would have been made in accordance with the fashions of the twenties and thirties A.D.

To see the depicted queen as Hypepyria does not allow for her descent from a Thracian dynasty (Rostovtsev 1916, pp. 22–23; Saprykin 2002, p. 96), for in the present bust the dynastic symbolism of the Achaemenids is used. However, it has now been conclusively demonstrated that the "Achaemenid" style in the depictions at Nemrud Dağ (with which Rostovtsev compares the bust) was a complete invention. The vestments and Darius's headgear, as well as his kinship to Antiochos, who is glorified by the monument, is entirely fictional (Smith 1988, p. 101; Smith 1991, p. 227). As far as Hypepyria is concerned, the information about her comes from coins and one inscription on a silver plate. She is not mentioned in any written source and her images are unknown to us. Thus, the dearth of information about her provides no basis for a final conclusion. The question as to who is depicted in the bronze bust of a queen cannot yet be conclusively settled.

This bust was created within a framework of artistic tradition that differs from local Bosporan sculpture and Italo-Roman bronzes. However, it seems possible to link it to an artistic center in northern Syria, known for late Hellenistic monuments. Thus the bronze statue of the Iranian satrap Shami (Smith 1988, pp. 101, 173, pl. 57, nn. 95, 96) has a certain stylistic similarity, especially in the harsh linear engraving, the rendering of the hair, and the symbolism of the ornamentation.

A. T.

BIBLIOGRAPHY: Rostovtsev 1916, p. 1–23; Gaiduke-vich 1955, p. 128, fig. 41; Molchanov 1971, p. 101, pl. 4; Voshchinina 1974, p. 194, pls. CVI, CVII; Sokolov 1976, p. 93; Parlasca 1979, pp. 397–98; *Great Art* 1994, pp. 330–31, no. 317; Treister 1998b, p. 169; Saprykin 2002, p. 96.

86

86

Miniature Portrait of Livia

Eastern Mediterranean
First century A.D. (possibly after A.D. 42)
H: 3.5 cm
Glass
Nymphaion, 1983. Excavations of N. L. Grach
Acquired in 1983
Inv. NF.83.235

Miniature portrait of a woman's head cast in glass using the lost-wax technology. The state of preservation of the sculpture makes it impossible to assess whether the head was part of a bust or a whole figurine: some of the right side of the face, pieces of the hair at the back of the head, and almost the entire neck have been lost.

The head is slightly turned to the right. The hair is parted and frames the face with thick locks. On top of the hair is a diadem in the form of a ribbon. In spite of the chipping on the back of the head, it is clear that the hairstyle included a knot in the back that came down to the neck. The individual characteristics, such as the low forehead, widely spaced eyes, firmly shut mouth with thin lips, small chin, and hairstyle with a knot of hair coming down to the shoulders are

187

typical for portraits of Livia, the wife of
Emperor Augustus. The ribbon (diadem)
points to Livia being depicted as a goddess in
this portrait.

The deification of Livia occurred in A.D.
42, so it follows that this portrait was not
created earlier than that. The glass portrait
found in the Bosporan city of Nymphaion,
along with other evidence, indicates that
there was a cult of Livia in the Bosporan
kingdom. In the nineteenth century two
bases for statues of Livia were found on the
territory of the Bosporan kingdom. Judging
from the inscriptions on these bases, one
statue was erected by the Bosporan queen
Dynamis, the granddaughter of Mithridates
VI Eupator, and the other by Pithodorida,
the wife of Polemon, the Bosporan ruler
(reigned 13–8 B.C.). This miniature sculp-
ture is the only known cast-glass portrait of
Livia. It adds to the small series of minia-
ture glass depictions of emperors and their
families, among which the portrait of
Emperor Augustus found in Cologne is the
most important.

N.K.

BIBLIOGRAPHY: *Tesori d'Eurasia* 1987, p. 45, cat. 180;
Great Art 1994, p. 331, no. 318; Kunina 1997, cat. 78;
Kunina 1998, p. 51–53, pl. XVI; *Nymphaion* 1999,
cat. 186; Kunina 2000, pp. 251–54; *Nymphea* 2002,
cat. 77.

87

Bottle

Syria
Second half of the first century A.D.
H: 17.1 cm; Diam (max.): 8 cm;
 Diam (mouth): 2.4 cm; Diam (foot): 3.7 cm
Glass
Necropolis of Nymphaion. Former collection
 of A. V. Novikov
Acquired in 1900
Inv. E.642

Bottle made from transparent light-blue glass.
The bottle was blown as a four-sectioned
form, as can be seen from the seams that con-
nect the parts. The vessel has an elongated

87

tight neck with a socket-shaped lip, a spheri-
cal body with a stepped shoulder, and a
flat bottom. It has a relief decoration: on the
shoulders and the lower part of the body
are double rows of small circles; in the middle
of the body there is a broad band of large

overlapping rings with a dot in the middle of each. On the bottom is a circle made in relief.

<div align="right">N.K.</div>

BIBLIOGRAPHY: Kunina 1997, cat. 126; *Nymphaion* 1999, cat. 193; *Nymphea* 2002, cat. 80.

88

Pitcher

Eastern Mediterranean
First century A.D.
H: 19 cm; Diam (max.): 12.4 cm; Diam (mouth): 4.4 cm; Diam (foot): 6.8 cm
Glass
Necropolis of Nymphaion. Former collection of A. B. Novikov
Acquired in 1900
Inv. E.684

Pitcher made of transparent cobalt-blue free-blown glass. The neck, crowned by an everted massive lip, flares out toward the bottom and the body is in the form of a slightly flattened sphere. The lower part of the body changes into a greatly narrowed foot with a concave bottom. The ribbed handle with a vertical upper protrusion is smoothly bent.

<div align="right">N.K.</div>

BIBLIOGRAPHY: *Great Art* 1994, p. 259, no. 240; Kunina 1997, cat. 250; *Nymphaion* 1999, cat. 204; *Nymphea* 2002, cat. 81.

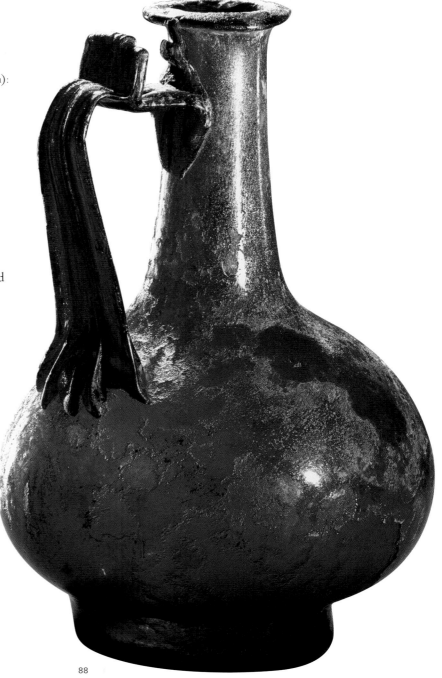

88

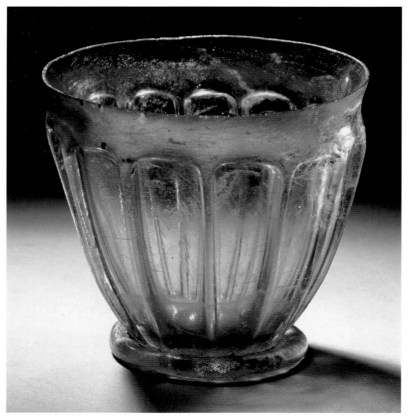

89

Beaker

Northern Italy
First half of the first century A.D.
H: 7.5 cm; Diam (mouth): 8 cm;
 Diam (foot): 5 cm
Glass
Necropolis of Nymphaion. Former collection
 of A. B. Novikov
Acquired in 1900
Inv. E.663

Beaker made of transparent aquamarine free-blown glass. The slightly rounded body, which widens to the mouth, has thirteen ribs on the exterior. The upper part of the body is smooth. The edge is cut off. The protruding foot, together with the bottom, is concave, forming a hemispherical kick inside the glass.

N.K.

BIBLIOGRAPHY: Kunina 1997, cat. 302; *Nymphaion* 1999, cat. 196.

89

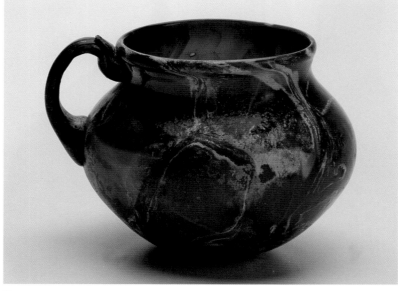

90

Jar

Eastern Mediterranean
First century A.D.
H: 6 cm; Diam: 7.5 cm; Diam (mouth): 5.5 cm;
 Diam (bottom): 2.8 cm
Glass
Necropolis of Nymphaion. Former collection
 of A. B. Novikov
Acquired in 1900
Inv. E.689

The jar is free-blown from transparent dark-blue glass with stains of milky-white opaque glass. The convex rim, concave neck, swollen middle part of the body, and flat bottom make the vessel similar in appearance to a small pot. The looplike bent handle rises slightly above the mouth.

N.K.

BIBLIOGRAPHY: Kunina 1997, cat. 315; *Nymphaion* 1999, cat. 199.

90

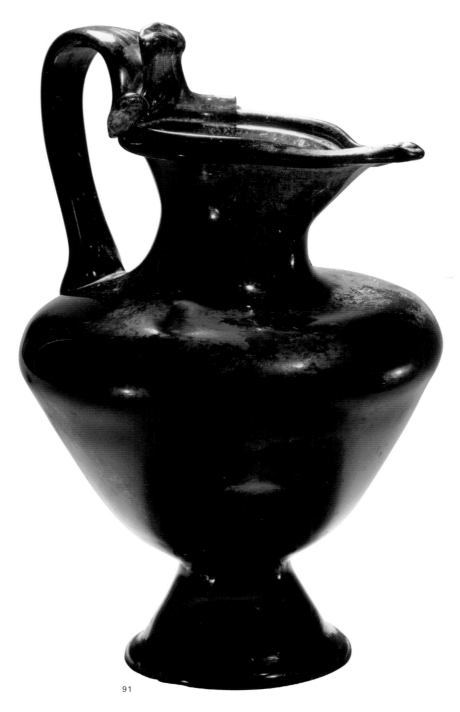

91

Pitcher

Eastern Mediterranean
Third–fourth century A.D.
H: 19.8 cm; Diam (max.): 13.6 cm; Diam (mouth):
 6.6 cm; Diam (foot): 7.5 cm
Glass
Necropolis of Nymphaion. Former collection
 of A. B. Novikov
Acquired in 1900
Inv. E.683

Pitcher made of dark cherry-colored, trans-
parent free-blown glass. Funnel-like mouth
with narrow stretched-out spout and inward-
slanting edge. The short neck broadens
toward the horizontal shoulder. The cone-
shaped body greatly narrows at the bottom
and rests on a conical foot, flaring toward the
bottom. The ribbonlike handle bent above
the mouth has three vertical protrusions
at the attachment to the rim (one large and
two small ones).

N.K.

BIBLIOGRAPHY: Kunina 1997, cat. 392.

91

92

Sarcophagus Appliqué: Niobid

Bosporan Kingdom
First–second century A.D.
Terracotta
H: 27.6 cm; W: 16 cm
Necropolis of Pantikapaion, 1832. Stone chest.
 Excavations of D. V. Kareisha
Acquired in 1851
Inv. P.1832.22

Part of a relief composition that adorned a wood sarcophagus: figure of a nude boy, fallen on his knees, turning to his left. With his left arm bent at the elbow the boy holds the folds of his himation, which is thrown over his body and billows behind him. The lap of the himation is shown by two protrusions—from the left forearm and buttocks. A large part of the right arm has been broken off, but judging from the remaining fragment, it was upraised or placed behind the head. The relief is made in one piece from local clay in various shades of red: darker, red-brown tones in the upper part of the figure and lighter, almost orange hue in the lower part. As a result of misfiring, the superficial layer, especially on the reverse side, is a pale yellow-gray color. The reverse side of the relief is flat, with an uneven surface and clotted clay. At the bend of the leg and in the middle of the stomach are deep traces of fittings or work with a tool. The front of the relief was covered with a layer of white small-grained plaster that served as a foundation for the painting. Traces of pink paint are preserved in the folds of the hima-tion on the shoulder, at the bend in the elbow, and the edge below.

Traditionally, since the time of the publi-cation by S. A. Zhebelev, this figure was taken to represent a Niobid son struck in the back by Apollo's arrow. According to A. V. Kruglov's observation, the upper part of the figure represents a variant of the statue type of silenus with a wineskin, depicted on the well-known relief *Dionysos Visiting the Dramatic Poet* (Watzinger 1946/47; Kruglov 1987, fig. on p. 34; *Muzy i maski* 2005, cat. 7, p. 52). Most likely this statue type was used

by the sculptor who fashioned the cast for the terracotta relief and adapted by him in accordance with the compositional and conceptual problems of the adornment of a sarcophagus.

N. J.

BIBLIOGRAPHY: Zhebelev 1901, p. 15, fig. 23.

93

Sarcophagus Appliqué: Niobid

Bosporan Kingdom
First–second century A.D.
H: 27. cm; W: 15 cm
Terracotta
Necropolis of Pantikapaion, 1832. Stone chest.
 Excavations of D. V. Kareisha
Acquired in 1851
Inv. P.1832.23

Terracotta relief similar to cat. no. 92. As in that relief, with his left arm bent at the elbow, the youth holds the folds of his himation, which is thrown over his back and billowing. The himation's uneven line forms the edge of the relief along the back, from the left elbow to the feet. Compared to cat. no. 92, this relief is somewhat better preserved. The details and features are more distinct and it is therefore clear that the left hand is clutching, along with the himation, the upper part of a wineskin executed in low relief, whose lower part protrudes from the left forearm. S. A. Zhebelev interpreted this detail of the relief as a hunting bag, thus the man as an African servant (Zhebelev 1901, p. 15). However, the head with the high sloping forehead is unmistakably topped by an ornamental band or wreath. The right hand has not survived and the shoulder has been chipped. The relief is made in one piece of local clay, reddish orange in color. The back side is flat with an uneven surface, clotted clay, and the same indentations as cat. no. 92. In the middle of the back side there is a small irregularly formed patch with uneven edges made of the same clay as the entire figure but of a lighter

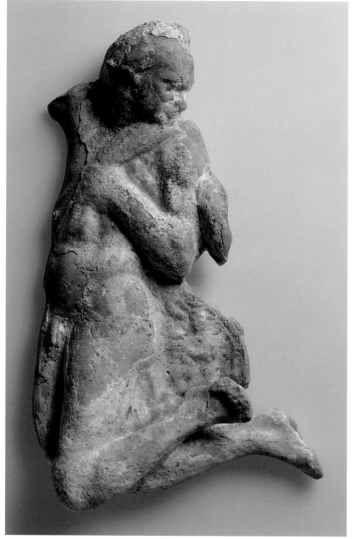

92

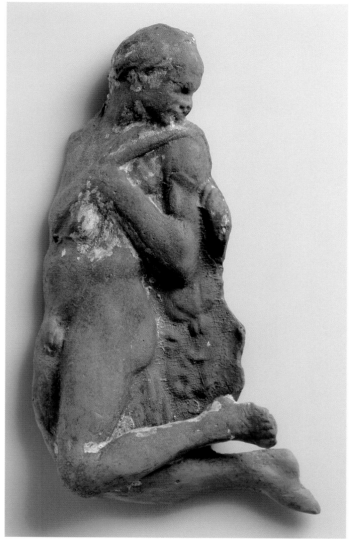

93

hue. The front of the relief was covered with a thin layer of white plaster, whose traces have been preserved on different parts of the surface.

The relief was part of a multifigured composition adorning the panel of a wood sarcophagus. Like cat. no. 92 it depicts a Niobid youth struck in the back by Apollo's arrow. According to Zhebelev's theory, the fact that there were twin pieces of identical reliefs in a group of finds in the same complex indicates that there were two sarcophagi in the tomb.

N.J.

BIBLIOGRAPHY: Not previously published.

94

Sarcophagus Appliqué: Niobid

Bosporan Kingdom
First–second century A.D.
Terracotta
H: 21.8. cm; W: 17.4 cm
Necropolis of Pantikapaion, 1862.
 Stone vault no. 55, with four niches, in a
 kurgan on Mount Mithridates
Acquired in 1862
Inv. P.1862.52

Part of a relief composition adorning a wood sarcophagus—a figure of a young woman fallen to her knees. The female Niobid, struck by Artemis's arrow, is shown in a complicated turn (the legs and the lower part of the torso are in right profile, the upper part of the torso is frontal, the thrown-back head is turned in profile to the left with the face turned upward). The girl is wearing a chiton, which almost completely covers the legs; only the right foot is visible. The right hand is behind her head and the left is hidden by the peplos, which cascades down from her shoulders in heavy folds.

The relief was made of local reddish-orange clay. The back side is concave, uneven, and roughly smoothed over with a spatula. The decoration is from a group that accounts

for the largest number of terracotta relief figures ever found in burials. S. A. Zhebelev has proposed that they decorated one sarcophagus, for no pairs have been found in this assemblage (Zhebelev 1901, p. 18). It is important that there are no analogies and prototypes of this particular figure in other well-known artifacts dealing with the myth of the destruction of the Niobids (Waldhauer 1945; Pinelli and Wąsowicz 1986; Pinelli 1987) such as the Strangford Shield of Athena (London, The British Museum), the marble relief from the Campana collection (St. Petersburg, The State Hermitage Museum), or red-figure vessels and paintings (Zhebelev 1901, pp. 40–44). Only on the longer panel of the marble sarcophagus in the Glyptothek in Munich (Zhebelev 1901, p. 23, fig. 28; Robert 1968, cat. 312, pl. XCIX, pp. 373–85) does the central female figure represent the reverse variant of one of the daughters of Niobe, resembling our terracotta relief. Explanation of this fact may be rooted in the thoroughly creative reworking of the traditional statuary types and artistic concepts by a Bosporan coroplast, whose work was in the spirit and tradition of local art. It may also be due to the circumstances of the delivery of the Kerch finds to the Imperial Hermitage. For instance, items from a stone tomb that was discovered in 1832 entered the museum in several rounds: the first delivery happened in the year of the discovery but the second not until 1851. Because fakes and remakes were common in the antique market, and because pieces originating from various places in the region were often combined, objects could easily be added to the original finds from a tomb group. Though this is largely guesswork, the idea should be checked thoroughly.

N.J.

BIBLIOGRAPHY: CR 1863, pl. IV.3; CR 1868, p. 63 (7); Zhebelev 1901, p. 10 (17a), fig. 15; Prichernomor'e 1983, cat. 337; LIMC 6, s.v. "Niobidai," p. 922, no. 42m.

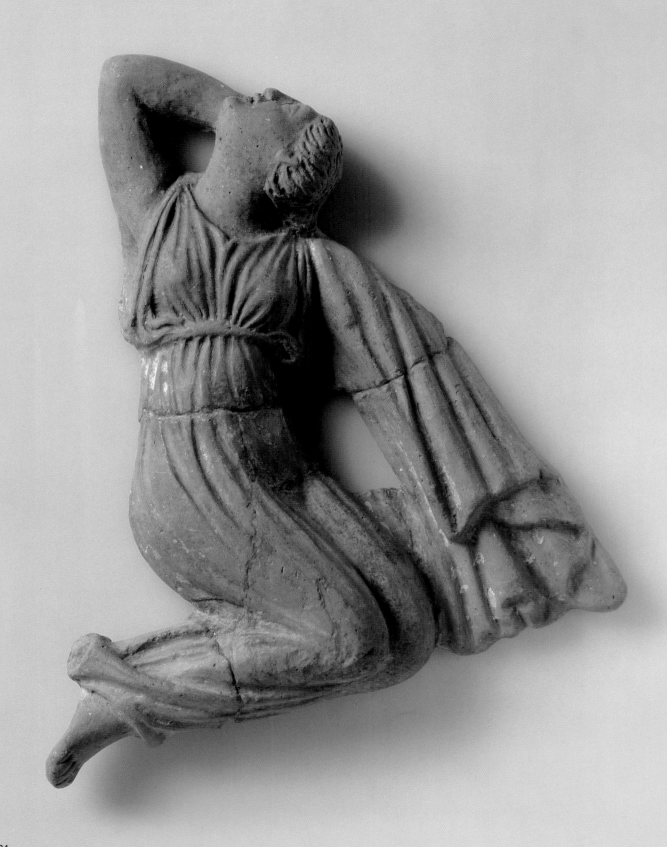

94

especially in the definition of the facial features. The general outlines of the figure and the details of the modeling indicate that both figures could have been made from the same mold. Some of the differences in size (more noticeable in the height and absolutely insignificant in the width) and the state of preservation can be explained by the fragility of the plaster, which is subject to disintegration. On the other hand, clay may lose more than 7 percent of its volume during firing and drying (Berzina 1962, p. 245). In all likelihood, however, environmental factors are more likely to affect a plaster object in the ground than a terracotta one.

N. J.

BIBLIOGRAPHY: Not previously published.

96

Sarcophagus Appliqué: Niobid

Bosporan Kingdom
First–second century A.D.
H: 24.5 cm; W: 20.5 cm
Terracotta
Necropolis of Pantikapaion, 1867. Bedrock
 on northern slope of Mount Mithridates.
 Catacomb 115
Acquired in 1867
Inv. P.1867.60

Figure of a woman wearing a chiton girded under the breasts and a billowing himation. She is running to the right, her right hand thrown back, her left hand raised high, holding the himation. The figure is presented in a complex turn: the head, shoulders, and the upper part of the torso are shown frontally; the lower part of the figure is turned to the right; the right foot is in profile; the left is hidden by the numerous folds of the chiton. The modeling of the entire figure is meticulous and the rich relief is clearly detailed. The thick hair is neatly combed and parted in even locks covering the ears. The hairstyle is rendered through shallow, short incised lines. The face has a narrow forehead,

95

95

Sarcophagus Appliqué: Niobid

Bosporan Kingdom
Second half of first–first half
 of second century A.D.
H: 20.5 cm; W: 17.5 cm
Plaster
Purchase. I. I. Tolstoy's Collection
Acquired in 1967
Inv. E.3206

Figure of a young woman fallen on her knees. Plaster version of the terracotta relief cat. no. 94. There are remains of brown and light blue color on the Niobid's clothing and pink color on her neck and hands. The back side is flat. The plaster version is in a much worse state of preservation than the terracotta,

196

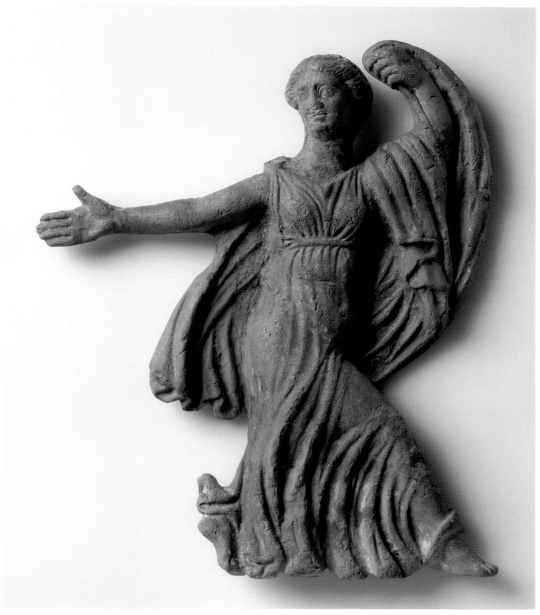

96

large nose, and soft, roundish cheeks. The
large eyes under the relief eyelids especially
stand out. The head is slightly turned toward
the left, the long neck transitions smoothly
to the exposed upper part of the chest seen
above the folds of the chiton. The muscular
hands are disproportionately large. The relief
of the body—small, girlish breasts, the round
surface of the belly showing the belly button,
and the turn of the hips—is skillfully
revealed beneath the undulating folds of the
clothing. The toes are indicated on the bare

foot by short incisions. The back side is
uneven, with clotted clay and indentations at
the back of the head, the middle of the figure,
and the back of the left hand. The clay is
Bosporan, with a reddish-brown tint. A figure
in the State Historical Museum in Moscow
(Zhebelev 1901, p. 10, fig. 11) is analogous to
this one, although it has differences in the
execution of the head, especially the hairstyle
and face, which are rougher and heavier
in the Moscow example. Zhebelev suggested
that the treatment of the clothing and the

general artistic solu-tions of the terracotta Niobids could have been derivative; he named the Chiaramonti Niobid as a possible sculptural prototype (Zhebelev 1901, p. 32, fig. 39).

<div align="right">N.J.</div>

BIBLIOGRAPHY: CR 1868, pl. II.8, p. 64.(14); Zhebelev 1901, p. 9 (13b); Silant'ieva 1974, p. 34, no. 199, pl. 45.4; *Prichernomor'e* 1983, cat. 334 ill.

97a

97b NNF.76.45

97

Sarcophagus Appliqué: Cerberus Mask

Bosporan Kingdom
First–second century A.D.
H: 8.9 cm; W: 8 cm
Terracotta
Necropolis of Pantikapaion, 1862. Earthen tomb no. 62 in the kurgan on Mount Mithridates
Acquired in 1862
Inv. P.1862.70

Mask of a dog with pointed ears and a wedge-shaped snout. The mask is executed in high relief. The details of the composition of the head have been rendered precisely. The middle line of the forehead is rendered through a shallow indentation and the arc above the eyes merge with the bridge of the nose. The triangular ears, indented in the middle, are thick at the edges. The deep-set eyes with round, convex pupils and molded eyelids are rendered in relief. The mouth gapes open; a sharp instrument was used to delineate whiskers and the thin lines that represent the fur, which frames the head in a sumptuous collar. The back of the piece is uneven and deeply concave. Only the ears and the edge of the mask are smoothed over.

Masks of Cerberus endowed with apotropaic qualities were mounted on the panels of sarcophagi to protect souls reposing in the realm of the dead. This mask was part of a group of twelve identical adornments in one sarcophagus (CR 1862, p. 12, no illustrations).

Two analogous plaster masks, retaining traces of black and pink color, were discovered in 1976 during the excavations of the Nymphaion necropolis in a burial cut into a cliff, the so-called stone chest, with fragments of a wooden sarcophagus (collection of the State Hermitage Museum, inv. NNF.76.45; Grach 1999, pp. 49–50, 209).

<div align="right">N.J.</div>

BIBLIOGRAPHY: Not previously published.

98a

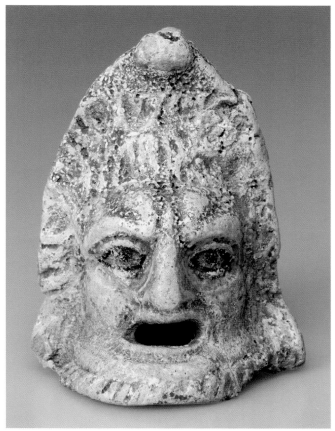

98b

98a,b

Two Sarcophagus Appliqués: Tragic Theatrical Masks

Bosporan Kingdom
Second half of first–first half of
 second century A.D.
Plaster
H: 11.4 cm W: 8 cm; H: 11.4 cm W: 8.4 cm
Necropolis of Pantikapaion, 1901. Glinishche.
 Stone chest no. 30 (28) on the edge of
 the kurgan. Excavations by V. V. Shkorpil
Acquired in 1925
Inv. P.1901.3/1–2

Two plaster adornments of a wood sarco-phagus in the form of small-scale painted theatrical masks of a wrathful or heroic character with a stern gaze, eyebrows severely drawn together, and open, shouting mouth. The masks were cast in a deep mold with magnificently worked relief to define all the features of the face with great verisimilitude: the folds on the forehead and its heavy frowning eyebrows, the deep-set open eyes under relief eyelids, the large hooked nose, and the sunken cheeks and beard. The modeling is meticulous. The nasolabial folds extend from the clearly rendered nostrils to the corners of the well-defined cut-out mouth. A certain measure of conventionality can be observed only in the rendering of the beard, the curls, and the pointed headdress of each. The curls of the hair and the short beard are shown through small indentations applied with a blunt instrument. The outline of the mask is triangular, its top marked by the round terminal of the hat (*onkos*). The painting, in black and light blue, is applied to a primer coating of completely white small-grained plaster. The shape of the eyes is framed by black paint; the pupils are also black. The eye sockets are painted with a broad light-blue band. Traces of black paint have been preserved in the channels of the relief on the hair and beard. The reverse side

199

is greatly indented. The lower part of the mask has been trimmed with a tool.

The masks were found in a grave next to the remains of a wood sarcophagus in which seventy whole plaster adornments of all shapes and forms were found. There were fifteen theatrical masks, which are now in the Hermitage. Many misshapen pieces of rubble—the byproducts of the production process—were found near the burial. This indicates that the plaster items were fastened to the walls of the sarcophagi directly next to the place of burial, evidently not long before the burial ceremony.

<div align="right">N.J.</div>

BIBLIOGRAPHY: *Antichnye gosudarstva* 1984, pp. 80–81.

99

Sarcophagus Appliqué: Gorgon Mask

Bosporan Kingdom
Second half of first–first half of
 second century A.D.
H: 11.6 cm; W: 12.0 cm
Plaster
Necropolis of Pantikapaion, 1901. Glinishche.
 Stone chest no. 30 (28) on the edge of
 the kurgan. Excavations by V. V. Shkorpil
Acquired in 1925
Inv. P.1901.4

Gorgoneion painted in light ocher, black, and light blue paint on a primer coating of pure white small-grained plaster. The almost round relief is a representation of the head of Medusa, a traditional symbol in Greek art that had an apotropaic function. The curly locks of hair frame the face, the intertwining bodies of the snakes are tied in a knot under the chin, the tails are placed on the face in undulating relief lines, the upper parts and heads of the reptiles, seemingly crawling out from under the hairstyle to the forehead, and raised up on their underbellies, are squirming in different directions. Between them is a decorative knot of tightly braided hair. The mold-made mask presents the face of

the Medusa as childishly puffy, with full cheeks, neat straight nose, small chin and mouth, and soft lips. Although the relief is rather high, the attempt to transmit the terrible countenance of this mythological monster is made not so much through plastic means as by painterly ones. The face of Medusa preserves its naive expression rather than being menacing or frightening. The knitted brows and shape of the large eyes framed by the relief eyelids are painted black. The locks of hair are covered in ocher; the bodies of the snakes are painted light blue. The back side is flat, with an indentation in the middle that deepens toward the center, and it is roughly finished at the edges, with traces of fastening on the surface.

Several types of Medusa masks are known. They were widespread not only in Bosporan plaster arts but also in coroplastic arts and in the adornment of marble sarcophagi (Pinelli and Wąsowicz 1986, cat. 26, 28–34, pp. 89, 91–101; *Tesori d'Eurasia* 1987, cat. 181, 182, p. 146; Walker 1990, cat. 44b, pl. 17, p. 40, cat. 49, pl. 19, pp. 42–43, cat. 52, pl. 22, p. 45). However, as the authors of the catalogue of the Louvre collection of plaster adornments of wooden sarcophagi write, the majority of these objects from Kerch and its environs are this type (Pinelli and Wąsowicz 1986, cat. 30a, b, pp. 93–94).

The mask comes from the same complex of the necropolis of Pantikapaion, where many plaster adornments were found, including the theatrical masks in cat. no. 98.

<div align="right">N.J.</div>

BIBLIOGRAPHY: Not previously published.

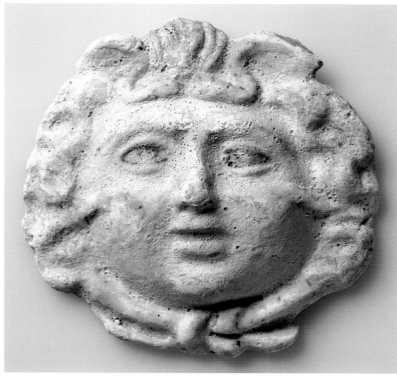

99

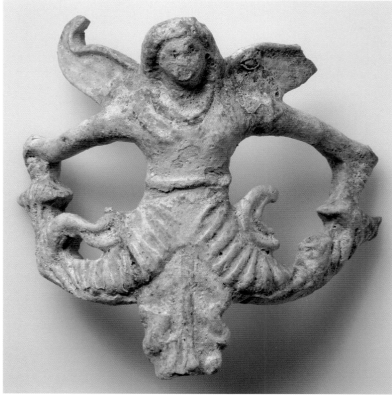

100

100

Sarcophagus Appliqué: Serpent-legged Goddess

Bosporan Kingdom
Second half of first–first half of
 second century A.D.
H: 14.4 cm; W: 12.3 cm; D: 6.5 cm
Plaster
Necropolis of Pantikapaion, 1901. Glinishche.
 Stone chest no. 30 (28) on the edge of
 the kurgan. Excavations by V. V. Shkorpil
Acquired in 1925
Inv. P.1901.13

Seven wood sarcophagus adornments in the
form of a winged serpent-legged goddess
were found in the same complex as the masks
in this exhibition (cat. nos. 98, 99). This is
one of the most mysterious and unusual
female divinities of the ancient world to be
represented by artists and craftsmen. In
the northern Pontic area, the image of the
serpent-legged goddess is found in the
decoration of architecture, as gravestones
(Sokolov 1976, cat. 115, p. 57), horse harness
ornaments (Artamonow 1966, p. 54, cat. 186,
p. 112), and sewn-on gold plaques (*Greek Gold*
2004, pp. 97–98, fig. 58). In many cases the
goddess is depicted as half maiden and half
serpent, as Herodotos refers to her (Hdt.
4.9), that is, she has serpents for legs—thus,
she was called "Serpent-legged." Often,
however, the lower part of the body of this
divinity ends in curls of vegetative sprouts
or acanthus leaves (see cat. 143, 169). The
divinity seems to grow out of the ground,
thus indicating her ties to both the vegetative
powers of nature and the underworld. This
is a visual representation of a cult in which
there is an indissoluble intertwining of ideas
regarding the eternal cycle of life and death
(Machinskii' 1978, p. 136); like many ancient
symbolic figures, the Serpent-legged goddess
became representational and gradually
acquired a certain conventionality as it took
its place among the traditional ornamental
motifs (Jijina 2004, p. 245, figs. 1, 2).

This figure of the goddess is one of her
more widespread types. She is seen frontally;
with her hands set apart she is holding the

201

ends of luxuriant plant shoots with leaves and flowers. Light blue wings with yellowish-gray borders and arched ends rise from her back. Curling downward from her waist spread broad acanthus leaves, transitioning into upward-curling shoots, and terminating in blossom clusters growing from the conventionally depicted calyx lobes the goddess holds in her hands. The entire surface of this part of the image is covered with small indentations of slanted fluting in which the light blue of the background is interrupted by the white stripes of the vegetal shoots. Between two light blue leaves there is a third central pink leaf with a wavy edge and a central vein in relief. The human part of the figure shows a woman with thick, smooth hair cascading down to the shoulders. The unexpressive facial features are not executed with care. The eyes, set somewhat deeply, are outlined in black. The goddess wears a necklace, indicated through a continuous shallow relief line colored yellow-gray. Its line is repeated by the contours of the cutaway of her short-sleeved garment, which is girded with a sash, in relief, at the waist.

Appliqués of this type, found in 1901, including the one in the exhibition, differ from the majority of similar ones in that they were supposedly made to adorn the surface of a sarcophagus on half-columns. This seems to be indicated by the curvature of their smooth, concave backs.

N.J.

BIBLIOGRAPHY: *IAK* 7, p. 81 (no illus.); *OAK* 1901, p. 59, fig. 119; Berzina 1962, p. 241. fig. 2b.

IOI

Sarcophagus Appliqué: Tragic Mask

Bosporan Kingdom
Second half of the first–first half of the
 second century A.D.
H: 10.5 cm; W: 7.5 cm
Plaster
Necropolis of Nymphaion, 1974. Earthen tomb
 K-26. Excavations of N. L. Grach
Acquired in 1974
Inv. NNF.74.562

This tragic theatrical mask belongs to the type of masks with painted eyes and mouth (as opposed to those with perforated eyes and mouth). The upper edge of the headgear (*onkos*) and part of the hair are slightly bent forward. The curls at the sides of the face are rendered like imprecise and slanting cylinders. The mask was cast in a deep mold. The reverse side is concave. The painting has been executed with bright colors—light blue, pink, black, and light ocher.

In the first centuries A.D. theatrical masks were one of the traditional adornments of Roman marble sarcophagi. They were mostly used as corner akroteria or were included in the relief compositions on the walls, together with depictions of figures of Eros with garlands or Dionysian or Muse scenes. During the excavations of Bosporan burials the exact placement of the masks on the panel or lids of wooden sarcophagi was impossible to determine. To this day it is only possible to speculate about where on the panel or lids of sarcophagi such adornments would have been placed, and reconstructions remain only hypothetical (Wąsowicz 1998, pp. 193–95; Jijina 2001, pp. 261–62, figs. 9–10). Features such as the almost right-angled lower edge and the depth of the concave back are very important. In addition to several similar adornments from this complex were found triangular console supports that went under the chin for mounting the masks on a smooth vertical surface (cf. Jijina 2001, p. 258, figs. 7–8).

N.J.

202

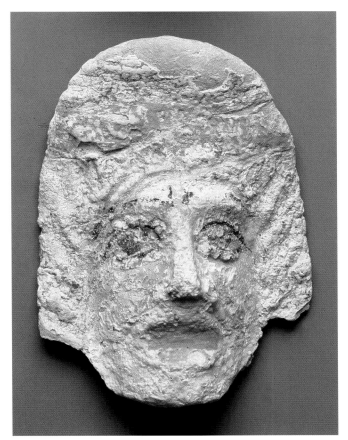

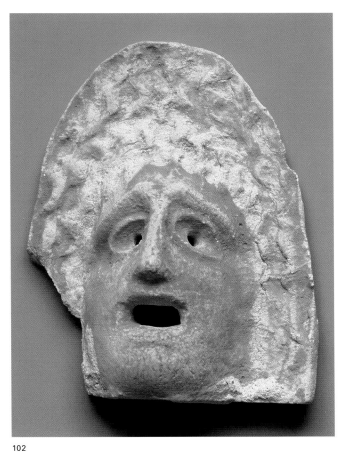

101

102

BIBLIOGRAPHY: *Novye postuplenia* 1977, cat. 871, p. 123
(no ill.); *Tesori d'Eurasia* 1987, cat. 183, p. 146; Jijina
1997, p. 158, fig. 22; *Nymphaion* 1999, cat. 351, p. 124
(no ill.); Jijina 2001, p. 262, fig. 10; *Nymphea* 2002,
no. 156.

102

Sarcophagus Appliqué: Tragic Mask

Bosporan Kingdom
Second half of the first–first half of
 the second century A.D.
H: 10.5 cm; W: 6.5 cm
Plaster
Necropolis of Nymphaion, 1976. Stone chest
 A-68. Excavations of N. L. Grach
Acquired in 1976
Inv. NNF.76.50

This solid theatrical mask is an example of
the type of mask with holes in place of the

eyes and a cut-out mouth. The face has a
narrow forehead with tragically knotted brow
above the bridge of the nose and outlines
of slanting eye sockets, a straight nose, and
round chin surrounded by a billowy surface
representing locks of hair. The mask is almost
completely covered with pink paint and there
are no traces of other colors. The relief is
high and clear. On the lower, thick, cut-off
edge the traces of fastening to the sarcopha-
gus have been preserved—patches of plaster
with which the mask was attached to the
cornice, or protrusion on the lid. The reverse
side is smooth at the sides; in the middle
there is an indentation where the openings
were made for the eyes and mouth.

 This type of mask can be seen, for
example, on the marble sarcophagus in the
British Museum with a depiction of a poet
and muse (Walker 1990, cat. 25, p. 28, pl. 10).

N.J.

BIBLIOGRAPHY: *Tesori d'Eurasia* 1987, cat. 183, p. 146;
Grach 1999, pp. 49–50, fig. 13.2; *Nymphea* 2002, no. 157.

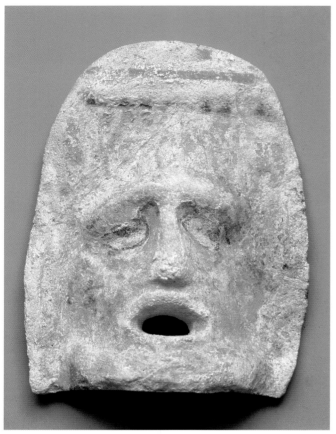

103a

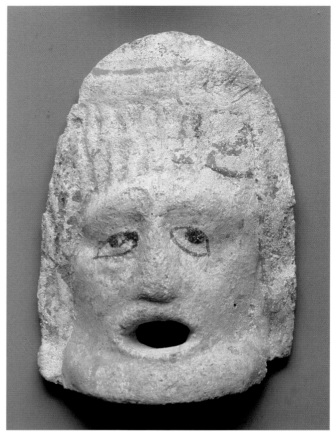

103b

103a, b

Sarcophagus Appliqué: Two Tragic Masks

Bosporan Kingdom
Second half of the first–first half of
 the second century A.D.
H: 10.5 cm; W: 8 cm; H (relief): 2.5 cm
H: 10.5 cm; W: 7.0 cm; H (relief): 3 cm
Plaster
Necropolis of Nymphaion, 1976. Stone chest
 A-68. Excavations of N. L. Grach
Acquired in 1976
Inv. NNF.76.52, NNF.76.55

Two tragic masks of the third type, with a cut-out mouth and painted eyes. This type of mask was made in different molds in comparison with other types with perforated mouths: the upper edge of these is rounded and does not form a triangular top. The relief is less precisely made. Both the molding and the painting have been carelessly executed. The painting of the features—the lines of the eyes and eyebrows and the painting of the locks of hair and the *onkos*—was executed with quick brushstrokes. Unlike other masks of similar type—with a cut-out mouth and thick, evenly cut edge (see cat. no. 102)—the relief locks of hair are rendered in low vertical cylinders that do not wave chaotically on the surface. The face and part of the ornamental bands of the headgear are painted pink. The eyes, eyebrows, locks of hair, and the rest of the bands of the *onkos* are painted black.

The masks with the perforated mouth shown in the exhibition come from the same burial in the necropolis of Nymphaion. This is the so-called stone chest—a rectangular tomb carved into the rock and covered with stone slabs. There was only one sarcophagus in the tomb, which was decorated with masks from different types of molds. This detail is important as one more documented piece

of archaeological evidence that confirms unequivocally the hypothesis that the decorations were not only fastened to the sarcophagus immediately before the burial ceremony, but that they also were made at the burial site.

N. J.

BIBLIOGRAPHY: Grach 1999, pp. 49–50, fig. 13.1 (inv. NNF.76.52); *Nymphea* 2002, nos. 158–59.

104

Marionette: Man Playing a Double Pipe

Bosporan Kingdom
Late first–early second century A.D.
H: 21.5 cm; W (across ears): 5.5 cm;
 W (lower edge of clothing): 5.5 cm
Terracotta
Necropolis of Pantikapaion, 1911. Grave no. 38
 (13). Excavations of V. V. Shkorpil
Acquired in 1915
Inv. P.1911.24

Male piper with pendulous legs and phallus, clumsily and schematically executed. The face has a protruding nose and ears, and there is a vertical protrusion on top of the head. The man is playing a double pipe (*díaulos*), which he holds with both hands. There are traces of white coating on the back side of the head, shoulders, hands, dress, and flute. On top of the coating the eyebrows are painted black and the eyes are circled with black paint. The figure is dressed in a shirt that flares out bell-like toward the bottom. The figure has holes for strings to which the legs and phallus were attached: one hole on the back of the head, two in the lower part of the shirt at the back, and one each in the upper ends of the legs and the phallus. By pulling on the strings, the legs and phallus were set in motion. The legs are rendered in a generalized manner with thick calves and flat, triangular feet. The phallus curves forward.

N. K.

BIBLIOGRAPHY: Silant'ieva 1974, p. 45, pl. 54.4.

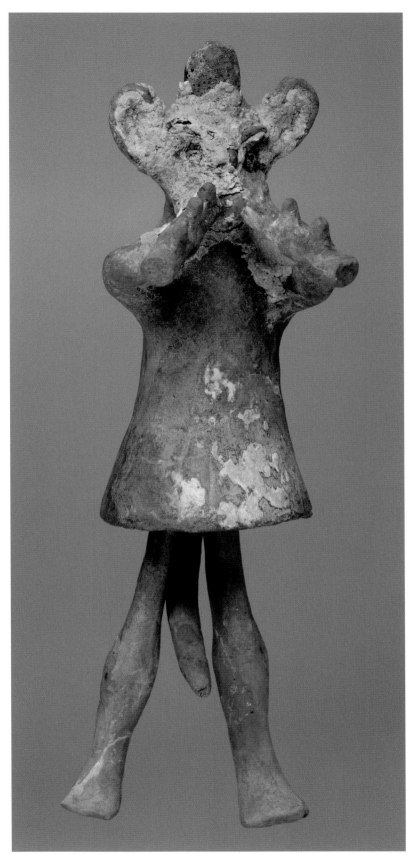

104

205

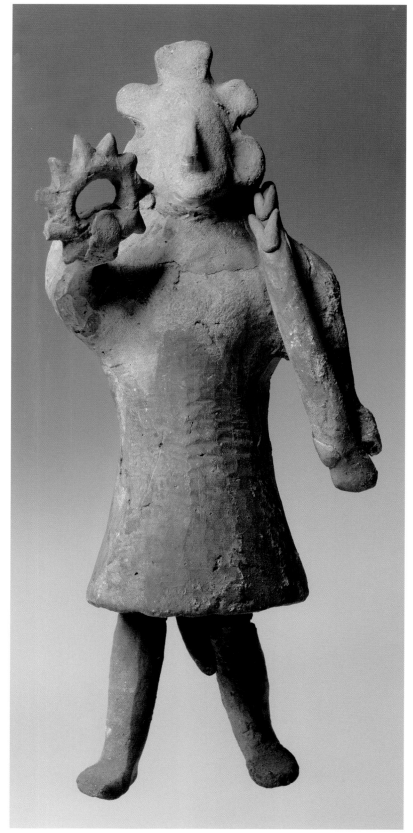

105

Marionette: Male Divinity with Wreath and Cereal Stalk

Bosporan Kingdom
Third century A.D.
H: 23 cm; W(shoulders): 8.8 cm;
 Diam (lower edge of clothing): 6.8 cm
Terracotta
Necropolis of Pantikapaion, 1872. Catacomb.
 Excavations of A. E. Liutsenko
Acquired in 1872
Inv. P.1872.55

Male figure with pendulous legs and phallus, clumsily and schematically executed. The elongated oval face has a large nose and big ears. The marionette is wearing a headgear with three protrusions. The short garment flares out in a bell shape at the bottom. In his upturned right hand the divinity holds a wreath and in the lowered left one, a cereal stalk, whose upper end rests on his left shoulder and touches his ear. The figure has holes for string, from which the legs and phallus were suspended: one hole in the crown of the head, two in the lower part of the shirt in back and, one each in the upper part of the legs and the phallus. By pulling on the strings, the legs and phallus were set in motion. The legs are rendered in a generalized manner with flat, triangular feet. The phallus curves forward.

N.K.

BIBLIOGRAPHY: Silant'ieva 1974, p. 46, pl. 56:3.

105

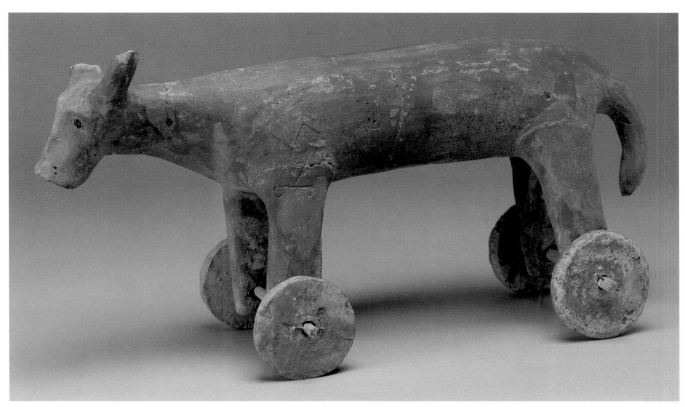

106a

106

Figure of a Bull
on Four Wheels

Bosporan Kingdom
Second half of the first–first half of
the second century A.D.
H: 14.7 cm; L: 23.2 cm; Diam (wheels): 5–5.6 cm
Terracotta
Necropolis of Pantikapaion, 1903. Grave 312
(189). Excavations of V. V. Shkorpil
Found together with cat. no. 107
Acquired in 1904
Inv. P.1903.133

Schematic rendering of a bull with an elon-
gated body, small horns, and short tail.
The head is primitively executed and only
approximately resembles a bull's head. The
eyes are round indentations; in one, the
stone insert has been preserved. At the end
of the round, horizontally truncated snout
the mouth is depicted as a large round
indentation (diam: 0.9 cm; depth: 2.5 cm).
The legs are in the form of rectangular plates.

They have holes at the bottom for the front
and back axles, at the ends of which two pairs
of wheels were fixed on the outside of the
legs. On the left shoulder a sign in the form
of a brand has been incised (see fig. 106b).

N. K.

BIBLIOGRAPHY: see cat. no. 107.

106b

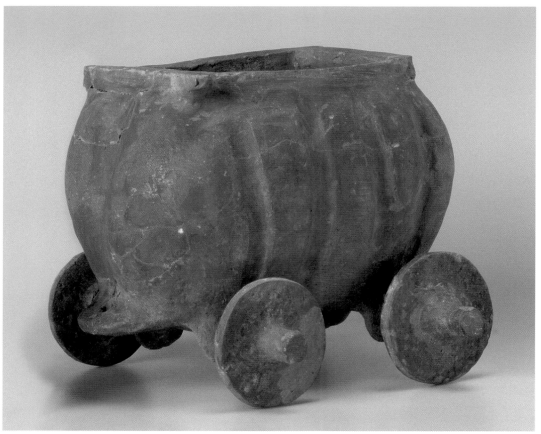

107

107

Cart on Four Wheels

Bosporan Kingdom
Second half of the first–first half of
 the second century A.D.
H: 22.8 cm; L: 27.7 cm; W: 19.5 cm;
 Diam (wheels): 8.8–9.3 cm
Terracotta
Necropolis of Pantikapaion, 1903. Grave 312
 (189). Excavations of V. V. Shkorpil
Found together with cat. no. 106
Inv. P.1903.132

Cart with convex carriage body on four
wheels. The body is open on top. The walls
of the body have vertical grooves: three on
each side and one each in the front and the
back. On top of the corners of the body
were small protrusions, of which only one has
survived. On the lower part of the front wall
of the body is a protrusion with a hole for

the carriage pole, which connected the cart
to the harness of the bull. The wheels of the
carriage have hollow cylinders for the axles.
The axles went through the openings of
the vertical semicircular projections in the
lower corners of the carriage.

N.K.

BIBLIOGRAPHY: Silant'ieva 1974, p. 37, no. 230, pl. 51.1;
Rome Faces the Barbarians 1993, cat. nos. 15.02–15.03, p.
27 illus.

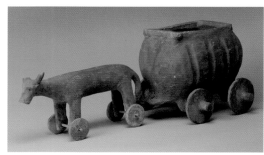

106 and 107

108

Statuette of Cybele

Bosporan Kingdom
Third century A.D.
H: 19.2 cm; W (max.): 12.6 cm; Diam (base):
 7.5 cm
Terracotta
Necropolis of Pantikapaion, 1910. Accidental find
Inv. P.1910.145

The goddess is sitting on a throne with a
high pyramid back. The parts of the woman's
body are disproportionate: the head and
hands are very large and the body is small.
The feet are resting on a stool. The face of
the goddess is elongated, with a large nose,
a horizontal strip for the mouth, and a
sharp chin. In her right hand she is holding a
round fruit and in her left, a libation cup.
She is wearing a conical headdress and a thin
chiton with folds enveloping her breasts
and knees. From the bottom of the chiton the
tips of her feet stick out. Remains of white
coating and paint have been preserved on
some parts of the statuette. There are traces
of black paint around the eyes. On the left
side of the back of the throne is a red stripe
and under the right arm along the left lower
edge of the statuette is a wavy red design.
Inside the libation cup, on the white coating,
are remains of dark red paint.

N.K.

BIBLIOGRAPHY: Silant'ieva 1974, p. 35, no. 214, pl. 48.3;
Kobylina 1961, p. 161, n. 18 (mistakenly listed as inv.
P.1910.14).

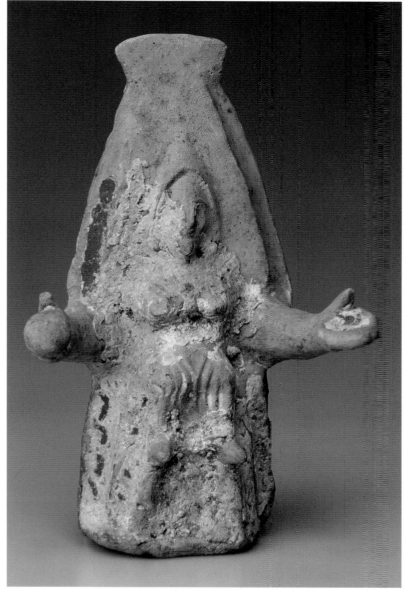

108

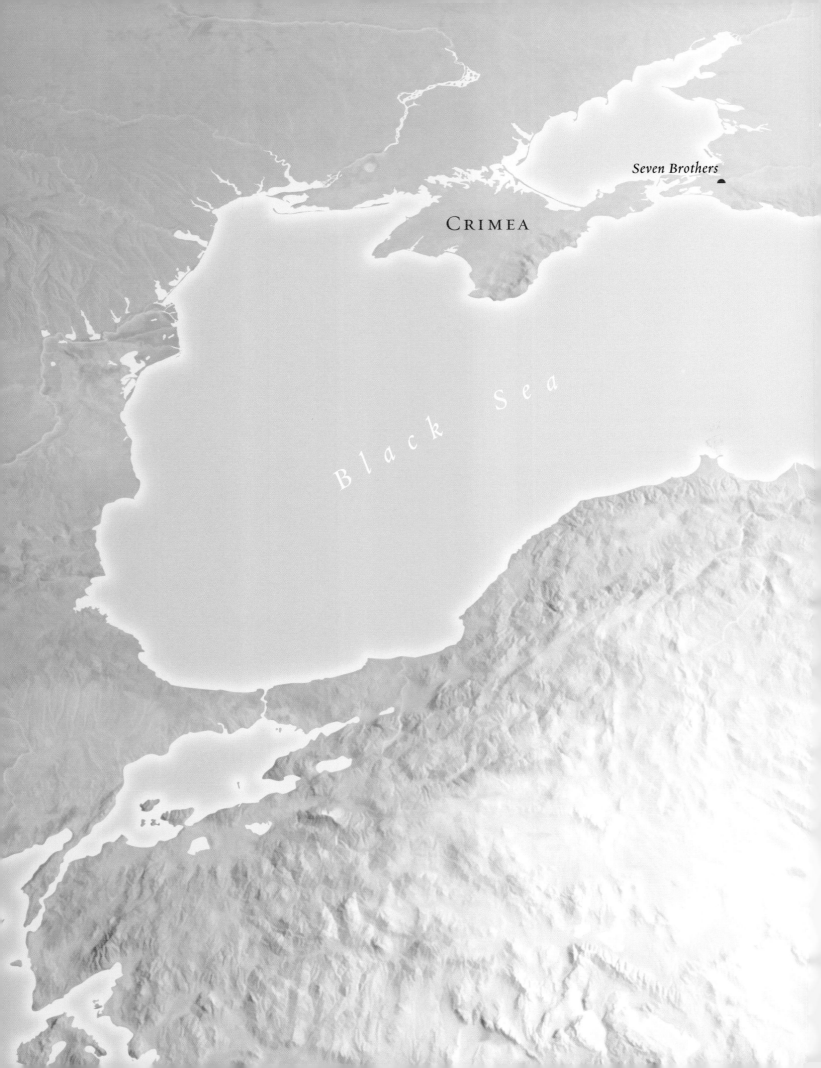

Seven Brothers

CRIMEA

Black Sea

Seven Brothers Kurgans

THE SEVEN BROTHERS KURGANS ARE LOCATED AT THE LOWER COURSE of the Kuban River on the Taman Peninsula. According to a local legend, the seven tumuli are called "Sem' Bratiev" because seven brothers were buried in them (fig. 11). These kurgans were excavated in 1875, 1876, and 1878 by Baron V. G. Tiesenhausen, a member of the Imperial Archaeological Commission. Depending on their size, the kurgans were called Great or Small. The height of the largest one is 15 meters. For these kurgans, raw tombs with wood covers were typical. Such a tomb would be in the center of the kurgan and consisted of two or more sections. In kurgan no. I there was a stone tomb. All of the burials were individual. The deceased lay in sarcophagi under coverlets. In several of the kurgans were found fragments of cloth with images or ornamentation. It is supposed that the cloth articles were made in the Bosporus (Gerziger 1973).

Local non-Greek burial rituals are characteristic of the Seven Brothers kurgans. The dead had gold jewelry (cat. no. 116); their clothing was decorated with gold plaques with images of animals and gods (cat. nos. 109–15). The funerary items were placed by the head of the deceased or in a special part of the tomb. These included weapons and armor; ceramic vessels produced in Attika and locally; bronze goods from Etruria and Magna Graecia; as well as unique gold and silver vessels of different provenance: an Achaemenid silver rhyton, silver kylikes made by Greek craftsmen (cat. no. 119), and gold drinking horns (cat. no. 120) possibly produced in the Kuban region. In all of the kurgans horses were buried with harnesses whose bronze fittings are in animal style (cat. nos. 122–25).

The construction of the Seven Brothers kurgans began in the middle of the fifth century B.C., when the Bosporus was ruled by the Archeanactids (480–438 B.C.) The last ones appeared during the reign in the Bosporus of Leukon I (389/8–349/8 B.C.) from the Spartocid dynasty.

Apparently all of those buried in the kurgans were from different generations of the same clan. These seven kurgans can be seen as a single burial complex. Most scholars believe that they belonged to the Sindians. In these kurgans were buried the representatives of the highest Sind aristocracy, possibly even Sind kings.

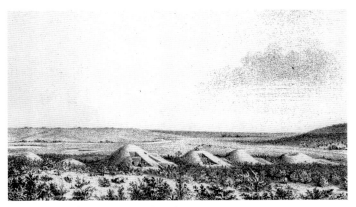

Fig. 11. View of the Seven Brothers kurgans. From *ABC*.

The area of the Sindoi encompassed the Taman peninsula and part of the Black Sea coast. On this shore the Greeks founded the city of Sindikos Limen (later Gorgippia). According to ancient authors, the Sindoi were ruled by kings. In the middle of the fifth century they already had their own state and minted coins. Evidently there were good relations between the Sindoi and the Greeks and between the Sindoi kings and the rulers of the Bosporan kingdom (Archeanctids, Spartokids). The territory of the Bosporan kingdom included the northwest part of the Taman peninsula, next to the lands of the Sindoi. On the European side of the Bosporus certain kurgans are attributed to the Sind nobility. Proper names including the ethnonym *Sind*—Sindos, Sindokos, Sindeos—were widespread there.

The originally independent Bosporan poleis began to unite in the fifth century B.C. In the fourth century B.C. the non-Greek population on the Asiatic side of the Bosporus (Sindoi, Toretai, Dandarioi, Psessoi) came under the rule of the Bosporan kings. The Sindoi lost their independence, and their ruler ceased to be called king. It is thought that the last Sind king with a purely Greek name, Hekataios (Ἑκαταιος), was buried in Seven Brothers kurgan no. III.

Some hold that the Seven Brothers kurgans were built by the Scythians, but they did not live permanently on the Taman peninsula. According to Herodotos they wintered there, crossing from the Crimea over the Kerch Strait (Hdt. 4.28). It is believed that the Sind royal house was allied through dynastic marriages to the Scythian royal dynasty, as indicated by the Scythian name of the son of the Sind king Hekataios—Oktamasad.

Sind weapons were based on Scythian types, albeit with Greek elements. The horse harnesses from the Seven Brothers kurgans (cat. no. 118) as well as those from the Tuzlinsk necropolis (cat. no. 69) and the Great Bliznitsa kurgan (cat. no. 172) have their own regional stylistic traits.

There is no doubt that Scythian culture influenced the Sindoi. The scale of the burial structures and the wealth and makeup of the inventory of the Seven Brothers kurgans are comparable to the "royal" Scythian kurgans of the fourth century B.C. However, no "royal" Scythian burials are known to be contemporary with the Seven Brothers kurgans. Therefore, the significance of the Seven Brothers kurgans extends far beyond the framework of the Taman peninsula and the Kuban region. Because of the proximity of the Sind and Scythian worlds as well as the continuous interaction of the Sindoi and the Greeks, the Seven Brothers kurgans is a very important monument of the history and culture of the Sindoi, the Greeks, and the Scythians.

E. V.

SEVEN BROTHERS KURGANS

BIBLIOGRAPHY: *CR* 1875, pp. IV–XV; *CR* 1876, frontispiece, pp. III–VIII, 5, 115, 118, 122–27, 129–38, 147–49, 219, pls. I.1–5; II.2–9, 15–22, III.1–36, IV; *CR* 1877, pp. 6–28, pls. I.1–4, II; *CR* 1878–79, pp. VII–VIII, 120–34, pls. IV–V; *CR* 1880, pp. 95–97, pl. IV.11–18; *CR* 1881, pp. 5–11, pl. II.4; Minns 1913, pp. 25–27; Rostovstev 1925, p. 262; Silant'ieva 1967; Artamonov 1970, p. 39, fig.—pl. VII; Gaidukevich 1971, pp. 58–60; Grach 1972; Chernenko 1973; Gerziger 1973; Maslennikov 1981, pp. 36–37; Shelov 1981; Tolstikov 1984, pp. 37–38; *Greek Gold* 1994, pp. 128–31; *Zwei Gesichter* 1997, pp. 81–92; Tokhtas'ev 1998, p. 300; Vinogradov 2001, p. 85; Vlasova 2001; Maslennikov 2002; Tokhtas'ev 2002, pp. 10–32.

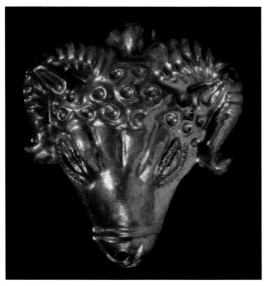

109 2:1

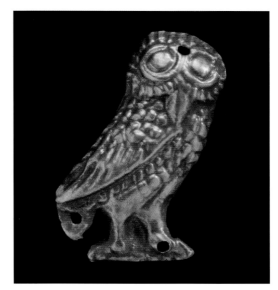

110 2:1

109

Plaque: Head of Ram

Middle–third quarter of the fifth century B.C.
3.4 × 2.9 cm
Gold
Seven Brothers kurgan no. II, 1875.
 Excavations of Baron V. G. Tiesenhausen
Acquired in 1876
Inv. SBr.II.1

Plaque showing the frontal head of a ram with large lowered horns and curls on the forehead that form a kind of rosette in the middle. On the nose and horns of the ram are holes for sewing the appliqué onto clothing.

E. V.

BIBLIOGRAPHY: *CR* 1876, p. 122, no. 27, pl. III.15; *CR* 1875, *Album des dessins*, 23A, no. 78; Artamonov 1970, p. 28, fig. 48; *Greek Gold* 1994, p. 130, no. 73; Jacobson 1995, pp. 166–67, no. IV.B.5, fig. 42; *Zwei Gesichter* 1997, p. 84, no. 8; *Greek Gold* 2004, p. 77, fig. 47, p. 79.

110

Plaque: Owl

Middle–third quarter of the fifth century B.C.
3.2 × 2.1 cm
Gold
Seven Brothers kurgan no. II, 1875.
 Excavations of Baron V. G. Tiesenhausen
Acquired in 1876
Inv. SBr.II.2

Appliqué in the form of an owl; the body is in profile but the head is frontal. The plumage has been rendered through ovals and short lines. There are attachment holes on the head, tail, and leg.

E. V.

BIBLIOGRAPHY: *CR* 1875, *Album des dessins*, 23A, no. 79; *CR* 1876, p. 121 no. 19, pl. III 7; Artamonov 1970, p. 27, fig. 43; Schiltz 1994, p. 128, fig. 98E; Jacobson 1995, pp. 166–67, no. IV.B.6, fig. 44; *Zwei Gesichter* 1997, pp. 84–85, no. 9.

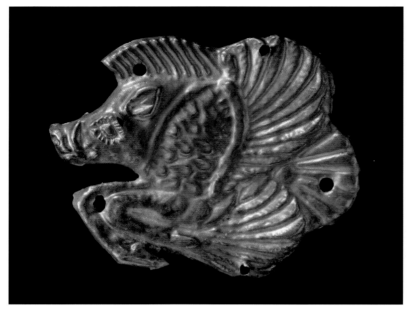

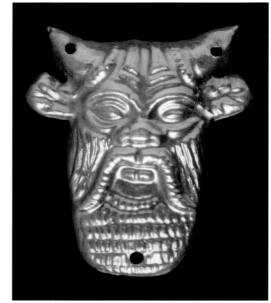

111 2:1

112 2:1

III

Plaque: Winged Boar

Middle–third quarter of the fifth century B.C.
4.1 × 3.3 cm
Gold
Seven Brothers kurgan no. II, 1875.
 Excavations of Baron V. G. Tiesenhausen
Acquired in 1876
Inv. SBr.II.3

Plaque in the form of a protome of a winged
boar in profile. The snout of the animal is
closed; the legs are bent; the small eye is in a
ribbed frame. The mane has been rendered
through a row of slanting lines and the fur
through oval curls. The protome terminates
in a molding, behind which is the wing in
the form of a crooked semicircle with arclike
lines. A similar smaller wing is placed be-
hind the hoofs. Between the wings there is a
palmette, presumably depicting the tail.
There are attachment holes on the mane,
feet, and palmette tail.

E. V.

BIBLIOGRAPHY: CR 1875, *Album des dessins,* 23A, no. 80;
CR 1876, p. 122, no. 29, pl. III.17; Artamonov 1970,
p. 29, fig. 49; Jacobson 1995, pp. 166–67, no. IV.B.7,
fig. 45; *Zwei Gesichter* 1997, p. 85, no. 10.

II2

Plaque: Mask of Acheloös

Middle–third quarter of the fifth century B.C.
3 × 3.4 cm
Gold
Seven Brothers kurgan no. II, 1875.
 Excavations of Baron V. G. Tiesenhausen
Acquired in 1876
Inv. SBr.II.5

Plaque stamped in the form of a frontal male
head with oval eyes, oval ears sticking out to
the sides, triangular horns, wrinkled forehead,
bulbous nose, long drooping mustache, and a
broad roundish beard rendered through rows
of small sticks. There are attachment holes
on the horns and beard. Some scholars refer
to this plaque as a head of Silenus, others as a
mask of Acheloös.

E. V.

BIBLIOGRAPHY: CR 1875, *Album des dessins,* 23A, no. 82;
CR 1876, p. 121, no. 24, pl. III.12; Artamonov 1970,
p. 28, fig. 46; *LIMC* I, s.v. "Acheloos," p. 22, no. 165;
Jacobson 1995, pp. 166–67, no. IV.B.4, fig. 41; *Zwei
Gesichter* 1997, p. 85, no. II.

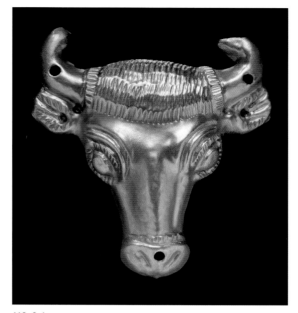

113 2:1

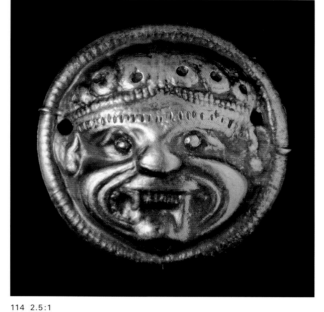

114 2.5:1

113

Plaque: Head of a Bull

Middle–third quarter of the fifth century B.C.
3.4 × 3.6 cm
Gold
Seven Brothers kurgan no. II, 1875.
 Excavations of Baron V. G. Tiesenhausen
Acquired in 1876
Inv. SBr.II.10

Plaque in the form of the frontal head of a bull with upturned horns and oval eyes and ears. On the snout is a narrow horizontal band with incisions, at the base of the horns there are vertical bands. There are also incisions on the ears and incisions representing strands of fur on the forehead. There are attachment holes on the nose and horns.

E. V.

BIBLIOGRAPHY: CR 1876, p. 121, no. 25, pl. III.13; CR 1875, Album des dessins, 23A, no. 87; Artamonov 1970, p. 28, fig. 47; Greek Gold 1994, p. 130, no. 72; Jacobson 1995, pp. 166–67, no. IV.B.5, fig. 43; Zwei Gesichter 1997, pp. 86–87, no. 13; Greek Gold 2004, p. 77, fig. 46, p. 79.

114

Plaque: Gorgoneion

Middle–third quarter of the fifth century B.C.
Diam: 2.7 cm
Gold
Seven Brothers kurgan no. II, 1875.
 Excavations of Baron V. G. Tiesenhausen
Acquired in 1876
Inv. SBr.II.15

Plaque in the form of the frontal head of Medusa. The appliqué has a beaded border. Medusa's eyes are oval with a bead in the middle. On the head are large curls with indentations in the middle; the tongue sticks out. Attachment holes are on the ears and tongue.

E. V.

BIBLIOGRAPHY: CR 1876, p. 121, no. 22, pl. III.10; CR 1875, Album des dessins, 23A, no. 91; Artamonov 1970, p. 27, fig. 45; Greek Gold 1994, p. 131, no. 74; Zwei Gesichter 1997, p. 87, no. 14.

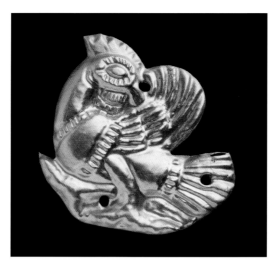

115 2:1

116

Necklace

Mid-fifth century B.C.
L: 27.5 cm; H (pendants): 3 cm
Gold
Seven Brothers kurgan no. II, 1875.
 Excavations of Baron V. G. Tiesenhausen
Acquired in 1876
Inv. SBr.II.27

The necklace consists of nineteen acornlike pendants interspaced with pierced beads, alternating with eighteen oval beads. The beads consist of two halves. Lateral, flat, smooth facets alternate with facets covered with crosshatched incisions; the pierced oval beads follow the same design. The lower end of each pendant consists of a small bead set off from the pendant by a fillet. The top of each pendant is a cylindrical spool connecting the pendant to a pierced bead. The necklace was probably made in the Black Sea region in one of the workshops of the Taman Peninsula.

E. V.

BIBLIOGRAPHY: *CR* 1876, p. 120, no. 11, pl. IV.7; Ruxer 1938, pl. H 2, XIV a 1; Artamonov 1970, p. 26, fig. 41; *Greek Gold* 1994, p. 129, no. 71; *Zwei Gesichter* 1997, p. 83, no. 7.

115

Plaque: Cock

Middle–third quarter of the fifth century B.C.
2.8 × 2.4 cm
Gold
Seven Brothers kurgan no. II, 1875.
 Excavations of Baron V. G. Tiesenhausen
Acquired in 1876
Inv. SBr.II.22

Plaque in the form of a cock depicted in profile, his head turned back. The right wing, rendered by a row of straight incisions, is raised up and considerably bigger than the left one, which is rendered by two rows of incisions. There are also incisions on the tail, the frame around the oval eye, the beard, the vertical bands between the neck and the body, as well as at the middle of the body and the base of the tail. The left leg is straight; the right one is raised and stretched forward. On top of the comb are semicircular indentations. There are attachment holes between the head and the wing, on the tail, and between the legs.

E. V.

BIBLIOGRAPHY: *CR* 1876, p. 122, no. 33, pl. III.21; Artamonov 1970, p. 29 fig. 50; Jacobson 1995, pp. 166–67, no. IV.B.3, fig. 40; *Zwei Gesichter* 1997, p. 88, no. 16.

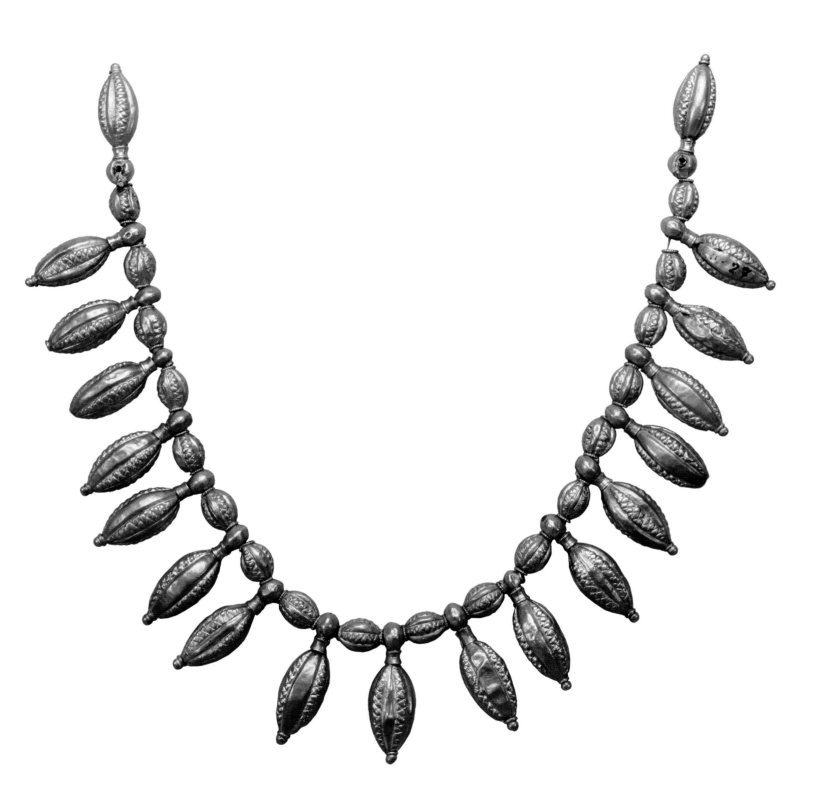

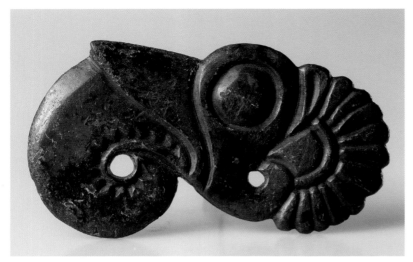

117

117

Plaque: Head of Bird with Palmette

Mid-fifth century B.C.
9.4 × 5.4 cm
Bronze
Seven Brothers kurgan no. II, 1875.
 Excavations of Baron V. G. Tiesenhausen
Acquired in 1875
Inv. SBr.II.55

Appliqué in the form of a bird of prey in profile to left with a large round eye. The head terminates in the back with an eleven-petal palmette adjacent to the ear—there is a petal with an indentation in the middle.

E. V.

BIBLIOGRAPHY: CR 1876, p. 126, no. 60; Minns 1913, p. 209, fig. 109; Artamonov 1970, pl. 115; Schiltz 1994, p. 31, ill. 13.

118

Bridle Frontlet: Stag

Mid-fifth century B.C.
H: 6.5 cm, 4 × 2.5 cm
Bronze
Seven Brothers kurgan no. II, 1875.
 Excavations of Baron V. G. Tiesenhausen
Acquired in 1876
Inv. SBr.II.56

Frontlet from a horse harness in the form of a stag head on an oval base. The branching antlers are connected to each other by a bridge and rest on the long ears. The top part is smooth while the lower part has incisions. The eye has a round pupil and is elongated. There are incisions on the snout. There are four attachment holes on the base.

E. V.

BIBLIOGRAPHY: CR 1876, p. 126, no. 59; Artamonov 1970, pl. 114.

118 2:1

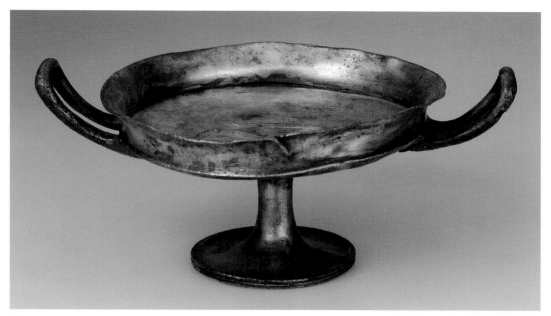

119a

119

Kylix: Nike

> Athens
> Second quarter of the fifth century B.C.
> (ca. 470 B.C.)
> H: 6.7 cm; Diam (with handles): 16 cm
> Silver, gilding
> Seven Brothers kurgan no. IV, 1876.
> Excavations of Baron V. G. Tiesenhausen
> Acquired in 1876
> Inv. SBr.IV.15

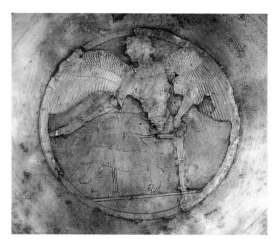

119b

Silver kylix; the tondo has an engraved depiction of Nike, covered with gilding. The goddess is sitting on a stool with carved legs, with her wings spread, and leans against the stool with her left hand while in her outstretched and slightly lowered right hand she holds a cup. The head and legs are shown in profile while the upper part of the figure and the wings are frontal.

E. V.

BIBLIOGRAPHY: *CR* 1881, pp. 5–7, pl. I.1–2; Gorbunova 1971, p. 20–23, 33, 35–36, figs. 1, 5; *Antichnoe serebro* 1985, pp. 13, 15, cat. 1; *LIMC* 6, s.v. "Nike," p. 865, no. 153.

120

Drinking Horn with a Half-Figure of a Dog

> Mid-fifth century B.C.
> L: 27.5 cm; Diam: 5.7 cm
> Gold
> Seven Brothers kurgan no. IV, 1876.
> Excavations of Baron V. G. Tiesenhausen
> Acquired in 1876
> Inv. SBr.IV.1

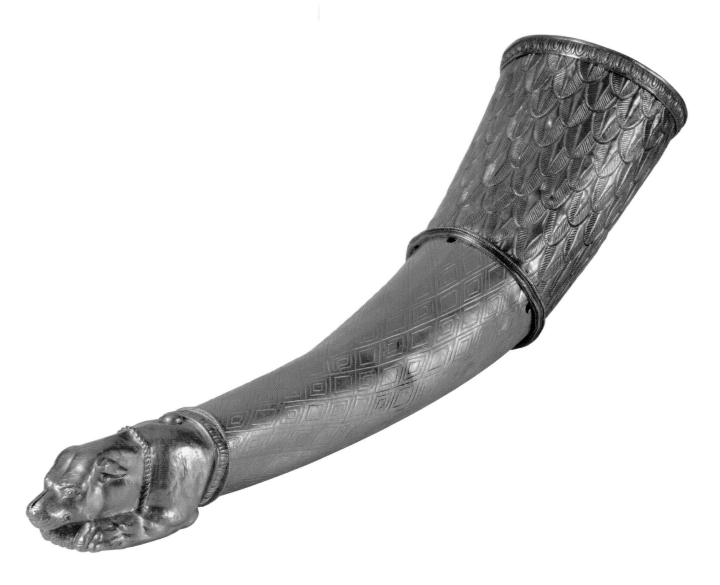

120

The drinking horn consists of three parts: a half-figure of a recumbent dog, a middle part in the form of a truncated cone with four holes for attachment at the upper end, and an upper part in the form of a short, slightly bent truncated cone. The upper part is decorated with lotus petals, the middle part with double and triple rhombuses. The adornment was applied without any preliminary sketching, resulting in variations in the sizes of the petals and some overlapping of the rhombuses. A narrow ring with ova is soldered to the mouth of the horn; between the middle and the upper parts is a narrow ring with beaded edges; between the protome and the middle part is a narrow ring with ova ornamentation and a ring of beaded wire. A band of beaded wire is soldered to the neck of the

dog. Its head rests on its outstretched front legs, which have a total of seven toes. The protome is fastened to the middle part by a gold linchpin whose head can be seen on the back of the dog, while the ends of the pin are bent over the belly of the animal.

This vessel is not complete; an inset made of wood or horn, has not survived. The mouth of the inset was usually decorated with applied gold plates.

E. V.

BIBLIOGRAPHY: CR 1876, pp. VI–VII; CR 1877, pl. I.7; Rostovtsev 1931, pp. 314–16; Artamonov 1970, p. 34, fig. 59; Marazov 1978, p. 18, fig. 10; *Great Art* 1994, pp. 310–11, no. 295; Jacobson 1995, p. 218, no. VI.G.2.C; *Zwei Gesichter* 1997, p. 89–90 no. 17; Vlasova 2001, pp. 20–27 and 82–83, cat. 5, fig. 4; *Greek Gold* 2004, p. 51, fig. 25.

SEVEN BROTHERS KURGANS

121

Plaque: Eagle Carrying a Hare

Mid-fifth century B.C.
H: 11 cm; W: 9.8 cm
Gold
Seven Brothers kurgan no. IV, 1876.
 Excavations of Baron V. G. Tiesenhausen
Acquired in 1876
Inv. SBR.IV.6

Triangular plaque with relief in repoussé technique: an eagle carrying a hare is shown in profile. The eagle has grabbed the hare by the throat with his beak and has sunk his talons in its back. The head of the hare is thrown back, the front legs are extended downward, the back legs are somewhat bent, the tail is bent upward. The fur is indicated with small incisions. The wings and tail of the bird are rendered with petals. The tail forms a seven-petal palmette. Between the tail and the wing is a four-petal palmette. At the lower end of the plaque, under the legs of the hare, is a seven-petal palmette resting on volutes in which the terminals of an arc curve inward. Along the top edge is a band of ova with a three-petal palmette adjacent to it on the right. The lower corner of the appli-

qué is rounded; the upper edge is bent. Along the perimeter of the appliqué are holes for attachment nails. Some nails have been partially preserved.

E. V.

BIBLIOGRAPHY: *CR* 1877, pl. II 4–5; Minns 1913, pp. 211, 265, fig. 112; Rostovtsev 1931, pp. 314–16; Artamonov 1970, pl. 118; Jacobson 1995, p. 218–19, no. VI.G.2.d, fig. 96; *Zwei Gesichter* 1997, pp. 90–91, no. 18; Vlasova 2001, pp. 86–87.

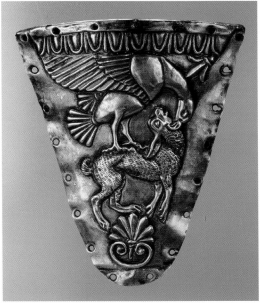

121

Horse Harnesses

Horse harnesses in animal style from the fifth and fourth centuries B.C. have been found in the Seven Brothers kurgans and in the Tuzlinski (cat. no. 69) and Great Bliznitsa (cat. no. 172) kurgans in the same region, as well as in the Nymphaion kurgans on the European side of the Bosporus (cat. nos. 127–30). Usually the depictions on harnesses do not show scenes of struggle, but rather a single animal, whether realistic or fantastic, in profile. In most cases the whole animal is not shown, but only its protome or different parts of its body: the head, paw, hoof, claw, beak, ear, or horns. Sometimes the image is in profile, or, turned 90 degrees, frontal, in which case the details of the image are perceived differently (cat. no. 129).

The horse harnesses from the Seven Brothers kurgans present fragments of iron bits and bronze details: frontlets, cheekpieces (psalia), plaques, and buckles. Some of the frontlets are platelike, in the form of stag heads (cat. no. 118), fantastic birds (cat. no. 123), or S-shaped lions (cat. no. 124). There are buckles in the form of ducks and a large plaque of a recumbent lion in profile on whose back a panther has a claw hold. Among the small plaques are a recumbent stag (cat. no. 122), a recumbent elk, and a boar's head. Among the two-hole

221

psalia there are straight, ⌐-shaped, and s-shaped ones. Sometimes the whole animal is depicted on them, as the s-shaped lion (cat. no. 124). Sometimes one end of the psalion is a leg, hoof, or without any adornment, while the other has a depiction of a bird in profile (cat. no. 125) or a protome or head of an animal (cat. no. 127) or a frontal depiction of the head of an animal (cat. nos. 69, 172).

Images of animals with "twisted" bodies come primarily from the Kuban region. These objects represent a single animal. Depictions of animals with twisted bodies are more typical of the Asiatic steppe zone (the Issyk kurgan in Kazakhstan, the Altai and Tuva kurgans, items from the Siberian collection of Peter I), where there are not only images of individual animals but also scenes of struggle. Palmettes, semipalmettes, ova, and volutes are used in animal style just as they are widely used by the Greeks. There are palmettes on heads (cat. no. 117) and tails (cat. no. 125) of birds on bronze objects. A tail-palmette (cat. nos. 111, 121) is seen on gold objects. Antlers on the bronze stag-plaque (cat. 122) are reminiscent of symmetrically curved half-palmettes, while minor arched sprouts are curved like volutes. The gold plaque (cat. 121) is ornamented with a row of ova and a palmette on volutes. Palmettes and semi-palmettes are present on bronze objects in the form of akroteria and semi-akroteria from the third century B.C. made as adornments for a chariot from the Vasiurinskaia Gora kurgan (cat. nos. 173, 174).

E.V.

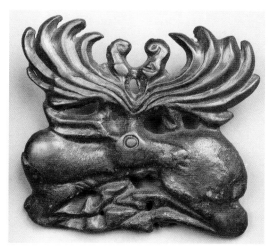

122

Recumbent stag with its head forced around 180° in such a way that the head reaches the middle of the body. The stag has a round eye, elongated snout, and long ear resting on its back. This complicated turn of the animal results in equal and symmetrical allocation of all parts of the figure: head, neck, rear of the body, and hoofed legs. The curved antlers present two separate symmetrical parts. Their design resembles a six-petal half-palmette with two short central sprouts, whose curved ends form volutes. There is a loop on the back side.

E.V.

BIBLIOGRAPHY: *CR* 1876, p. 136, no. 8; Artamonov 1970, pl. 130.

122

Bridle Attachment: Recumbent Stag

Mid-fifth century B.C.
6.6 × 6 cm
Bronze
Seven Brothers kurgan no. IV, 1876.
 Excavations of Baron V. G. Tiesenhausen
Inv. SBr.IV.49

222

123

Frontlet: Fantastic Bird

Mid-fifth century B.C.
L: 4.8 cm; H: 4 cm
Bronze
Seven Brothers kurgan no. IV, 1875.
 Excavations of Baron V. G. Tiesenhausen
Acquired in 1875
Inv. SBr.IV.40

Frontlet from a horse harness in the form
of a fantastic bird with a long neck, head
turned to the side, and wavelike horns. The
eye is round, the beak is large and hooked,
and the ear is elongated with incisions in
the lower part. The cylinder of the neck is
decorated with incisions, as are the folded
wings, separated into three rows. On the
reverse side, part of an arclike loop has been
preserved.

E. V.

BIBLIOGRAPHY: Artamonov 1970, p. 36, fig. 65;
Jacobson 1995, p. 270, no. X.D.2, fig. 139.

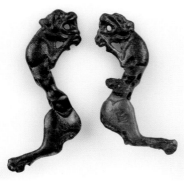

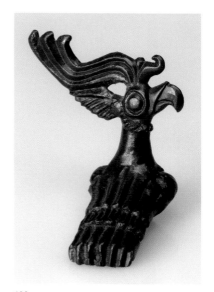

123

124

125

124

Two Psalia: S-shaped Lions

Mid-fifth century B.C.
L: 9.5 cm
Bronze
Seven Brothers kurgan no. IV, 1876.
 Excavations of Baron V. G. Tiesenhausen
Acquired in 1876
Inv. SBr.IV.54

Two bronze psalia (cheekpieces from a
horse harness) in the form of S-shaped lions;
the trunks are twisted 180 degrees in the
middle. The front legs are pressed to the
open mouth, the hind legs are stretched out.
On one of the psalia are the remains of an
iron loop for the bit.

E. V.

BIBLIOGRAPHY: Artamonov 1970, p. 34, fig. 61;
Jacobson 1995, p. 274, no. X.E.3.

125

Psalion: Bird

First quarter of the fourth century B.C.
L (rod): 11.8 cm; L (plaque): 9 cm
Bronze
Seven Brothers kurgan no. III, 1876.
 Excavations of V. G. Tiesenhausen
Acquired in 1876
Inv. SBr.III.20

Two-holed psalion with one straight end
and the other in the form of an openwork
plate with a profile depiction of a seated bird
with a large curved beak and long legs with
the ends spiraled as rolutes. The tail is in the
form of a palmette.

E. V.

BIBLIOGRAPHY: Artamonov 1970, pl. 135.

223

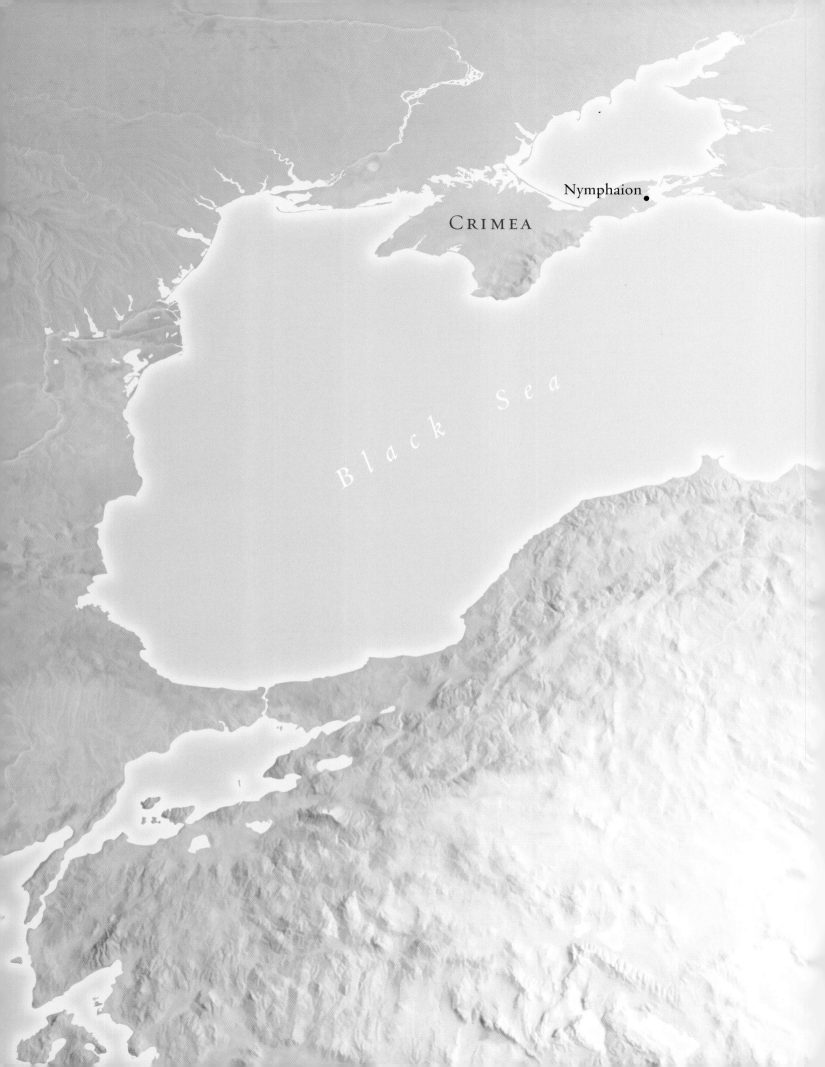

CRIMEA

Nymphaion

Black Sea

The Necropolis
of Nymphaion

THE NECROPOLIS OF NYMPHAION IS LOCATED ON AN EXTENSIVE PLATEAU west of the city. The necropolis is seemingly framed by kurgans around its perimeter. The mounds were often erected on top of natural rocky elevations. In general, graves with Greek burial ritual prevail. One of the richest deposits of this type was found in 1866 (cat. nos. 132, 133). At the same time a group of burials with the characteristics of non-Greek rituals stand out: the burial of horses along with humans, the presence of Scythian as well as Greek weapons, and Scythian horse harness fittings (cat. nos. 127–30). In this connection, the abundance of Greek objects that became part of the local way of life is remarkable. The early stage of the cultural rapprochement between the local population and the Greeks is reflected in the finds of the kurgans of Nymphaion as well as the Seven Brothers kurgans.

Y. K.

BIBLIOGRAPHY: Rostovtsev 1931, pp. 344–348; Gaidukevich 1971, pp. 289ff.; Silant'ieva 1959, fig. 1.

Kurgan no. XXIV, Tomb 19

This kurgan was excavated by A. E. Liutsenko in 1876. It consists of a mound with a diameter of nearly 172 meters and a height of 25 meters. In the middle of the kurgan, under a cover of rock rubble, was found a burial chamber covered with stone slabs. Inside was a wood sarcophagus decorated with inlay work containing the burial of a warrior. The burial had obvious non-Greek characteristics: to the sides of the main tomb there were eight horses. In addition to high-quality imported Greek objects, the grave goods consisted of a gold collar, stamped plaques, a gold cap, and Scythian bronze horse harness trappings. Kurgan no. XXIV is undoubtedly one of the most outstanding complexes of the so-called local barbarian groups of burials in the necropolis, reflecting the early period of active contacts between the inhabitants of Nymphaion and the nomadic Scythians in the second quarter of the fifth century B.C.

D.C.

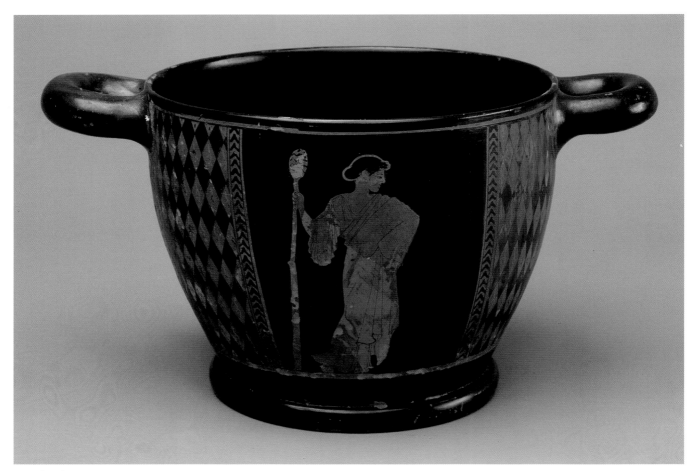

126a Side A

126

Red-figure Skyphos

Attributed to the Amphitrite Painter
Attika
470–460 B.C.
Diam: 18.5 cm; H: 14.5 cm
Terracotta
Necropolis of Nymphaion, 1876. Kurgan
 no. XXIV. Excavations of A. E. Liutsenko
Acquired in 1876
Inv. GK/N.98

Skyphos on a broad flattened ring foot with
massive loop handles. Cups of this form
are characteristic of the second quarter of
the fifth century B.C.

SIDE A. Standing female in a chiton and
himation with a thyrsos in her right hand.

SIDE B. Standing female to left in a chiton and
himation and with a phiale. Above her head
an inscription ΚΑΛ[·]. Flanking the panel on
each side and under the handles is a checker-
board pattern of elongated rhomboids alter-
nating with vertical bands of herringbone.

D.C.

BIBLIOGRAPHY: *OAK* 1876, p. 18; Silant'ieva 1959,
pp. 58–59, fig. 27; Piotrovskii', Galanina, Grach 1987,
pls. 112–13; *Nymphaion* 1999, pp. 36–37, cat. 51;
Nymphea 2002, p. 53, cat. 20.

127

Fragmentary Psalion with Finial in the Shape of a Griffin

First half of the fifth century B.C.
L: 9.1 cm
Bronze
Necropolis of Nymphaion, 1876. Kurgan
 no. XXIV. Excavations of A. E. Liutsenko
Acquired in 1876
Inv. GK/N.106

Cast psalion with two holes. The lower
part has been lost. On the upper part is the
stylized head of a griffin. The eye of the
hybrid creature is round and convex. The
hooked beak is clearly separated from the
head by a projection.

D.C.

BIBLIOGRAPHY: *OAK* 1877, p. 231; Silant'ieva 1959,
pp. 68, 70–71, fig. 37.3; Artamonov 1966,
pl. 91; Piotrovskii', Galanina, Grach 1987, pl. 96.

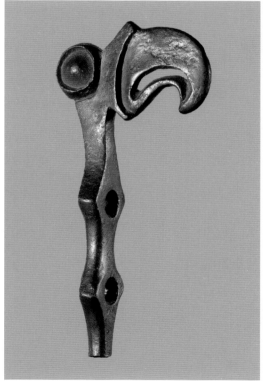

126b Side B

127

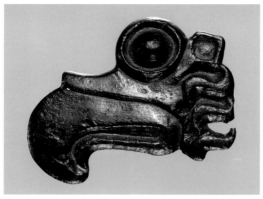

128

128

Plaque in the Shape of a Griffin's Head

First half of the fifth century B.C.
L: 3.8 cm; H: 2 cm
Bronze
Necropolis of Nymphaion. Kurgan no. XXIV,
 1876. Excavations of A. E. Liutsenko
Acquired in 1876
Inv. GK/N.118

The plaque and the psalion (cat. no. 127) are both executed in typical Scythian animal style. The head of the hybrid creature is depicted with a large convex eye projecting from the general contour of the head. The beak is strongly hooked. On the back side of the buckle is a Π-shaped loop for the bridle strap.

D.C.

BIBLIOGRAPHY: Silant'ieva 1959, pp. 69, 70–71, fig. 37, 8; OAK 1877, p. 232; Artamonov 1966, pl. 92; Piotrovskii', Galanina, Grach 1987, pl. 91.

Kurgan no. I, Tomb 14 (cat. nos. 129–30)

Kurgan no. I in the Nymphaion necropolis was explored in 1878 by S. I. Verebriusov. It consisted of a monumental mound (Diam: 115 meters; H: 6 meters) built on a natural rock outcropping. A tomb made of enormous limestone slabs was found inside the kurgan under stone rubble. The fact that fragments of the scales of a lamellar armor, arrowheads, and part of a sword were found indicate that the tomb was the burial of a warrior. The bronze horse harness trappings in Scythian animal style, as well as the non-Greek feature of the burial of a horse, make it likely that the man buried in this kurgan was a member of the Scythian aristocracy.

D.C.

129

Plaque: Animal Paw and Snout of an Elk

First half of the fifth century B.C.
L: 8.5 cm; H: 5.3 cm
Bronze
Necropolis of Nymphaion, 1878. Kurgan no. I,
 Tomb 14. Excavated by S. I. Verebriusov
Acquired in 1878
Inv. GK/N.163

The cast bridle plaque combines two visual motifs: in the horizontal position it shows the head of an elk to the left with stylized antlers and a lenticular eye with an accentuated lower eyelid. The mouth is marked by a double volute. In the vertical position it depicts the paw of a predatory animal with haunches and conventionally rendered claws. On the back is a loop for fastening the bridle strap.

D.C.

BIBLIOGRAPHY: Silant'ieva 1959, pp. 83–84, 106, fig. 47.7; *Nymphaion* 1999, p. 99, cat. 246, ill. p. 95; *Nymphea* 2002, p. 122, cat. 114.

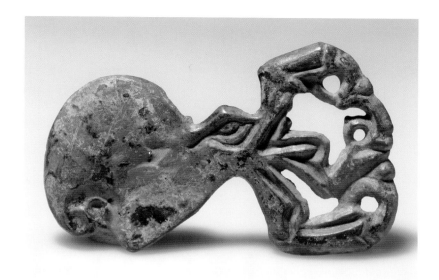

129

130

Plaque: Elk

First half of the fifth century B.C.
L: 5.5 cm
Bronze
Necropolis of Nymphaion, 1878. Kurgan no. I,
 Tomb 14. Excavations of S. I. Verebriusov
Acquired in 1878
Inv. GK/N.170

Cast bridle plaque with the head of an elk to left. The eye is convex and strongly outlined. Two inverted birds' heads with large eyes and long volute-like beaks serve as antlers. There is a palmette between the beaks of the birds. On the reverse side is a loop for attaching the bridle strap.

D.C.

BIBLIOGRAPHY: Silant'ieva 1959, pp. 83–84, 106, fig. 47.5; *Nymphaion* 1999, p. 99, cat. 245, ill. p. 95; *Nymphea* 2002, p. 121, cat. 113.

130

Kurgan no. XVII, Tomb 8 (cat. no. 131)

The kurgan was excavated by A. E. Liutsenko in 1876. In the middle of the kurgan, under stone rubble, was a grave made of stone slabs with the remains of a wooden sarcophagus inside. Next to it was an indentation with several horse skeletons. On the human skeleton, whose head faced east, were found gold adornments: a necklace (cat. no. 131), a ring with the depiction of a flying Nike, numerous garment attachments, and eight boat-shaped earrings. When put in groups on larger rings, they might have served, in the opinion of P. F. Silant'ieva, as temporal pendants, but since this is a male burial, they could have served a more utilitarian role as clasps. Weapons were found inside and outside the sarcophagus: swords, daggers, spearheads, arrowheads, fragments of a helmet, a scale corselet, a greave, and bronze horse harness trappings. The deceased was accompanied by a rich collection of bronze vessels, two black-figure kylikes, an alabaster alabastron, and a sponge. The combination of local and Greek burial rituals is clear: the burial items consist of imported and local objects, while some of the adornments were used in a manner that did not follow Greek customs.

Y. K.

BIBLIOGRAPHY: *CR* 1876, pp. VIII–XXX; Rostovtsev 1931, p. 345ff.; Silant'ieva 1959, pp. 71–78, 105–6, figs. 38–42.

131

Necklace

Third quarter of the fifth century B.C.
L: 18.5 cm; Weight: 25.33 g
Gold, enamel
Necropolis of Nymphaion, 1876. Kurgan
 no. XVII. Excavations of A. E. Liutsenko
Acquired in 1876
Inv. GK/N.16

The necklace consists of ten perforated box-shaped links. To each are attached three graniform pendants. The fronts of the links are decorated with a design of granules in the form of arcs with opposite volutes and filigree rosettes with petals filled with blue and green enamel. Two links with broad embossed palmettes served as the finials of the necklace. This necklace resembles somewhat one in this exhibition from the necropolis of Pantikapaion (see cat. no. 57). That one consists of filigreed links and graniform pendants and masks of Acheloös decorated with plant motifs. L. F. Silant'ieva

considers this item not to be a necklace but a diadem. D. Williams has dated this necklace to the last quarter of the fifth century B.C. (*Greek Gold* 1994, p. 133).

Y. K.

BIBLIOGRAPHY: *CR* 1877, pl. III, 34; Ruxer 1938, pp. 225, 268, pl. XXXII.10; Silant'ieva 1959, fig. 37.1; Artamonov 1970, pl. 90; *Greek Gold* 1994, no. 76; Jacobson 1995, p. 129, no. II.D.3; *Zwei Gesichter* 1997, no. 4; *Greek Gold* 2004, fig. 12.

131a

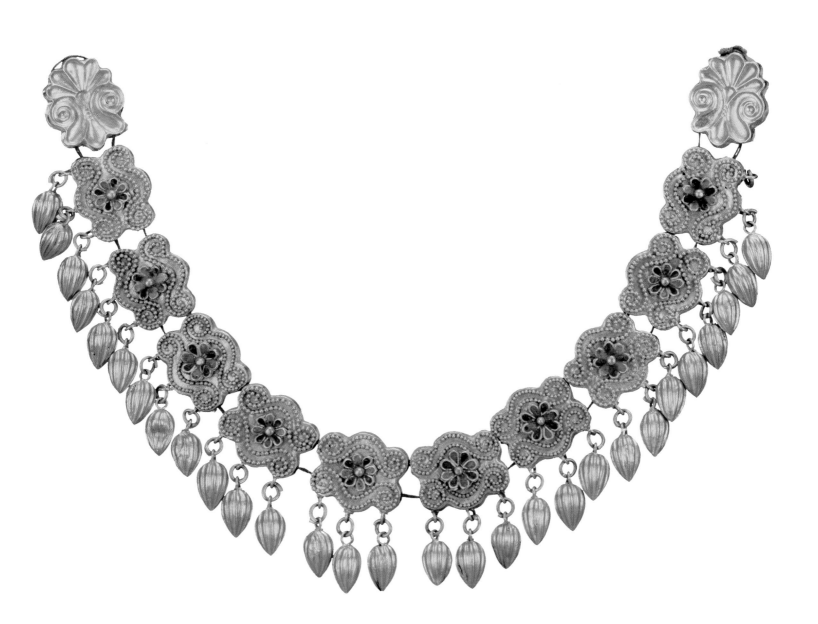

131b

Burial Excavated in 1866 (cat. nos. 132–33)

Discovered by peasants in a stone tomb under a kurgan. The objects were acquired by the Archaeological Commission for the Hermitage via art dealers. The items include: a pair of gold earrings (one of them is cat. no. 132), eight rosettes (cat. no. 133), part of a necklace, the setting for a ring, and a cylindrical stamp whose truncated facets depict the battle of Apollo and Herakles over the tripod.

Y.K.

BIBLIOGRAPHY: *CR* 1867, pl. XVI; *CR* 1868, pl. I.2–4; Silant'ieva 1959, p. 7, fig. 2.

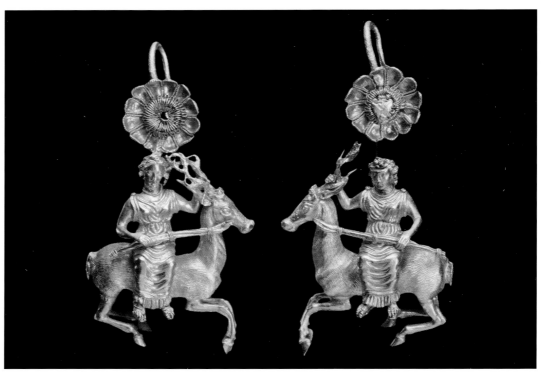

132 2:1

132

Earring with Pendant: Artemis Riding a Doe

Second quarter of the fourth century B.C.
H: 4.3 cm
Gold
Necropolis of Nymphaion, 1866. Accidental discovery by peasants
Year of acquisition unknown
Inv. GK/N.2

One of a pair. Each earring consists of a complex rosette and a pendant. In the middle of the rosette are petals framed by beaded wire, three layers of petals and stamen threaded on a short tube, covered on the top by a figure of a bee (only one is preserved). The many-layered rosettes from the same burial are similarly made (see cat. no. 133). The partially obscured hook on the back of the rosette terminates in a snake's head. The pendant represents a miniature sculpted group: Artemis is riding sidesaddle on a doe

232

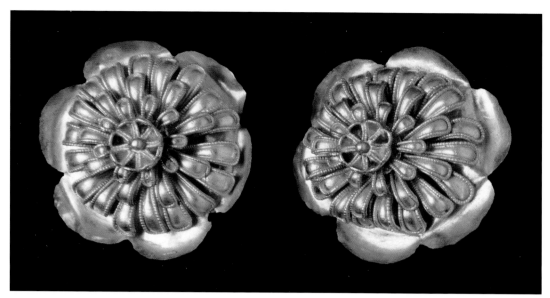

133 3:1

and holds a torch, one of her major attributes. The goddess and the deer were cast separately; the legs and antlers of the deer and feet of the goddess were also made separately and attached. Her facial features, hair, and folds of clothing, as well as the eyes and nostrils of the deer, have been rendered with extraordinary subtlety. The fur of the deer has been indicated by delicate incisions covering the animal's body. Artemis's earrings, necklace, and the buckles on the back are made of beaded wire.

Based on their style, the earrings can be dated to the second quarter of the fourth century B.C. The goddess-huntress was considered to be the mistress of the plant and animal world; this position is indicated by the bee in the center of the rosette. In addition, Artemis symbolized purity and chastity, and brides would appeal to her before their marriage. She protected the wedding and aided in childbirth (*RE* II, col. 1347), which possibly explains the meaning of the torch in her hand. Earrings depicting Artemis were an appropriate wedding or spousal gift.

Y. K.

BIBLIOGRAPHY: *CR* 1868, p. 6; Silant'ieva 1959, p. 7, fig. 2.2; *Greek Gold* 1994, no. 110; *Zwei Gesichter* 1997, cat. 48; *Greek Gold* 2004, fig. 15.

133

Two Multilayered Rosettes

Fourth century B.C.
H: 0.8 cm; Diam: 2 cm
Gold, enamel
Necropolis of Nymphaion, 1866. Accidental discovery by peasants
Inv. GK/N.1

Out of the eight multilayered rosettes bought by the Archaeological Commission, these two stand out for their high artistry and subtlety of execution. The rosettes consist of five layers, differing in form and size. Six petals of the outermost layer were cut from gold plate with inward-bent edges in the form of the aureole of a sweetbriar flower. The next three layers of narrow outward-bent petals framed by thin beaded wire are threaded on a post that is soldered to the lower layer. The construction finishes with an eight-petaled rosette, also framed by beaded wire. The inward-bent rosette petals are filled with blue and greenish enamel; in the middle is a spherical granule. The rosette is soldered to a nail passing through the plug, the end of which comes out on the other side of the object. On the bottom of the rosette is

soldered a narrow gold band, whose free ends were used to attach the ornament to fabric.

The design of the rosettes is identical to the multilayered rosettes from the Great Bliznitsa kurgan (cat. no. 165). The positioning of the rosettes in the grave has not been established, and their purpose is not known. Presumably they could have served as adornments for a woman's diadem or fillet. The style of the jewelry from the burial with the multilayered rosettes, the technique of the master-jeweler, and the level of execution indicate the Greek character of the burial.

<div align="right">L.N.</div>

BIBLIOGRAPHY: *CR* 1867, p. XVI, pl. V, 1; *CR* 1868, pl. 1.2–3; Silant'ieva 1959, pp. 7.45. fig. 2.1; *Zwei Gesichter* 1997, p. 137, no. 49; *Greek Gold* 2004, p. 79.

134
Red-figure Kylix

Attributed to the Amphitrite Painter
Attika
460s B.C.
H: 4 cm; Diam (without handles): 12.5 cm
Terracotta
Necropolis of Nymphaion, 1876. Kurgan no. XX, stone tomb 9. Excavations of A. E. Liutsenko
Inv. GK/N.49

Miniature stemless cup on a low ring foot. In the tondo is a depiction of a warrior holding two spears in his left hand. He wears a chlamys, sandals with high lacings, and a broad-rimmed traveling hat, which rests on his shoulders.

<div align="right">D.C.</div>

BIBLIOGRAPHY: *OAK* 1876, p. 16; Silant'ieva 1959, pp. 40–41, fig. 17; *Nymphaion* 1999, pp . 36–37, cat. 54; *Nymphea* 2002, p. 54, cat. 22.

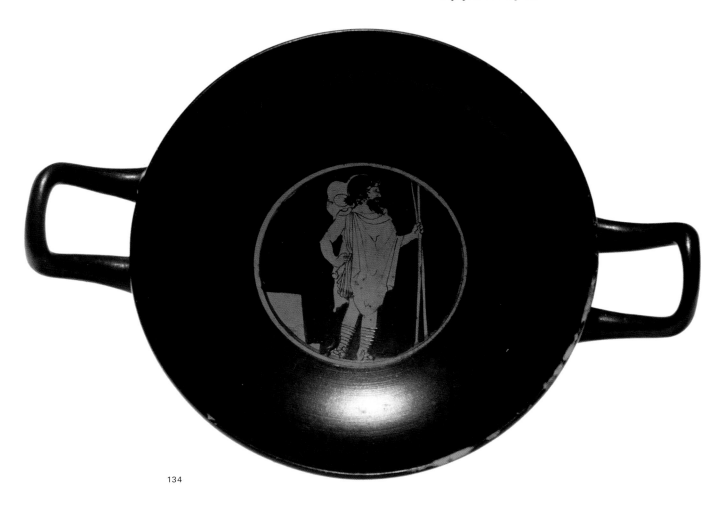

134

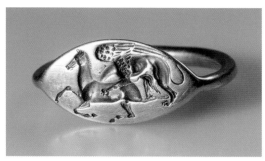

135 2:1

135

Ring

Attributed to the workshop of Dexamenos
Middle of the second half of the fifth century B.C.
Bezel: 2 × 1.1 cm
Gold
Necropolis of Nymphaion, 1876. Excavations of
A. E. Liutsenko
Inv. GK/N.125

Griffin attacking a horse.

O.N.

BIBLIOGRAPHY: Silant'ieva 1959, p. 46, fig. 19;
Neverov 1973, p. 58, fig. on p. 58, no. 1.

136–37

Two Masks of Medusa

The Bosporus
First–second century A.D.
H: 11.5 cm
Terracotta
Necropolis of Nymphaion, 1876. Earth tomb
no. 1. Excavations of N. P. Kondakov
Acquired in 1876
Inv. GK/N 151, 152

Two similar terracotta relief masks of
Medusa. Medusa's head is framed by long
wavy hair. Above the forehead of each are two
wings, and in the center of each, a lock of
hair is raised high between the wings. There
are two snakes on the neck of each Medusa.

D.C.

BIBLIOGRAPHY: Silant'ieva 1959, pp. 92, 103, fig. 51.2;
Nymphaion 1999, pp. 174–75, cat. 176; *Nymphea* 2002,
p. 87, cat. 75.

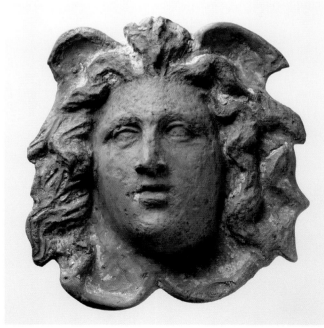

136

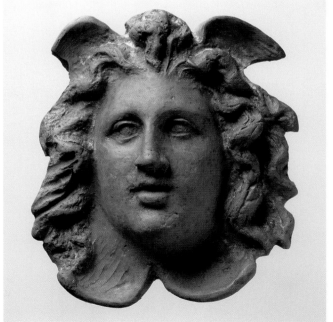

137

235

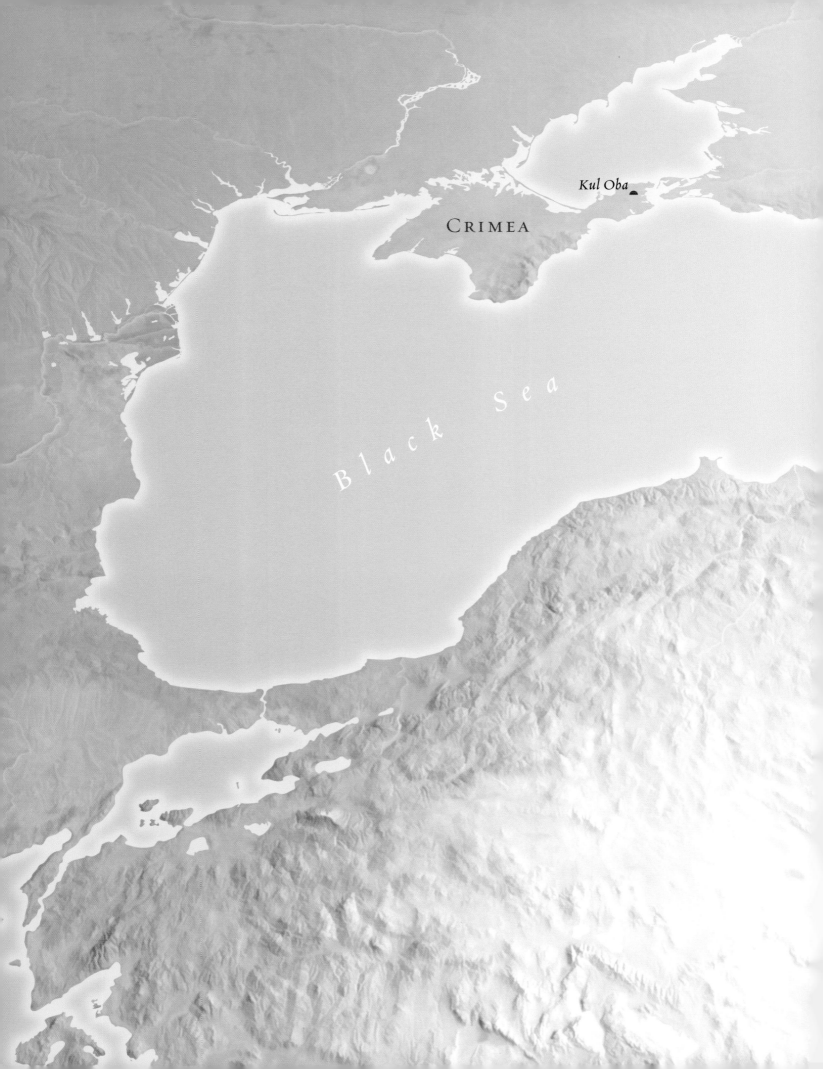

Kul Oba

CRIMEA

Black Sea

Kul Oba
Kurgan

IN 1830 PAUL DUBRUX EXCAVATED A KURGAN 6.4 KILOMETERS WEST OF KERCH, called Kul Oba by the local inhabitants. This name, which is of Turkic origin, means "ash kurgan," which accurately describes the exterior appearance of the hill, which is covered with ash-colored stone. The stone burial chamber with a short dromos and a stepped pyramidal vault was a rectangular room with three burials (fig. 12). A considerable part of the burial chamber was taken up by the wood sarcophagus with the remains of a man who lay with his head at the west end. His felt hat was decorated with gold strips and his clothing with gold plaques; around his neck was a gold torque, on his hands and feet were gold bracelets (cat. no. 140). Next to him were arms with gold cover, greaves, a black stone with a gold plug, and other objects. Dubrux called this man "a king."

Next to the sarcophagus were the remains of a woman lying on a couch. Her grave goods contained an abundance of gold: on her head was a magnificent headdress, which included a diadem; around her neck were a necklace and torque, on her chest was a pair of pendants with the head of Athena (cat. no. 141), and she had three earrings executed in microtechnique (cat. no. 142); on her arms were bracelets; by her head was a bronze mirror with a gold sheath on the handle; and between her knees was a gold vessel depicting Scythians (cat. no. 138), as well as plaques.

Along the southern wall were the remains of a man who was possibly resting on a couch. By his head were six iron knives with bone handles and a knife with a gold-sheathed hilt. Gold plaques were strewn about, and in a pit in the floor were the bones of a horse and military equipment.

Along the walls of the burial chamber were silver (cat. no. 147) and bronze (cat. no. 148) vessels and amphorae. As the site was not guarded at night, robbers were able to penetrate the burial chamber: under the slabs of the floor of the chamber they opened a grave that is often called the "hiding place." Dubrux found out about this from one of the robbers, who gave him his share of the booty: a finial of a torque in the shape of a lion's head and a large plaque in the form of a stag. The other objects went missing; some were taken out of Russia and wound up in other museums.

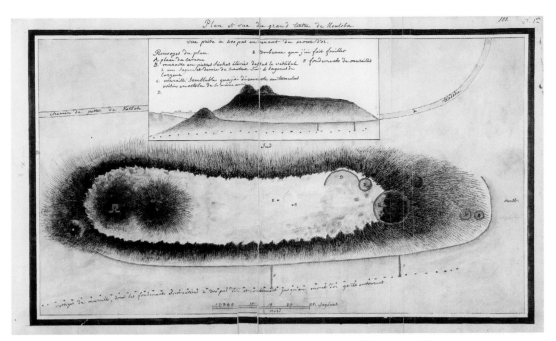

Fig. 12. The Kul Oba kurgan. Plan and section. From The State Hermitage Museum Archives.

The question arose as to who was buried in the Kul Oba kurgan. Dubrux was the first to note the Scythian character of the collective burial and saw in it an illustration to the stories of Herodotos (Hdt. 4.70–71). This was supported by many researchers. Some think that the main deceased person was himself a Bosporan king. V. F. Gaidukevich has noted that "in Kul Oba the Scythian burial rites contain obvious traces of Greek cultural influences." In his opinion, the dead man was one of the "nomarchs [magistrates] who maintained friendly relations with the Bosporus." A similar burial was discovered in 1821 in the Pantinioti kurgan, not far from Kul Oba (Gaidukevich 1971, pp. 286–89).

At first it was thought that three people had been buried at the same time in the complex, but N. L. Grach thought that Kul Oba was in use for a long time (*Zwei Gesichter* 1997, pp. 155–57). Apparently, the Kul Oba kurgan should be seen as a family vault, with consecutive burials. Most likely, the first burial was the one discovered under the slabs of the floor, whose inventory testifies to the high social status of the deceased. It could date from the fifth century B.C. The burial chamber was built at a later time, and the date of the last burial can be determined from a Thasian amphora with a seal dating from 345–335 B.C. The burials in Kul Oba apparently belong to the highest Scythian aristocracy.

E. V.

BIBLIOGRAPHY: *ABC* 1892, pp. 6–16, IX–LI; Gavignet, Ramos, Schiltz 2000, pp. 323–74; Gaidukevich 1971, 8, pp. 283–89; Artamonov 1970, pp. 69–74; *Greek Gold* 1994, pp. 136–51; *Zwei Gesichter* 1997, pp. 155–57; Tunkina 2002, pp. 161–73, 547–52; Alexeyev 2003, pp. 262, 276–77.

138

Vessel with Relief of Scythians

Greek
Middle–third quarter of the fourth century B.C.
H: 13 cm; Diam (mouth): 7 cm;
 Diam (body): 10.7 cm
Gold
Kul Oba, 1830. Excavations of P. Dubrux
Acquired in 1831
Inv. KO.11

Spherical vessel on a low foot with a narrow neck and a high mouth slightly tapering toward the top. An ornamental braid divides the body into two parts: the lower one with petals and the upper one presenting scenes with Scythians in relief. The figures of the Scythians are shown in profile and are divided into four scenes. (a) Two conversing figures; a man in a hood kneels with one hand leaning on his knee and the other on his spear and shield; the man wearing a fillet or diadem is seated on a rock, his head leaning against his spear, which he holds with both hands. (b) A figure in a hood (*bashlyk*) stringing a bow. (c) Two squatting figures without headgear, one is treating the other's teeth or jaw. (d) Two figures sitting with their legs stretched out in front of them; the man in the hood is dressing the wounded leg of the bare-headed man.

In these scenes the Greek artist depicted Scythians in clothing decorated with designs or sewn-on plaques; bow cases (*gorytoi*) hang from their hips; they lean against spears and shields with their hands. These scenes evidently take place in an encampment on the steppes, indicated by the flowers in the landscape.

E. V.

BIBLIOGRAPHY: Dubois de Montpereux 1843, pl. XXII.1, XXIV.1; CR 1864, p. 142; ABC 1892, pl. XXXIII.1; Minns 1913, p. 200, ills. 93–94; Artamonov 1970, pls. 226–29, 232, 233; Sokolov 1973, p. 48, no. 30; Sokolov 1976, p. 35, no. 30, fig. 30; *Schatzkammern* 1993, pp. 90–92, no. 41; *Great Art* 1994, pp. 300–310, no. 282; Jacobson 1995, pp. 203–5, no. VI.D.1, fig. 84; *Zwei Gesichter* 1997, pp. 168–71, no. 74.

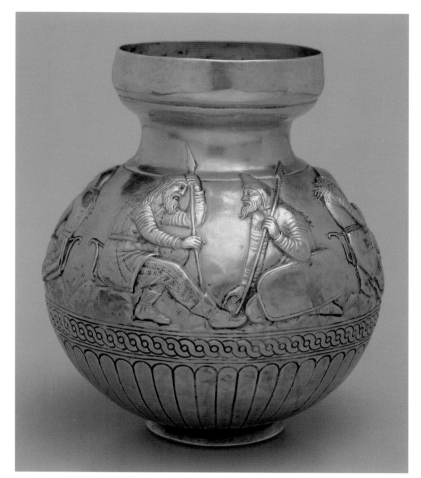

138a

138b

138c

138d

138e

239

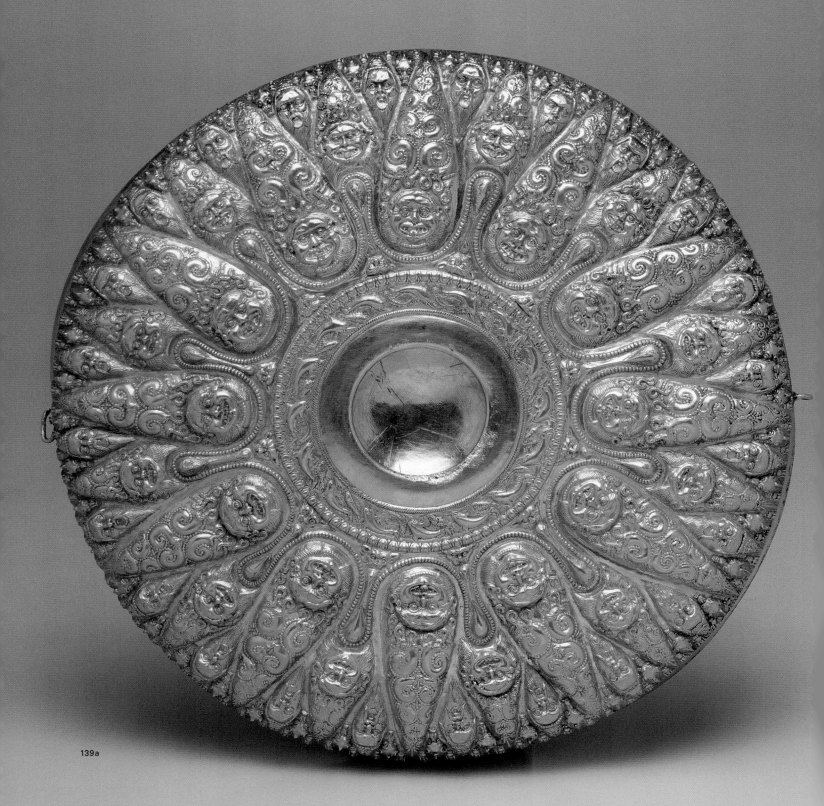

139a

139

Phiale with Relief Images

Greek
Fourth century B.C.
H: 2.5 cm; Diam: 23 cm
Gold
Kul Oba, 1830. Excavations of P. Dubrux
Inv. KO.31

Phiale with an omphalos, around which,
on the exterior, is a smooth rim, a narrow
beaded fringe, a frieze with a depiction of
dolphins and two species of fish, and an
ornamental band of ova. The heads of twelve
panthers squeeze up against the band of ova
with the tops of their heads and ears (139d);
each panther head is surrounded by a wavy
beaded line, outside of which, as a decoration,
there are other images in full face: twelve
large and twelve smaller heads of Medusa
(fig. 139c), twenty-four heads of a bearded
Silenus (fig. 139b), forty-eight snouts of wild
boars, and ninety-six bees.

E.V.

BIBLIOGRAPHY: Dubois de Montpereux 1843, pl.
XXI.13; *ABC* 1892, pl. XXV; Minns 1913, p. 204, fig. 99;
Artamonov 1970, pl. 207.21; *Gold der Skythen* 1993,
no. 59; *Schatzkammern* 1993, pp. 80–81, no. 34; Jacobson
1995, pp. 215–16, no. VI.F.2, fig. 94; *Zwei Gesichter* 1997,
pp. 163–65, no. 70.

139b

139c

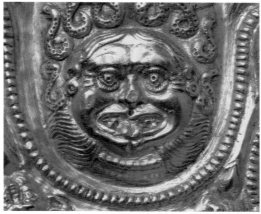

139d

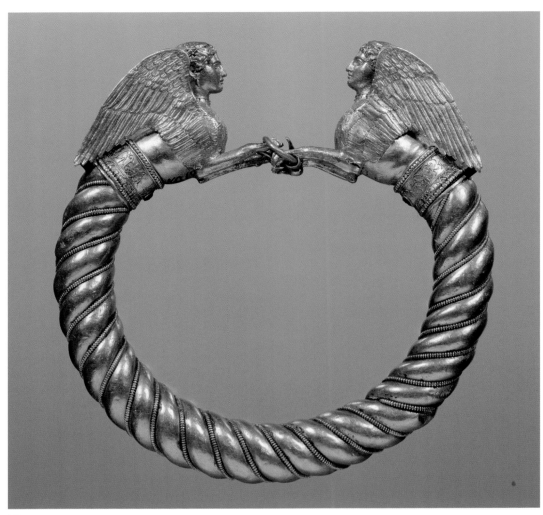

140

140

Bracelet with Sphinx Protomes

Greek
First half of the fourth century B.C.
10.5 × 10.2 cm
Gold, enamel, bronze
Kul Oba, 1830. Excavations of P. Dubrux
Acquired in 1831
Inv. KO.19

One of a pair. The bronze core of the bracelet is covered by gold leaf. The hoop resembles a twisted spiral whose coils are separated from each other by beaded gold wire. The finials—sphinx protomes with frontally extended paws—are tied to each other by wire. The protomes consist of several parts, made of sheet gold and supplemented with minute details. The wings, with three rows of plumage, are connected to each other behind the head and the back of the sphinx. The collars of the bracelet terminals are edged with beaded fillets, between which there is a frieze decorated with a band of ova and a band of palmettes and lotuses covered with enamel; the collars are fastened to the hoop with bronze rivets.

E.V.

BIBLIOGRAPHY: Dubois de Montpereux 1843, pl. XXI.3; *ABC* 1892, pl. XIII.1; Minns 1913, p. 199, fig. 92.1; Artamonov 1970, pls. 200, 205; Sokolov 1973, p. 49, no. 32; Deppert-Lippitz 1985, p. 190, fig. 138; *LIMC* 8, s.v. "sphinx," p. 1160, no. 164; *Schatzkammern* 1993, pp. 88–89, no. 40; *Greek Gold* 1994, p. 263, no. 199; Jacobson 1995, p. 134, no. II.E.3; *Zwei Gesichter* 1997, pp. 162–63, no. 69; *Greek Gold* 2004, pp. 28–29, fig. 7a–b.

242

141

Pendant: Head
of Athena

Greek
First half of the fourth century B.C.
L: 18.5 cm; Diam (disk): 7.2 cm
Gold, enamel
Kul Oba, 1830. Excavations of P. Dubrux
Acquired in 1831
Inv. KO.5

One of a pair of pendants in the form of a
medallion with the head of Athena and a net
of woven chains with rosettes, urnlike
pendants, and wire spirals. At the top of the
back side is a wire loop for hanging. The
medallion is made of sheet gold. The outer
edge is bordered by plain and beaded wire;
the smooth area between the wires is deco-
rated with tendrils and ivy leaves colored
with blue and green enamel. Attached to the
lower border are alternating six-petaled
rosettes of foil with a graniform bead in the
middle and ivy leaves (one with its green
enamel preserved). On the slightly convex
medallion is a relief of the head of Pheidias's
famous statue of Athena Parthenos. The head
of the goddess, turned three-quarters to the
right, wears a helmet whose front piece is
decorated with dotted spirals and is similar in
form to a diadem. Above the front piece is a
row of alternating heads of stags and griffins.
The crest has a sphinx flanked by Pegasoi.
On the turned-up cheekpieces are depictions
of griffins. On the side of the helmet is an
adornment in the form of a spiral. An owl—
an attribute of Athena—sits on the left
cheekpiece. On each side of the goddess are
coiled snakes, one of them supposedly
wrapped around the spear. Athena wears
disk earrings with pyramidal pendants, and a
three-tiered necklace. The repoussé image
has small details etched into the gold with a
stylus-like instrument. On the back of the
medallion are rings soldered on for attaching
details. From the lower edge of the medallion
hangs an openwork net made of thin loop-in-
loop chains with urnlike pendants; some of
the pendants are beaded and decorated with
granules and small tongues covered in green
and blue enamel. At the intersections of the

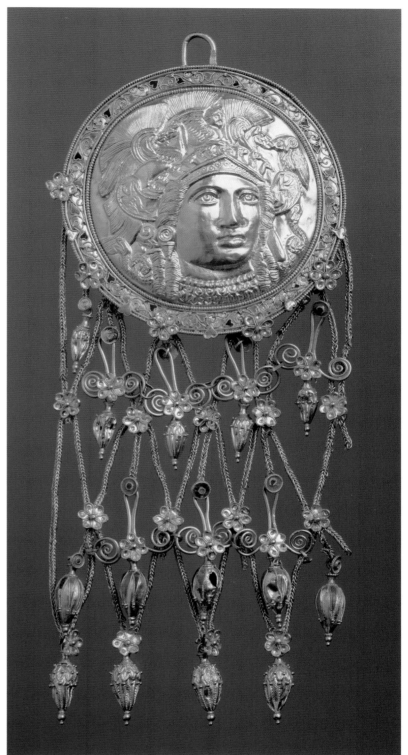

141

net are rosettes and small disks covered with enamel with a circle in the middle. The pendant was broken in antiquity and during the repair wire loops with terminals twisted into spirals replaced the torn chains.

E.V.

BIBLIOGRAPHY: Dubois de Montpereux 1843, pl. XX.3; *ABC* 1892, pl. XIX.1; Minns 1913, p. 195, fig. 88 1; Higgins 1961, p. 128, pl. 29; Artamonov 1970, pls. 214–15; Sokolov 1973, p. 49, fig. 32; *LIMC* 2, s.v. "Athena," p. 983, no. 298; *LIMC* 7, s.v. "Pegasos," p. 216, no. 30; *LIMC* 8, s.v. "sphinx," p. 1155, no. 74; *Great Art* 1994, p. 296, no. 280; Jacobson 1995, pp. 88–89, no. I.C.1, fig. 4; *Zwei Gesichter* 1997, pp. 166–67, no. 72; Minasian 1999, pp. 35–39; *Greek Gold* 1994, pp. 144–45, no. 87.

142

Earring with Boat-Shaped Pendant

Greek
Mid-fourth century B.C.
H: 9.1 cm; Diam (disk): 2.2 cm
Gold, enamel
Kul Oba, 1830. Excavations of P. Dubrux
Acquired in 1831
Inv. KO.7

This microtechnique earring consists of a disk, a boat-shaped pendant, and garlands of urnshaped pendants on chains. The flat disk has a low raised edge; gold granules topped off with a grain bead have been soldered on to both sides of the raised edge. On the inside of the disk, from the edge to the middle, are: a circle made of thick, smooth wire; a circle of braided wire; a circle of thin wire; a frieze with applied zigzag wire ornament; a circle of twisted wire; and a multilayered head of a flower. The surface of the boat is decorated with plain and beaded wire and granules. At the scoop of the boat is an upside-down palmette, framed by a heart shape with two curls going downward and two curls upward. At the ends of the boat are three-layered palmettes with pointed leaves and an oval middle filled with cinnabar. Next to the palmettes are small winged figures of Nike in profile, tying her sandal. Along the lower

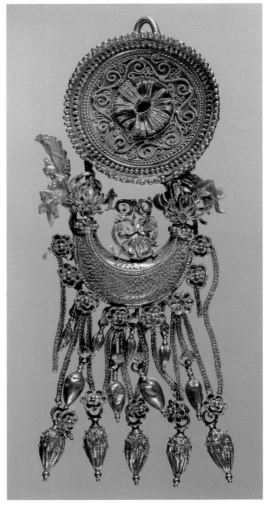

142a

edge of the boat are eight two-layer six-petal rosettes with a bead in the center, from which hangs a garland of chains with urn-shaped pendants and rosettes. Going from top to bottom the urnshaped pendants increase in size: small, medium, large; some of them are smooth, while others have relief ornamentation and granules. In the places where the chains connect to the pendants are disks decorated with blue and green enamel and two-layered, six-petaled rosettes with a graniform bead.

E.V.

BIBLIOGRAPHY: *ABC* 1892, pl. XIX.4; Artamonov 1970, pl. 304; *Schatzkammern* 1993, p. 106, no. 52; *Greek Gold* 1994, pp. 148–49, no. 89; Jacobson 1995, pp. 91–92, no. I.C.3, fig. 6; *Greek Gold* 2004, pp. 38–39, fig. 14.

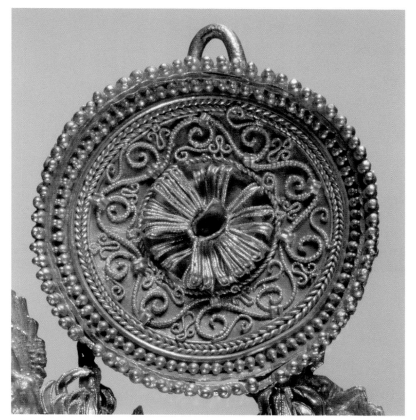

142b

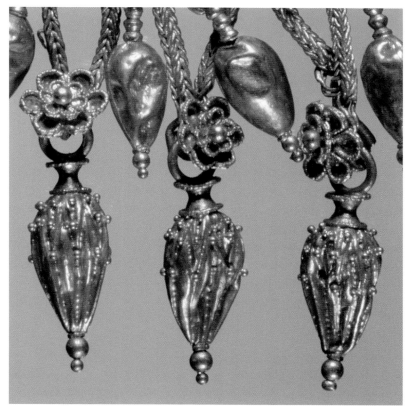

142c

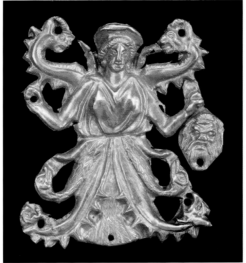

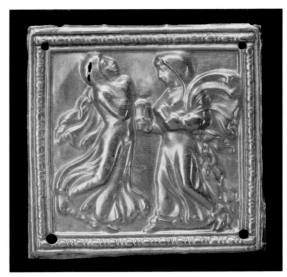

143 2:1 144

143

Plaque: Serpent-legged Goddess

Greek
Mid-fourth century B.C.
H: 3.2 cm
Gold
Kul Oba, 1830. Excavations of P. Dubrux
Acquired in 1831
Inv. KO.70

Stamped plaque with a frontal depiction of a female mythical figure. She is wearing a peplos pinned at the shoulders and a kalathos on her head. From her shoulders grow narrow wings as well as the heads of griffins with long necks and crests that touch the wings with their spouts. In her right hand she is holding a curved knife and in her left, a bearded mask of a Silenus. The lower part of her body is rendered as a type of palmette, in the middle of which are scales; the diverging leaves of the palmette are presented in the form of snakes, the heads of birds on long necks; and the heads of griffins on long necks with webbed manes. The plaque has seven attachment holes.

This image has been variously interpreted (Kopeikina 1986, p. 54). It is possibly connected with the snake woman from the legend related by Herodotos (Hdt. 4.8–10). See also cat. 100 and 169.

E.V.

BIBLIOGRAPHY: *ABC* 1892, pl. XX.8; Artamonov 1970, pl. 230; *Prichernomor'e* 1983, cat. 342; Kopeikina 1986, pp. 53–55, p. 153, no. 24; Jacobson 1995, pp. 172, 174, no. IV.E.6, fig. 58; *Zwei Gesichter* 1997, no. 77.

144

Plaque: Two Dancers

Mid-fourth century B.C.
4.8 × 4.8 cm
Gold
Kul Oba, 1830. Excavations of P. Dubrux
Acquired in 1831
Inv. KO. 50

Square stamped plaque with two dancing female figures with covered heads in profile facing each other. Their clothing billows with the movement, revealing the outlines of their bodies. The left figure's head is thrown back, her right hand pressed to her neck; her right foot is raised behind her. The right figure is holding krotala in her hands. The figures are inside a frame of beaded thread between two smooth fillets. In the corners are attachment holes.

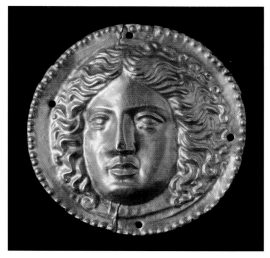

145

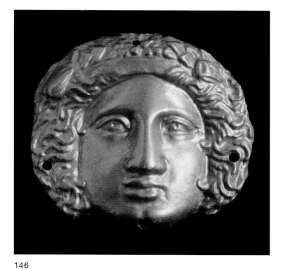

146

Some believe that this is a depiction of maenads, participants in Dionysian rites, while others believe them to be muses or korai or Charites.

E. V.

BIBLIOGRAPHY: Dubois de Montpereux 1843, 4th series, pl. 24.5; *ABC* 1892, pl. XX.5; Minns 1913, p. 197, pl. 90; Artamonov 1970, pl. 234; Kopeikina 1986, pp. 40–41, 149, no. 5; *Greek Gold* 1994, p. 150, no. 90; Jacobson 1995, pp. 172, 176, no. IV.E.16; *Zwei Gesichter* 1997, no. 76; *Greek Gold* 2004, pp. 97–98, fig. 60; *Muzy i maski* 2005, no. 135.

145

Plaque: Human Head

Mid-fourth century B.C.
Diam: 5.6 cm
Gold
Kul Oba, 1830. Excavations of P. Dubrux
Acquired in 1831
Inv. KO.53

Round, stamped plaque depicting a head in three-quarter view. The young face with large, regular features is framed by luxuriant curly hair. The plaque has a beaded border and four attachment holes. Some consider the face to be male and see it as Dionysos, Apollo, or Orpheus. Others consider it to be female and see Aphrodite or a maenad. L. V. Kopeikina (Kopeikina 1986, p. 43) considers

the face to be female and sees snake-heads in the curls, and therefore interprets it as the Gorgon Medusa.

E. V.

BIBLIOGRAPHY: *ABC* 1892, pl. XXI.11; Artamonov 1970, pl. 219; Kopeikina 1986, pp. 43–44, 149, no. 8; *Greek Gold* 1994, p. 151, no. 91; Jacobson 1995, pp. 172, 176, no. IV.E.14; *Greek Gold* 2004, fig. 59.

146

Plaque: Head with Wreath

Mid-fourth century B.C.
H: 3.8 cm; W: 3.6 cm
Gold
Kul Oba, 1830. Excavations of P. Dubrux
Acquired in 1831
Inv. KO.54

Round stamped plaque with four attachment holes. The frontal head has short wavy hair and is wearing a wreath of ivy and berries. The features of the face are regular and large. This could be a depiction of the head of Dionysos, a maenad, or the Gorgon Medusa.

E. V.

BIBLIOGRAPHY: *ABC* 1892, pl. XXI.10; Minns 1913, p. 197, pl. 90; Artamonov 1970, pl. 216; Kopeikina 1986, pp. 44, 150, no. 9; *Greek Gold*, 1994, p. 137, no. 81; Jacobson 1995, pp. 172, 175, no IV.E.13; Gavignet, Ramos, and Schiltz, 2000, p. 369, fig. 14; *L'Or des Amazones* 2001, p. 129, no. 106; *Muzy i maski* 2005, no. 139.

147

Round-bottomed Vessel: Animal Combat

Fourth century B.C.
H: 10.6 cm; Diam (mouth): 5.9 cm;
 Diam (body): 10.2 cm
Silver, gilding
Kul Oba, 1830. Excavations of P. Dubrux
Acquired in 1831
Inv. KO.97

Round-bottomed vessel without handles
with a short neck and everted mouth. On the
body of the vessel are several bands. From
the top they are: petals framed by smooth
lines; broad gilded relief with depictions of
three scenes of animal combat in profile
(two griffins attack a mountain goat, a lion
and lioness attack a stag, and a lion attacks a
boar); a band of petals; and a band with
relief garlands of flowers. On the bottom is a
multipetaled rosette with a small fourteen-
petal rosette in the middle. It is believed that
similar vessels of precious stone were used
for rituals and that their form derives from
local, including Scythian, ceramics with
carved ornamentation.

E.V.

BIBLIOGRAPHY: *ABC* 1892, pl. XXXIV.3, 4; Artamonov
1970, pls. 242, 245, 246; Grach 1984, pp. 100–103, 104,
pl. 11; *Antichnoe serebro* 1985, p. 21, no. 12, fig. on p. 17;
Schatzkammern 1993, p. 93, no. 43; Jacobson 1995, p. 207,
no. VI.D.4, figs. 88–89.

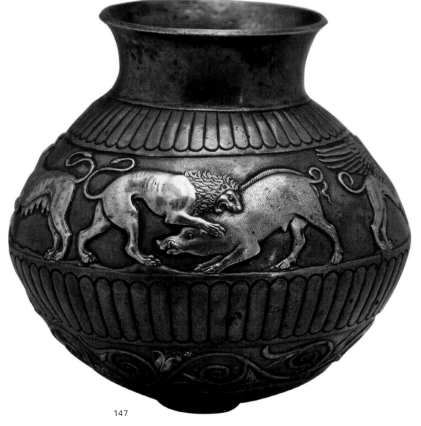

147

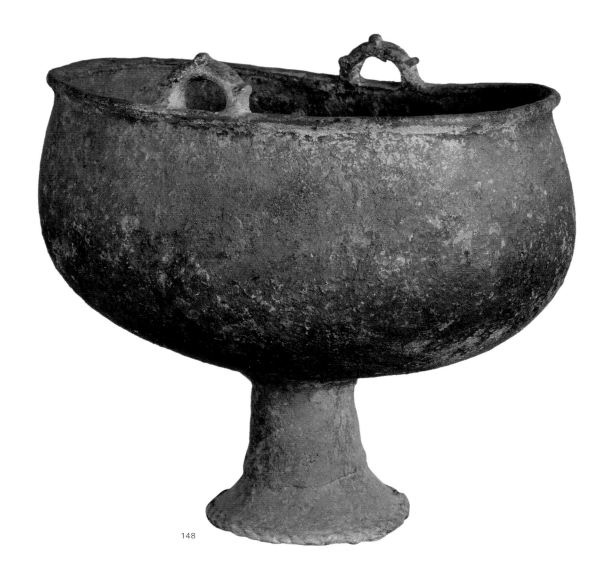

148

148

Cauldron

Fourth century B.C.
H: 38 cm; Diam (oval mouth): 45 × 30 cm
Bronze
Kul Oba, 1830. Excavations of P. Dubrux
Acquired in 1831
Inv. KO.109

Oval cauldron with a body compressed from the sides and with a slightly bent and thickened mouth in the form of a cylinder, to which two vertical loop handles have been attached with three protuberances on each. The high foot, shaped like that of a wine glass, flares out toward the bottom. The edge of the foot is decorated with a twisted rope pattern.

E. V.

BIBLIOGRAPHY: *ABC* 1892, p. 276, pl. XLIV.13.

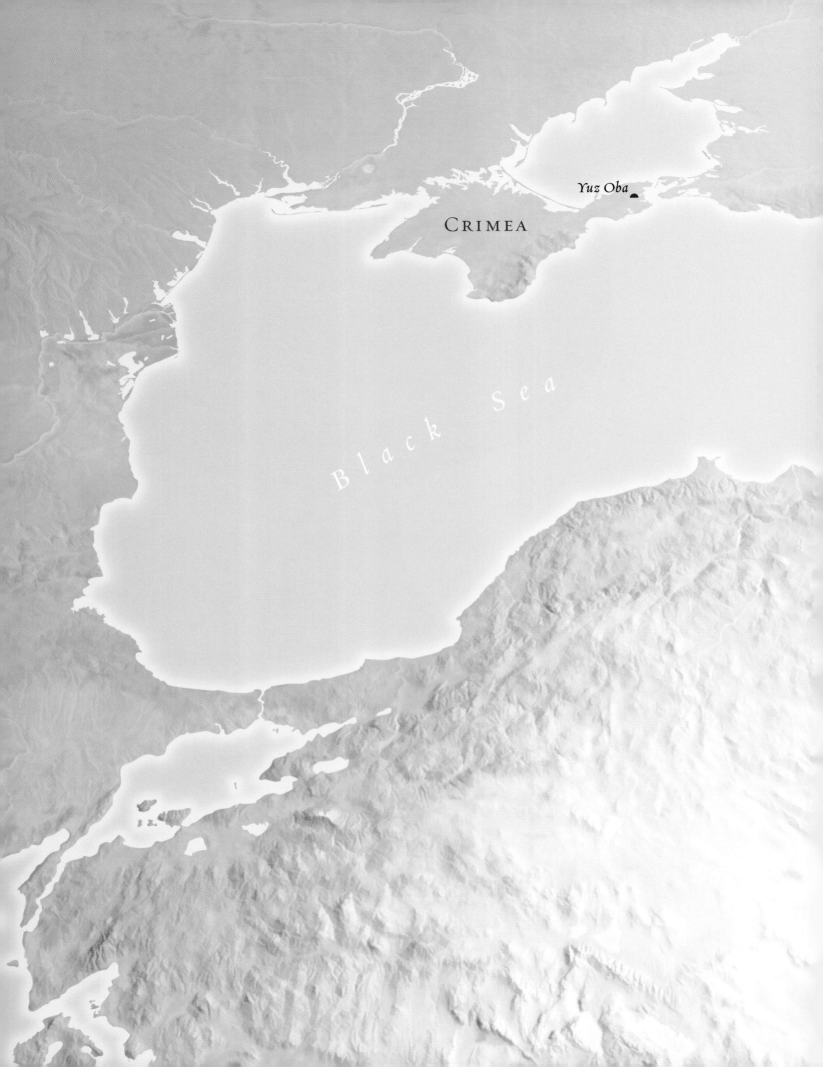

Yuz Oba

CRIMEA

Black Sea

Kurgans on the Yuz Oba Ridge

ALONG THE KERCH PENINSULA, GOING FROM EAST TO WEST, THERE IS a range of hills, the longest of which, rising toward the strait, terminates with Mount Mithridates. Modern Kerch is situated on the slopes of this range, having sprung up on the same site as ancient Pantikapaion. South of the city rises a range called Yuz Oba ("one hundred hills" in Tatar), named for the numerous kurgans that rise over the area. Two lines of kurgans beginning at the high shore of the Kerch Strait, one with the Ak-Burun kurgan and the other with the Pavlovsky kurgan, join at Yuz Oba in a chain of mounds erected along the top of the range of natural, sometimes rocky hills. Gradually descending in height toward the west, after a few kilometers Yuz Oba seems to dissolve into the hilly steppes, ending with a kurgan containing the burial of a warrior in a stepped burial chamber on the former territory of the Kekuvatsky Mirza. Most of the burial chambers under the kurgan hills were made of meticulously fitted slabs, with covers laid out in step-like fashion on top of other slabs, creating the appearance of vaults—these are the so-called stepped burial chambers. Some of the objects in this exhibition come from the stepped burial chamber no. 50 in kurgan no. I: beautiful earrings with pendants in the form of maenads (cat. no. 153) and the scaraboid seal (cat. no. 155). In the smaller chamber of stepped burial chamber no. 48 from kurgan no. V (figs. 13–14) were found a scaraboid made by Dexamenos (cat. no. 154) and the red-figure hydria (cat. no. 150). From burial chamber no. 47 of kurgan no. VI come the red-figure lekanis (cat. no. 151) and the black pelike (cat. no. 149). Along with the stepped burial chambers, simpler ones looking like large boxes made of slabs were also constructed in the Pavlovsky kurgan. In general, the Yuz Oba kurgans from the fourth century B.C. form a necropolis of the Greek and the local hellenized nobility of Pantikapaion, the capital of the Bosporan kingdom at the height of its development.

Y. K.

BIBLIOGRAPHY: Rostovtsev 1931, pp. 174–78; Gaidukevich 1971, p. 259; Gaidukevich 1981, pp. 47, 48.

Fig. 13. Yuz Oba ridge. Kurgan V, burial chamber no. 48. From *CR* 1860.

Fig. 14. Yuz Oba ridge. Sarcophagus in the Hermitage room. St. Petersburg, The State Hermitage Museum, inv. YU.O.16.

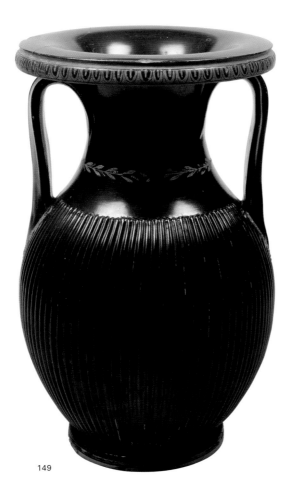

149

149

Pelike

Attika
Fourth century B.C.
H: 37.4 cm; Diam (mouth): 23.8 cm
Terracotta
Kurgan no. VI of Yuz Oba, 1860, stone burial
 chamber no. 47. Excavations of A. E. Liutsenko
Acquired in 1931
Inv. YU.O.31

The very broad mouth of this pelike is typical for the fourth century B.C. The body is covered with black glaze; the high overhanging lip is reserved and decorated with ova with added-white centers. Four gilded laurel branches with berries encircle the lower third of the smooth neck. Under the handles are cuttings of laurel. The broad body of the pelike, from the base to the lower handle attachments, is decorated with relief ribs, which together with the metallic shine of the black glaze create a fanciful interplay of light and shadow. Vases decorated in this manner were intended to imitate expensive metal vessels. This apparently explains the predom-

inance of relief details and the insignificant presence of painting.

A. P.

BIBLIOGRAPHY: *AM* 79 (1964): 41, no. 137, Beilage 26.2; *Prichernomor'e* 1983, cat. 301; *Greek Gold* 2004, fig. 59.

150

Hydria

Attika
375–370 B.C.
H: 33.0 cm; Diam (mouth): 12.7 cm
Terracotta
Kurgan no. V of Yuz Oba, in the mound above
 burial chamber no. 48, 1860. Excavations of
 A. E. Liutsenko
Acquired in 1862
Inv. YU.O.26

The form and proportions of the hydria are typical for the fourth century B.C. The vertical part of the overhanging lip is decorated with a band of ova. Similar bands are placed above and below the picture field; there are also narrow bands with ova at the handle roots. On the front of the body is a multi-figured composition, in the middle of which are Paris and Helen. The seminude Helen, depicted in three-quarter view to right, is sitting on a chair with intricately profiled legs. To the left of Helen, in right profile, is Paris, in splendid Oriental dress and a himation covered with ornamentation. Above the heads of Paris and Helen hover two small Erotes. Behind Paris stands a woman in a long chiton with an oinochoe in her hand; behind her, above, are a seated youth and woman. Behind Helen there are likewise three characters: a standing woman in a long chiton and a fan in her left hand, then behind her and above are a nude youth and a woman wrapped in a himation. The bodies and folds are precisely rendered in thick and dilute gloss, with added paint. The seminude body of Helen, the bodies of the Erotes, the chair, the fan, the jewelry, and Paris's headgear are executed in relief and gilded. On the reverse side of the hydria is an

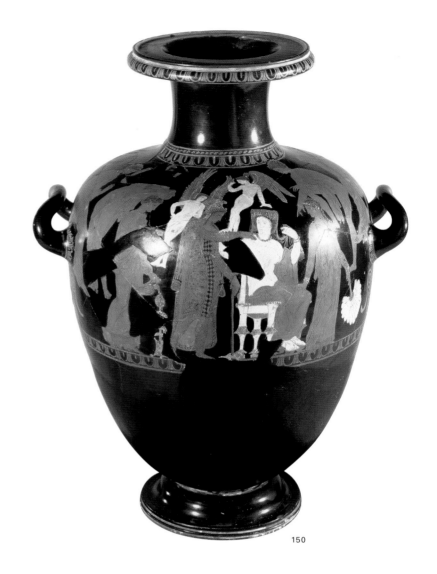

150

elaborate plant ornament consisting of palmettes and volute-like curls.

The Hermitage hydria—decorated with an intricate multifigured composition with added relief details made with applied clay, white paint, and gilding—is characteristic of the magnificent vases of the last period of the flowering of the red-figure technique of vase-painting. In these vases the sumptuous and painterly decoration, as well as the rendering of space and complex angles, prevailed over the earlier preference for architectonics.

A. P.

BIBLIOGRAPHY: Bohač 1958, fig. 7; *LIMC* I, s.v. "Aithra," p. 425, no. 55; *LIMC* 4, s.v. "Helene," p. 519, no. 98; Skrzhinskaya 2002, p. 28, fig. 3; *Liefde* 2003, cat. 134; *Byzantium* 2006, p. 133, cat. 17.

253

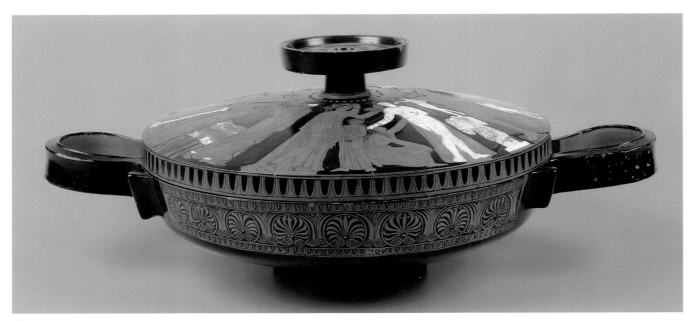

151a

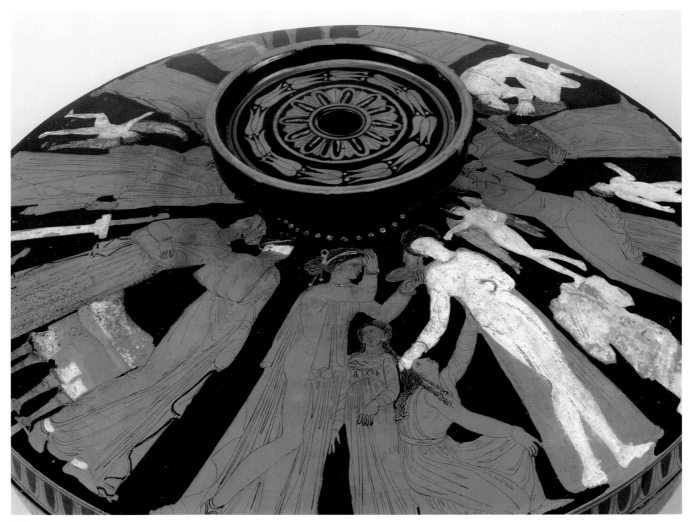

151b

YUZ OBA RIDGE

151

Red-figure Lekanis with Lid

Attributed to the Marsyas Painter
Attika
370–360 B.C.
H: 21 cm; Diam: 36.4 cm
Terracotta
Kurgan no. VI of Yuz Oba, stone burial chamber
no. 47, 1860. Excavations of A. E. Liutsenko
Acquired in 1862
Inv. YU.O.32

The lekanis is one of the typical forms of Kerch vases decorated with ornaments and figurative painting. In the middle of the lid is a handle; the upper surface of the disklike finial is enclosed by a band of ova; around it is a chain of horizontal buds to the left. The entire outside of the handle and the interior of the lekanis are covered with black gloss. The attachment of the handle to the lid is marked by a reserved raised fillet. On the lid, around the handle, is a ring of gilded raised dots. The entire surface of the lid is taken up by multifigured scenes of wedding preparations. On the vertical lip of the lid is a band of ova.

The handles of the lekanis are reserved on the inside. The sides of the body of the lekanis are adorned with a broad band of upright palmettes with lotus buds; above and below the band with the palmettes is a narrow band of ova.

The figurative decoration consists of a continuous scene of women and Erotes on the lid. The figures are organized into several groups. In the middle of one of them is a standing woman in right profile, whose body is draped in a himation. Her long hair is gathered at the back of her head, and she wears a headband; she holds a mirror in her hand. In front of her is a girl in long garments standing three-quarters to right. Behind the woman is another woman standing in three-quarter profile, and behind her is a stool with profiled legs and a pillow. Next comes a woman in left profile, behind a short column. To the right of the first group is a squatting woman in right profile, wearing long gar-

ments, her hair is loose. In front of her stands a frontally nude female character, who has a himation on her back, possibly Aphrodite, whose right hand is on the head of the squatting woman. The entire body of the woman is covered in white. Next comes a squatting woman with an Eros above. To the right of Eros is a woman seated on a himation with a boy standing to the right of her. The woman standing on the left, with a vessel in her hand, is pouring water on the head of a seated female. To the right of this group is a woman sitting on a chair; her hair is being combed by the woman standing to the left. The last group consists of two women (one combing her hair) with Eros between them.

The bodies of the Erotes and the women's jewelry are executed in low relief with added clay and gilding. The lekanis is an outstanding example of Kerch-style vases and was made by one of the foremost representatives of this form, the so-called Marsyas Painter.

A. P.

BIBLIOGRAPHY: *CR* 1861, pl. 1; Schefold 1930, pl. 15b; Schefold 1934, fig. 60, no. 19; Beazley *ARV*², p. 1475, no. 7; *Great Art* 1994, pp. 306–7, no. 291; *Zwei Gesichter* 1997, pp. 182–83, no. 84; *Byzantium* 2006, 133, cat. 18.

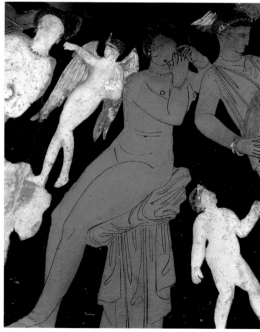

151c

255

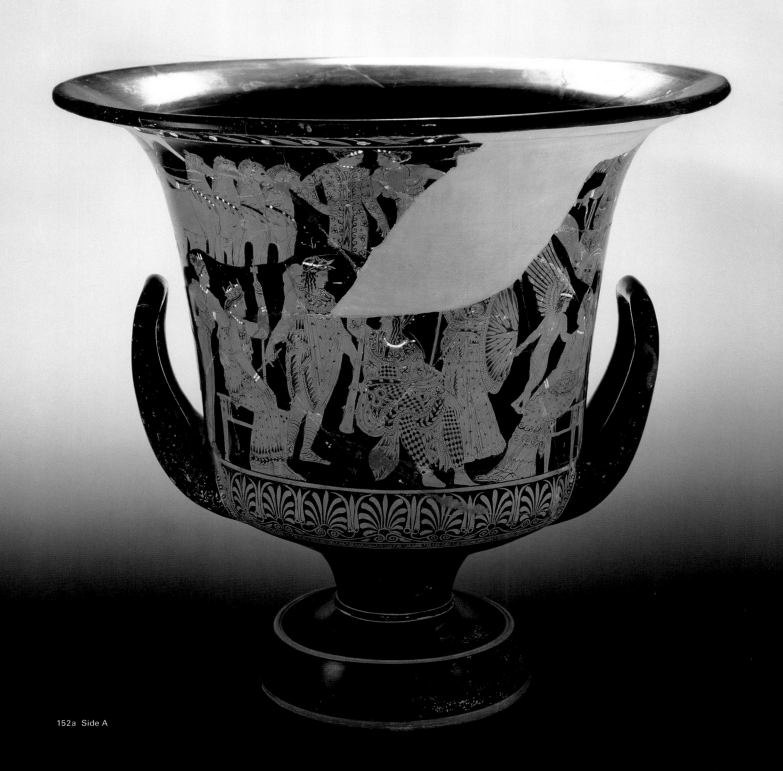

152a Side A

152

Red-figure Calyx-Krater

Attributed to the Kadmos Painter
Attika
Early fourth century B.C.
H: 49.5 cm; Diam (mouth): 52 cm
Terracotta
Kurgan no. VI of Yuz Oba, in the mound
 above burial chamber no. 48, 1860.
 Excavations of A. E. Liutsenko
Acquired in 1862
Inv. YU.O.28

Under the everted mouth two olive branches with white olives encircle the krater. On the lower part of the body, at the level of the handles, is a band of upright palmettes alternating with lotus buds. Under this band is a narrow cymation. The middle of the body is taken up with two multifigured registers of scenes.

SIDE A. Judgment of Paris. Names are written next to the figures. In the middle below, sitting to the right in three-quarter view, is Paris in richly decorated Oriental dress, leaning on a club; standing next to him are Hermes with a caduceus and Athena with a large shield. Behind Hermes is a seated Hera, and behind her a standing Hebe. Behind Athena is a seated Aphrodite with Eros hovering in front of her. In the upper register in the middle, Eris and Thetis converse with each other. To their sides are quadrigas driven by Iris and Nike; to the right of the chariot there is possibly Zeus, behind him a tripod (directly above the handle). The lower part of the figures of Eris and Thetis, as well as the lower part of the bodies of the horses, are seemingly obscured by a line of hills. The delicate painting, with details and drapery folds rendered in diluted gloss, is complemented by added white in the wreaths, diadems, bracelets, earrings, and horse harness.

SIDE B. Apollo and Dionysos. At the bottom in the middle is a depiction of an omphalos. To the left of it stands a maenad in right profile, placing a pillow on a chair. On the other side sits a satyr in left profile to right

playing the pipes. Above the omphalos is a palm flanked by Apollo (left) and Dionysos (right). Behind Apollo sits a maenad with a tympanon and a satyr with a thyrsos. Behind Dionysos a standing maenad and a seated satyr with a lyre face each other.

The invention of arranging the figures on different levels as if they were standing on uneven ground, the communication of the figures through glances and gestures within groups, their complex poses and viewing angles, and the special attention to depictions of drapery are attributed by ancient authors to the monumental painter Polygnotos.

A. P.

BIBLIOGRAPHY: *OAK* 1861, pls. 2–4; *CR* 1861, pls. 3–4; Beazley *ARV*², p. 1185, no 7; Beazley *Para*, p. 460; Shapiro 1977, pp. 58, 224, 233, no. 15, figs. 14, 184; Kossatz-Deissmann 1978, 149; Beazley *Add*², p. 167; *LIMC* 2, s.v. "Apollon," p. 279, no. 768a; *LIMC* 3, s.v. "Dionysos," p. 467, no. 513; *LIMC* 3, s.v. "Eris," p. 848, no. 7, pl. 608; *LIMC* 4, s.v. "Hebe 1," p. 462, no. 52; *LIMC* 4, s.v. "Hera," p. 707, no. 411; *LIMC* 5, s.v. "Iris 1," p. 753, no. 130; *LIMC* 7, s.v. "Paridis indicium," p. 180, no. 48; *LIMC* 8, s.v. "Themis," p. 1203, no. 18; *LIMC* 8, s.v. "Thyiades," p. 23, no. 3; Powell 1998, 165, fig. 7; Schliemann. Petersburg. Troy 1998, 127–28, cat. 52; Skrzhinskaya 2002, p. 27, fig. 2.

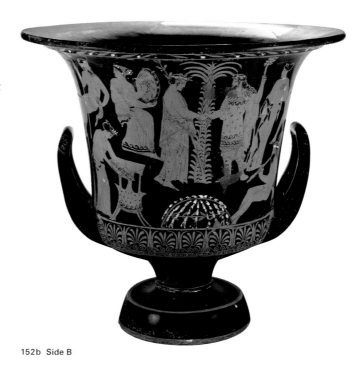

152b Side B

257

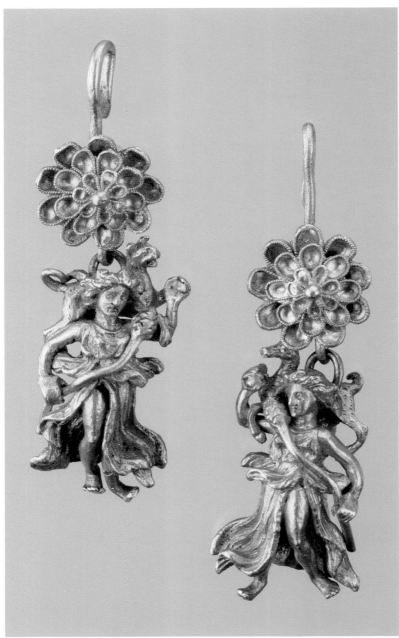

153 2:1

153

Earring with Pendant: Maenad

Fourth century B.C.
H: 4.4 cm
Gold
Kurgan no. I of Yuz Oba, burial chamber no. 50,
　1859. Excavations of A. E. Liutsenko
Acquired in 1862
Inv. YU.O.4

One of a pair of earrings found in the Yuz
Oba kurgan no. I. The earring consists of two
parts: a rosette and a pendant. The petals of
the three-layered multipetaled rosette are
fringed by thin beaded wire; there is a granule
in the center. An ear hook is soldered to
the upper part of the rosette. The pendant,
attached to the rosette by a ring, is in the
form of a dancing maenad whose clothing
billows as a result of her energetic movement,
exposing the dancer's left leg. She holds a
thyrsos in one hand, and with the other the
leg of a fallow deer, which she carries on
her shoulders. On the other earring in the
pair a panther is behind the maenad.

　　Figurines of dancing maenads are exam-
ples of miniature sculptures cast in gold
by master jewelers. The figures of animals
and smaller parts could have been cast
separately and soldered on. The folds of
the clothing, the maenads' hair, animal
fur, and other details of the pendants were
made with engraving.

　　Tiny cast figurines of divinities, dancers,
and mythical animals form a whole gallery
of miniature sculpture that was mostly used
in jewelry. The combination of cast pendant
figurines with rosettes on ear hooks is an
earring design found in other Bosporan
kurgans from the fourth century B.C. (see cat.
nos. 132, 159).

L.N.

BIBLIOGRAPHY: CR 1859, p. X; Muzy i maski 2005,
no. 141; Byzantium 2006, no. 11.

258

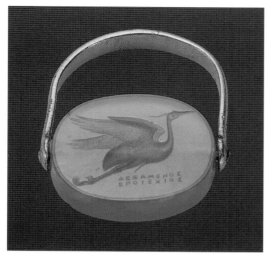

154a 2:1

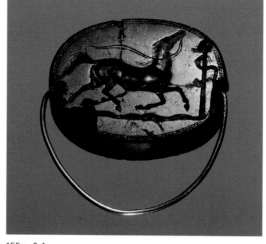

155a 2:1

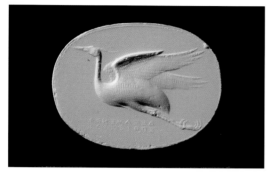

154b

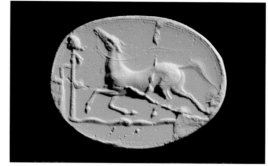

155b

154

Scaraboid

Chios or Greece
Signed by Dexamenos
Middle–second half of the fifth century B.C.
2.2 × 1.7 cm
Chalcedony
Kurgan no. V of Yuz Oba, burial chamber no. 48,
 1859. Excavations of A. E. Liutsenko
Acquired in 1862
Inv. YU.O.24

Flying heron. Signature: "Dexamenos of
Chios made it."

O.N.

BIBLIOGRAPHY: CR 1861, p. 142, pl. VI; Maximova
1926, p. 39, pl. II; Furtwängler 1900, pl. XIV.4;
Boardman 1969, figs. 29–30; Boardman 1970, pl. 468;
Neverov 1973, p. 53, on p. 55 fig. no. 5; Schatzkammern
1993, pp. 230–31, no. 117; Greek Gold 2004, fig. 53.

155

Scaraboid

Chios or Greece
Attributed to the workshop of Dexamenos
Middle–second half of the fifth century B.C.
2.3 × 1.8 cm
Jasper
Kurgan no. I of Yuz Oba, burial chamber no. 50,
 1860. Excavations of A. E. Liutsenko
Acquired in 1862
Inv. YU.O.7

Running horse and thyrsos.

O.N.

BIBLIOGRAPHY: CR 1860, p. 90, pl. IV; Maximova
1926, p. 42; Furtwängler 1900, pl. XIV.15; Vollen-
weider 1969, p. 118; Boardman 1970, pl. 475; Neverov
1973, p. 53, fig. 7.

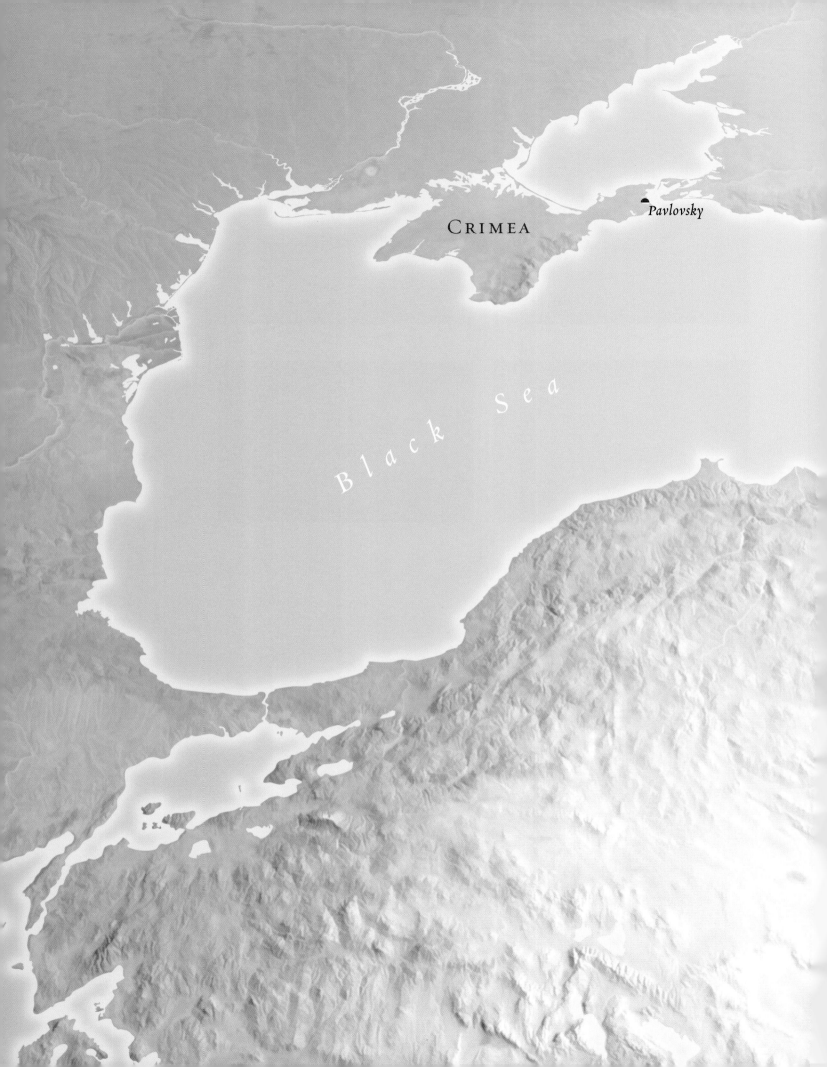

CRIMEA

Pavlovsky

B l a c k S e a

Pavlovsky Kurgan

D ISCOVERED BY A. E. LIUTSENKO IN 1858 ON THE EASTERN END OF the Yuz Oba ridge. The original height of the kurgan was over twelve meters and the diameter was almost sixty-four meters. It was surrounded by a wall (*krepis*), the northern part of which, constructed of rough stone blocks, faced Pantikapaion and a road that apparently passed by in antiquity. The mound consisted of alternating layers of earth and crushed rock raised above the bedrock; in the center was the burial chamber (fig. 15). Rostovtsev mistakenly called this burial chamber "stepped" (Rostovtsev 1931, pp. 178–80). In reality it is a stone box (its internal dimensions are: L: 4.33 m; H: 2.6 m; W: 2.2 m). In addition to the central burial chamber there are two later cremation tombs with a simple inventory and remains of a funeral meal with fragments of Thasian amphorae and other pieces of pottery.

Inside the tomb was a wooden sarcophagus, which had been crushed by falling roof slabs. In the sarcophagus (Vaulina and Wąsowicz 1974, pp. 75–82, no. 7, pls. XLIV–XLVIII) lay

Fig. 15. The Pavlovsky kurgan. North-south section. Drawings of the burial chamber. From *CR* 1859, pl. 5.

a skeleton of a very small woman, her head to the west. Jewels (see cat. nos. 157–60) and a scaraboid with a carved image of a woman on a swivel ring were found with her (Furtwängler 1900, pl. XIII.27). Fragments of her clothing, shroud (Minns 1913, p. 336, fig. 244; Gerziger 1973, pp. 80–81, fig. 10, p. 90, no. 25), and a pair of leather boots have survived. Next to her left hand was a bronze mirror with traces of gilding from the middle of the fifth century B.C. (Bilimovich 1976, p. 46, fig. 3). At her feet were three alabastra, a woven basket, a wooden painted basket, walnuts, and a bronze instrument. Around the sarcophagus were another nine alabastra (eight of alabaster and one of Phoenician glass), a plastic vessel in the form of a dancing barbarian, a black fluted oinochoe from the second quarter of the fourth century B.C., as well as a red-figure pelike (cat. no. 156). The Panti-kapaion silver coins found in the tomb have been variously dated: according to Anokhin, to 344–334 B.C. (Anokhin 1986, p. 34, pls. 3, 103); according to A. N. Zograf, to 325–300 B.C. (Zograf 1951, p. 177); and according to D. B. Shelov, to 315–300 B.C. (Shelov 1956, p. 105, pl. M.53).

<div align="right">Y. K.</div>

BIBLIOGRAPHY: *CR* 1859, pp. 5–15, pls. I–III, V; Gaidukevich 1971, pp. 274ff.

156

Red-figure Pelike

Attributed to the Eleusinian Painter
Attika
360–350 B.C.
H: 37.8 cm; Diam (mouth): 24.6 cm
Terracotta
Eastern end of the Yuz Oba ridge. Pavlovsky kurgan, 1858. Excavations of A. E. Liutsenko
Inv. PAV.8

The shape of the pelike is characteristic of the fourth century B.C. The vertical side of the overhanging lip is decorated with a red stripe and a row of semi-open hanging palmettes. The body on both sides is filled with multifigured compositions. Under the handles are magnificent palmettes and volutes. Above the figures, on the neck of the pelike, is a cymation above a broad band of upright palmettes and lotus buds. Under the figures, near the foot of the pelike, is a stopped meander broken with checkerboard squares.

SIDE A. Demeter is seated in three-quarter view to the left with a frontal face; she wears a kalathos on her head and holds a scepter. Above her head is a small figure of Triptolemos in a winged chariot. In front of Demeter is a small Plutos with a cornuco-pia. To her left stands Eumolpos, frontal, wearing long elegant garments, and holding a torch in each hand. Behind him, somewhat higher, is a frontally depicted nude Herakles with a club and scepter; seated below him is Aphrodite, at whose feet squats a small Eros with spread wings. To the right of Demeter is a frontally depicted standing Persephone with a long torch, leaning against a column; behind and slightly above her is a seated nude Dionysos with a thyrsos in three-quarter view to right; under Dionysos sits a female figure in profile to left. The figures are painted with thick and dilute gloss, complemented by relief detail (in applied clay) and applied paint. The nude parts of the bodies of Persephone, Aphrodite, Plutos, and Eros are covered in added white. Demeter's crown, Herakles' club, the horn of plenty, the wreaths crowning the figures, torches, and wings are executed in relief and gilded.

SIDE B. In the middle Athena in a helmet and long garments strides to the left and looks back; above her flies a small Nike to left in profile. To the left of Athena—half obscured by the frame—is a goddess (Gaia?) standing

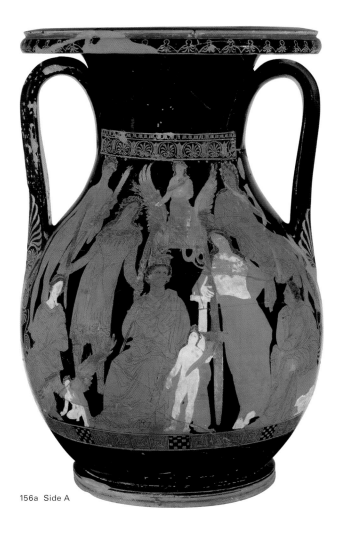

156a Side A

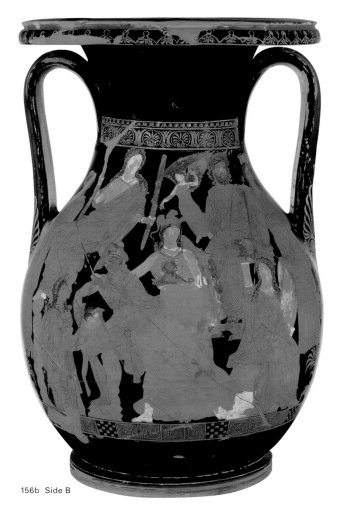

156b Side B

to right in profile; she presents an infant (Erichthonios?) to Hermes. Above them is a seated goddess in three-quarter view to left with torches in her hands (Persephone? Hekate?); behind her is a standing female figure. Above, to the right of Athena, Zeus is seated on his throne; below him sits Demeter and behind her stands Hera. The painting is complemented by relief details of added clay and added colors. The nude parts of the bodies of Persephone, Athena, Demeter, and Hera are rendered in added white. Hermes' hat, the wreaths and crowns of the gods, and Nike's wings are gilded.

This pelike with figures in complex poses and angles, composed in several tiers, with elegantly and lightly depicted bodies and drapery and abundant use of added white and gilding, is a splendid example of Kerch-style

vase-painting. At present, the pelike is dated 360–350 B.C.; previously, dates of 380–360 B.C. (Luk'ianov and Grinevich 1915) and 340–330 B.C. (Schefold 1934) have been proposed.

A.P.

BIBLIOGRAPHY: *CR* 1859, p. 32, pls. I–II; Luk'ianov and Grinevich 1915, 38; Schefold 1934, 368, pl. 35; Furtwängler and Reichhold 1904–32, pl. 70; Beazley *ARV*[2], p. 1476, no. 1; Metzger 1965, pp. 40–42, pl. 24; Beazley *Para*, p. 496; Beazley *Add*[2], p. 381; Boardman 1989, pl. 392; Valavanes 1991, pls. 122–23, 127a; *LIMC* 3, s.v. "Eileithyia," p. 693, no. 79; *LIMC* 4, s.v. "Eubouleus," p. 44, no. 7; *LIMC* 4, s.v. "Eumolpos," p. 58, no. 27; *LIMC* 4, s.v. "Ge," p. 174, no. 29; *LIMC* 6, s.v. "Hekate," pp. 991–92, no. 24; *LIMC* 6, s.v. "Keryx," p. 37, no. 6; *LIMC* 7, s.v. "Styx," p. 819, no. 6a; *LIMC* 8, s.v. "Kybele," p. 748, no. 7; *LIMC* 8, s.v. "Zagreus," p. 305, no. 1; Clinton 1992, pp. 172–73, pls. 20–21; *Greek Gold* 1994, p. 167, no. 152; *Zwei Gesichter* 1997, 177, no. 80; Simon 1998, pp. 174–75, pl. 15.1–4; *Greek Gold* 2004, fig. 38.

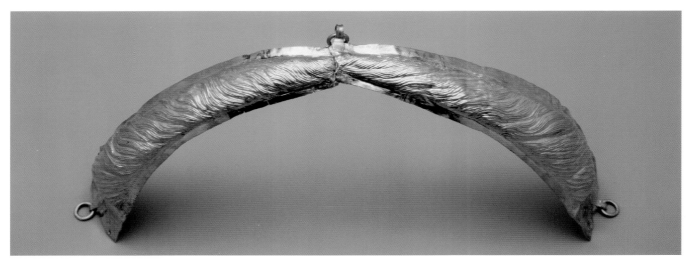

157

157

Stlengis

The Bosporus (?)
Middle–third quarter of the fourth century B.C.
L: 28 cm
Gold
Eastern end of the Yuz Oba ridge. Pavlovsky
 kurgan, 1858. Excavations of A. E. Liutsenko
Inv. PAV.1

Stlengis—an adornment for the forehead
imitating strands of hair parted in the
middle—found on the head of a buried
woman. It consists of two halves connected
by a plate with a loop and ring soldered on
the reverse side. Two more rings are soldered
to the upper rim of the *stlengis* with loops
for tying it to the head. The repoussé relief
was finished with engraved details. In several
places small tears in the gold leaf that
occurred during subsequent working on the
details can be seen.

Three other *stlengides* are known: two
from the Great Bliznitsa kurgan, where they
form parts of priestly attire used by their
female owners while they were alive, and
the third found in the necropolis of Gorgip-
pia, made of gold leaf specially as part of a
woman's funerary adornments.

Y. K.

BIBLIOGRAPHY: *CR* 1859, pl. III.2; *Griechische Klassik*
2002, no. 429a.

158

Necklace with Three-blade Pendants

Third quarter of the fourth century B.C.
Length: 33.9 cm; Weight: 42.18 g
Gold
Eastern end of the Yuz Oba ridge. Pavlovsky
 kurgan, 1858. Excavations of A. E. Liutsenko
Inv. PAV.2

The necklace is a band of loop-in-loop chains
to which filigree rosettes with beechnut
pendants have been attached. The necklace
terminates in stylized lions' heads, each
holding a ring in his mouth. The necklace was
worn by tying a string through these rings.
The woman's slightest movement—even just
breathing—would cause sunlight or lamp-
light to be reflected on the blades of all of the
pendants. To some researchers the pendants
are reminiscent of beechnuts (*CR* 1865,
p. 48; *Greek Gold* 1994, p. 168; Saverkina 2001,
p. 97, fig. 3); to others, arrowheads or spears.
The treasury of the Temple of Artemis on
Delos listed two among gifts to the goddess
as "spear-head shaped" (Michel 1900, no. 833,
v. 23–24).

Y. K.

BIBLIOGRAPHY: Ruxer 1938, p. 206, pl. XXVII.3;
Artamonov 1970, pl. 277; *Greek Gold* 1994, no. 106;
Zwei Gesichter 1997, no. 82.

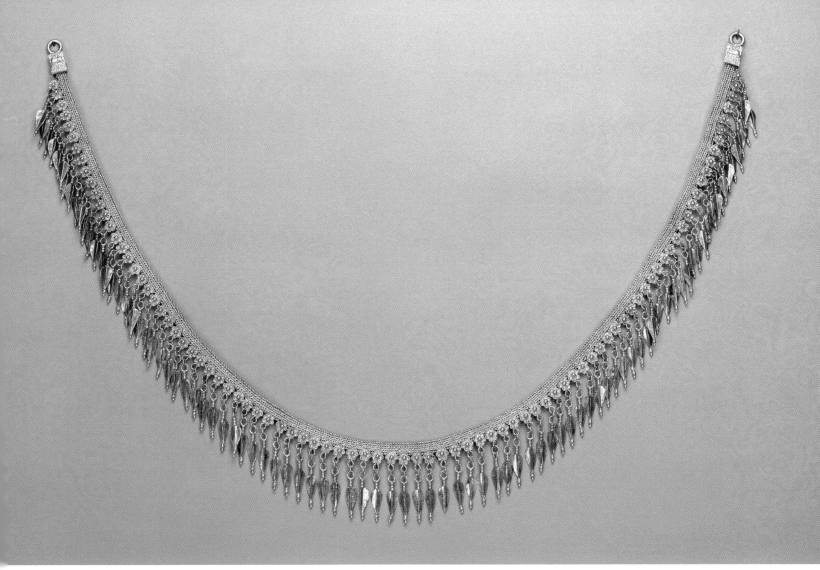

158a

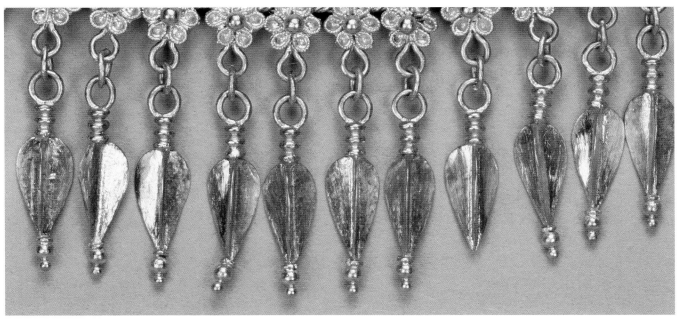

158b

PAVLOVSKY KURGAN

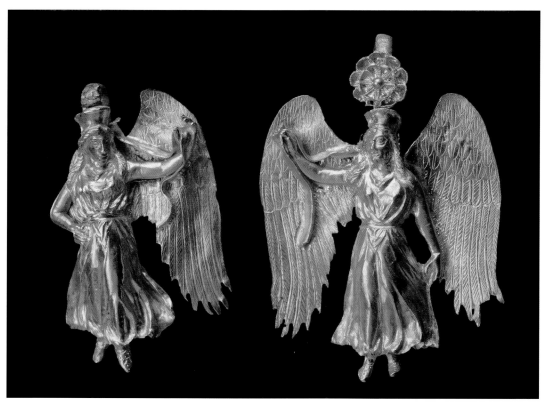

159 2:1

159

Earring with Figure of Nike

Mid-fourth century B.C.
H: 4.8 cm; Weight: 18 g
Gold
Eastern end of the Yuz Oba ridge. Pavlovsky
 kurgan, 1858. Excavations of A. E. Liutsenko
Acquired in 1859
Inv. PAV.3

One of a pair of earrings consisting of a
figurine of a flying Nike with a ribbon
(taenia) in her hand. A rather broad hook is
covered by a two-layer rosette. The figurine
was cast in a flat mold, and the arms, wings,
feet, and ribbon were cast separately and
soldered to the figurine. The hair, facial
features, folds of the chiton, and plumage of
the wings are exquisitely detailed. Judging
from the position of the hand and the turn
of the body, this is a left earring; the Nike
of the second, right earring mirrors the
gesture of the raised hand with the ribbon.

That earring was repaired in antiquity, which
indicates it was worn for a long time. Appar-
ently, as in the case with the Nymphaion
earrings (see cat. no. 132) the model for the
master miniaturist was a monumental
sculpture—a statue or a relief.

Y. K.

BIBLIOGRAPHY: CR 1859, pl. III.3; Hadaczek 1903,
p. 38, fig. 66; Artamonov 1970, pl. 273; *Greek Gold*
1994, no. 107; Jacobson 1995, pp. 98–99, no. I.D.5;
Zwei Gesichter 1997, no. 81.

160

Ring with Movable Bezel

Mid-fourth century B.C.
L (bezel): 1.8 cm
Gold, blue and transparent glass
Eastern end of the Yuz Oba ridge. Pavlovsky
 kurgan, 1858. Excavations of A. E. Liutsenko
Acquired in 1859
Inv. PAV.4

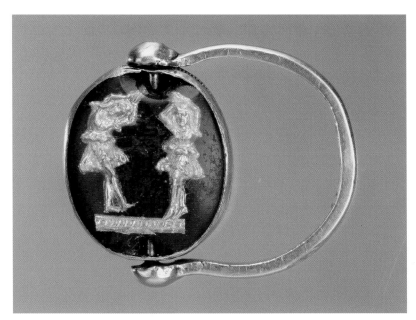

160a 2:1

The gold ring with glass bezel is designed the
same way as scarab stamps, but unlike those
this ring has a purely decorative function.
The setting of the double-sided bezel is
decorated with gold. The bezel consists of a
plate of blue glass, squeezed between two
colorless pieces of glass—one convex and one
flat. The stamped images, cut from gold foil,
are set against a blue background. Under the
convex glass are small figures of two female
dancers performing an *oklasma* dance, thought
by the Greeks to be of Persian origin. The
movements of this dance are also depicted on
appliqués from the Great Bliznitsa kurgan
(see cat. no. 170). On the flat side of the bezel
is a sea monster (*ketos*) surrounded by fish
and dolphins. The setting of the bezel and
the hoop have traces of wear and ancient
repair work.

This piece of jewelry, along with four
glass rings from the second half of the fourth
century B.C.—one from the Kurdzhips
kurgan in the north Caucasus, in the Hermit-
age; one in the Louvre; and two in the British
Museum—is an early example of combining
glass with gold foil—a technique popular
in Hellenistic times (Coche de la Ferté 1956,
pl. XXII; Galanina 1980, pp. 42 illus., 89, no. 34;
Greek Gold 1994, nos. 159, 160).

Y. K.

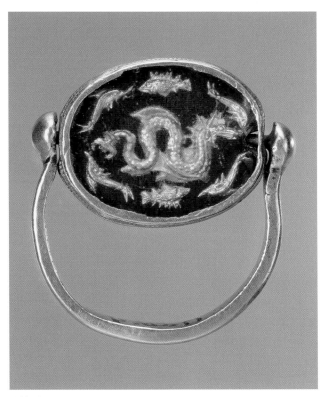

160b 2:1

BIBLIOGRAPHY: *CR* 1859, pl. III.4–5; Artamonow
1970, pls. 274–75; Boardman 1970, p. 233, pl. 822;
Greek Gold 1994, no. 108; *Zwei Gesichter* 1997, no. 83;
Kunina 1997, no. 68; *Greek Gold* 2004, fig. 61.

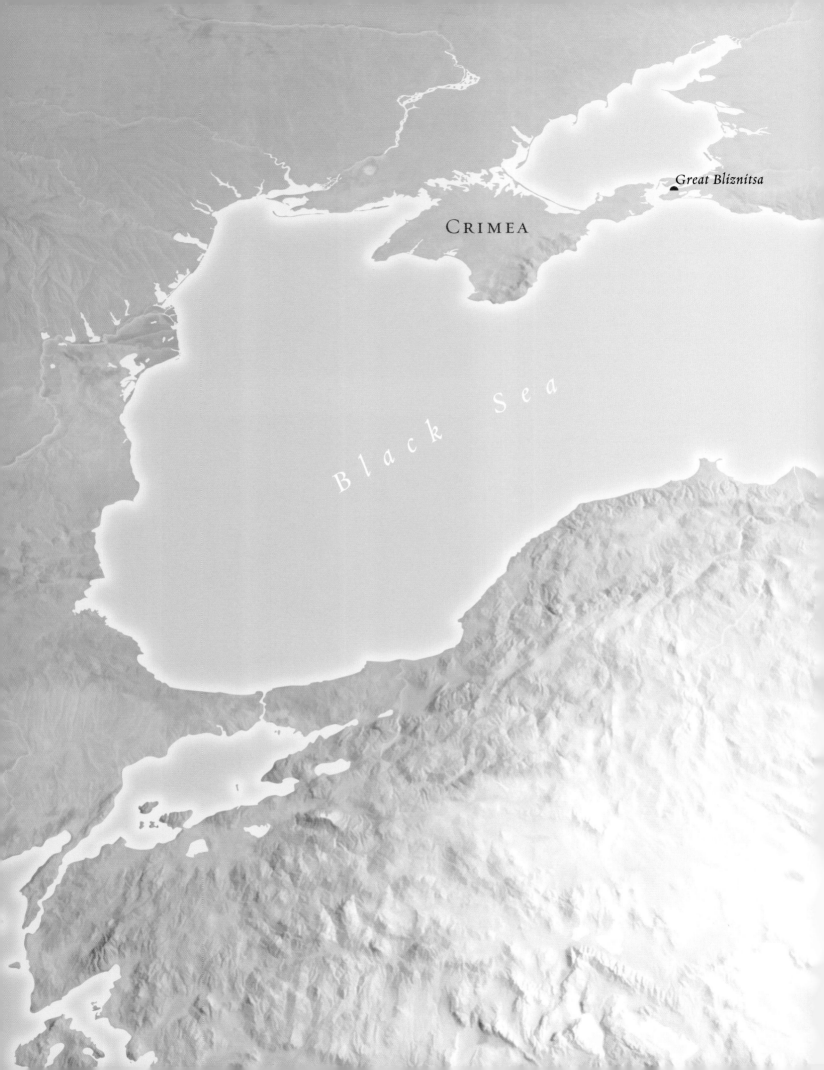

CRIMEA

Great Bliznitsa

B l a c k S e a

Great Bliznitsa Kurgan

THE GREAT BLIZNITSA KURGAN IS LOCATED ON THE TAMAN PENINSULA, on a high ridge running east-west along the Tsukursky lagoon northwest of the Cossack village of Vyshesteblievska'ia. Nearby is another big kurgan, Mala'ia Bliznitsa, which explains the name of the kurgans (the Greater Twin and the Minor Twin) The exploration of the kurgan lasted several years; it was started in 1864 by A. E. Liutsenko, Baron V. G. Tiesenhausen, and S. I. Verebriusov (fig. 16). The kurgan was 15 meters high. Three burial chambers with stepped roofs, two slab tombs, and a funeral pyre with remains of a woman were found. Among the melted remains of her jewelry was an earring pendant—a miniature figurine of a female dancer. One of the burial chambers was looted, but the wall painting—of which the most important part was a head of Demeter or Kore in the middle of the stepped vault (fig. 17)—had been preserved. One burial chamber held a woman (chamber 1) and another one a warrior (chamber 3) buried with his weapons. With a wreath on his head, he lay in a richly adorned sarcophagus. Judging from the fluted black-glazed pelike, the burial dates from the second half of the fourth century.

The woman buried in stepped chamber no. 1 lay in a wood sarcophagus decorated with ivory carvings and inlay. Her attire is distinguished by extraordinary opulence. It included a gold kalathos—a headdress in the form of a basket—decorated with relief figures of Arimasps fighting griffins. The hair was covered by a *stlengis* similar to the one found in the Pavlovsky kurgan (cat. no. 157). Pendants (cat. no. 161) and earrings (cat. no. 162) were found by her head. She had two necklaces (one is cat. no. 163), bracelets with lionesses (cat. no. 164), and four rings on her left hand. Her clothing was adorned with 1,585 assorted gold plaques (including cat. nos. 166–68). Possibly the dots on the Nereid carrying armor on the temporal pendant (cat. no. 161) represent similar appliqués. A red-figure vase and horse harnesses (cat. no. 172) were also found in the tomb. The general consensus is that this woman was a priestess of Demeter or Aphrodite.

The woman buried in one of the slab tombs was dressed in a similar but more modest ritual dress. Her kalathos has not been preserved; only the relief plaques sewn on it remain. The basketlike kalathos headdress was an attribute of divinities responsible for

Fig. 16. The Great Bliznitsa kurgan. Excavations of burial chamber no. 1. View from the west. From Rostovtsev 1913–14, pl. 5.1.

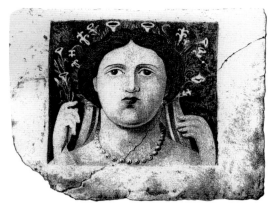

Fig. 17. The Great Bliznitsa kurgan. The ceiling painting of burial chamber no. 3. From CR 1865.

fertility, abundance, and prosperity. These were symbolized by the basket, which was used during sowing, fruit harvesting, and domestic chores (specifically, for keeping wool). As an attribute of Demeter, the basket played an important role in the Eleusinian mysteries. Demeter is commonly the goddess of the productive forces of nature, depicted wearing a kalathos. The same headdress is seen on the heads of girls performing a dance (see cat. no. 171).

It is impossible to say with complete certainty which goddess the priestess of burial chamber 1 served, but the most widespread interpretation of this complex is that she was a priestess of Demeter. In the opinion of V. F. Gaidukevich (Gaidukevich 1971, p. 228), however, she was a priestess of Aphrodite at the nearby Apatur shrine. Yet another theory proposes that she was a priestess of a female divinity, related to the Great Goddess, worshipped in various parts of the Greek world, the Near East, and Scythia (Machinskii' 1978, p. 136). In general, the kurgan was the burial place of an aristocratic family whose members were buried in the second half of the fourth century B.C. In these complex burial rituals there is an intertwining of local and Greek traditions. Thus the wreath on the head of the warrior signified his posthumous status as a hero, and the burial itself was in a magnificent sarcophagus with a black-glazed fluted pelike, while the priestess was buried with horse harness from a burial chariot (cat. no. 172).

Y. K.

BIBLIOGRAPHY: Gaidukevich 1971, pp. 296–300; Schwarzmaier 1996.

161

Pendant with a
Relief of a Nereid

Fourth century B.C.
H: 15.5 cm; Weight: 78.38 g
Gold, enamel
Great Bliznitsa kurgan. Burial chamber I,
 1864. Excavations of I. E. Zabelin and
 A. E. Liutsenko
Acquired in 1864
Inv. BB.31

One of a pair of pendants consisting of
a disk with a relief image and intricate net of
pendants with different shapes, sizes, and
decorations attached to the disk. The inter-
sections of the braided chains and their
attachments to the disk are covered by
miniature two-layered filigree rosettes with a
graniform sphere in the center. The point of
attachment of the graniform and amphora
pendants to the chain is hidden by tiny shield
bosses and ivy leaves. A ring for fastening is
soldered to the upper rim of the reverse side
of the disk. The pendants are decorated with
filigree and granulation. The filigree petals
on the pendants and the leaves of ivy are
filled with blue and green enamel. A band of
filigreed rosettes frames the lower half of the
disk, which has strips of plain and beaded
wire around the rim. The small details of the
relief have been done in repoussé.

The convex disk bears a relief depiction
of a Nereid sitting on a hippocamp swim-
ming to right. Beneath it is a dolphin in
relief. This subject is connected with Achilles,
the hero of the Trojan War. A Nereid—
perhaps his mother, Thetis—is carrying the
weapons forged for him by Hephaistos.
On this pendant the Nereid holds a cuirass
in her right hand, in the companion pendant
she holds a greave. Achilles became immortal
after his death at Troy and resided on the
island of Leuke in the northwestern part of
the Black Sea. His cult was widespread on the
northern Black Sea coast and was reflected
in the works of Greek art, including jewelry
in this region.

L.N.

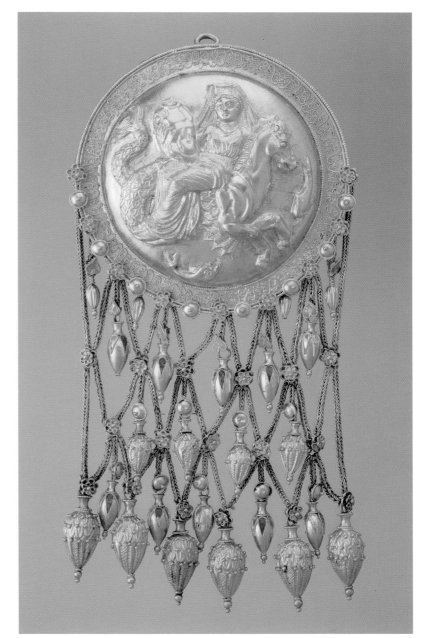

161

BIBLIOGRAPHY: *CR* 1865, pl. II.1; Artamonov 1970,
pl. 296 (right); *Greek Gold* 1994, no. 120; Jacobson
1995, pp. 89–91, no. I.C.2, fig. 5; *Zwei Gesichter* 1997,
pp. 187–89, no. 86; Minasian 1999, p. 39; *Greek Gold*
2004, p. 104.

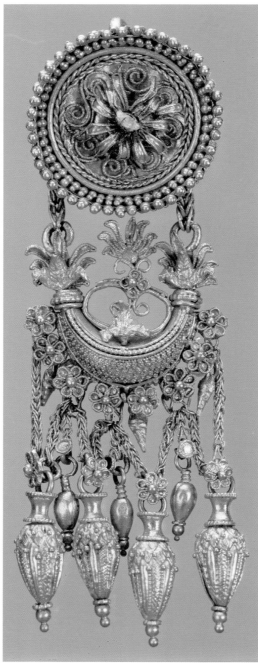

162 3:1

162

Earring with a Boat-Shaped Pendant

Third quarter of the fourth century B.C.
H: 5.8 cm; Weight: 10 g
Gold
Great Bliznitsa kurgan. Burial chamber 1,
 1864. Excavations of I. E. Zabelin and
 A. E. Liutsenko
Acquired in 1864
Inv. BB.32

The earring, one of a pair, consists of a disk
and a boat-shaped pendant attached by chains.
The disk is decorated with filigree and a
double ring of granules around the edge; in
the center is a flower with two layers of thin
petals. The body of the boat is decorated with
four-granule clusters. The chains that con-
nect it to the disk are covered with acanthus
leaves. Attached to a row of light rosettes
along the lower edge of the boat are three
die-struck triton shells and a system of chains
from which two types of pendants hang.
D. Williams associates these earrings and
the temporal pendants (cat. no. 161) with a
similar system of chains from the same
workshop (*Greek Gold* 1994, p. 190). The
analogous designs of the necklaces from Kul
Oba and Great Bliznitsa (see cat. no. 163)
(Grach 1986, pp. 82–86) and of the temporal
pendants (cat. nos. 141, 161) (Minasian 1999,
p. 39) all seem to be products of this workshop.

Y. K.

BIBLIOGRAPHY: *CR* 1865, pls. 2, 3; *Greek Gold* 1994,
no. 122; *Zwei Gesichter* 1997, no. 87; Saverkina 2001,
p. 6, fig 3.

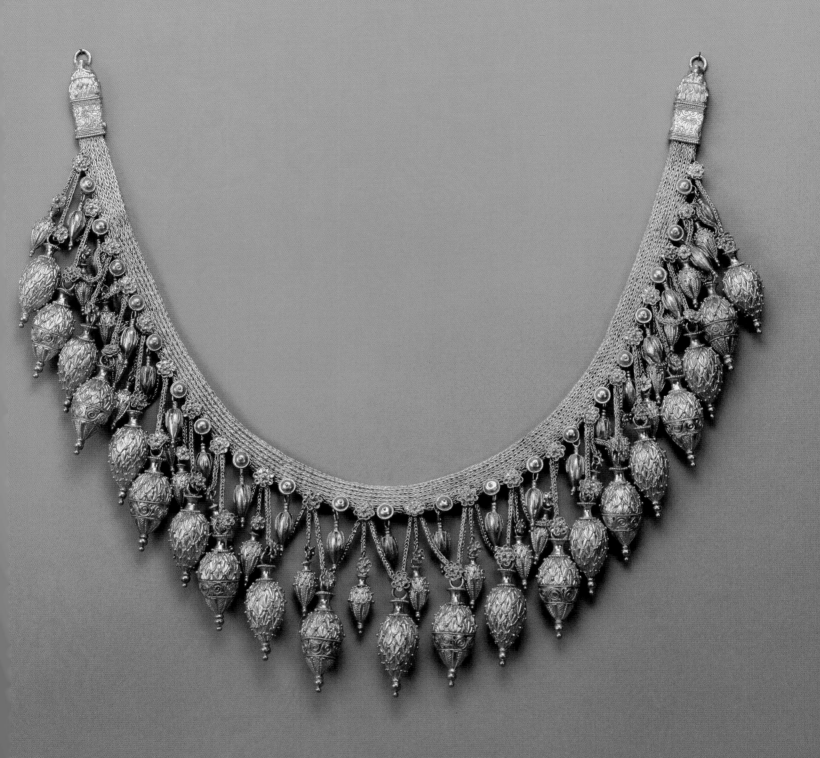

163a

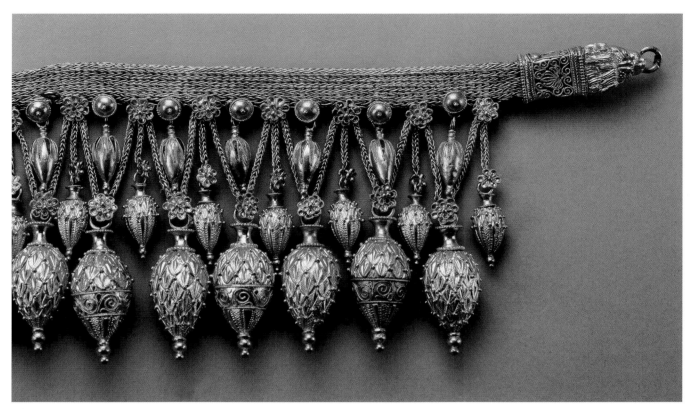

163b

163

Strap Necklace with Three Rows of Pendants

Third quarter of the fourth century B.C.
L: 37.8 cm; Weight: 63.64 g
Gold, enamel
Great Bliznitsa kurgan. Burial chamber I, 1864.
 Excavations of I. E. Zabelin and
 A. E. Liutsenko
Acquired in 1864
Inv. BB.34

The basis of this necklace is a strap consisting of five doubled loop-in-loop interlinked chains. The terminals are in the form of stylized lions' heads holding a ring in their mouths. Double filigreed rosettes with double and single chains are attached to the lower edge of the strap so their pendants remain in the correct position when the wearer moves. In the top row, inside the double chains, are bud pendants that seem to emerge from the leaves, which are covered in blue and green

enamel. Larger amphora-like pendants are fastened to single chains in an intermediate row, and the largest pendants, suspended from double chains, form the bottom tier. All the pendants are soldered together from two die-stamped halves; they were filled with mastic to give them firmness (in the upper part of the large pieces one can see the openings through which the fill was introduced). The pendants were decorated with granulation and filigree.

It should be noted that in spite of the uniqueness of this necklace, a very similar one is partially preserved from the Kul Oba kurgan (Grach 1986, pp. 82–86, figs. 5–7, pl. 1). D. Williams believes that this necklace and the temporal pendants with a relief of a Nereid (cat. no. 161) were made in the same workshop (*Greek Gold* 1994, p. 189) (cf. cat. no. 162).

Y.K.

BIBLIOGRAPHY: *CR* 1865, pl. II.4; Artamonov 1970, pl. 305; Ruxer 1938, pp. 200, 228, pl. XXVI; *Greek Gold* 1994, no. 121; Jacobson 1995, pp. 126–27, no. II.D.1, fig. 26; *Zwei Gesichter* 1997, no. 88; *Greek Gold* 2004, fig. 28.

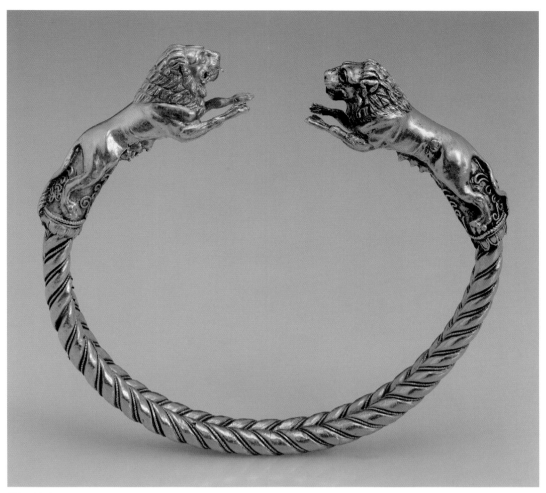

164a 1.5:1

164

Bracelet with Maned Lioness Terminals

Second half of the fourth century B.C.
W: 7.3 cm; H: 6.5 cm; Weight: 46.54 g
Gold, bronze, enamel
Great Bliznitsa kurgan. Burial chamber 1,
 1864. Excavations of I. E. Zabelin and
 A. E. Liutsenko
Acquired in 1864
Inv. BB.35

The bracelet, one of a pair, consists of a
bronze hoop with open ends, around which
are wound convex strips of gold leaf with
braided cord between them. Each terminal is
a figure of a jumping lioness made of two
die-stamped halves soldered together. The
small details (tails, teeth, teats, tongues) were
made separately and soldered to the finished
figures. Remains of enamel are visible in the
filigree ornamentation of the eyes. The heads
of the rivets connecting the bronze founda-
tions of the lionesses to the terminals show
through in the lionesses' ribs.

Y. K.

BIBLIOGRAPHY: CR 1865, pl. II.6; Artamonov 1970,
pl. 313; Schatzkammern 1993, p. 85, no. 38; Greek Gold
1994, no. 124; Jacobson 1995, pp. 132–33, no. II.E.I, fig.
28; Zwei Gesichter 1997, no. 89; Greek Gold 2004, fig. 63.

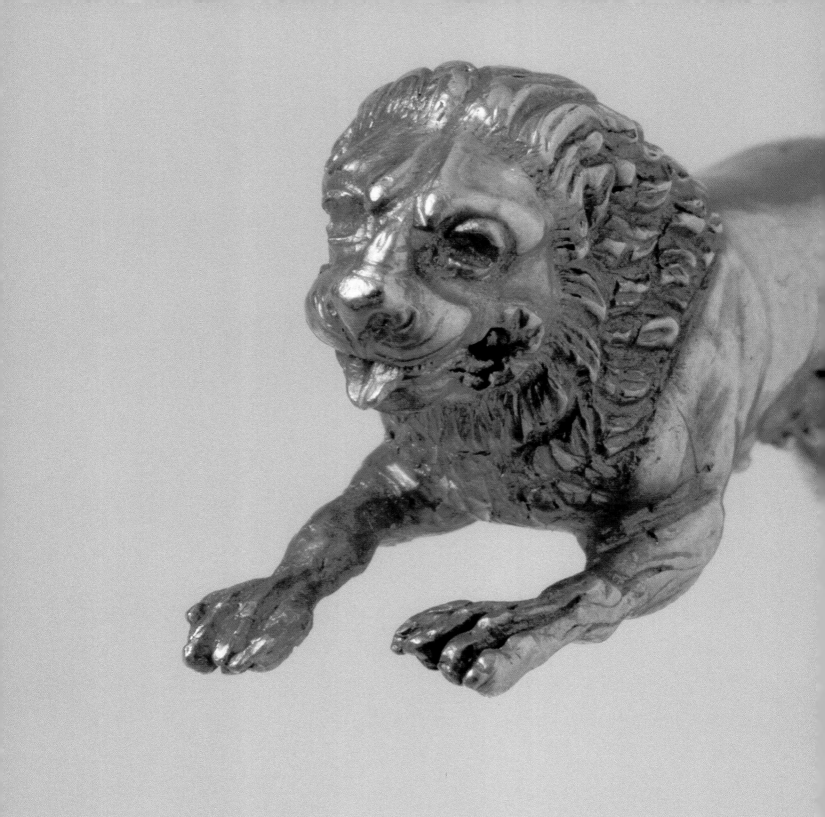

164b

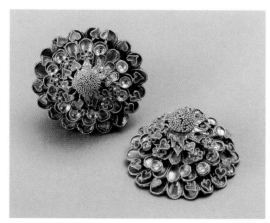

165 1.5:1

165

Two Multilayered Rosettes

Fourth century B.C.
H: 1.2 cm; Diam: 2 cm; Weight: 4.02 and 4.06 g
Gold, enamel
Great Bliznitsa kurgan. Burial chamber 1,
 1864. Excavations of I. E. Zabelin and
 A. E. Liutsenko
Acquired in 1864
Inv. BB.41

Two of seven preserved rosettes consisting
of eight layers threaded on a hollow tube
with a domelike finial, densely filled with
very small granulation. The decoration of the
rosettes is distinguished by great diversity
and subtlety of execution. The pyramid of
layers consists of multipetaled blades, ivy
leaves, concave disks, and six-petaled rosettes
on wires; topping off the pyramid is a nine-
petaled star with granules on the ends of the
rays. All the layers of the rosette are movable,
and each element is edged by a finely beaded
wire. The green and white enamel on the
ivy leaves is only partially preserved. Three
narrow bands with sharpened ends are
soldered to the reverse side for attaching the
rosettes to clothing. The rosettes from the
Great Bliznitsa are similar to less complex
multipetaled rosettes from the Nymphaion
necropolis (cat. no. 133).

L. N.

BIBLIOGRAPHY: CR 1865, pl. III.21; Greek Gold 1994,
no. 130; Zwei Gesichter 1997, pp. 195–96, no. 92.

166–68

Square Appliqués

Fourth century B.C.
5.8 × 5.8 cm
Gold
Great Bliznitsa kurgan. Burial chamber 1,
 1864. Excavations of I. E. Zabelin and
 A. E. Liutsenko
Acquired in 1864

These appliqués, identical in form, come
from the rich burial of a woman in the
Great Bliznitsa kurgan. They have depictions
of the heads of Demeter, Persephone, and
Herakles. All of these characters from the
distinctive group of appliqués are connected
to the Eleusinian mysteries of the veneration
of the goddess of agriculture, Demeter, and to
the patrons of plant and animal life in gen-
eral. It is possible that the priestess buried in
the kurgan celebrated the cult of the god-dess
of fertility. The interest in these cults in the
northern Black Sea region is confirmed by
other archaeological finds. However, the fact
that this original set of appliqués from the
Great Bliznitsa is associated with one subject
sets them apart from similar square and cut-
out plaques from the same area.

The appliqués were adornments for
clothing. Each one has eight punched holes
at the edges to allow them to be sewn onto
the fabric. The repoussé images of the heads
are placed in frames of ova. The details are
finished with a sharp implement.

L. N.

BIBLIOGRAPHY: CR 1865, pl. II.7–9; Artamonov
1970, figs. 145–47; LIMC 5, s.v. "Herakles," p. 154, nos.
3203a–c; Greek Gold 1994, nos. 127–29; Zwei Gesichter
1997, no. 93–95; Greek Gold 2004, pp. 105–6.

166

Demeter

(One of fifteen plaques)
Weight: 4.55 g
Inv. BB.46

Demeter is shown in three-quarter view.
The slight inclination of the head and a
hint of sadness on the face of the goddess
add to the expressiveness of the image.
Her image is combined with a lit torch
(an attribute of the goddess); it lights the
way in her quest to find her abducted
daughter Persephone in the underworld
realm of Hades. Demeter's jewelry are
a wreath, a necklace with large beads, and
a disk earring with a pyramid pendant.

L. N.

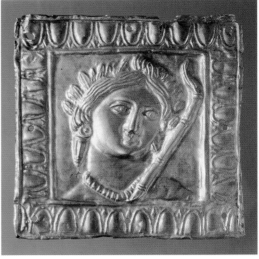

166

167

Persephone

(One of thirteen plaques)
Weight: 4.32 g
Inv. BB.45

Frontal image of the young Persephone,
daughter of the goddess Demeter, abducted
by Hades, the lord of the underworld.
The frontal image emphasizes the majesty of
the great goddess of the underworld. The
necklace of large beads and the disk earrings
with pyramid pendants are identical to
Demeter's jewelry (see cat. no. 166). A veil
over Persephone's head frames her face.
The adornment of her hairstyle with stalks
of grain represents her association with
the life-giving forces of nature when, with
Zeus's permission, she leaves the underworld
to spend part of the year on earth with her
mother, Demeter.

L. N.

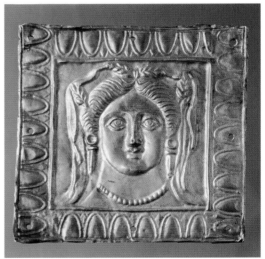

167

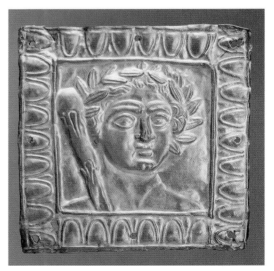

168

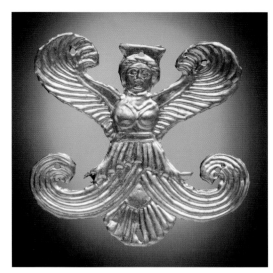

169

169

Plaque: Winged Female Semi-Figure

Fourth century B.C.
H: 5.3 cm
Gold
Great Bliznitsa kurgan. Burial chamber 1,
 1864. Excavations of I. E. Zabelin and
 A. E. Liutsenko
Acquired in 1864
Inv. BB.49

The appliqué, embossed and cut out along the contour, depicts a female divinity wearing a kalathos and a short girded chiton. Instead of legs, a palmette flanked by two diverging volutes emerges from under the chiton. Similar appliqués of different sizes were found in three graves of the Great Bliznitsa kurgan. This is one of sixteen from the same grave.

Winged semi-figures, mostly female, with lower bodies of vegetative shoots, serpent bodies, or other ornamental elements, appear in archaeological monuments of the northern Black Sea region of the fourth century B.C. They have been found not only on numerous plaques but also on a silver vessel, and horse front piece. In the Roman era they are found in the plaster and wood decoration of Pantikapaion sarcophagi (see cat. no. 100).

Similar depictions of fantastic divinities in Greek art embodied images of gods of the worlds of flora and fauna. On Bosporan soil they reflect religious ideas closer to the local population, connected in particular with the Scythian legend of a serpent-legged goddess—the female ancestor of the Scythians. (See also cat. 100.)

L.N.

BIBLIOGRAPHY: Artamonov 1970, pl. 308; Jacobson 1995, p. 180, no. IV.G.1, fig. 60; *Zwei Gesichter* 1997, no. 96; *Greek Gold* 2004, fig. 58.

168

Herakles

(One of fourteen plaques)
Weight: 4.87 g
Inv. BB.44

Herakles' head is adorned with a magnificent olive wreath; a club leans against his right shoulder. Deep folds on the forehead and shoulder emphasize the hero's virility. The relationship of this to the Demeter (cat. no. 166) and Persephone (cat. no. 167) appliqués is apparently based on the association of all of these gods with the Eleusinian mysteries. It is known that Herakles was initiated into the mysteries of Demeter and that his image played a considerable role in spreading her cult outside Greece.

L.N.

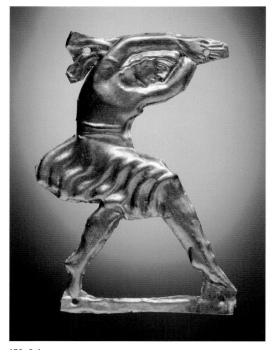

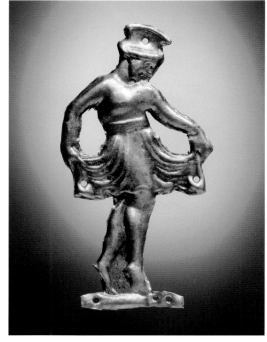

170 2:1 171 1.5:1

170

Plaque: Dancer

Fourth century B.C.
H: 4.8 cm
Gold
Great Bliznitsa kurgan. Burial chamber 1,
 1864. Excavations of I. E. Zabelin and
 A. E. Liutsenko
Acquired in 1864
Inv. BB.50

One of twelve plaques embossed and cut out along the contour shows a female dancer with hands closed above her head in a pose characteristic for the *oklasma* dance. The girl is wearing a short girded chiton; there is a fillet on her head. The direction of the folds of the chiton, the billowing ribbon on the fillet, the inclination of the body, and her leaping step transmit the expression of her dance.

This dancer—together with the one in the kalathos on the blue glass bezel ring from the Pavlovsky kurgan (cat. no. 160) and the appliqué from this same burial of a dancer in a kalathos (cat. no. 171)—probably had a direct connection to the ritual conducted by the priestesses buried in the kurgans.

Evidently the dancers were linked to the cult of the goddess of fertility, Demeter, a connection supported by the depictions of the goddess with the personages of the Eleusinian mysteries on the red-figure pelike from the Pavlovsky kurgan (cat. no. 156) and the series of square plaques from the Great Bliznitsa kurgan, which is linked to the same subject matter (cat. nos. 166–68).

L. N.

BIBLIOGRAPHY: *CR* 1865, III.1; Artamonov 1970, pl. 266 (reversed); *Zwei Gesichter* 1997, no. 98.

171

Plaque: Female Dancer with a Kalathos

Fourth century B.C.
H: 5.3 cm
Gold
Great Bliznitsa kurgan. Burial chamber 1,
 1864. Excavations of I. E. Zabelin and
 A. E. Liutsenko
Acquired in 1864
Inv. BB.51

280

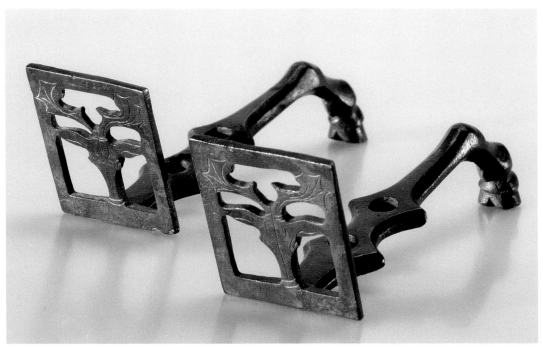

172

One of twelve identical embossed plaques cut out along the contour with a depiction of a dancer. Five round holes in the plaques allowed them to be sewn to the vestments of the dead woman.

Holding out her short chiton, which is girded under the breast, she is dancing to the right on her toes. On her head is a kalathos—a headdress similar in form to the one on the head of the woman buried in this grave. In Greek a *kalathos* is a woven basket, flared out at the top, used for household needs, including gathering fruit. A headdress of the same shape on Demeter, the goddess of fertility, symbolizes wealth on the red-figure pelike from the female burial in the Pavlovsky kurgan; there she is depicted surrounded by the participants in the Eleusinian mysteries (see cat. no. 156). On the glass ring from the same kurgan (cat. no. 160) the gold-foil figures of female dancers are directly analogous to the female dancers from the burial of the priestess of Demeter from the Great Bliznitsa kurgan (cat. nos. 170 and 171). Evidently it was the dance of young girls with baskets on festive occasions in honor of Demeter and Artemis that was being depicted by the ancient artists.

L.N.

BIBLIOGRAPHY: *CR* 1865, pl. III.2; Artamonov 1970, pl. 267 (reversed); Jacobson 1995, pp. 180–81, no. IV.G.4, fig. 64; *Zwei Gesichter* 1997, no. 97; *Muzy i maski* 2005, no. 140.

172

Two Psalia: Stag Heads and Legs

Second half of the fourth century B.C.
L (rods): 12.8 cm; H (plates): 5.2, 4.3 cm
Bronze
Great Bliznitsa kurgan, 1864. Excavations of
 I. E. Zabelin
Acquired in 1864
Inv. BB.77

Cast paired psalia with two holes. One end has been fashioned as a hoof and the other as a flat stag head, seen frontally, in a square frame. The ears and antlers are stretched out horizontally to the sides of the frame. On one side there are meagerly engraved details.

E.V.

BIBLIOGRAPHY: Artamonov 1970, p. 79, fig. 151.

281

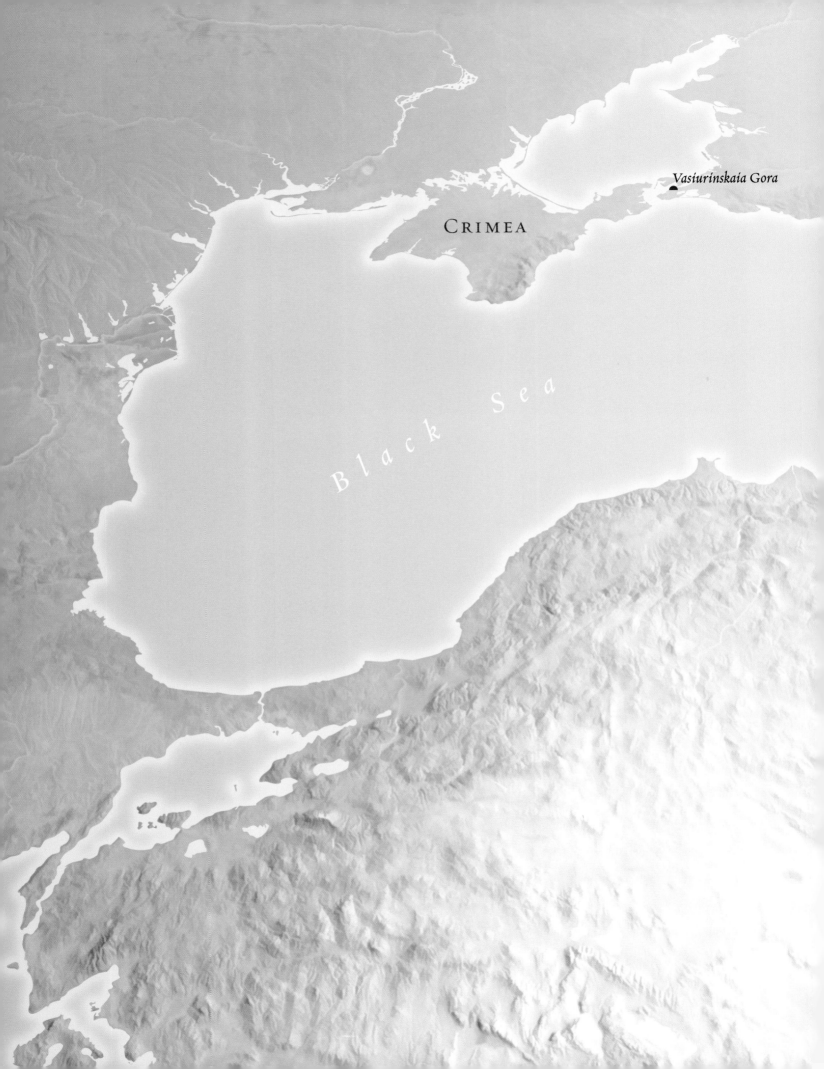

Vasiurinskaia Gora

CRIMEA

Black Sea

Vasiurinskaia Gora Kurgan

V ASIURINSKAIA GORA ("MOUNTAIN") IS A NATURAL ELEVATION ON THE Taman peninsula, which served as a burial place in the third to second century B.C. Five kurgans were erected on it: one large, two medium, and two small ones. In 1862–72 they were excavated by the members of the Imperial Archaeological Commission, Baron V. G. Tiesenhausen, and the director of the Kerch Antiquities Museum, A. E. Liutsenko. The burial complexes provide evidence of the ties between the barbarian and Greek worlds. In the large and in the medium kurgan no. I were stone burial chambers with semicircular vaults that were repeatedly used for burials; the burial chamber of the large kurgan was painted. There were horse burials in the kurgans. In the medium kurgan no. I, beside a horse were the remains of an iron chariot with cast bronze adornments in the form of figurines of a standing woman in a kalathos, embossed profile figurines of dragons with serpents' bodies and fishtails, and full (cat. no. 173) and half akroteria (cat. no. 174). The adornments of the chariot are in the Greek tradition.

E. V.

BIBLIOGRAPHY: Rostovtsev 1913–14, pp. 30–69, pls. XI–XXIV; Akimova 1988, pp. 60–97; Davydova 1994, pp. 261–67; Vlasova 2004b, pp. 158–74.

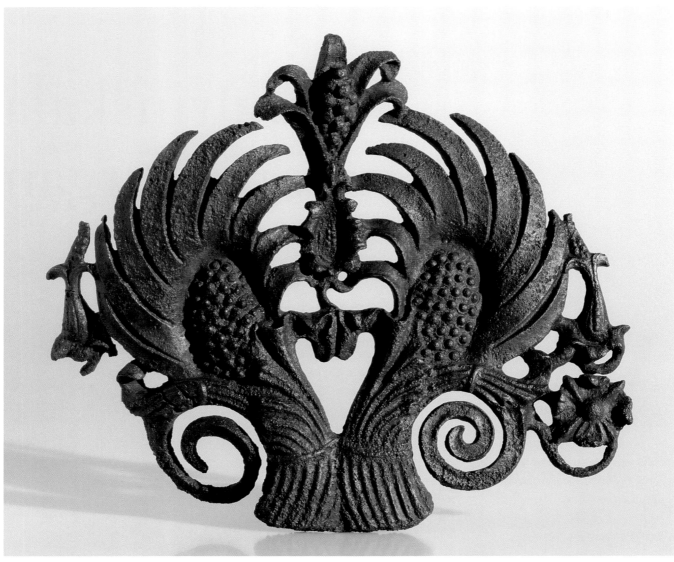

173

173

Chariot Decoration: Akroterion

Third century B.C.
19.5 × 22.1 cm
Bronze
Vasiurinskaia Gora kurgan, 1871.
 Excavations of A. E. Liutsenko
Inv. VAS.72

Solid cast akroterion, in relief on the obverse and flat on the reverse. At the bottom are two thick fluted acanthus stems tied together. Growing sideways out of them are flowers of the araceae family, whose petals form palmettes. The petals curve in at the center and touch a small araceae flower, and above it, a lily-shaped flower, which tops off the akroterion. On the sides, acanthus shoots curl into volutes adjoined by flower-rosettes and araceae buds.

E. V.

BIBLIOGRAPHY: Rostovtsev 1913–14, p. 51, pl. XXIII.4; Vlasova 2004b, pp. 166–67, ill. 17.

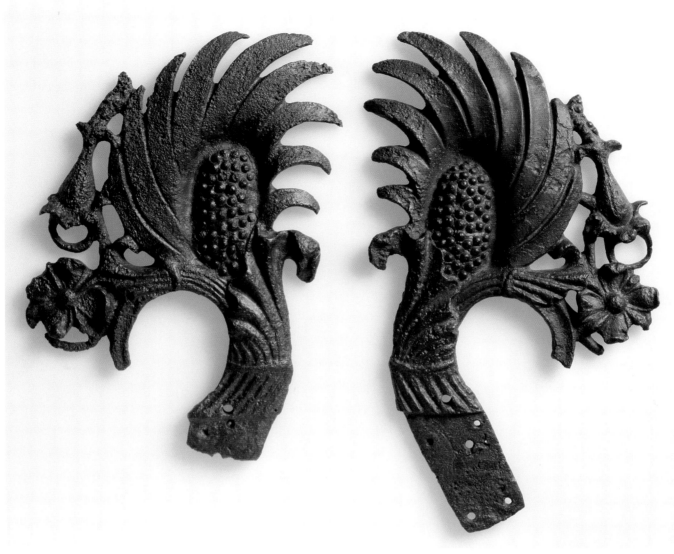

174

174

Two Adornments of a Chariot: Akroterion Halves

Third century B.C.
16.9 × 11.4 cm; 19.9 × 11.2 cm
Bronze
Vasiurinskaia Gora kurgan, 1871.
 Excavations of A. E. Liutsenko
Acquired in 1871
Inv. VAS.73

Two halves of an akroterion in the form of
a fluted acanthus stem, out of which grows
a blossom and leaf of the araceae family,
forming a demipalmette. From the side grow
a flower-rosette and a bud of the araceae
family.

E. V.

BIBLIOGRAPHY: Rostovtsev 1913–14, pp. 51–52,
pl. XXIII.2–3; Vlasova 2004b, pp. 166–67, ill. 18.

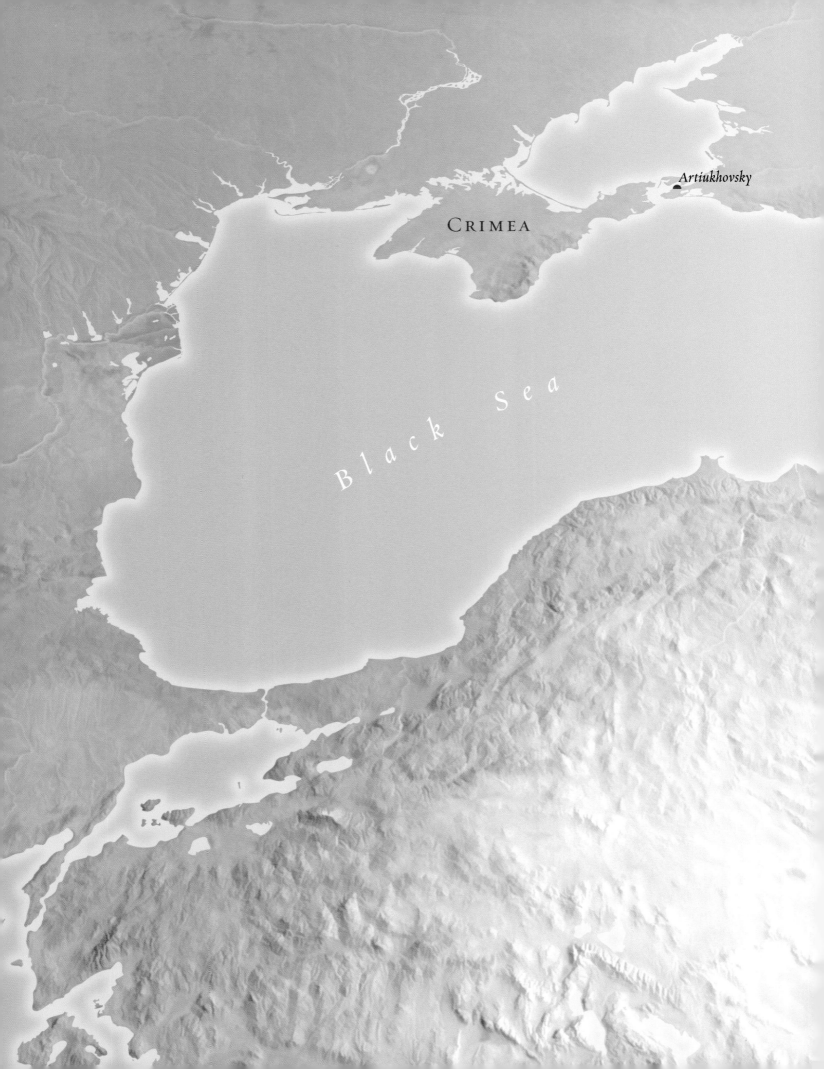

Artiukhovsky Kurgan

THE ARTIUKHOV KURGAN IS SITUATED ON THE EASTERN SHORE OF THE bay that cuts deeply into the Taman peninsula. It was excavated in 1879 by Baron V. G. Tiesenhausen and later by S. I. Verebriusov. Eight different graves were found under a 6.4-meter-high mound: three stone boxes; two burial chambers with semi-circular vaults, not stepped like the Yuz Oba and Great Bliznitsa vaults; and several plain earthen graves. Three of the tombs had not been looted. Two contained paired burials—apparently spouses who had died at different times. Like Great Bliznitsa, this kurgan was the family burial place of the wealthy inhabitants of one of the neighboring cities, most likely Kepoi.

The items here are from tomb no. 1, a stone box made of hewn slabs placed at ground level. The burial had no coffin; the dead woman lay directly on the ground. At her feet was a tile partition enclosing fragments of iron locks and keys belonging to caskets and a small moldmade amphora with a relief on the body, as well as other clay vessels. The inside measurements of the tomb were 2 meters long and approximately 70 centimeters wide. The burial contained a rich assortment of gold jewelry: a magnificent diadem with a Herakles knot in the center, a pair of earrings and one unpaired earring, a pair of spiral bracelets, three finger rings, a plaque with depictions of Aphrodite and Eros, six necklaces (including cat. no. 175), and a pin (cat. no. 176). A neck adornment was also found, indicating the noble origin of the deceased.

Traditionally, the kurgan was dated to the second half of the third or the second century B.C. (e.g., Rostovtsev 1931, p. 251). On the basis of an analysis of the coins, M. I. Maximova has dated all the approximately contemporaneous, unlooted burials to 140–25 B.C. (Maximova 1979, pp. 7–9).

Y. K.

BIBLIOGRAPHY: CR 1878–79, pp. XI, XLIV–LI; CR 1880, p. 1; Rostovtsev 1931, p. 245; Maximova 1960, pp. 46–58; Maximova 1979, pp. 7–9.

175

Necklace

Third quarter of the second century B.C.
L: 45 cm
Gold, emerald, garnet, glass
Artiukhovsky kurgan, 1879. Tomb I.
 Excavations of Baron V. G. Tiesenhausen
 and S. I. Verebriusov
Acquired 1879
Inv. ART.6

The middle part of the necklace consists of a square emerald and two oval garnets in frames. Two sections of the gold cord consisting of small rings are connected to them with small lynx's heads with striped glass beads imitating sardonyx. The clasp is fashioned in the form of two ivy leaves made from garnets. The main impression is created by the vivid composition of colored stones in the middle of the necklace, while the gold plays a secondary role. The setting of the stones and the heads of the lynxes are connected to each other by joints whose shafts are decorated with small beads. This is apparently one of the first examples of jewelry using such a connection. Similar jewelry was also worn in Roman times (cat. no. 41).

Y. K.

BIBLIOGRAPHY: CR 1880, pl. 1.6; Minns 1913, p. 431, fig. 321; Maximova 1979, p. 57, fig. on p. 29; *Zwei Gesichter* 1997, p. 204, no. 102.

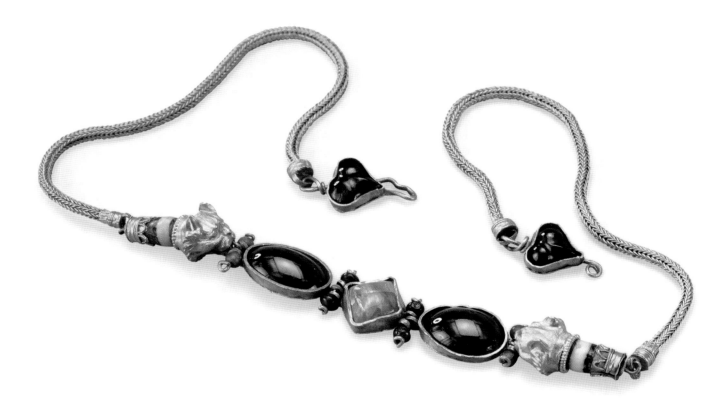

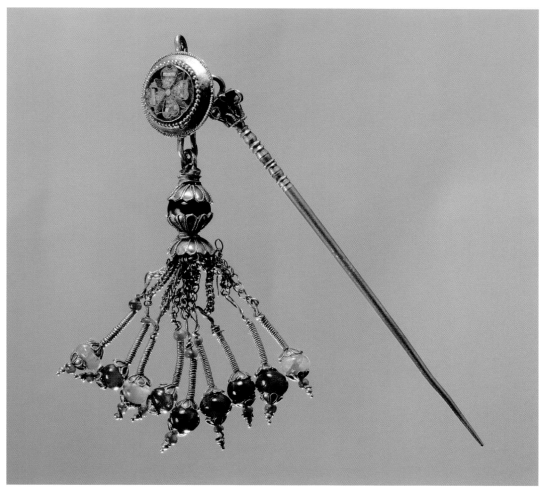

176 2:1

176

Pin

Middle of the second century B.C.
L: 7.7 cm
Gold, emerald, garnet, glass paste
Artiukhovsky kurgan, 1879. Tomb I.
 Excavations of Baron V. G. Tiesenhausen
 and S. I. Verebriusov
Acquired in 1879
Inv. ART.7

The pin consists of a needle with a head in the form of an openwork small capital terminating in a ring, from which is suspended a medallion with a rosette linked by two loops to a large bead and a cluster of pendants on chains. The rosette on the medallion was made using a method remi-niscent of cloisonné—an enamel technique that appeared only much later. The outlines of the rosette are vertical strips of gold, filled with pieces of green and brown glass. The head of the pin, the rim of the medallion, and the cupped rosettes holding the beads are decorated with filigree. The pendants of the cluster consist of stone beads and granules on twisted wires suspended from chains, which makes them very mobile. A pin of the same type, but simpler in its execution, was found in tomb II.

Y. K.

BIBLIOGRAPHY: CR 1880, pl. I.17; Minns 1913, p. 431; *Zwei Gesichter* 1997, pp. 205–6, no. 103; Maximova 1979, p. 49–50, fig. on p. 26; *Greek Gold* 2004, fig. 31.

Glossary

ACHELOÖS
mythical Greek river god

AGON
competitive struggle or contest

ALOPEKIS
Thracian cap of animal skin, usually fox

AKROTERION/-A
freestanding ornament or figure decorating the apex or corners of a gable

AMAZON
member of a mythical race of female warriors inhabiting the northern Black Sea and Eurasian steppe regions

AMAZONOMACHY
battle involving Amazons

AMPHORA
two-handled storage jar

AMULET
object worn for protection against evil and harm

ANASTOLE
upswept hair forming a tuft above the middle of the forehead; characteristic of portraits of Alexander the Great

ANTA/-AE
pilaster-like terminations of side walls of a temple

APOTROPAIC
averting evil

APHRODITE
Greek goddess of erotic love and beauty

ARIMASPS
mythical tribe of one-eyed people in the distant north

ARTEMIS
virgin Greek goddess of the hunt, wild animals, and childbirth

ASKOS
small container taking its name from the Greek word for wineskin, which its shape resembles

ASSOS/-OI
mold-cast (as opposed to struck) bronze coin

ATHENA
virgin Greek goddess of wisdom, warfare, and arts and crafts

AULOS
Greek wind instrument (pipe); the double pipe

BEZEL
flat, usually decorated, part of a finger ring

CERBERUS
mythical monstrous dog guarding the entrance to the underworld

CHITON
long or short belted garment of thin fabric, often buttoned at the shoulders and arms

CHORA
the delimited territory controlled by a polis

CHTHONIC
pertaining to fertility and the underworld

CURULE CHAIR
Latin *sella curulis*; a backless stool with curved legs reserved for high-ranking Roman dignitaries

CYBELE
Anatolian mother-goddess who was assimilated into the Greek and Roman pantheons

DANAË
mythical woman impregnated by Zeus in the guise of a golden rain, which produced the hero Perseus

DEMETER
Greek goddess of agriculture and fertility

DINOS
large bowl with a globular body and no handles used for mixing wine and water; a dinos is often placed on a tall stand

DIONYSOS
Greek god of wine, vegetation, and theater

DROMOS
entry passage to a burial chamber

ELECTRUM
natural alloy of gold and silver used in the earliest coinage in Asia Minor

EROS
son of Aphrodite, winged Greek god of love

GORGON
one of three monstrous sisters with snakes for hair whose gaze turned men to stone

GORGONEION
severed head of the Gorgon Medusa, used as an apotropaic device

GRANULATION
technique of gold-working where tiny spheres of the gold are applied to a surface

GREAVE
piece of armor for the lower leg

GRIFFIN
mythological hybrid creature combining characteristics of a lion, a raptor, and a snake

GRYPHOMACHY
battle involving griffins

HERAKLES
important Greek hero known for his strength and for his Ten Labors

HERAKLES KNOT
a square knot with apotropaic meaning; a symbol often incorporated into ancient jewelry

HERMES
Greek god of travel and commerce, messenger of the gods and guide of the souls of the deceased to the underworld

HETAIRA/-AI
female companion at male drinking parties (symposia)

HIMATION
heavy, woolen outer garment formed of a rectangular piece of cloth worn wrapped around the body

HIPPOCAMP
mythical sea creature that is part horse

HYDRIA/-AI
three-handled vessel for transporting water

KALATHOS
woven basket with flaring mouth, often used for storing wool; a woman's headdress of similar shape

KERYKEION (CADUCEUS)
staff of a messenger with two snakes intertwined at the top; Hermes used his kerykeion to guide the dead to the underworld

KITHARA
stringed musical instrument

KORE/-AI
maiden; in art, a statue of a standing young woman who is modestly dressed

KRATER
deep, wide-mouthed, two-handled vessel for mixing wine and water

KROTALON/-A
kind of castanet/s, used to keep time in a dance

KURGAN
burial mound enclosing a central burial chamber and, often, several secondary burials

KYLIX/KYLIKES
two-handled cup

LEBES GAMIKOS/LEBETES GAMIKOI
large round-bottomed bowl with a broad neck and mouth and upright looped handles on the side; attached to a tall, conical stand and usually lidded; associated with wedding ritual

LEKANIS/-IDES
shallow dish, usually with a lid, used by women for toiletries and other items, associated with wedding ritual

LEKYTHOS
tall cylindrical oil bottle with a narrow neck, thick rim, and one handle

LIBATION
liquid offering (e.g., wine) to the gods or the dead

MAENAD
female follower of Dionysos, often inspired to ritual frenzy

MEDUSA
Gorgon who was beheaded by the hero Perseus

NAOS
Greek: temple

NEREID
any of the seven sea nymphs, daughters of Nereus

NIKE
winged Greek goddess personifying victory

NIOBID
one of the children of the mythical Niobe, all of whom were killed by the god Apollo and his sister, Artemis

OIKOUMENE
the settled land

OINOCHOE/-AI
one-handled wine pitcher

OLPE/-AI
small to medium-sized oinochoe

OMPHALOS
Greek: navel. A stone in Delphi was known as the omphalos, for the Greeks considered Delphi the center of the world

ONKOS
projection at the top of a theatrical mask, used to support a high wig

PALAISTRA/-AI
place for athletic exercise, particularly wrestling

PELIKE/-AI
two-handled vessel resembling an amphora, widest toward the bottom

PENELOPE
wife of the mythical Greek hero Odysseus, renowned for her marital fidelity

PEPLOS/-OI
sleeveless woolen garment formed from a rectangular piece of fabric, pinned at the shoulders and open on one side

PERSEPHONE
daughter of the goddess Demeter

PHIALE/-AI
shallow libation bowl occasionally used for drinking

PHRYGIAN CAP
soft hat with a peak

POLIS/-EIS
Greek city-state, i.e., a usually small city and the surrounding countryside under its political control

PSALION/-A
cheekpiece of a horse bridle

PYXIS/-IDES
small, cylindrical, lidded container

QUADRIGA
chariot pulled by four horses

RESERVED
in vase-painting, the area left unpainted, showing the color of the clay

SAKKOS
sacklike cloth covering for a woman's hair

SATYR
mythical woodland follower of Dionysos combining male features with those of a horse and goat

SCARABOID
gem worked with one flat face, often engraved, and one curved, like the back of a scarab or beetle

SCYTHIANS
broad cultural grouping of seminomads, who dominated the Eurasian steppes between the eighth and first centuries B.C.

SILENUS
satyr of advanced age

SPHINX
mythical monster with a human head and a lion's body

STATER
standard Greek unit of weight; hence, the main denomination of early Greek coinage

STLENGIS/-IDES
adornment for the hairline of the forehead imitating strands of hair parted in the middle

TAENIA/-AI
ribbon or band

TEMENOS/-OI
a holy area, usually enclosed; often the area surrounding a temple

THYRSOS/-OI
long staff ending in a large pinecone; associated with Dionysos and his entourage

TORQUE
rigid metal necklace with an opening for inserting the neck

TRIREME
ship with three tiers of oarsmen

TYMPANON
tambourine

292

Bibliography

AA. Archäologischer Anzeiger.

ABC 1892. S. Reinach. *Antiquités du Bosphore Cimmérien.* 2 vols. Paris.

ABSA. Annual of the British School at Athens.

ACSS. Ancient Civilizations from Scythia to Siberia. Leiden, 2006.

AGSP 1955. *Antichnye goroda Severnogo Prichernomor'ia. Ocherki istorii I kul'tury.* [Vol. 1.] Moscow and Leningrad.

AIB. Arkheologi'ia i istori'ia Bospora. Fasc. 2. Simpheropol'. 1962.

AJA. American Journal of Archaeology.

AK. Antike Kunst.

Akimova 1988. L. I. Akimova. "K probleme 'geometricheskogo' mifa: shakhmatnyi' irnament." *Zhizn' mifa v antichnosti. Vipperovskie chteni'ia.* 1985. Moscow. Fasc. 18, pt. 1: 60–97.

Alexeyev 2003. A. Y. Alexeyev. *Khronografi'ia Evrope'iskoi' Skifii.* St. Petersburg.

Alexeyev, Murzin, and Rolle 1991. A. Yu. Alexeyev, V. Yu. Murzin, and R. Rolle. *Chertomlyk: Skifskii' tsarskii' kurgan IV v. do n. e.* Kiev.

AM. Mitteilungen des Deutschen Archäologischen Instituts, Athenische Abteilung.

Andreyev 1996. Yu. V. Andreyev. "Greki i varvary v Severnom Prichernomor'e (osnovnye metodologicheskie i teoreticheskie aspekty problemy mezhetnicheskikh kontaktov)." *VDI.* No. 1 (216): 3–17.

Andrukh 1995. S. I. Andrukj. *Nizhnedunai'ska'ia Skifi'ia v VI–nachale I v. do n. e.* Zaporozh'e.

Anokhin 1986. V. A. Anokhin. *Monetnoe delo Bospora.* Kiev.

Anokhin 1988. V. A. Anokhin. "O tak nazyvae- mykh gir'kakh Berezani." *Antichnye drevnosti Severnogo Prichernomor'ia.* Kiev. 174–79.

Antichna'ia koroplastika 1976. *Antichna'ia koroplastika.* Exh. cat. The State Hermitage Museum. Leningrad.

Antichna'ia skul'ptura Khersonesa 1976. *Antichna'ia skul'ptura Khersonesa.* Exh. cat. Ed. A. P. Ivanova and L. G. Kolesnikova. Kiev.

Antichnaia torevtika 1986. *Antichnaia torevtika. Sbornik nauchnykh trudov.* The State Hermitage Museum. Leningrad.

Antichnoe serebro 1985. *Antichnoe khudozhestvennoe serebro.* Exh. cat. St. Petersburg.

Antichnost' v Peterburge 1993. *Sankt-Peterburg i antichnost'.* Exh. cat. Mramornyi' dvorets. St. Petersburg.

Antichnye gosudarstva. Antichnye gosudarstva Severnogo Prichernomor'ia. Arkheologiia SSSR. Moscow.

Artamonov 1970. M. Artamonov. *Goldschatz der Skythen in der Eremitage.* Prague and Leningrad.

ASGE. Arkheologicheski' sbornik Gosudarstvennogo Ermitazha. Leningrad and St. Petersburg. [1959–].

Ashik 1848–49. A. B. Ashik. *Bosporskoe tsarstvo s ego paleograficheskimi i nadgrobnymi pamiatnikami, raspisnymi vazami, planami, kartami i vidami.* Vols. 1–3. Odessa.

Ashik 1854. A. B. Ashik. *Drevnosti Bosfora Kimmeri- iskogo.* Vols. 1–2. St. Petersburg.

Basch 1985. L. Basch. "The ΙΣΙΣ of Ptolemy II Philadelphus." *The Mariner's Mirror,* vol. 71.2: 129–52.

Beazley 1939. J. D. Beazley. "The Excavation at Al Mina, Sueidia. III. The Red-figure Vases." *JHS* 59: 1–44.

Beazley *ABV.* J. D. Beazley. *Attic Black-figure Vase- Painters.* Oxford, 1956.

Beazley *Add².* T. H. Carpenter, T. Mannack, and M. Mendonça. *Beazley Addenda.* 2nd edn. Oxford, 1989.

Beazley *ARV*[1]. J. D. Beazley. *Attic Red-figure Vase-Painters*. Oxford, 1942.

Beazley *ARV*[2]. J. D. Beazley. *Attic Red-figure Vase-Painters*. 2nd edn. Oxford, 1963.

Beazley *AV* 1918. J. D. Beazley. *Attic Red-figured Vases in American Museums*. Cambridge, MA.

Beazley *AV* 1925. J. D. Beazley. *Attische Vasenmaler des rotfigurigen Stils*. Tübingen.

Beazley *Para*. J. D. Beazley. *Paralipomena: Additions to Attic Black-figure Vase-Painters and to Attic Red-figure Vase-Painters*. Oxford, 1971.

Belov 1948. G. D. Belov. *Khersones Tavricheski'. Istoriko-arkheologicheski' ocherk*. The State Hermitage Museum. Leningrad.

Belov 1976. G. D. Belov. "Terrakotova'ia golova [Gerakla] iz Khersonesa." *SA* fasc. 4.

Berzina 1962. S. I. Berzina "Proizvodstvo gipsovykh izdelii' na Bospore." *AIB* fasc. 2: 237–56.

Bich 1958. O. Bich. "Arkhivnye dannye o statuiakh, naidennykh v Kerchi v 1850 godu." *SA* 28: 87–90.

BICS. Bulletin of the Institute of Classical Studies. London.

Bilimovich 1976. Z. A. Bilimovich. "Grecheskie bronzovye zerkala ermitazhnogo sobrani'ia." *TGE* 17: 32–66.

Blavatski' 1961a. V. D. Blavatski'. *Antichna'ia arkheologi'ia Severnogo Prichernomor'ia.* 231.

Blavatski' 1961b. V. D. Blawatsky. "Graeco-Bosporan and Scythian Art." *Encyclopaedia of World Art*. London (1962). Vol. 6, pp. 862–65.

Blavatski' 1961c. V. D. Blavatsky. "Graeco-Bosporani e scitici centri." *Encyclopedia Universale dell'arte*. Rome. Vol. 6, pp. 766–83.

Blavatski' 1961d. V. D. Blavatsky. "Crimea." *Encyclopedia Universale dell'arte*. Rome. Vol. 2, pp. 930–36.

Blavatski' 1962. V. D. Blavatski'. *Otchet o raskopkakh Pantikapei'a v 1945–1953 gg.* MIA 103.

Blavatski' 1985. V. D. Blavatski'. *Antichna'ia arkheologi'ia i istori'ia*. Moscow.

Boardman 1964. J. Boardman. *The Greeks Overseas*. Harmondsworth, Middlesex.

Boardman 1969. J. Boardman. "Three Greek Gem Masters." *Burlington Magazine* 111 (1969): 587–96.

Boardman 1970. J. Boardman. *Greek Gems and Finger-Rings*. London.

Boardman 1989. J. Boardman. *Athenian Red Figure Vases: The Classical Period*. London.

Boardman 1994. J. Boardman. *The Diffusion of Classical Art in Antiquity*. London.

Boardman and Hayes 1966. J. Boardman and J. Hayes. *Excavations at Tocra 1963–1965: The Archaic Deposits*. Vol. 1. London.

Bohač 1958. J. M. Bohač. *Kercske vazy*. Prague.

Bohm 1989. C. Bohm. *Imitatio Alexandri in Hellenismus: Untersuchungen zur politischen Nachwirken Alexanders des Grossen in hoch- und späthellenistischen Monarchien*. Munich.

Boriskovska'ia 1989. S. P. Boriskovska'ia. "Ol'vi'a i Navkratis. K probleme rannikh kontaktov Severnogo Prichernomor'ia s Egiptom." In *Drevni' Vostok i antichna'ia tsivilizatsi'ia*. Leningrad. 111–19.

Borisova 1966. V. V. Borisova. *Khersones. Keramicheskoe proizvodstvo i antichnye stroitel'nye materialy. Arkheologiia SSSR. Svod arkheologicheskikh istochnikov* G1–20. Moscow.

Borysthenes-Berezan' 2005. *Borysthenes-Berezan'. Nachalo antichnoi' epokhi v Severnom Prichernomor'e*. Ed. S. L. Solovyev. Exh. cat. The State Hermitage Museum. St. Petersburg.

BPh. Bosporski' Phenomen. Materialy mezhdunarodnoi' konferentsii. 5 vols. St. Petersburg, 1998–2006.

BSA. Annual. British School at Athens.

Byzantium 2006. *The Road to Byzantium: Luxury Arts of Antiquity*. London.

Cambridge History 1975. *The Cambridge Ancient History*. Vol. 6, ch. 17, part 2. Ed. J. B. Bury, S. A. Cook, and F. E. Adcock. Cambridge.

Capolavori di Euphronios 1990. *Capolavori di Euphronios: Un pioniere della ceramografia attica*. Arezzo.

Chernenko 1973. E. V. Chernenko. "Oruzhie iz Semibratnikh kurganov." *Skifskie drevnosti*. Kiev. 64–81.

Clinton 1992. K. Clinton. *Myth and Cult: The Iconography of the Eleusinian Mysteries*. Stockholm.

Coche de la Ferté 1956. É. Coche de la Ferté. *Les Bijoux antiques*. Paris.

Cohen 1978. B. Cohen. *Attic Bilingual Vases and Their Painters*. New York.

Collignon 1911. M. Collignon. *Les Statues funéraires dans l'art grec*. Paris.

Cook 1933–34. R. M. Cook. "Fikellura Pottery." *BSA* 34: 1–98.

Cook 1952. R. M. Cook. "A List of Clazomenian Pottery." *BSA* 47: 123–52.

Cook 1964. R. M. Cook. *Niobe and Her Children: An Inaugural Lecture*. Cambridge.

Cook and Dupont 1998. R. M. Cook and P. Dupont. *East Greek Pottery*. London and New York.

CR. Comptes rendus de la Commission Impériale archéologique. St. Petersburg.

Crimean Chersonesos 2003. *Crimean Chersonesos: City, Chora, Museum, and Environs*. Institute of Classical Archaeology; National Reserve of Tauric Chersonesos. The Univ. of Texas at Austin.

CVA. Corpus Vasorum Antiquorum.

Danilenko 1969. V. N. Danilenko. "Nadgrobnye stely." *SKhM* 4.

Davydova 1990. L. I. Davydova. *Bosporskie nadgrobnye rel'efy v v. do n. e.–III v. n. e.* Leningrad.

Davydova 1994. L. I. Davydova "Zhivopis' Etrurii i Bospora—dva primera pogrebal'nykh rospisei." In *Etruski i Sredizemnomor'e. Vipperovskie chtenia 1990*. Fasc. 23: 261–67.

Davydova 2006. L. I. Davydova. "'Bosporskoe iskusstvo': problema definitsii." In *Greki i varvary na Bospore Kimmeri'iskom. VII–I vv. do n. e.* Materialy Mezhdunarodnoi' nauchnoi' konferentsii. Taman' (Rossiia). October 2000. The State Hermitage Museum. St. Petersburg. 51–53.

Deppert-Lippitz 1985. B. Deppert-Lippitz. *Griechische Goldschmuck*. Mainz.

Domanskii', Vinogradov, Solovyov 1986. I. V. Domanskii, I. G. Vinogradov, S. L. Solovyov. "Berezanska'ia arkheologicheska'ia ekspeditsi'ia v 1982 godu (predvaritel'nye itogi)." In *Drevnie pamiatniki kul'tury na territorii SSSR*. Leningrad. 25–36.

Dubois 1996. L. Dubois. *Inscriptions grecques dialectales d'Olbia du Pont*. Geneva.

Dubois de Montpereux 1843. F. Dubois de Montpereux. *Voyage autour du Caucase, chez les Tcherkesses et les Abkases, en Colchide, en Géorgie, en Arménié et en Crimée*. Vol. 5. Paris.

Ducat 1966. J. Ducat. *Les Vases plastiques Rhodiens*. Paris.

Effenterre and Ruzé 1995. H. van Effenterre and F. Ruzé. *NOMIMA. Recueil d'inscriptions politiques et juridiques de l'archaïsme grec*. Vol. 2. Rome.

Euphronios Maler 1991. *Euphronios der Maler*. Berlin.

Euphronios peintre 1990. *Euphronios peintre à Athènes au VIᵉ siècle avant J.C.* Paris.

Fittschen and Zanker 1983. K. Fittschen and P. Zanker. *Katalog der römischen Porträts in den Capitolinischen Museen*. Vol. 3. *Kaiserinnen- und Prinzessinnenbildnisse, Frauenporträts*. Mainz am Rhein.

Frolov 1967. E. D. Frolov. *Russka'ia istoriografi'ia antichnosti (do serediny XIX v.)*. Leningrad.

Frolov 1999. E. D. Frolov. *Russka'ia nauka ob antichnosti. Istoriograficheskie ocherki*. St. Petersburg.

Frolova 1997. N. A. Frolova. *Monetnoe delo Bospora*. Moscow.

Furtwängler 1900. A. Furtwängler. *Die antiken Gemmen: Geschichte der Steinschneidekunst im klassischen Altertum*. Vols. 1–3. Berlin.

Furtwängler and Reichhold 1904–32. A. Furtwängler and K. Reichhold. *Griechische Vasenmalerei*. Munich.

Gagen 1997. L. P. Gagen. *Restavratsiia antichnoi freski iz Nimfeia III v. do n. e. Restavratsionnyi sbornik*. St. Petersburg. 23–30.

Gagen and Gavrilenko 1985. L. P. Gagen and L. S. Gavrilenko. "The Study and Restoration of Antique Fresco from Nymphaeum. Third Century B.C." In *Fifth International Restorers' Seminar*, Budapest. Vol. 1: 159–63.

Gaidukevich 1949. V. F. Gaidukevich. *Bosporskoe tsarstvo*. Moscow and Leningrad.

Gaidukevich 1955. V. F. Gaidukevich. "Istori'ia antichnykh gorodov Severnogo Prichernomor'ia (kratkii ocherk)." *AGSP*: 23–148.

Gaidukevich 1971. V. F. Gajdukevich. *Das Bosporanische Reich*. 2nd rev. and enl. edn. Berlin.

Gaidukevich 1981. V. F. Gaidukevich. *Bosporskie goroda. Ustupchatye sklepy. Ellinisticheska'ia usad'ba. Ilurat*. Leningrad.

Galanina 1980. L. K. Galanina. *Kurdzhipskii kurgan*. Leningrad.

Gavinet, Ramos, and Schiltz 2000. J.-P. Gavinet, E. Ramos, and V. Schiltz. "Paul Du Brux et les Scythes: Présence de Paul Du Brux dans les archives françaises." *Journal des Savants*: 323–74.

Geominy 1984. W. A. Geominy. *Die Florentiner Niobiden*. 2 vols. Ph.D. diss. Bonn Univ.

Gerziger 1973. D. S. Gerziger "Antichnye tkani v sobranii Ermitazha." In *Pamiatniki antichnogo prikladnogo iskusstva*. Sb[ornik] statei'. The State Hermitage Museum. Leningrad. 71–100.

Gilby 1996/98. D. M.Gilby "Weeping Rocks: The Stone Transformation of Niobe and Her Children." Ph.D. diss. Univ. of Wisconsin, Madison, 1996; Ann Arbor, 1998.

Gilevich 1972. A. M. Gilevich. "Klad 'assov' iz Ol'vii." *Numizmatika i epigrafika* 10: 74–78.

Gorbunova 1964. K. S. Gorbunova. "Krasnofigurnye kiliki iz raskopok ol'vii'skogo temenosa." In *Ol'via: Temenos i Agora.* Ed. V. F. Gaidukevich. Moscow and Leningrad.

Gorbunova 1966. K. S. Gorbunova. "Samosskaia amfora s komastami." *SGE* 27: 35–38.

Gorbunova 1970. K. S. Gorbunova. "Kilik Oltosa iz raskopok v Ol'vii v 1968 godu." *Wissenschaftliche Zeitschrift der Universität Rostok* 19: 573–74.

Gorbunova 1971 . K. S. Gorbunova. "Serebrianye kiliki s gravirovannymi izobrazheni'iami iz Semibratnikh kurganov." In *Kul'tura i iskusstvo antichnogo mira.* Leningrad. 18–38.

Gorbunova 1982. K. S. Gorbunova. "Atticheskai'a chernofigurnai'a keramika iz raskopok 1962–1971 gg. nauchastke Gostrova Berezan." In *Khudozhestvennye izdeliia antichnykh masterov.* Leningrad. 36–49.

Gorbunova and Peredol'skaya 1961. K. S. Gorbunova and A. A. Peredol'skaya. *Mastera grecheskikj raspisnykh vaz.* Leningrad.

Gorbunova and Saverkina 1975 K. S. Gorbunova and I. I. Saverkina. *Iskusstvo Drevnei' Gretsii i Rima v sobranii Ermitazha.* Leningrad.

Grach 1972. N. L. Grach. "Fragment stely v v. do n. e. iz Pantikapei'a." *TGE* 13: 56–61.

Grach 1972. N. L. Grach. "K nakhodke sindskoi monety v Mirmekii." *VDI* 3: 133–41.

Grach 1984. N. L. Grach. "Otkrytie novogo istoricheskogo istochnika v Nimfee (predvaritel'noe soobshchenie)." *VDI:* 81–104.

Grach 1985. N. L. Grach. "Nimfei v kontse IV–I vv. do n. e. Osobennosti razvitiia." *Prichernomor'e v epokhu ellinizma.* Materialy III Vsesoiuznogo simpoziuma po drevnei istorii Prichernomor'ia. Tskhaltubo [Georgia], 1982. Tbilisi, Georgia.

Grach 1986. N. L. Grach. "Greben' i ozherel'e iz kurgana Kul'-Oba (dve rekonstruktsii)." In *Antichna'ia torevtika.* Leningrad.

Grach 1987a. N. L. Grach. "Nova pam'iatka ellenistichnogo chasu z Nymphe'iu." *Arkheologi'ia,* no. 57: 81–94.

Grach 1987b. N. L. Grach. "Das neuentdecktes Fresce aus hellenistischer Zeit in Nymphaeum in der Kertsch." *Scythika.* 46–65.

Grach 1989. N. L. Grach. "Nimfei'ska'ia arkheologicheska'ia ekspeditsi'ia (osnovnye itogi issledovanii za 1973–1987 gg.)." In *Itogi rabot arkheologicheskikh ekspeditsii' Gosudarstvennogo Ermitazha.* Leningrad.

Grach 1999. N. L. Grach. *Nekropol' Nimfe'ia.* St. Petersburg.

Grakov 1971. B. N. Grakov. "Eshche raz o monetakh-strelkakh." *VDI* 3: 125–27.

Great Art 1994. *Great Art Treasures of the Hermitage Museum, St. Petersburg.* Vol. 1. St. Petersburg and New York.

Grecheskaya kolonizatsia 1966. V. V. Lapin. *Grecheskaya kolonizatsia Severnogo Prichernomor'ia.* Kiev.

Greek Gold 1994. D. Williams and J. Ogden. *Greek Gold: Jewellery of the Classical World.* Exh. cat. London.

Greek Gold 2004. Y. Kalashnik. *Greek Gold from the Treasure Rooms of the Hermitage.* Exh. cat. The State Hermitage Museum. Amsterdam.

Greek Vase-Painting 1979. *Greek Vase-Painting in Midwestern Collections.* Exh. cat. The Art Institute of Chicago.

Greki i varvary Severnogo Prichernomor'ia v skifskuiu epokhu 2005. St. Petersburg.

Griechische Klassik 2002. *Die griechische Klassik: Idee oder Wirklichkeit.* Exh. cat. Berlin.

Grinevich 1926. K. E. Grinevich. "Steny Khersonesa Tavricheskogo. Chast'. 1. Podstennyi' sklep no. 1012 i vorota Khersonesa, otkrytye v 1899 g." *Khersonesskii' sbornik.* Sevastopol'. Fasc. 1.

Hadaczek 1903. K. Hadaczek. *Der Ohrschmuck der Griechen und Etrusker.* Abhandlungen des archäologisch-epigraphischen Seminars der Universität Wien. Vienna. N.s. 1, 14.

Hausmann 1975. U. Hausmann. *Römerbildnisse.* Stuttgart.

Hekler 1909. A. Hekler. "Römische weibliche Gewandstatuen." *Münchener archäologische Studien.* Munich.

Higgins 1961. R. A. Higgins. *Greek and Roman Jewellery.* London.

Himmelmann 1989. N. Himmelmann. *Herrscher und Athlet: Die Bronzen vom Quirinal.* Milan.

Historia, Historia. Zeitschrift für alte Geschichte. Einzelschriften. Wiesbaden.

Höckmann 1985. O. Höckmann. *Antike Seefahrt.* Munich.

Höckmann 1999a. O. Höckmann. "Graffiti of Hellenistic Ships from the Aphroditeion at Nymphaion." In *Bosporski' gorod Nimphei': novye issledovani'ia i materially i voprosy izucheni'ia antichnykh gorodov Severnogo Prichernomor'ia.* St. Petersburg. 94–97.

Höckmann 1999b. O. Höckmann. "Naval and Other Graffiti from Nymphaion." *Ancient Civilizations from Scythia to Siberia. An International Journal of Comparative Studies in History and Archaeology.* Vol. 5.4: 303–56.

Hölbl 1999. G. Hölbl. "Die Aegyptiaca vom Aphroditentempel auf dem Zeytintepe." *AA:* 345–71.

IAK. Izvestiia Arkheologicheskoi komissii. St. Petersburg.

Ilyina 2001. J. I. Ilyina. "Early Red-Figure Pottery from Berezan." *Northern Pontic Antiquities in the State Hermitage Museum.* Colloquia Pontica 7. Leiden, New York, Cologne. 159–69.

Isler-Kerényi 1971. C. Isler-Kerényi. "Ein Spätwerk des Berliner Malers." *AK* 14: 25–31.

Ivanova 1945. A. P. Ivanova. "Cherty mestnogo stila v dereviannoi rez'be Bospora rimskogo vremeni." *TGE* I: 167–97.

Ivanova 1953. A. P. Ivanova. *Iskusstvo antichnykh gorodov Severnogo Prichernomor'ia.* Moscow.

Ivanova 1955. A. P. Ivanova. "O nekotorykh osobennostiakh bosporskoi' zhivopisi." *AGSP.* 286–96.

Ivanova 1961. A. P. Ivanova. *Skul'ptura i zhivopis' Bospora.* Kiev.

Ivanova 1964. A. P. Ivanova. "Skul'pturnye izobrazheni'ia Dionisa iz Khersonesa." *SA* fasc. 2: 134–39.

Jacobson 1995. E. Jacobson. *The Art of the Scythians: The Interpretation of Cultures at the Edge of the Hellenic World.* New York.

JdI. Jahrbuch des Deutschen Archäologischen Instituts.

Jeffery 1990. L. H. Jeffery. *The Local Scripts of Archaic Greece.* Rev. edn. Oxford.

JHS. Journal of Hellenic Studies. London.

Jijina 1997. N. Jijina. "Kompleks gipsovykh rel'efov iz zemlianogo sklepa nekropolia Nimfe'ia i voprosy rekonstruktsii dekora bosporskikh dereviannykh sarkofagov rimskogo vremeni." *TGE* 28: 149–66.

Jijina 1998. N. Jijina. "Nymphaion Necropolis in Bosporos." In *Nécropoles et pouvoir: Idéologies, pratiques et interprétations.* Actes du Colloques Théories de la nécropole antique, Lyons 21–25 January 1995. Ed. S. Marchegay, M.-T. Le Dinahet, and J.-F .Salles. Travaux de la Maison de l'Orient Méditerranéen 27. Paris, Lyons, Athens. 199–216.

Jijina 2001. N. Jijina. "Wooden Sarcophagi with Plaster-Cast Appliqués from Nymphaeum." In *Northern Pontic Antiquities in the State Hermitage Museum.* Ed. J. Boardman, S. L. Solovyov, and G. R. Tsetskhladze. Colloquia Pontica 7. Leiden. 249–66.

Jijina 2004. N. Jijina. "Synthesis of Cultures or Local Interpretation of Greek Art and Tradition (after the Materials from Great Burials and Necropoli of the Bosporan Area)." *Les Cultes locaux dans les mondes Grec et Romain. Actes du colloque de Lyon 7–8 Juin 2001.* Ed. G. Labarre et al. Lyons. 235–47.

Jijina 2005. N. Jijina. "Chetyre gipsovye applikat-sii I–II vv. iz raskopok Nimfe'ia v sobranii Ermitazha." *SGE* 63: 77–82.

Kalashnik 2004. Y. P. Kalashnik. "Dva ozherel'ia iz Khersonesa (ob ellinisticheskikh traditsi'iakh v rimskom i'uvelirnom iskusstve)." In *Ellinisticheskie shtudii. Sbornik statei. K 60-leti'iu M. B. Piotrovskogo.* The State Hermitage Museum. St. Petersburg.

Kallistov 1949. D. P. Kallistov. *Ocherki po istorii Severnogo Prichernomor'ia antichnoi' epokhi.* Leningrad.

KBN 1965. *Korpus bosporskikh nadpisei.* Moscow and Leningrad.

KBN 2004. *Korpus bosporskikh nadpisei: Al'bom illiustratsii (KBN-al'bom).* St. Petersburg.

Κεφαλιδου 2002–3. Ε. Κεφαλιδου, Μια ομάδα ιδιόμορφων αγγειων αρχαϊκής εποχης, Εγνατια 7. 61–107.

Khudiak 1962. M. M. Khudiak. *Iz istorii Nympe'ia VI–III vv. do n. e.,* Leningrad.

Kisel' 1993. V. A. Kisel'. "Stilisticheska'ia i tekhnologicheska'ia atributsi'ia serebrianogo zerkala iz-Kelermesa." *VDI.* No. I. III–25.

Kisel' 2003. V. A. Kisel'. *Shedevry i'uvelirov Drevnego Vostoka iz skifskikh kurganov.* St. Petersburg.

Kleiner 1953. G. Kleiner. "Bildnis und Gestalt des Mithridates." *JdI* 68: 73–95.

Knipovich 1955a. T. N. Knipovich. "Khudozhestvenna'ia keramika v gorodakh Severnogo Prichernomor'ia." *AGSP:* 356–91.

Knipovich 1955b. T. N. Knipovich. "Osnovnye linii razviti'ia iskusstva gorodov Severnogo Prichernomor'ia v antichnu'iu epokhu." *AGSP*: 164–87.

Kobylina 1951a. M. M. Kobylina. "Pozdnie bosporskie peliki." MIA 19: 136–70.

Kobylina 1951b. M. M. Kobylina. "Skul'ptura Bospora." MIA 19: 170–88.

Kobylina 1961. M. M. Kobylina. *Terrakotovye statuetki Pantikape'ia i Phanagorii*. Moscow.

Kobylina 1962. M. M. Kobylina. "Skul'pturnyi' portret iz Fanagorii." *SA* fasc. 3: 210–14.

Kobylina 1972. M. M. Kobylina 1972. *Antichnaia skul'ptura Severnogo Prichernomor'ia*. Moscow.

Kopeikina 1979. L. V. Kopeikina. "Razvitie chernofigurnogo stilia v klazomenskoi' keramike." In *Iz istorii Severnogo Prichernomor'ia v antichnuiu epokhu*. Leningrad. 7–25.

Kopeikina 1981. L. V. Kopeikina. "Elementy mestnogo kharaktera v kul'ture Berezanskogo poseleni'ia arkhaicheskogo perioda." In *Demogra-ficheska'ia situatsi'ia v Prichernomor'e v period Velikoi' grecheskoi' kolonizatsii*. Tbilisi, Georgia. 163–74.

Kopeikina 1986. L. V. Kopeikina. "Raspisna'ia keramika arkhaicheskogo vremeni iz antichnykh poselenii' Nizhnego Pobuzh'ia i Podneprov'ia kak istochnik dlia izucheni'ia torgovykh i kul'turnykh sviazei." *ASGE* 27: 27–153.

Kossatz-Deissmann 1978. A. Kossatz-Deissmann. *Dramen des Aischylos auf westgriechischen Vasen*. Mainz am Rhein.

Krahmer 1925. G. Krahmer. "Eine Ehrung von Mithridates VI Eupator in Pergamon." *JdI* 40: 183–205.

Krapivina 1986. V. V. Krapivina. "Arkhaicheskie vesovye giri Berezani i Ol'vii." In *Ol'viia i ee okruga*. Kiev. 105–11.

Kruglov 1987. A. V. Kruglov. "O kompozitsii i datirovke fragmenta rel'efa 'Poseshchenie Dionisom dramaticheskogo poeta.'" *SGE* 52: 33–36.

KSIA. Kratkie soobshcheniia Instituta Arkheologii AN SSSR. Moscow and Leningrad.

Kunina 1997. N. Z. Kunina. *Ancient Glass in the Hermitage Collection*. The State Hermitage Museum. St. Petersburg.

Kunina 1998. N. Z. Kunina. "A Glass Portrait from Nymphaion." *Archeologia* 48: 51–53.

Kunina 2000. N. Z. Kunina. "Steklianny̆i' skul'pturnyi' portret iz Nimfe'ia." In *ΣΥΣΣI-TIA. Pamiati Yu. V. Andreeva*. St. Petersburg. 251–54.

Lange 1938. K. Lange. *Herrscherköpfe des Altertums im Münzbild ihrer Zeit*. Berlin.

Latyshev 1887. V. V. Latyshev. *Issledovani'ia ob istorii i gosudarstvennom stroe goroda Ol'vii*. St. Petersburg.

Levi 1985. E. I. Levi. *Ol'viia. Gorod epokhi ellinizma*. Leningrad.

Liefde 2003. Liefde uit de Hermitage. Amsterdam.

LIMC. Lexicon iconographicum mythologiae classicae. 8 vols. 1981–97. Zurich.

Lisippo 1995. Lisippo: L'arte e la fortuna. Exh. cat. Ed. Paolo Moreno. Rome.

L'Or des Amazones 2001. L'Or des Amazones: Peuples nomades entre Asie et Europe, VIe siècle av. J.-C.–IVe siècle après J.-C. Exh. cat. Paris.

Luk'ianov and Grinevich 1915. S. S. Luk'ianov and Y. P. Grinevich. "Kerchenska'ia kal'pida 1906 goda i pozdni'aia krasnofiguna'ia zhivopis'." *MAR*.

Machinskii' 1978. D. A. Machinskii' "Pektoral' iz Tolstoi' mogily i velikie zhenskie bozhestva Skifii." In *Kul'tura Vostoka. Drevnost' i rannee srednevekov'e*. Sb. statei. Leningrad. 131–50.

Mal'mberg 1892. V. K. Mal'mberg "Opisanie klassicheskikh drevnostei', naidennykh v Khersonese v 1888–1889 godakh." *MAR* 7: 3–31.

Mantsevich 1987. A. P. Mantsevich. *Kurgan Solokha*. Leningrad.

Manzewitsch 1932. A. Manzewitsch. *Ein Grabfund aus Chersonnes*. Leningrad.

MAR. Materialy po arkheologii Rossii. St. Petersburg (1866–1918).

Marasov 1978. I. Marasov. *Ritonite v Drevna Trakii'a*. Sofia.

Margos 1980. R. Margos. "Une péliké attique à figures rouges du IVe siècle avant J.-C." *Bulletin des Musées royaux d'Art et d'Histoire* 50 [1978].

Maslennikov 1981. A. A. Maslennikov. *Naselenie Bosporskogo gosudarstva v VI–II vv. do n.e.* Moscow.

Maslennikov 2002. A. A. Maslennikov. "'Tsar-skaia' khora Bosporan a rubezhe V–IV vv. do n.e. (K voprosu o lokalizatsii)." *VDI* 1: 185–89:

Maximova 1926. M. I. Maximova. *Antichnye reznye kamni v sobranii Ermitazha. Putevoditel' po vystavke.* The State Hermitage Museum. Leningrad.

Maximova 1927. M. I. Maximova. *Les Vases plastiques dans l'antiquité.* Paris.

Maximova 1954. M. I. Maximova. "Serebrianoe zerkalo iz Kelermesa." *SA* 21: 281–305.

Maximova 1955. M. I. Maximova. "Reznye kamni." *AGSP*: 437–45.

Maximova 1956. M. I. Maximova. "Gliniana'ia tkatska'ia podveska s ottiskom pechati." *MIA* 50: 190–96.

Maximova 1960. M. I. Maximova. "O date Artiukhovskogo kurgana." *SA* fasc. 3:46–58.

Maximova 1979. M. I. Maximova. *Artiukhovskii kurgan.* The State Hermitage Museum. Leningrad.

Maximova and Nalivkina 1955. M. I. Maximova and M. A. Nalivkina. "Skul'ptura." *AGSP*: 297–325.

Metzger 1965. H. Metzger. *Recherches sur l'imagerie athénienne.* Paris.

MIA. *Materialy i issledovaniia po arkheologii SSSR.* Moscow and Leningrad.

Michel 1900. C. Michel. *Receuil d'inscriptions grecques.* Brussels.

Minasian 1999. R. Minasian. "O pervonachal'nom oblike zolotykh podvesok s izobrazheniem golovy Afiny iz kurgana Kul'-Oba." *SGE* 58: 35–39.

Minns 1913. E. H. Minns. *Scythians and Greeks: A Survey of Ancient History and Archaeology on the North Coast of the Euxine from the Danube to the Caucasus.* Cambridge.

MM. *Mitteilungen des Deutschen Archäologischen Instituts, Madrider Abteilung.*

Molchanov 1971. A. A. Molchanov. "Iskusstvo portreta na antichnom Bospore (po numizmaticheskim materialam)." *Vestnik MGU* 4: 98–104.

Mommsen 1994. T. Mommsen. *Istoriia Rima.* 1994. Moscow.

Μουσειο Ἐρμιταζ 1980. Μουσειο Ἐρμιταζ. Μνημεια ἀρχαιας ἑλληνιχης τεχνης ἀπο τὸν Εὐξεινο Ποντο. Ρεμπραντ. Ρωσοι Ζωγραφοι του 18ου και 19ου αἰωνα.

Muzy i maski 2005. *Muzy i maski: Teatr i muzyka v antichnosti. Antichnyi mir na peterburgskoi' stsene.* Exh. cat. The State Hermitage Museum. St. Petersburg.

Naumov 2002. V. Naumov. "Novyi' tip litoi' monety?" *Drevnii mir* no. 3: 33.

Neverov 1968. O. Y. Neverov. "Mitridat Evpator i perstni-pechati iz Pantikapeia." *SA* fasc. 1: 235–39.

Neverov 1971a. O. Y. Neverov. *Antichnye kamei v sobranii Ermitazha. Gosudarstvennyi Ermitazh.* Leningrad.

Neverov 1971b. O. Y. Neverov. "Mitridat i Aleksandr. K ikonografii Mitridata VI." *SA* fasc. 2: 86–118.

Neverov 1972. O. Y. Neverov. 1972. "K ikonografii Mitridata Evpatora." *SA* fasc. 2: 86–119.

Neverov 1973. O. Y. Neverov. "Dexamen Chiosskii i ego masterskai'a." *Pamiatniki antichnogo prikladnogo iskusstva.* Leningrad. 51–61.

Neverov 1983. O. Y. Neverov. *Gemmy antchnogo mira.* Moscow.

Neverov 1986. O. Y. Neverov. "Metallicheskie perstni epokhi arkhaiki, klassiki i ellinizma iz Severnogo Prichernomor'ia (opyt klassifikatsii)." *Antichnaia torevtika.* The State Hermitage Museum. Leningrad.

Novye postuplenia 1977. *Novye postuplenia Ermitazha. 1966–1977.* Exh. cat. The State Hermitage Museum. Leningrad.

Nowicka 1998. M. Nowicka. "Le Sarcophage de Kertch." In *Au Royaume des ombres: La peinture funéraire antique. IVᵉ siècle avant J.-C.–IVᵉ siècle après J.-C.* Paris. 66–70.

Nymphaion 1999. *Drevnii' gorod Nimfei'.* Exh. cat. The State Hermitage Museum. St. Petersburg.

Nymphea 2002. *Nymphea: Confin de Oikoumene. Fondos Arqueológicos Ermitage.* Valencia, Spain.

OAK. *Otchety Arkheologicheskoi komissii.*

Ogden 1982. J. Ogden. *Jewellery of the Ancient World.* London.

Olbia 1964. *Ol'vi'a. Temenos i Agora.* Ed. V. F. Gaidukevich. Moscow and Leningrad.

Olympism 1993. *Olympism in Antiquity.* Exh. cat. Lausanne.

Olynthus V. *Excavations at Olynthus.* Part 5. Baltimore, Oxford, London. 1938.

Onaiko 1971. N. A. Onaiko. "Bronzovyi biust-giria iz raskopok antichnogo poseleniia v Shirokoi balke." *KSIA* 128: 73.

Parlasca 1979. K. Parlasca. "Das sog. Porträt der Königin Dynamis in der Ermitage." In *Problemy antichnoy istorii i kultyry: Akten des 14 Eirene-Kongresses, 18.23. Mai 1976 in Erevan.* 2: 397–98. Erevan, Armenia.

Peredol'skaya 1945. A. A. Peredol'skaya. "Vazy Ksenofanta." *TGE*. 47–67.

Peredol'skaya 1957. A. A. Peredol'skaya. "Novy' zlomok Eufroniu'v." *Listy Filologicke* 80: 10–11.

Peredol'skaya 1967. A. A. Peredol'skaya. *Krasnofigurnye atticheskie vazy v Ermitazhe.* Leningrad.

Pfrommer 1990. M. Pfrommer. "Untersuchungen zur Chronologie früh- und hochhellenistisch-en Goldschmucks." *Istanbulische Forschungen* 37.

Pharmakowsky 1904. B. V. Pharma-kowskii'. "Raskopki v Ol'vii." *OAK* 1902. 1–27.

Pharmakowsky 1906. B. V. Pharma-kowskii'. "Raskopki v Ol'vii. v 1902–1903 godakh." *IAK* 13: 1–306.

Pharmakowsky 1908. B. Pharmakowsky. "Funde in Südrussland im Jahre 1907." *AA*, 140–92.

Pharmakowsky 1912. B. Pharmakowsky. "Funde in Südrussland im Jahre 1911." *AA*, 323–81.

Pharmakowsky 1913. B. Pharmakowsky. "Funde in Südrussland im Jahre 1912." *AA*, 178–234.

Pharmakowsky 1914a. B. Pharmakowsky. "Funde in Südrussland im Jahre 1913." *AA*, 205–91.

Pharmakowsky 1914b. B. V. Pharmakowskii'. "Raskopki v Ol'vii." *OAK* 1911. St. Petersburg 1914. 1–25.

Pharmakowsky 1914c. B. V. Pharmakowskii'. "Arkhaicheskii' period v Rossii." *MAR* 34: 13–78.

Pharmakowsky 1915. B. V. Pharmakowskii'. *Olbia.* St. Petersburg. 1915.

Pharmakowsky 1918. B. V. Pharmakowskii'. "Raskopki v Ol'vii." *OAK* 1913–1915. 1–51.

Pharmakowsky 1925. B. V. Pharmakowskii'. "Bospor'ski Spartokidi v aten'skomu rizbiar-stve." In *Zbirnik na poshanu akad.Bagali.* Str. 1136. Kiev.

Piatysheva 1956. N. V. Piatysheva. *Yuvelirnye izdeli'ia Khersonesa.* Moscow.

Pinelli 1987. P. Pinelli "A propos d'un décor de sarcophage provenant de Kertch." *La Revue du Louvre et des Musées de France* 4: 273–77.

Pinelli and Wąsowicz 1986. P. Pinelli and A. Wąsowicz. *Catalogue des bois et stucs grecs et romains provenant de Kertch.* Musée du Louvre. Paris.

Piotrovskii' 2000. B. B. Piotrovskii'. *Istoriia Ermitazha. Kratkii ocherk. Materialy i dokumenty.* Moscow.

Piotrovskii', Galanina, Grach 1987. B. Piotrovskii', L.Galanina, and N. Grach. *Scythian Art.* Oxford.

Pivorovich 2000. V. B. Pivorovich. "Drevneishie denezhnye znaki Severnogo Prichernomor'ia." *Letopis' Prichernomor'ia* 4: 119–22.

Powell 1998. B. B. Powell. *Classical Myth.* 2nd edn. Upper Saddle River, NJ.

Prichernomor'e 1983. *Kul'tura i iskusstvo Prichernomor'ia v antichnuiu epokhu: Vystavka iz sobranii muzeev Bolgarii, Rumynii i Sovetskogo So'iuza.* Exh. cat. State Pushkin Museum. Moscow.

Prushevskaia 1941. E. O. Prushevskaia. "Iz ol'vii'skikh nakhodok krasnofi-gurnoi' keramiki strogogo stilia." *SA* 7: 318–24.

Prushevskaia 1955. E. O. Prushevskaia. "Khudozhestvenna'ia obrabotka metalla (torevtika)." *Antichye goroda Severnogo Prichernomor'ia. Ocherki istorii i kul'tury.* Moscow and Leningrad. 325–55.

Raevskii' 1977. D. S. Raevskii'. *Ocherki ideologii skifo-sakskikh plemen. Opyt rekonstruktsii skifskoi mifologii.* Moscow.

RE. A. F. Pauly and G. Wissowa. *Real-Encyclopädie der klassischen Altertumswissenschaft.* Stuttgart, 1893– .

Reinach 1890. T. Reinach. *Mithridate Eupator, roi de Pont.* Paris.

Richter 1946. G. M. A. Richter. *Attic Red-figure Vases: A Survey.* New Haven.

Richter 1958. G. M. A. Richter. "Ancient Plaster Casts of Greek Metalware." *AJA* 62.4: 369–77, pls. 88–95.

Richter 1984. G. M. A. Richter. 1984. *The Portraits of the Greeks.* Abridged and rev. by R. R. R. Smith. Oxford.

Robert 1968. C. Robert, ed. *Die Antiken Sarkophag-reliefs.* Vol. 2. Rome.

Robertson 1992. M. Robertson. *The Art of Vase-Painting in Classical Athens.* Cambridge.

Rome Faces the Barbarians 1993. *Rome Faces the Barbarians: 1000 Years to Create an Empire.* Exh. cat. Trans. C.W. L. Wilson. Abbaye de Daoulas.

RossA. Rossiiskaia arkheologi'ia. Moscow.

Rostovtsev 1913–14. M. I. Rostovtsev. *Antichna'ia dekorativna'ia zhivopis' na yuge Rossii.* St. Petersburg.

300

Rostovtsev 1916. M. I. Rostovtsev. "Bronzovyi biust tsaritsy Dinamii i istoriia Bospora v epokhu Avgusta." *Drevnosti Bospora Kimmerii'skogo* 25: 1–23.

Rostovtsev 1925. M. I. Rostovtsev. *Skifiya i Bospor.* Leningrad.

Rostovtsev 1931. M. I. Rostowzew. *Skythien und der Bosporus.* Berlin.

Rusiaeva 1979. A. S. Rusiaeva. *Zemledel'cheskie kul'ty v Ol'vii dogetskogo vremeni.* Kiev.

Rusiaeva 1982. A. S. Rusiaeva. *Antichnye terrakoty Severo-Zapadnogo Prichernomor'ia (VI–I vv. do n.e.).* Kiev.

Ruxer 1938. M. S. Ruxer. *Historia naszyjnika greckiego.* Poznań, Poland.

SA. Sovetskaia arkheologi'ia. Moscow.

Sabat'e 1850. P. Sabat'e. "Otkrytie dvukh drevnikh statui v Kerchi." *Zapiski arkheologicheskogo obshchestva.* St. Petersburg.

SAI. Archeologi'ia SSSR. Svod arkheologicheskikh istochnikov. Moscow.

Saprykin 2002. S. Y. Saprykin. *Bosporskoe tsarstvo na rubezhe dvukh vekov.* Moscow.

Saverkina 1979. I. I. Saverkina. *Römische Sarkophage in der Ermitage.* Berlin.

Saverkina 1986. I. I. Saverkina. *Grecheska'ia skul'ptura V v. do n. e. v sobranii Ermitazha. Originaly i rimskie kopii.* Leningrad.

Saverkina 2001. I. I. Saverkina. "'Rich Style' Earrings in the Hermitage and Other Museums." *Northern Pontic Antiquities in the State Hermitage Museum.* Leiden, Boston, Cologne.

Savostina 1999. E. A. Savostina. *Monographia o pamiatnike.* Vol. 1. *Tamanskii' relief: Drevnegrecheska'ia stela s dvumia voinami.* Moscow.

Savostina 2001. E. A. Savostina. *Monographia o pamiatnike.* Vol. 2. *Bosporskii' friz so stsenoi' srazheni'ia.* Moscow.

Savostina 2004. E. A. Savostina. *Ellada i Bospor. Istoriko-kul'turnye vzaimodei'stvi'ia I grecheskii' impul's v razvitii plastiki Severnogo Prichernomor'ia.* Thesis abstract. Moscow.

Savostina forthcoming. E. A. Savostina. *Tsar' Bospora: skul'pturnyii portret v sobranii Ermitazha. Sfinks ili mifologi'ia byti'ia.* St. Petersburg.

Schatzkammern 1993. Aus den Schatzkammern Eurasiens: Meisterwerke antiker Kunst. Exh. cat. Kunsthaus Zürich.

Schauss 1986. G. P. Schauss. "Two Fikellura Vase Painters." *ABSA* 81. 251–95.

Schefold 1930. K. Schefold. *Kertscher Vasen.* Berlin.

Schefold 1934. K. Schefold. *Untersuchungen zu den kertscher Vasen.* Berlin and Leipzig.

Schiltz 1994. V. Schiltz. *Les Scythes et les nomades des steppes: VIIIᵉ siècle avant J.C.–Iᵉʳ siècle après J.C.* Paris.

Schliemann. Petersburg. Troy 1998. *Katalog vystavki v Gosudarstvennom Ermitazhe.* Exh. cat. St. Petersburg.

Schwarzmaier 1996. A. Schwarzmaier. "Die Gräber in der Grossen Blisniza und ihre Datierung." *JdI* 111: 105–37.

Scott and Taniguchi 2002. D. A. Scott and Y. Taniguchi. "Archaeological Chemistry: A Case Study of a Greek Polychrome Pelike." *Color in Ancient Greece: The Role of Color in Ancient Greek Art and Architecture (700–31 B.C.).* Ed. M. A. Tiverios and D. S. Tsiafakis. Proceedings of the conference held in Thessaloniki 12–16 April 2000. Thessaloniki. 235–44.

Semenov 1995. G. L. Semenov. "Prazdnik Ploiafesii' v Nimfee." In *Ermitazhnye chteni'ia 1986–1994 godov pamiati V. G. Lukonina.* The State Hermitage Museum. St. Petersburg. 222–27.

SGE. Soobshcheni'ia Gosudarstvennogo Ermitazha. Leningrad/St. Petersburg.

Shapiro 1977. H. A. Shapiro. *Personifications of Abstract Concepts in Greek Art and Literature to the End of the Fifth Century B.C.* Baltimore.

Shapiro forthcoming. H. A. Shapiro. "Notes on Attic Red-Figure Pottery from Berezan." In *Borysthenes–Berezan. The Hermitage Archaeological Collection.* Vol. 2. Ed. S. L. Solovyov. St. Petersburg.

Shelov 1956. D. B. Shelov. *Monetnoe delo Bospora.* Moscow.

Shelov 1981. D. B. Shelov. "Sindy i Sindika v epokhu grecheskoi kolonizatsii." *Demograficheskaia situatsiia v Prichernomor'ie v period Grecheskoi kolonizatsii.* Tbilisi. 238–43.

Shtal 2000. I. V. Shtal. *Svod mifo-epicheskikh siuzhetov antichnoi' vazovoi' rospisi po muze'iam Rossii'skoi' Federatsii i SNG. Peliki, IV v. do n. e. Kerchenskii' stil'.* Vol. 1. Moscow.

Shtal 2004. I. V. Shtal. *Svod mifo-epicheskikh siuzhetov antichnoi' vazovoi' rospisi po muze'iam Rossii'skoi' Federatsii i SNG. Lekany, aski, lekify, oinokhoi. IV v. do n. e. Kerchenskii' stil'.* Vol. 2. Moscow.

Silant'ieva 1959. P. F. Silantieva "Nekropol' Nimfeia." *MIA* 69: 5–107.

Silant'ieva 1967. P. F. Silant'ieva. "Semibratnie kurgany i ikh znacheni'ia dlia izucheni'ia kul'tury sindov." In *Gosudarstvennyi' Ermitazh. Tezisy nauchnykh dokladov*. Leningrad. 46–48.

Silant'ieva 1974. P. F. Silant'ieva. "Terrakoty Pantikapeia." *SAI* G1–11, part 3: 5–46.

Silant'ieva 1976. P. F. Silant'ieva. "Spiralevidnye podveski Bospora." *TGE* 17: 123–37.

Simon 1998. E. Simon. *Ausgewählte Schriften*. Vol. 1. *Griechische Kunst*. Mainz.

SKhM. Soobshcheniia Khersonesskogo muzeia.

Skrzhinskaya 1984. M. V. Skrzhinskaya. "Zerkala arkhaicheskogo perioda iz Ol'vii i Berezani." In *Antichnaia kul'tura Severnogo Prichernomr'ia*. Kiev. 105–29.

Skrzhinskaya 1994. M. V. Skrzhinskaya. "Iz istorii antichnykh iuvelirnykh izdelii'" *RossA* fasc. 1: 18–25.

Skrzhinskaya 2002. M. V. Skrzhinskaya. "Illiustratsii literaturnykh proizvedenii' na atticheskikh vazakh iz raskopok Bospora." *RossA* fasc. 1: 24–37.

Skudnova 1962. V. M. Skudnova. "Skifskie zerkala iz arkhaicheskogo nekropolia Ol'vii." *TGE* 7: 5–27.

Skudnova 1966. V. M. Skudnova. "Rodosskaia keramika s o. Berezan'." *SA* 2: 153–67.

Skudnova 1970. V. M. Skudnova. "Terrakoty iz Nymphei'a." *SAI* G1–11. Terrakoty Severnogo Prichernomor'ia. Moscow. 83–89.

Skudnova 1988. V. M. Skudnova. *Arkhaicheski' nekropol' Ol'vii*. Leningrad.

Smith 1988. R. R. R. Smith. *Hellenistic Royal Portraits*. Oxford.

Smith 1991. R. R. R. Smith. *Hellenistic Sculpture*. London.

Smith 2007. T. J. Smith. "Athenian Black-figure Pottery." In *Borysthenes–Berezan. The Hermitage Archaeological Collection*. Vol. 2. Ed. S. L. Solovyov. St. Petersburg.

Sokolov 1973. G. I. Sokolov. *Antichnoe Prichernomor'e Pamiatniki arkhitektury, skul'ptury, zhivopisi i prikladnogo iskuustva*. Leningrad.

Sokolov 1976. G. I. Sokolow. *Antike Schwarzmeerkünste: Denkmäler der Architektur, Bildhauerei, Malerei und angewandten Kunst*. Leipzig.

Sokolov 1999a. G. I. Sokolov. *Iskusstvo Bosporskogo tsarstva*. Moscow.

Sokolov 1999b. G. I. Sokolov. *Ol'vi'ia i Khersones. Ionicheskoe i doricheskoe iskusstvo*. Moscow.

Sokolova 2004. O. Y. Sokolova. "Kompleks nakhodok ellinisticheskogo vremeni iz Nimfe'ia (raskopki 1984 goda)." In *Ellinisticheskie shtudii v Ermitazhe. Sbornik statei K 60-leti'iu M. B. Piotrovskogo*. St. Petersburg. 175–85.

Sokolskii' 1969. N. I. Sokolskii'. *Antichnye dereviannye sarkofagi Severnogo Prichernomor'ia. SAI* G1–17.

Sokolskii' 1971. N. I. Sokolskii'. "Derevoobrabatyvaiushchee remeslo v antichnykh gosudarstvakh Severnogo Prichernomor'ia." *MIA* 178.

Solomonik 1969. E. I. Solomonik. "Pamiatniki s nadpisiami." *SKhM* 4: 55–77.

Solomonik 1973. E. I. Solomonik. *Novye epigraficheskie pamiatniki Khersonesa: Lapidarnye nadpisi*. Kiev.

Solovyov 1999. S. L. Solovyov. *Ancient Berezan: The Architecture, History and Culture of the First Greek Colony in the Northern Black Sea*. Colloquia Pontica 4. Leiden, New York, Cologne.

Solovyov 2005. S. L. Solovyov, ed. *Borisfen–Berezan'. Nachalo antichnoi epokhi v Severnom Prichernomor'e*. Exh. cat. The State Hermitage Museum. St. Petersburg.

Solovyov 2006. S. L. Solovyov. "Monetary Circulation and Political History of Archaic Borysthenes." *ACSS* 12, nos. 1–2: 63–74.

Stephani 1878. L. Stephani. "Holzsarkophag einer Grabkammer des Mithridasberg bei Kertch mit Darstellung der Niobiden in Gipsrelief." *CR* 1875 [1878].

Stroganov 1863. S. Stroganov. "Doklad o dei'stvi'iakh Imperatorskoi' arkheologicheskoi' komissii za 1862 god." *IAK*, fasc. 7: I–XXII.

Strzheletskii 1969. S. F. Strzheletskii. "XVII bashnia." *SKhM* 4.

Tesori d'Eurasia 1987. Tesori d'Eurasia: 2000 anni di storia in 70 anni di Archeologia Sovietica. Ed. B. B. Piotrovskij. Exh. cat. Palazzo Ducale, Venice. Milan.

TGE. Trudy Gosudarstvennogo Ermitazha. Leningrad/ St. Petersburg.

Thomas 1976. E. Thomas. *Mythos und Geschichte*. Cologne.

Tokhtas'ev 1998. S. R. Tokhtas'ev. "K chteniiu i interpretatsii posviatitel'noi nadpisi Levkona i s Semibratnego gorodishcha." *Hyperboreus* 4. Fasc. 2. St. Petersburg.

Tokhtas'ev 2002. S. R. Tokhtas'ev. ΣΙΝΔΙΚΑ. *Tamanskaia starina* 4. St. Petersburg.

Tokhtas'ev 2005. S. R. Tokhtas'ev. "Pis'mo." In *Borisfen—Berezan'. Nachalo antichnoi epokhi v Severnom Prichernomor'e.* Ed. S. L. Solovyov. Exh. cat. The State Hermitage Museum. St. Petersburg. 142—43.

Tolstikov 1984. V. P. K. Tolstikov. "K Probleme obrazovani'ia Bosporskogo gosudarstva. Opyt rekonstruktsii voenno-politicheskoi' situatsii na Bospore v kontse. VI—pervoi' polovine V v. do n. e." *VDI* 3.

Treister 1997—98. M. Y. Treister. "Further Thoughts about the Necklaces with Butterfly-shaped Pendants from the North Pontic Area." *Journal of the Walters Art Gallery.* 55—56.

Treister 1998a. M. Treister. "Ionia and the North Pontic Area: Archaic Metalworking: Tradition and Innovation. The Greek Colonisation of the Black Sea Area." *Historia* 121: 179—99.

Treister 1998b. M. Y. Treister. A. V. Dmitriev, and A. A. Malyshev. "Bronzova'ia statuetka ellinistiche-skogo pravitelia iz raskopok poseleni'ia Myskhako pod Novorossii'skom." *RossA* 4: 160—71.

Treister 2001. M. Treister. *Hammering Techniques in Greek and Roman Jewellery and Toreutics.* Colloquia Pontica 8. Leiden, Boston, Cologne.

Trillmich 1974. W. Trillmich. "Ein Bildnis der Agrippina Minor von Milreu, Portugal." *MM* 15: 184—202.

Tsvetaeva 1966. G. A. Tsvetaeva. Keramicheskoe proizvodstvo. Nymphei//*SAI* G.1—20. Keramicheskoe proizvodstvo i antichye Keramicheskie stroitel'nye materialy. Moscow.

Tugusheva 2003. O. Tugusheva. *Attic Red-Figured Vases. CVA.* Pushkin State Museum of Fine Arts, Moscow, fasc. 6. Rome.

Tunkina 2002. I. V. Tunkina. *Russka'ia nauka o klassicheskikh drevnostiakh iuga Rossii (XVIII—seredina XIX v.).* St. Petersburg.

Tunkina 2003. I. V. Tunkina. *Russka'ia nauka o klassicheskikh drevnostiakh iuga Rossii (XVIII—seredina XIX v.).* St. Petersburg.

Vakhtina 2005. M. Yu. Vakhtina. "Grecheskoe iskusstvo I iskusstvo Evropei'skoi' Skifii." *Greki i varvary Severnogo Prichernomor'ia v skifsku'iu epokhu.* St. Petersburg. 297—397.

Valavanes 1991. P. Valavanes. *Panathenaikoi amphoreis apo ten Eretria: Symvole sten Attike angeio 4ou p.Ch. AI.* Athens.

Valdgauer 1945. O. F. Valdgauer. "Mif o gibeli Niobid v iskusstve V veka do kh. e." *TGE.* 5—45.

Vaulina and Wąsowicz 1974. M. Vaulina and A. Wąsowicz. *Bois grecs et romains de l'Ermitage.* Breslau.

VDI. Vestnik drevnei istorii. Moscow. [1938—].

Vestnik MGU. Vestnik Moskovskogo Gosudarst-vennogo Universiteta.

Vinogradov 1971. Y. G. Vinogradov. "Drevneishee grecheskoe pis'mo s ostrova Berezan'." *VDI* 4: 74—100.

Vinogradov 1989. Y. G. Vinogradov. *Politicheskaia istoriia Ol'viiskogo polisa VII—I vv. do n. e. Istoriko epigraficheskoie issledovanie.* Moscow.

Vinogradov 1994. Y. G. Vinogradov. "Ot Rindaka do Borisfena." *Arkheologi'ia* 2: 144—48.

Vinogradov 1998. Y. G. Vinogradov. "The Greek Colonisation of the Black Sea Region in the Light of Private Lead Letters." The Greek Colonisation of the Black Sea Area, Historical Interpretation of Archaeology. *Historia* 121: 153—78.

Vinogradov 1999. Y. G. Vinogradov. "Der Staatbesuch der 'Isis' im Bosporos." *Ancient Civilizations from Scythia to Siberia. An Internat-nional Journal of Comparative Studies in History and Archaeology.* Vol. 5.4: 271—302.

Vinogradov 2001. Yu. A. Vinogradov. "Kurgany varvarskoi znati V v. do n.e. v paione Bospora Kimmeriiskogo (Opyt interpretatsii)." *VDI* 4.

Vinogradov 2006. Y. A. Vinogradov. "Bospor Kimmeriiski': Osnovnye etapy istorii v dorimsku'iu epokhu." In *Greki i varvary na Bospore Kimmeri'skom. VII—I vv. do n. e.* Materialy Mezhdunarodnoi' nauchnoi' konferentsii. Taman' (Rossiia). October 2000. The State Hermitage Museum. St. Petersburg. 36—43.

Vinogradov and Kryžickij 1995. Y. G. Vinogradov and S. D. Kryžickij. *Olbia: Eine altgriechische Stadt im nordwestlichen Schwartzmeerraum. Mnemosyne,* suppl. 149. Leiden, New York, Cologne.

Vlasov 1960. V. D. Vlasov. "Dva pamiatnika grecheskoi skul'ptury v sobranii Odesskogo arkheologicheskogo muzei'a." *ZOAO* I, no. 34.

Vlasova 2001. E. V. Vlasova. "Sosudy v forme roga iz Semibratnikh kurganov." *Iuvelinoe iskusstvo i materialnaya kultura.* SPB. 20—27.

Vlasova 2004a. E. V. Vlasova. *Kurgany Vasiurinskoi' Gory.* BPh 2: 275—87.

Vlasova 2004b. E. V. Vlasova. "Kurgan Vasiurinska'ia Gora na Tamanskom po-luostrove." In *Ellinisticheskie shtudii v Ermitazhe.* St. Petersburg. 158–74.

Vollenweider 1969. M. Z. Vollenweider. "Un autre cachet de Δεξαμὲνος retrouvé." *Connaissance des arts* 213. November.

Voshchinina 1974. A. I. Voshchinina. *Le Portrait romain: Album et catalogue illustré de toute la collection.* Musée de l'Ermitage. Leningrad.

Voshchinina and Chodza 1971. A. Voščinina and E. Chodza. "Zwei Porträtstatuen aus Kertsch: Zu Stil und Datierung." In *Wissen-schaftliche Zeitschrift der Universität Rostock.* Rostock.

Waldhauer 1924. O. F. Waldhauer. "Ancient Marbles in the Moscow Historical Museum." *JHS* 44: 45–54.

Waldhauer 1929. O. F. Waldhauer. "Ein Askos aus der Sammlung Chanenko in Kiew." *JdI* 44: 235–66.

Waldhauer 1945. O. F. Waldhauer. "Mif o gibeli Niobid v iskusstve v veka do kh. e." *TGE* 1: 5–45.

Walker 1990. S. Walker. *Catalogue of Roman Sarcophagi in the British Museum.* Corpus of the Sculptures of the Roman World. Great Britain. Vol. 2, fasc. 2. London.

Walter-Karydi 1973. E. Walter-Karydi. *Samische Gefässe des 6. Jahrhunderts v. Chr.* Samos. Vol. 6.1. Bonn.

Wąsowicz 1998. A. Wąsowicz. "Bustes-minia-tures." In *Nécropoles et pouvoir: Idéologies, pratiques et interprétations.* Actes du Colloques Théories de la nécropole antique. Lyons 21–25 January 1995. Ed. S. Marchegay, M.-T. Le Dinahet, and J.-F .Salles. Travaux de la Maison de l'Orient Méditerranéen 27. 191–98.

Watzinger 1905. K. Watzinger. *Griechische Holzsarkophage aus der Zeit des Alexanders des Grossen.* Leipzig.

Watzinger 1946–47. K. Watzinger. "Theoxenia des Dionysos." *JdI* 61–62: 76–87.

Willers 1967. D. Willers. "Zum Hermes Propylaios des Alkamenes." *JdI* 82: 37–109.

Wilson 1997–98. J.-P. Wilson. "The 'Illiterate Trader'?" *BICS* 42: 29–53.

Winter 1894. F. Winter. "Mithridates VI Eupa-tor." *JdI* 9: 245–48.

Winter 1903. F. Winter. *Die Typen der figürlichen Terracotten.* Vol. 2. Berlin.

Zaitseva 1962. K. I. Zaitseva. "Mestnaia keramika Ol'vii ellinisticheskogo vremeni." *TGE* 7: 184–206.

Zhebelev 1901. S. A. Zhebelev. "Pantikapeiskie Niobidy." *MAR* 24.

Zhebelev 1923. S. A. Zhebelev. *Vvedenie v arkheologi'iu. Istori'ia arkheologicheskogo znani'ia.* St. Petersburg.

ZOAO. Zapiski Odesskogo archeologicheskogo obhchestva. Odessa.

Zograf 1951. A. N. Zograf. *Antichnye monety.* MIA 16.

ZOOID 1844. Zapiski Odesskogo *Obshchestva istorii i drevnostei.* Odessa.

Zwei Gesichter 1997. *Zwei Gesichter der Eremitage.* Vol. 1. *Die Skythen und ihr Gold.* Exh. cat. Bonn.

Contributors

ALEXANDER M. BUTYAGIN (A.B.)

Butyagin graduated from the archaeology section of the History Department of St. Petersburg State University in 1993 and that same year began working at the State Hermitage Museum. He is the head of the North Pontic Section of the Hermitage Department of Classical Antiquities and also director of the Museum's archaeological expedition at Myrmekion. In addition, he is a lecturer in archaeology and art history in the History Department of St. Petersburg State University and the author of more than seventy scholarly publications.

DMITRY E. CHISTOV (D.C.)

In 1993 Chistov graduated from the archaeology section of the History Department of St. Petersburg State University. He is now a researcher in the Department of Classical Antiquities of the State Hermitage Museum and curates archaeological materials from the kurgans of the Nymphaion necropolis. Since 2004 he has been director of the Berezan (Lower Bug) archaeological expedition of the Hermitage, exploring the ancient settlement on Berezan Island as well as the Olbian chora.

LYUDMILA I. DAVYDOVA (L.D.)

Senior researcher at the Hermitage Department of Classical Antiquities and a curator of Greek sculpture, Davydova is also an associate professor at St. Petersburg Academy of Fine Arts. There she obtained her Ph.D. with a dissertation on Bosporan grave reliefs from the second century B.C. to the second century A.D. Her research focuses on ancient sculpture of the fifth and fourth centuries B.C. and the culture and art of the Bosporan kingdom.

YULIA I. ILYINA (Y.I.)

A graduate of the Ancient Greece and Rome section of the History Department at St.

Petersburg State University, Ilyina has been working at the Hermitage since 1974. She is a senior researcher in the Department of Classical Antiquities and curator of the archaeological materials from the excavations in Olbia. She also participates in archaeological expeditions on the island of Berezan and at Nymphaion. Her scholarly focus is Archaic East Greek and Attic ceramics.

NADIA C. JIJINA (N.J.)

Senior researcher at the Hermitage Department of Classical Antiquities and curator of part of the Pantikapaion archaeological collection, Jijina graduated as archaeologist from St. Petersburg State University. Her scholarly interest concentrates on the archaeology and art history of the North Pontic area, particularly burial rituals, with an emphasis on the plaster ornaments of Bosporan wooden sarcophagi of the Roman period. She participated in the Hermitage excavations of ancient Nymphaion and its necropolis from 1973 to 1984. Together with colleagues Jijina arranged temporary exhibitions on sports and games in classical antiquity (1994) and on the history of Nymphaion (1999). As a member of the Greek Gold exhibition team (1994–95) she translated the greater part of the catalogue from English into Russian. From 1995 to 2004 she worked as a translator of scholarly texts for the Hermitage periodicals. Since 2003 she has been executive secretary of the editorial board for publishing popular literature at the Hermitage. She is also a lecturer on Greek and Roman art history at the History Department of St. Petersburg State University.

YURI P. KALASHNIK (Y.K.)

After studying classical archaeology at St. Petersburg State University, Kalashnik joined the staff of the State Hermitage Museum in 1965. He is currently curator of ancient monuments from Chersonesos and of jewelry from

the Pantikapaion necropolis. In the 1960s and 1970s he took part in the excavations on Berezan Island, in the Bosporan cities of Myrmekion and Nymphaion, and at Chersonesos. From 1979 to 1991 Kalashnik headed the Chersonesos expedition of the Hermitage, investigating the ancient and medieval periods of the city. He has written *Greek Gold from the Treasure Rooms of the Hermitage* (2004) and articles on Roman influence on the north coast of the Black Sea. He has curated "Two Faces of the Hermitage: Scythians and Their Gold" (Bonn, 1997) and "Greek Gold from the Treasury of the Hermitage" (Amsterdam, 2004).

NINA Z. KUNINA (N.K.)

After graduating from the History Department of St. Petersburg State University, where she specialized in the archaeology of the North Pontic region, Kunina worked at the Kerch Historical and Archaeological Museum. From 1957 to 1959 she did postgraduate studies at the State Hermitage Museum, and since 1960 she has been a senior researcher at the Hermitage Department of Classical Antiquities, and from 1992 to 2005 she was the head of the department's North Pontic section. Since 1958 Kunina has participated in the Nymphaion archaeological expedition of the Hermitage, and she is curator of the collections from the necropolis of Pantikapaion. She is a specialist in the archaeology of the Bosporan kingdom, with particular interest in ancient glass. She has been co-curator of many exhibitions of ancient art and culture at the Hermitage, at museums in Moscow and other Russian cities, as well as in several museums in other parts of the world. Kunina is the author of more than sixty scholarly works on Bosporan archaeology and ancient glass as well as a fundamental catalogue of the Hermitage collection of ancient glass (1997, both Russian and English editions).

LYUDMILA A. NEKRASOVA (L.N.)

As chief curator of the Hermitage Department of Classical Antiquities, Nekrasova is responsible for the department's entire collection. She herself is curator of gold jewelry from archaeological excavations in the Bosporan area. Nekrasova graduated from the Ancient Greece and Rome section of the History Department of St. Petersburg State University and has been working at the Hermitage since 1982. Her research focuses primarily on ancient jewelry of the Classical period.

OLEG Y. NEVEROV (O.N.)

Neverov graduated from St. Petersburg State University, where he majored in art history. He did postgraduate studies at the Hermitage and wrote a doctoral dissertation on Roman portraiture. He is now senior researcher in the Hermitage Department of Classical Antiquities and curator of ancient gems. He is a corresponding member of the German Archaeological Institute and on the editorial staff of the journals *History of Collecting* (Oxford) and *Jewelry* (London). Neverov has written more than a hundred scholarly articles.

ANNA E. PETRAKOVA (A.P.)

Petrakova graduated from St. Petersburg Academy of Fine Arts and obtained her Ph.D. in 2004 with a dissertation on problems of composition and decorum on Attic drinking-cups of the sixth and fifth centuries B.C. Since 2004 she has been a scientific member of the Hermitage Department of Classical Antiquities. Her scholarly interests are attribution and iconography of Attic vase-painting of the sixth and fifth centuries B.C.

OLGA Y. SOKOLOVA (O.S.)

Sokolova graduated from the archaeology section of the History Department of St. Petersburg State University. Since 1979 she has been working in the Hermitage Department of Classical Antiquities, where she is currently a senior researcher and curator of the Nymphaion excavations collection. She has been director of the Nymphaion archaeological expedition of the Hermitage since 1991. Her scholarly interests are the archaeology of the North Pontic region, the Bosporan kingdom, Hellenistic ceramics, and architecture.

SERGEI L. SOLOVYOV (S.S.)

Solovyov graduated from St. Petersburg State University with a major in classical archaeology. Since 1981 he has been working in the Hermitage Department of Classical Antiquities. He received his Ph.D. in 1990. He is the director of the integrated archaeological antiquities expedition of the Hermitage.

ANNA A. TROFIMOVA (A.T.)

An art historian and the head of the Hermitage Department of Classical Antiquities, Trofimova's main scholarly fields are Greek and Roman portraiture, Hellenistic art, and museology, especially the refurbishment of old museums and their displays. She has directed the projects of the reconstruction and rearrangement of the ancient art galleries in the Hermitage. She has curated several exhibitions, including one on the Stroganoff collection, "Stroganoff: The Palace and Collections of a Russian Noble Family" (Portland Art Museum and Kimbell Art Museum, Fort Worth, 2000), "The Road to Byzantium: Luxury Art from Antiquity in the Hermitage Rooms in Somerset House" (London, 2006), "Alexander the Great: March to the East" (The Hermitage Museum, 2007), and the present exhibition.

LYUBOV' M. UTKINA (L.U.)

Utkina graduated from St. Petersburg State University and has been working in the Hermitage Department of Classical Antiquities since 1968. She has been the curator of Attic vases since 1979, specializing in the problem of authentication.

ELENA V. VLASOVA (E.V.)

Since graduating from two sections of the History Department of St. Petersburg State University—those of archaeology and of the history of Ancient Greece and Rome— Vlasova has been working in the Hermitage Department of Classical Antiquities. Her main scholarly interests focus on North Pontic classical antiquity, especially bronzeware and Graeco-Scythian contacts. In her studies Vlasova also pays special attention to the history of archaeological investigations in the Kerch peninsula in the nineteenth century.